A £4 50

3

A £4 50

Masterpieces of Glass

A selection compiled by D. B. HARDEN, K. S. PAINTER, R. H. PINDER-WILSON, HUGH TAIT

Published by the TRUSTEES OF THE BRITISH MUSEUM, *London 1968*

Paper : SBN 7141 0014 5

Cloth : SBN 7141 0016 1

Printed in Great Britain by Alden & Mowbray Ltd at the Alden Press, Oxford

CONTENTS

PRE-ISLAMIC PERSIAN AND MESOPOTAMIAN, ISLAMIC AND CHINESE by R. H. PINDER-WILSON

EUROPEAN: MIDDLE AGES TO 1862 by HUGH TAIT

FOREWORD

This exhibition of outstanding pieces of glass, entirely from the collections of the British Museum, has been mounted on the occasion of the Eighth International Congress of Glass held in London from 1st to 6th July, 1968. The display has been deliberately restricted to fewer than 300 items, but it ranges in date from the earliest glass produced in Egypt in the middle of the 15th century B.C. to European productions of the 18th century.

The choice of the pieces was made in the Departments of Egyptian, Western Asiatic, Greek and Roman, Oriental and British and Medieval Antiquities; Dr. Donald Harden, Director of the London Museum, has been closely associated with the preparation of the exhibition throughout, and has not only given invaluable assistance but has contributed notably to the catalogue; Miss Margaret Hall, the Museum's Exhibitions Officer, has been responsible for the display, and Mr. Henry Jacob, the Museum's Publications Officer, for the production of the catalogue. The exhibition has been organized under the general supervision of Dr. A. E. Werner, Keeper of the Research Laboratory, and Chairman of the Papers Committee of Section B of the International Congress.

The Trustees of the British Museum are most grateful to Lord Pilkington and the firm of Pilkington Brothers for a substantial donation towards the cost of setting up the exhibition.

SIR FRANK FRANCIS
Director and Principal Librarian

April 1968

ABBREVIATIONS

B.M. Dept.: Department of British and Medieval Antiquities

E. Dept.: Department of Egyptian Antiquities

G.R. Dept.: Department of Greek and Roman Antiquities

Or. Dept.: Department of Oriental Antiquities

W.A. Dept.: Department of Western Asiatic Antiquities

D: Diameter

G: Greatest

H: Height

L: Length

T: Thickness

W: Width

SOME TECHNICAL TERMS

BASE-RING: A separate ring of glass added to the base after the main body of the vessel is formed

BLOW-PIPE: Hollow metal pipe for blowing glass

BUBBLES: Internal pockets of gas trapped in the metal during manufacture

COIL-BASE: A trail or coil drawn on, forming a ring on which the vessel stands

CRIZZLING: A state of deterioration in the chemical make-up of the glass resulting in the tears of alkaline moisture forming on the surface—often referred to as 'weeping' or 'sweating'

FROSTING: A network of small cracks on the surface of the glass

GROZING: Flaking an unworked rim or edge of a piece of glass by nipping with a pincer-tool

IRIDESCENCE: A rainbow-like effect on the surface of the glass due to the presence of very thin layers of weathering

KICK: A deep concavity in the base where pushed in by a tool

MARVER: Flat surface of stone or marble on which the vessel is rolled during manufacture

METAL: The substance, glass, both in its unworked state and after being worked up into objects

PAD BASE: Part of a second bulb of glass applied to the under part of the vessel and splayed out to form a ring

PONTIL: Solid metal rod, tipped with a wad or ring of hot glass, applied to the base to hold the vessel during manufacture. It often leaves an uneven scar or a ring-mark on the base when removed—hence 'pontil-mark'

STRAIN-CRACKING: Internal cracks in the wall of a vessel caused by strains and usually brought about by faulty annealing

TRAIL: A strip of warm glass dropped on and drawn out vertically, or else horizontally (in a single revolution) or spirally (in several revolutions) round the vessel

WEATHERING: Changes on the surface of the glass produced by exposure to adverse conditions which appear as dulling, frosting, iridescence and milky or enamel-like decomposition

NOTE: A bewildering number of old names (mainly German) for a vast variety of glass vessels occurs in post-medieval records but few can be translated into English—indeed, the meaning of most of them is not clear, even in German. Few can now be recognized and only the more generally accepted names have been used in this catalogue.

PRE-ROMAN GLASS Historical Introduction

by D. B. Harden

Recent research has made it clear that glass originated in western Asia rather than in Egypt. The earliest use of glass as an independent substance (as distinct from vitreous glaze on a stone or other base) seems to date from somewhere in the 3rd millennium B.C., and there is evidence for glass-making in Mesopotamia, and possibly also in the Caucasus, by 2000 B.C. For several hundred years thereafter only small objects, mainly beads, were made, and vessels do not occur much before *c*. 1500 B.C. A number of western Asiatic sites, such as Atchana/Alalakh, Nuzu, Assur and, most recently, Tell al Rimah, have produced fragments of vessels in strata of the late 16th and early 15th centuries B.C., whereas in Egypt vessels first occur during the reign of Tuthmosis III (1504–1450 B.C.). That monarch's Asiatic conquests began in 1481, and it seems reasonable to assume that one of their results was the foundation of a glass-vessel industry in Egypt by Asiatic workers during the 2nd quarter of the 15th century. One little jug bearing Tuthmosis III's cartouche is exhibited (no. 1) and his cartouche also occurs on two other vessels, one in Munich and the other in New York, indicating, perhaps, that this new industry was particularly anxious to honour the pharaoh that gave it birth (for there is no evidence that any of the three was Tuthmosis's personal property).

For two or three hundred years thereafter glass-working flourished both in Mesopotamia and in Egypt, and there may also have been workshops in Cyprus and the Aegean. After 1200 B.C. the disasters which ended the bronze-age civilization throughout the area introduced a period of near-anarchy. Production of glass vessels almost ceased and did not become active again until the 9th century, when the rise of new monarchies and their cultures revivified the market. Beads, seals and trinkets, however, continued to be made, especially in Syria, during the intervening years.

Curiously enough, the renascence of the industry took place in Asia only, not in Egypt; after the 11th century no glass vessels seem to have been made in Egypt until the famous Alexandrian workshops (p. 12) were founded in Ptolemaic times. In Asia, from the 9th century onwards, there were two main centres of manufacture, the Syrian coast and Mesopotamia. These centres were probably distinct, concentrating on different products for the tastes of different kinds of customers. It is likely, however, that both were under the influence of, if not staffed by, Phoenicians, and it was Phoenician traders who spread their products throughout the ancient world. By the 7th or the 6th century more westerly manufacturing centres may have grown up, especially in Rhodes (no. 12, from Camiros, may be a local Rhodian product), in Cyprus, and maybe in Greece itself. There was also an independent glass industry in Italy from at least the 9th century B.C. onwards, making beads and brooch-runners (no. 41) and even little vessels imitated from Greek shapes (no. 16), and either this industry itself, or its products, spread to the head of the Adriatic and Hallstatt in the 5th century B.C.

Towards the end of the 4th century, as a result of the political and economic consequences of Alexander's conquests, great changes took place in the relative importance of the former glass-making centres. After the disruption of the Achaemenian empire (which had produced much fine glassware) Mesopotamia virtually fades out of the picture for some centuries. The Syrian shops, on the other hand, prospered, developing particularly the manufacture of plain, moulded monochrome bowls of various colours. Egypt, too, once more came into prominence

with the foundation of the famous glass-works at Alexandria, the great metropolis of culture, learning and industry founded by Alexander in 332 B.C. No doubt Asiatic workers migrated hither to found these workshops soon after the city's foundation and the shops quickly began to pour out quantities of the finest glassware. Alexandrian glass was exported widely and much of the best glass of Hellenistic date found in Greece and Italy undoubtedly came from that centre.

Thus it was the Syrian coast and Alexandria which were the main centres of the Hellenistic glass industry. No doubt, however, as the occasion and need arose, workers migrated to set up shops elsewhere. This certainly happened in Italy after the republican Romans developed a strong taste for eastern luxuries from the 2nd century B.C. onwards. The Hellenistic techniques were probably brought to Italy in the 1st century B.C., if not earlier, by Alexandrians, who set up shops in Campania and, maybe later, near Rome itself. The Syrians, it would seem, did not come in force until later, after blowing was invented (p. 36), when they opened up glass-works in north Italy.

Techniques in Use during the Period

During this pre-Roman stage of the glass industry, before the blow-pipe came into use (p. 36), four techniques for making glass vessels were employed, and each one of them, as is evident from recent research, was already current before the end of the 15th century B.C. These techniques were:

 A. fashioning from molten glass on a core,
 B. building from sections of coloured rods on a core, or base,
 C. grinding and cutting from a raw block of glass,
 D. casting in closed or open moulds.

A. Fashioning from molten glass on a core. The majority of pre-Roman vessels now extant were made by this process. It could be used only for narrow-mouthed shapes. A modelled core[1] was fixed on a metal rod and then dipped in molten glass to collect enough to make the neck and body of the vessel. The outer surface was then smoothed on a flat stone slab ('marver') and, usually, coloured trails or blobs were added and pressed into the surface by further marvering. If required, the trails were combed one way or two ways, to make a festoon or zigzag pattern before the final marvering. Handles and footstands were then added, if the shape required them, and finally the rod and its core were removed and a rim trailed on and fashioned.

Core-made vessels normally averaged no more than 10–20 cm. in height, though a few much larger ones exist from Egyptian royal tombs. They were used for unguents and scents. The finest examples, in colour, shape and design, are those from the Egyptian workshops of the 18th and 19th dynasties, seven examples of which are exhibited (nos. 1–7). Note, particularly, (*a*) the little jug (no. 1) with the cartouche of Tuthmosis III, which is unique in that most of its decoration is executed in yellow and white powdered glass, fired on, but not fused, though the rim, base and handle carry the more normal trailed decoration; and

[1] It is now certain that whatever these cores were made of it was *not* sand. They seem rather to have been built of mud, with straw, perhaps, as a binder.

(*b*) the bottle in the shape of a fish (no. 6) from el Amarna, the new city founded by Akhenaten (1379–1362 B.C.).

Egyptian glasses of this kind were exported to Syria and the Levant and a number of them, most probably made in Egypt, were found at Enkomi in Cyprus (no. 8) and at Ras Shamra, for example. The core technique was also current in Mesopotamia (no. 9, from Ur), where the shapes are sufficiently distinct from those of Egypt to indicate independent workshops.

After *c.* 1200 there is a gap of several centuries before core-made glasses again appear in any quantity. The technique must have been preserved in Mesopotamia, and maybe in Syria too, however infrequent its use, during this intervening period, and when it was developed commercially again, in the 7th century, its headquarters was in the Levant, organized by and for the Phoenicians. The shapes are now quite different, and in the 6th and 5th centuries are based on the four well-known Greek shapes of alabastron, oinochoe, amphoriskos and round aryballos (nos. 10–15). Note the little stand of colourless glass on which no. 15 rests, which comes from the same tomb at Camiros and was probably intended to be used with it. Shapes degenerating from these were common in the 4th and 3rd centuries (though none is here exhibited), and then in the 2nd and 1st centuries new shapes, based on contemporary late Hellenistic ones, took their place, such as the amphoriskoi (nos. 17, 19), of shapes current in large wine amphorae of the time, and the fusiform alabastron (no. 18). Core-forming, in these shapes, was in use also in Italy from the 7th century B.C. onwards, as witness the rather crude little oinochoe (no. 16) with drawn-out spikes on its body, of a type which occurs only in Italy and must have been made somewhere in that peninsula.

B. Building from sections of coloured rods on a core, or base. This is the mosaic-glass technique. Until recently it had not been recognized as one of the earliest methods of making glass vessels, but finds at al Rimah and 'Aqar Quf (Dur Kurigalzu) in Mesopotamia, and Marlik and Hasanlu in north-west Iran have shown that it existed from the 15th century B.C. onwards. Most of these early examples are made up of circular sections of monochrome rods of various colours, though at least one fragment from 'Aqar Quf is built of sections of polychrome rods. Of these early examples we can show only one fragment from al Rimah (no. 20). The vessels were high beakers, usually with knobbed bases, or shallow dishes, and they were made by laying the sections out on a core of the shape of the inside of the required vessel, the sections being loosely fixed together with some adhesive substance. An outer mould was then applied to keep the sections together during fusion. When released from the mould the surfaces of the vessel were ground smooth (see C, below).

This technique apparently remained in use in western Asia during Assyrian and Achaemenian times, and we may guess that Asiatic workers introduced it to Alexandria when they set up shops there. They thus laid the foundation for the widespread production of mosaic vessels at that centre and, later, in Italy, down to the 1st century A.D., and also for the parallel production of fused mosaic plaques, with patterns built up from sections of mosaic rods, for which the Ptolemaic shops in Alexandria were equally famous. There is one fine mosaic dish (no. 21) in the group of glasses from a tomb at Canosa of the late 3rd century B.C. which almost certainly came from Alexandria, and one or two later examples are also exhibited (nos. 43, 44), as well as four pieces of fine inlay of Ptolemaic date (nos. 22–25), and one piece of the 1st or 2nd century A.D. (no. 56). All these,

too, had their surfaces ground smooth to give them their final finish (see C, below).

C. Grinding and cutting from a raw block of glass. This, which may be called more simply 'cold-cutting', is a transference of the stone-cutter's art to glass, which, with a hardness of about 6, can be readily cut or ground by harder materials such as quartz or flint. At times this technique was used for fashioning glass vessels and objects from a raw block of glass which had not previously been cast, but more often it was brought into use for finishing glass objects and vessels which were first made in the rough by casting. The technique was in use from the beginning, but it was not until the 8th century B.C. that it became at all common. Thereafter it was one of the main methods used for finishing the finest, and especially colourless, glassware in Assyrian, Achaemenian and Hellenistic times.

Three vessels made from a raw block of glass by grinding and polishing are shown. The earliest is the Egyptian ointment-pot of blue glass with gold plating at the edges (no. 26). The second, and most interesting, is the alabastron, no. 27, from Nimrud, inscribed with the name of Sargon II (722–705 B.C.) and thus firmly belonging to the late 8th century B.C. It shows clearly, inside, the spiral grooving left by the grinding tool, presumably a flint scraper. The third is the tall alabastron, no. 29, of sea-green glass, which must belong to the late 7th or 6th century B.C. The dark blue head of a staff (no. 28), Assyrian of the 8th to 7th century B.C., is a fourth example of this same technique, the hole ground out for the handle being of comparatively small diameter.

D. Casting in closed or open moulds. This method, borrowed from workers in pottery and faience, was used both for vessels and for solid objects such as inlays, ornaments and statuettes. The vessels so made were, perforce, open ones, such as jars, bowls and dishes, and the casting was done by the *cire perdue* process (pouring in viscous glass after the wax form was melted out), or by fusing powdered glass *in situ* between two parts of a closed mould (Schuler (1959)). Objects which required to be shaped on one side only (such as the flat-backed Astarte figurine from Atchana/Alalakh, no. 32) were pressed in open moulds, while those which are modelled in the round were cast in two-piece moulds. Two plain cast bowls are exhibited, no. 30 from Nimrud of the 8th or 7th century B.C., and no. 33 in the Canosa tomb-group of the late 3rd century B.C.

E. Miscellaneous. Three glasses that have been finished by grinding and cutting (C, above) after their shape had been cast in a mould (D, above) are in the Canosa group already mentioned. The colourless dish (no. 35) is ground smooth all over and has horizontal cut lines near its rim; the hemispherical bowl with bosses (no. 36) and the two-handled colourless cup (no. 37) show marks of the grinding-wheel all over their surfaces inside and out, and the bosses and petals on the one and the handles on the other, though perhaps cast in the rough (the handles perhaps as solid lugs), have without doubt been given their final form by cutting and grinding. Akin in its mixture of techniques to the bowl with bosses and the large colourless dish from Canosa, but probably several centuries earlier in date, is no. 34, the shallow bowl with flower petals in relief on the exterior. There are also examples among the early Roman glasses (nos. 44, 47, 48, 50, 51) illustrating this same mixture of techniques.

Five items—three vessels (nos. 38–40), a brooch runner (no. 41) and a set of game-pieces (no. 42)—remain to be mentioned.

Among the vessels let us take first the one which is perhaps the finest example of glass-making in this whole pre-Roman group, the sandwich gold-glass bowl from the Canosa tomb (no. 38). This piece, fine though it is, is not unique. It has a less well-preserved twin from the same tomb and other parallels come from Gordion, Tresilico in Calabria and elsewhere. The design of its gold-work suggests that it cannot be later than the late 3rd century B.C., the free-flowing foliage being typical of early Hellenistic art. It was, therefore, made long before blowing was invented (towards the end of the 1st century B.C., see p. 36) and it must have been formed by two castings, one inner and one outer, that were so carefully ground and polished that the outer fitted the inner like a glove. After the inner casting was finished and polished, the gold decoration was applied to it and then the outer casting was set in place. This outer casting reaches only to the bottom of the neck of the inner one, where it seems to have been lightly fused to it along its edge, to hold it in place. It is truly a *tour de force* of glass-making. The other two vessels are both alabastra and belong to the 2nd or 1st century B.C. One (no. 39) is built up of an opaque white section between blue ones, perhaps in a mould, and was finished by grinding and polishing. The other (no. 40) is of an elaborate technique that is difficult to fathom. It may have been core-built, first, like the mosaic glasses, then manipulated to produce the wavy effect, and perhaps then cast a second time into its final bullet-shaped form. This piece is one of the 'gold-band' glasses, so named because they contain in their decorative make-up bands of gold foil between layers of colourless glass.

The brooch-runner (no. 41), with its brooch, comes from Italy, and is of a type which, though common in that country, is rare, if not unknown elsewhere. It must therefore have been made locally, and since the series of brooches on which such runners occur begins no later than the 9th century B.C., it is clear that glass-working[1] had taken root in Italy by that time. The set of game-pieces (no. 42)—a new find of 1965—would appear to be unique in its completeness, and unique also in its individual components, for not even one single parallel piece has yet been located. Since the date of its deposition in the Welwyn burial (last quarter of the 1st century B.C.) puts it at the very end of our series, we make no excuses for placing it here as our tail-piece to this section of the Catalogue.

[1] In this instance glass-working is the safer term to use, rather than glass-making, for it may well be that the glass for small objects like this was imported in prepared ingots, and not made on the spot.

A. VESSELS FASHIONED FROM MOLTEN GLASS ON A CORE

i. 2ND HALF OF 2ND MILLENNIUM B.C.

1. One-handled Jug with Name of Tuthmosis III (c. 1504-1450 B.C.)

E. Dept. 47620 (O.C. 196) / 2nd qtr. 15th century B.C. / From Egypt.

Opaque light blue, with yellow, white, and dark blue opaque trails and white and yellow powdered glass fired on. Rim flat on top, with roll-moulding at edge formed by a yellow band trailed on; neck tapers downward to angular junction with shoulder; tall ovoid body; flattened base with yellow roll-moulding at edge; flat drawn handle from underneath rim to shoulder. On neck and body matt linear design in fired powdered glass: on neck, double band of yellow scales; at junction of neck and shoulder, band of white dots between yellow horizontal lines; on shoulder, hieroglyphic inscription,

𓊪 𓈖 𓆣 𓅓 𓏏𓊪

'The good god Men-Kheper-Rē, given life', yellow, flanked by scalloped pattern of white and yellow dots; on body, three vertical palm leaves, yellow. On handle, transversely, three pairs of white and dark blue marvered trails, with single yellow trails in the intervals between these pairs.

Core-formed, with ground and polished surface on rim and underneath base; intact and unweathered; some bubbles and sandy impurities.

H, 0.088m. GD, 0.038m.

BIBLIOGRAPHY: Dillon (1907), p.30; Kisa (1908), p. 39f., fig. 2; Wallis Budge (1925), p. 391; Harden (1933), p. 420, fig. 1; Fossing (1940), p. 10, fig. 3; Harden (1956a), pp. 320, 341, pl. 24, D; Haberey (1957), p. 507, fig. 5 (colour); Barag (1962), p. 24; Forbes (1966), fig. 21.

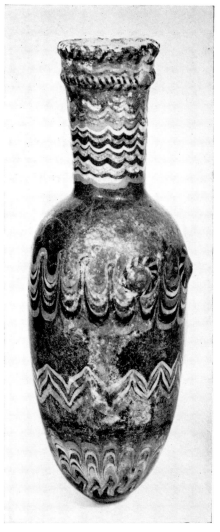

2

2. Tall-necked Bottle

E. Dept. 4739 (paper label S250) / 2nd half of 15th century B.C. / From Egypt.

Opaque royal blue, with black, white, yellow and turquoise opaque trails. Plain rim with a twisted black and white unmarvered trail at edge and another, the same, 0.01m. lower down; neck tapers slightly downwards to obtuse-angled junction with shoulder; elongated ovoid body with rounded base. On one side of shoulder are two raised 'eyes' close together, each composed of a yellow dot on a royal blue ground, ringed by a black and white twisted trail. On neck, a festoon pattern, combed upwards, of white, turquoise and yellow, alternating; on body, three bands of trails: (a) in festoon, combed upwards, yellow, white, turquoise, white, black and yellow; (b) in zigzag, combed two ways, white, turquoise, white and yellow; (c) in inverted festoon, combed downwards, black, turquoise, yellow, white, yellow and turquoise.

Core-formed; intact; enamel-like film, with some pitting, which has left iridescent surface in places.

H, 0.155m. D rim, 0.034m. D body, 0.052m.

BIBLIOGRAPHY: Steindorff (1900), fig. 115; Barag (1962), p. 24, fig. 12; Neuburg (1962), pl. 3.

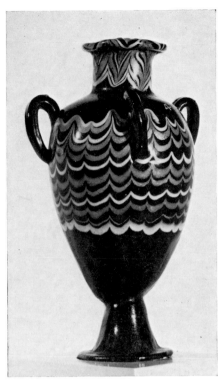

3

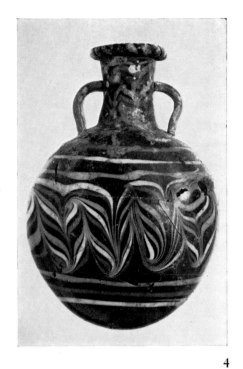

4

sumably refers to a sale of 1837; but details of the sale have not been traced.

BIBLIOGRAPHY: Wallis Budge (1925), p. 391; Fossing (1940), p. 16, fig. 8.

4. Lentoid Two-handled Flask

E. Dept. 64338 (90.11–8.1) / Mid to late 18th dynasty / From Egypt.

Translucent wine-coloured, with opaque turquoise handles, and yellow, white and turquoise opaque trails. Vertical rim, smoothed in flame, with bichrome twisted trail (white and wine-coloured) at edge; cylindrical neck joining shoulder in gentle curve; flattened globular body of 'pilgrim-flask' form with convex bottom. From neck to shoulder two vertical trailed handles, with alternating vertical ribs of yellow and turquoise. On neck, a fern-leaf pattern of alternating trails of turquoise, white and yellow; round the middle of the body, same pattern, same colours, with, above and below, three horizontal trails, one of each colour.

Core-formed; broken and mended, some tiny fragments missing; band of pitted weathering on neck and one side.

H, 0.101m. D rim, 0.028m. D body (max.), 0.068m. D body (min.), 0.038m.

BIBLIOGRAPHY: Dillon (1907), pl. ii, 1, and p. 23.

3. Ovoid Four-handled Necked and Footed Jar

E. Dept. 4743 (37.7–14.155) / Mid to late 18th dynasty / From Memphis / Purchased (Burton collection).

Opaque navy blue with white, yellow and turquoise opaque trails. Outsplayed rim with neck trails running over on to it; cylindrical neck, joining shoulder at sharp angle; elongated ovoid body; tall, hollow stem with splayed footstand. On shoulder, three (originally four) vertical trailed handles, navy blue. On neck, a fern-leaf pattern of alternating trails of white, yellow and turquoise; on body, a festoon pattern, combed upwards, of the same.

Core-formed; rim, stem and handles added to the body before core removed. A rough edge inside the rim, caused by core-forming, is still visible. One handle missing; some dulling of surface.

H, 0.101m. D rim, 0.029m. D body, 0.049m.

Register (B.M. Dept.) gives no find-place for 37.7–14.155 (i.e. acquisition no. 155, 14 July, 1837), but says, 'Bt. at Sotheby's Sale . . . lot 341'. This pre-

5. Lentoid Two-handled Flask

E. Dept. 29210 (97.5–8.48) / Mid to late 18th dynasty / From Egypt.

Opaque greenish-grey body and handles, with black and white opaque trails (rim only). Vertical rim, smoothed in flame and slightly outsplayed, with bichrome twisted trail of black and white at edge; shape of flask as no. 4, but body more globular. Two vertical drawn handles from neck to shoulder.

Core-formed; broken and mended, chips out of rim, half of one handle and part of side of body missing; surface dulled; very bubbly and many black impurities.

H, 0.127m. D rim, 0.048m. D body (max.), 0.084m. D body (min.), 0.058m.

BIBLIOGRAPHY: Wallis Budge (1925), p. 392.

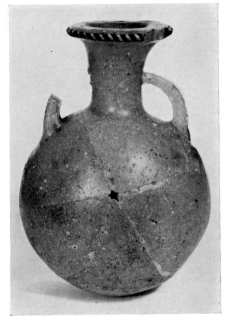

5

6. Bottle in Shape of Fish

E. Dept. 55193 (1921.10–8.127) / Late 18th dynasty / From El-Amarna, 1921 / Given by the Egypt Exploration Society.

Opaque sky blue, with white and yellow opaque trails, and a few opaque turquoise on the fins; eye-disks opaque black and white. Fish fully fashioned in the round, with hollow body. Mouth open and circular, with yellow trail round the edge; eye-disks formed of black spirals intertwined with white and linked all round the neck by a yellow trail; on body, white and yellow trails combed towards mouth; tail bifid and has mainly yellow, but also two white, trails combed as on body. The large dorsal fin is a mixture of sky blue, yellow, turquoise and white; the small pectoral fins each side of body are sky blue and turquoise; the pelvic pair of ventral fins are white and yellow, the anal pair of ventral fins are turquoise.

Core-formed; tail pressed out from body; fins trailed on; broken and mended, two tiny holes; milky surface film with some pitting and iridescence; bubbles and some impurities.

L, 0.141m. W, 0.069m. T, 0.036m. Inner D of mouth, 0.014m.

BIBLIOGRAPHY: Peet and Woolley (1923), 1, p. 24, pl. 12, no. 3; Wallis Budge (1925), p. 391; Dölger (1927), pl. 140, no. 5; Fossing (1940), p. 18, fig. 10; Haberey (1957), p. 507, fig. 6 (colour).

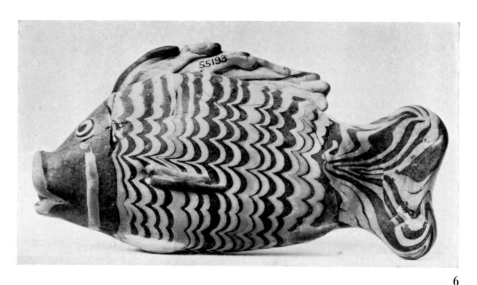

6

7. Bottle in Shape of Palm-leaf Column

E. Dept. 64334 (82.5–10.2) / Late 18th dynasty / From Egypt.

Opaque navy blue with white and yellow opaque trails. Holed mouth, slightly raised above a ring of nine palm leaves which spreads around it, curving outwards, representing the capital of the column. Upper half of column-shaft expands downwards, lower half cylindrical; footstand slightly splayed; inside of body cylindrical. Round the rim a white trail, round the leaf tips a yellow one; at base of capital a five-spiral unmarvered white trail; on lower half of column-shaft, two bands of trails, the upper fern-leaf, the lower upward-combed festoons, each band mainly white, but yellow at top and bottom, and in the middle; at edge of footstand, an unmarvered white trail.

Core-formed; tip of one leaf missing; milky film over most of surface.

H, 0.103m. D across top, 0.035m. D base, 0.025m. Inside D of body, 0.012m. Inside H of body, 0.082m.

BIBLIOGRAPHY: Neuburg (1962), pl. 4, *a*.

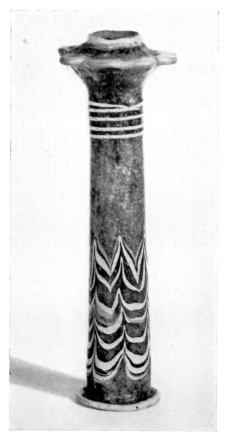

7

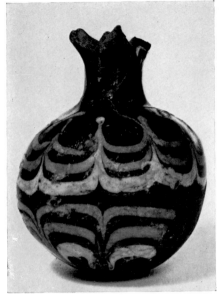

8

8. Bottle in Shape of Pomegranate

G.R. Dept. 97.4–1.1052 / 14th or 13th century B.C. / From Enkomi, Cyprus, tomb 66 / B.M. excavations, 1893–94; Miss E. Turner bequest.

Transparent amber, with blue, yellow and white opaque trails. Rim formed by a ring of six triangular fronds, outsplayed; neck concave; body spherical with rounded bottom. On body, two bands of blue, yellow and white trails, the upper band combed upwards into a festoon, the lower downwards into an inverted festoon.

Core-formed; half extant only, remainder restored in plaster, some tips of the rim-fronds missing; dulled.

H, 0.078m. D, 0.07m.

BIBLIOGRAPHY: Murray, Smith, and Walters (1900), pp. 24, 35–6, fig. 63.

9. Long-necked Ovoid Bottle

W.A. Dept. 120659 (1928.10–9.147) / Kassite period, c. 1300 B.C. / From a Kassite grave at Ur / British Museum and University of Pennsylvania excavations, 1926–27.

Opaque white body with opaque turquoise trails. Rim outsplayed and slightly thickened; cylindrical neck meeting shoulder in splayed, unbroken curve; ovoid body with pointed base. Turquoise trails combed to zigzag all over neck and most of body, except near base, where the lines are wavy only. This combing has left vertical ribs on neck and body.

Core-formed; fragmented and now much misshapen owing to rebuilding on a plaster core with wax infilling; turquoise colour well preserved but milky in patches, the white ground is partly weathered to a blackish tinge.

H, 0.113m. D rim, 0.032m. GD, 0.053m.

BIBLIOGRAPHY: Woolley (1927), p. 387; Fossing (1940), p. 31f., fig. 20; Harden (1956a), p. 319, fig. 294; Barag (1962), p. 18, fig. 8 (who states wrongly that the ground colour is brown); Woolley (1962), p. 131, pl. 29a (where it is suggested, wrongly, that the bottle might be Neo-Babylonian: see Barag (l.c.) for discussion of date and parallels); Neuburg (1962), pl. 17.

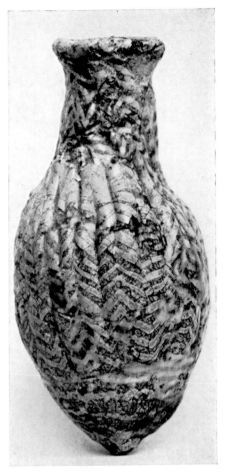

9

10. Alabastron

G.R. Dept. 78.12–30.3 / 6th to 5th century B.C. / J. Henderson bequest.

Dull green body and handles, with yellow and light blue opaque trails and one thin opaque red trail. Broad rim, flattened on top; short cylindrical neck; rounded shoulder; cylindrical body, widening a bit near bottom where it curves in to a convex base. Below shoulder, two vertical drawn ring-handles with tails. At rim, mixed yellow and light blue trails; on body, yellow spiral trail, horizontal above, then zigzag, below which is one zigzag light blue trail flanked by a thin red one; at bottom, a double band of mixed yellow and light blue trails.

Core-formed; part of rim trail missing; almost unweathered; very bubbly.

H, 0.088m. D rim, 0.03m. GD body, 0.026m.

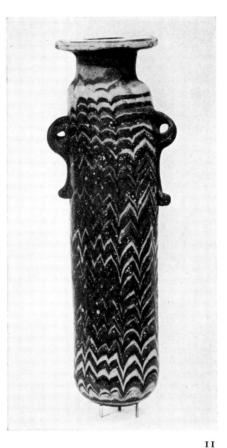

11

11. Alabastron

G.R. Dept. S15 / 6th to 5th century B.C. / Bequeathed by Felix Slade, 1868.

Opaque red body and handles with light blue and yellow opaque trails. Shape as no. 10. At rim, band of mixed yellow and light blue trailing; on body, and running over basal angle, mixed zigzag trailing of the same, combed two ways into zigzag.

Core-formed; intact (rim repolished in recent times?); almost unweathered; bubbly.

H, 0.10m. D rim, 0.028m. GD body, 0.023m.

BIBLIOGRAPHY: Nesbitt (1871), p. 5, no. 15, coloured pl. I, 3.

10

12. Oinochoe

G.R. Dept. 64.10–7.61 / 5th century B.C. / From Camiros, Rhodes, Fikellura tomb 242, c. 460–440 B.C. / B.M. exca-

vations by Salzmann and Biliotti, 1863–64.

Translucent dark blue body and handle, with light blue and yellow opaque trails. Pinched-in ('trefoil') lip; short cylindrical neck; ovoid body; splayed footstand. Vertical handle drawn on from underneath rim to shoulder. On edge of lip and round middle of neck, single light blue trails; on bulge of body, yellow spiral trail, horizontal above, zigzag lower down, where a light blue spiral mingles with it; on lower body, three single trails, yellow, blue and yellow; at edge of footstand, blue trail; at base of handle, flat disk of light blue with yellow spiral trail on surface. The trails on lip, neck and footstand and the handle-disk are unmarvered.

Core-formed; intact; some iridescence.

H, 0.105m. D, 0.068m.

BIBLIOGRAPHY: Haevernick (1960), p. 57f., pl. xi, no. 3. For the Fikellura excavations and the other contents of tomb 242, see Higgins (1954), pp. 30, 86, 92.

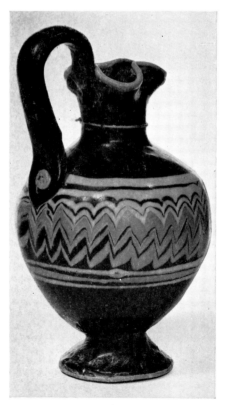

12

13. Amphoriskos

G.R. Dept. 78.12–30.11 / 6th to 5th century B.C. / J. Henderson bequest.

Opaque white body and handles, opaque wine-coloured trails. Splayed rim; short cylindrical neck; ovoid, ribbed body; disk base-knob. Two vertical drawn handles from underneath rim to shoulder. At edge of lip, single wine-coloured trail; on body, continuous spiral of the same, horizontal above, zigzag lower down, the combing for which has left vertical ribs on body. Lip trail unmarvered.

　Core-formed; complete, broken and mended; some iridescence and incipient strain-cracking; bubbly.

H, 0.116m. D, 0.06m.

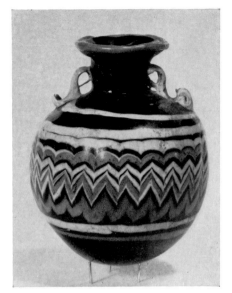

14

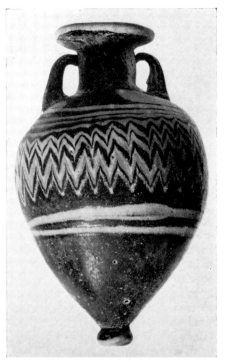

14

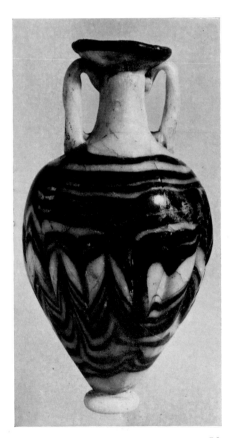

13

14. Round Aryballos

G.R. Dept. 78.12–30.10 / 5th century B.C. / J. Henderson bequest.

Transparent dark blue body, opaque yellow handles, light blue and yellow opaque trailing. Splayed rim; short cylindrical neck; globular, ribbed body. Two vertical drawn ring-handles with tails from underneath rim to shoulder. At edge of lip, light blue trail; on body, mixed light blue and yellow spiral trails, horizontal at top and bottom, zigzag in middle. The combing for the zigzag has left faint vertical ribs on body. Lip trail unmarvered.

　Core-formed; intact; some surface dulling.

H, 0.061m. D, 0.046m.

15

15. Amphoriskos and Stand

G.R. Dept. 64.10–7.1198 and 2006 / 1st half of 5th century B.C. / From Camiros, Rhodes, Fikellura, tomb 254, with Attic vases and other objects, including a similar amphoriskos and stand, 64.10–7.67 and 2007, *c.* 475–50 B.C. / B.M. excavations by Salzmann and Biliotti, 1863–64.

Amphoriskos (1198)
Blue body and handles, light blue and yellow opaque trails. Splayed rim; cylindrical neck; ovoid body, ending in a point, upon which is an added twirl of glass; two vertical handles from underneath rim to shoulder. At rim, yellow trail; on body, light blue and yellow spirals and lines, plain at top and bottom, combed to zigzag in middle; on base-knob, yellow twirl. Rim trail unmarvered.

　Core-formed; intact; dulled and iridescent.

H, 0.082m. GD, 0.053m.

Stand (2006)

Colourless. Low ring, with narrow splayed rim and broad splayed base, both sharp-edged and with concave 'neck' in between.

Ground and polished from a raw block of glass or a cast blank; chip out of rim; dulled with some iridescence.

H, 0.011m. D, 0.038m.

BIBLIOGRAPHY: For the Fikellura excavations see Higgins (1954), pp. 30, 86, 92.

16. Oinochoe

G.R. Dept. 48.8–3.69 / Italic, 6th to 5th century B.C. / Bought at Sotheby's, 19 July, 1848, lot 143.

Transparent dark blue. Pinched-in ('trefoil') lip; short cylindrical neck; tall ovoid body; splayed footstand. Vertical flat handle drawn on from edge of rim to shoulder. On body about four or five rows of very unevenly spaced flattened spikes, drawn out from the walls with a tool.

Core-formed; broken and mended, missing portions restored in plaster; pitted surface.

H, 0.065m. D, 0.04m.

BIBLIOGRAPHY: Haevernick (1959), p. 65, no. 6 and pl. 8, no. 2 (and see also, for dating, *id.* (1961), p. 137f.).

17. Amphoriskos

G.R. Dept. S38 / 2nd century B.C. / Bequeathed by Felix Slade, 1868.

Translucent blue body and handles, with opaque white trailing. Splayed rim; cylindrical neck; elongated ovoid body with vertical ribbing; knobbed base. Two vertical drawn handles from underneath rim to shoulder. Single spiral trail running from top of rim to just above base-knob, horizontal on rim and neck and near base, combed two ways into feather pattern on body, which is faintly ribbed in consequence.

Core-formed; intact; iridescent pitting on one side.

H, 0.146m. D rim, 0.032m. GD body, 0.048m.

BIBLIOGRAPHY: Nesbitt (1871), p. 8, no. 38, pl. *a*, fig. 15; Fossing (1940), p. 121, fig. 96.

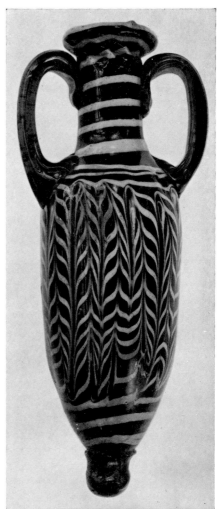

17

16

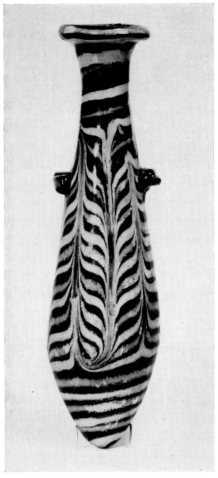

18

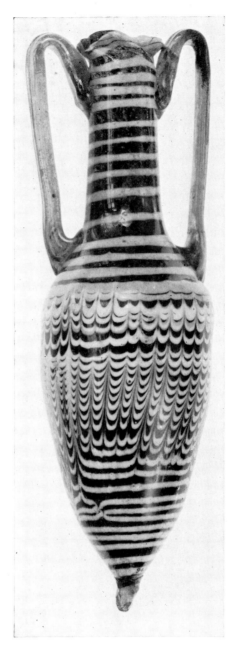

19

18. Fusiform Alabastron

G.R. Dept. 94.11–1.504 / 2nd century
B.C. / From Amathus, Cyprus, grave
228 / B.M. excavations, 1893–94: Miss
E. Turner bequest.

Translucent blue body with yellow and
light blue opaque trails. Flattened out-
splayed rim; slightly concave, tall neck,
merging gently into fusiform body with
greatest diameter near bottom, whence
sides taper to a rounded butt-end. Two
blobs added on shoulder to represent
handles. Mingled light blue and yellow
trails begin at neck and run continuously
to base, horizontally at top and bottom
and combed two ways into feather pat-
tern in middle.

Core-formed; intact; iridescence and
some pitting in parts.

H, 0.115m. D rim, 0.027m. GD body,
0.032m.

BIBLIOGRAPHY: Murray, Smith and
Walters (1900), p. 124, where the other
contents of the tomb are listed; Fossing
(1940), p. 112 (mention only, and with
no. falsely cited as 94.11–1.55).

19. Amphoriskos

G.R. Dept. 94.11–1.137 / 2nd to 1st cen-
tury B.C. / From Amathus, Cyprus, grave
53 / B.M. excavations, 1893–94: Miss
E. Turner bequest.

Brownish-green body with white and
yellow opaque trails, clear amber handles
and base-knob. Rim slightly outsplayed
and bevelled internally; tall cylindrical
neck; sloping shoulder; convex sides
narrowing to small base-knob. Two high-
swung handles from neck to shoulder.
Yellow trail in continuous spiral from
rim to shoulder, where it mingles with
white spiral trail, which then continues
alone to base-knob; trails straight at top
and bottom, combed upwards into fes-
toons in middle.

Core-formed; one handle broken and
mended, both handles and knob chipped;
some faint iridescence.

H, 0.165m. GD body, 0.05m.

BIBLIOGRAPHY: Murray, Smith and
Walters (1900), p. 118, where the other
contents of the tomb are listed and the
tomb is ascribed to two periods, Hellen-
istic and Roman, this amphoriskos being
placed in the earlier one.

B. BUILDING FROM SECTIONS OF COLOURED RODS ON A CORE OR BASE

20. Fragment of Mosaic Beaker

W.A. Dept. 134901 (1966.12–17.9) / 15th century B.C. / From Tell al Rimah, Iraq: excavations of the British School of Archaeology in Iraq and the University of Pennsylvania / Purchased.

Composed of circular sections of white, red (now mostly oxidized to green), yellow and dark brown (or dark blue?) opaque rods, set in horizontal zigzags to form the whole vessel in a pattern which has the same aspect inside and outside. The sections in each zigzag are all of one colour and the pattern thus consists of repeating groups of four zigzags of white, red, yellow and dark brown, always in this order reading downwards. Three fragments of the vessel are extant, including one small piece of the rim and two large pieces of the body; perhaps from a tall beaker of the well-known 'Nuzu' shape with a knobbed base; rim beaded, with external offset from which the sides of the (nearly cylindrical) body expand slightly downward.

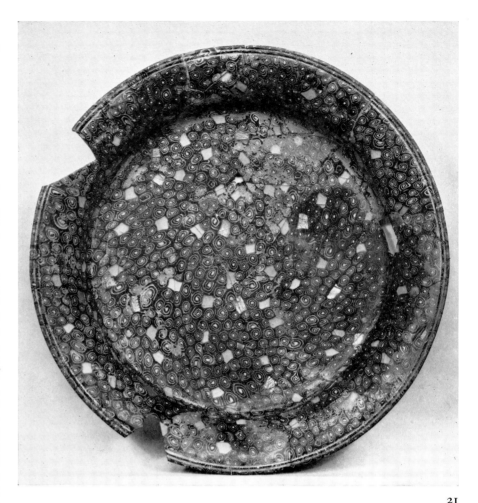

21

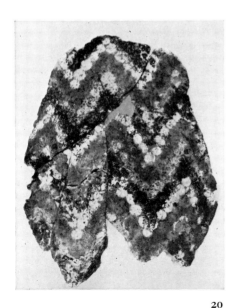

20

Built on a core, covered with an outer mould, and fused; exterior ground and polished; largely devitrified through oxidization and the colours often obscured by enamel-like surface weathering.

L of largest frag., 0.077m. W of ditto, 0.06m. Av. T, 0.004m. Av. D of sections, 0.002m.

BIBLIOGRAPHY: For part of the same or a similar vessel from these excavations see Oates (1966), p. 127, note 9, pl. xxxv, c. See also von Saldern (1966), p. 18, fig. 13; Harden (1968a), forthcoming.

21. Shallow Mosaic Dish

G.R. Dept. 71.5–18.3 / Late 3rd century B.C. / From Canosa, Apulia, Italy / Bought with nine other vessels (including nos. 33, 35–38 in this catalogue), all found in one tomb / Given by the executors of Felix Slade.

Composed mainly of sections of a coloured cane showing an opaque white spiral with opaque yellow centre in a clear deep blue ground, but containing also a number of sections of layered glass in which gold foil is sandwiched between layers of colourless and others of opaque white or opaque yellow, usually cased with colourless on one or both sides. Plain smooth-edged rim with two horizontal wheel-cuts flanking it, on inside of vessel; concave sides, slightly convex base.

Built on a core, covered with an outer mould, and fused; and finally ground and polished smooth all over. Broken and mended, some portions missing; iridescent and enamel-like film, surface lost in places.

H, 0.05m. D, 0.308m.

BIBLIOGRAPHY: Mentioned as found with no. 38 below by Dalton (1901b), pp. 225, 248, Dillon (1907), p. 46 and Honey (1946), p. 33. For full discussion of this group of 10 glasses see Harden (1968b).

22. Mosaic Plaque

E. Dept. 29396 (97.5–11.112) / Later Ptolemaic period / From Egypt / Purchased.

Blue 'square', with inlays of opaque white, opaque bright red, black and colourless; border strip opaque dark red and opaque white. Fragment of flat plaque with mosaic sections set in a backing of bitumen. The 'square' is formed of two equal halves, each cut from the same cane and bearing half a head in the form of a theatrical mask; hair and beard have opaque white and colourless strands alternating; face and ears mainly bright red, details opaque white, colourless and black. Border strip formed of two parallel rods, opaque dark red outside opaque white.

One of the half squares broken in two; border strip at top only; bitumen backing incomplete; no weathering (surface possibly repolished recently); bubbly with many whitish impurities.

L, 0.049m. W, 0.043m. Sides of 'square', 0.028m. L border, 0.033m. W border, 0.004m. T glass, 0.002m.

BIBLIOGRAPHY: Harden (1956a), p. 322, 338, pl. 24, E.

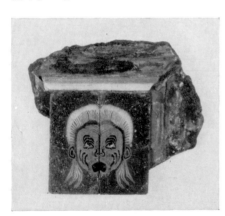

22

23. Mosaic Plaque

E. Dept. 64224 (98.9–2.16) / Later Ptolemaic period / From Dendera: Egypt Exploration Fund excavations, 1898.

Rectangular plaque composed of many small cane-sections of opaque colours from the range of light blue, dark blue,

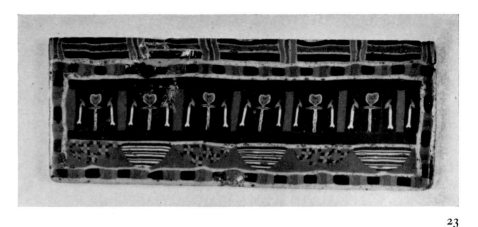

23

greenish blue, yellow, red, white, and colourless; backing is opaque brown, appearing black. The main bar consists of six and a half groups of ⚱ being the ankh-sign ('life') flanked by two was-signs ('dominion'), the groups divided by red panels; under the main bar are six pendent polychrome panels on a red ground in the form of the sign ⌣ ('all'); around the patterned area, a frame; at the top, a striped border.

Intact rectangle, except for one large and one small flake chipped from upper surface; no weathering; bubbly.

L, 0.083m. W, 0.032m. T, 0.006m.

BIBLIOGRAPHY: Petrie (1900), pp. 34–6; Dillon (1907), p. 32, pl. iii, 3.

24. Mosaic Plaque

E. Dept. 64263 (98.9–2.19) / Later Ptolemaic period / From Dendera: Egypt Exploration Fund excavations, 1898.

Within an opaque dull red background the pattern is built up of opaque colours—yellow, white, bright red, light blue, dark blue, and black. Square plaque. Eye of Horus made of three

separate sections of cane; eyebrows yellow and dark blue; pupil black and white; lower left-hand portion bright red and white; lower right-hand portion light blue, yellow and black. Back of plaque rough, for keying into backing (bitumen?), only traces of which remain.

Intact; no weathering.

L, 0.033m. W, 0.03m. T, 0.005–0.006m.

BIBLIOGRAPHY: Petrie (1900), pp. 34–6.

25. Mosaic Plaque

E. Dept. 64266 (98.9–2.19) / Later Ptolemaic period / From Dendera: Egypt Exploration Fund excavations, 1898.

Opaque white, opaque red and opaque dark blue. Rosette plaque; the flower has eight egg-shaped petals of white in a red surround, set in bitumen; this then inset in a square frame of dark blue.

Intact; no weathering.

H, 0.032m. W, 0.03m. T, 0.004–0.005m.

BIBLIOGRAPHY: Petrie (1900), pp. 34–6.

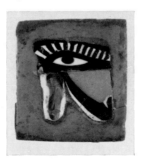

24

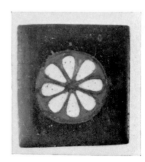

25

C. GRINDING, CUTTING AND POLISHING FROM A RAW BLOCK OF GLASS

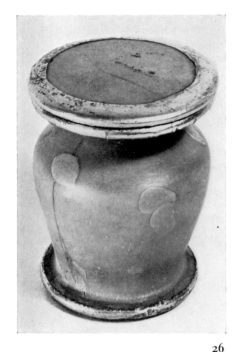

26

26. Lidded Ointment-pot

E. Dept. 24391 (92.12–12.5) / Middle of the 18th dynasty / From Egypt.

Opaque turquoise. Lid circular, convex above, flat below, with a raised disk in centre to fit hole-mouth of vessel; rim of vessel circular, flat above, with sharp-edged outside lip from which sides of neck taper rapidly downwards to an off-set ridge above a deeply constricted junction of neck and shoulder; shoulder spreads out to a sharp angle, whence sides taper inwards again to an outward splay near bottom; base flat. Inside of body tubular. Bands of thin gold plating at edge of lid, edge of rim and edge of base.

Lid and body both ground and polished from raw blocks of glass; lid intact, body broken and mended with some plaster filling; gold plating hammered on after vessel repaired, but seems to be ancient; about one-third of the plating on the rim of the pot is missing

and has been replaced with modern gold paint; surface dulled; some strain-cracking.

Total H, 0.064m. H body, 0.06m. D rim, 0.063m. D base, 0.052m. D tubular hole, 0.018m. H tubular hole, 0.045m.

BIBLIOGRAPHY: Wallis Budge (1925), p. 391; Haberey (1957), p. 507, fig. 5 (colour).

27. Alabastron Bearing the Name of Sargon II

W.A. Dept. 90952 / 722–705 B.C. / From the N.W. Palace, Nimrud: A. H. Layard's excavations, 1850.

Clear dark green. Squat alabastron; rim flat on top and slightly outsplayed from a short, concave neck; convex-sided body; rounded base. Two unpierced rectangular lugs at shoulder. Inside of body bag-shaped with slight knob at centre of bottom. On front and back, between the lugs, a horizontal line of engraving, comprising a lion, facing right, and a cuneiform inscription,

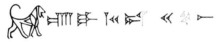

reading, on front, E. GAL ᵐMAN.DU (Palace of Sargon); on back, MAN KUR AS (King of Assyria).

Ground and polished from a raw block

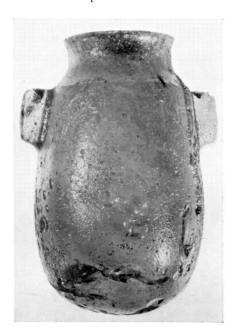

27

of glass (the marks of spiral grooving and the knob on the bottom, inside, are convincing proofs of this); complete. The outside surface has acquired a thick white to brown enamel-like weathering, now mainly flaked off, leaving a pitted iridescent surface with many gaps and seeming fractures caused by strain-cracking; the inside is similarly weathered and damaged at neck only, the remainder being almost clear; bubbly.

H, 0.08m. D rim, 0.037m. GD, 0.055m. H. interior, 0.07m. L lugs, 0.017m.

BIBLIOGRAPHY: Layard (1849), I, pp. 342–3; Layard (1853), pp. 196–7 and fig. on p. 197; Layard (1854), p. 223 (it is worthy of note that Layard recognized that this vase was 'turned from a block' and not blown); Dillon (1907), p. 40; Kisa (1908), pp. 102ff., 292, 631, fig. 22 (who thought it was modelled on a core); *B.M. Guide to Babylonian and Assyrian Antiquities* (2nd edn., 1908), p. 110, fig. on p. 111; *B.M. Guide to Babylonian and Assyrian Antiquities* (3rd edn., 1922), p. 196; Harden (1956a), pp. 321, 336, pl. 26 C, D, fig. 299; von Saldern (1959a), p. 27, fig. 3; von Saldern (1959b), p. 3, fig. 5; Neuburg (1962), pl. 19; Forbes (1966), p. 145, fig. 22.

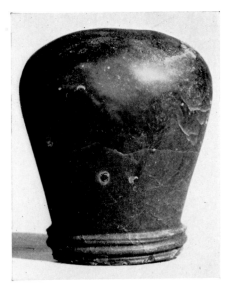

28

28. Staff Head

W.A. Dept. 98922 (1905.4–9.428) / 8th to 7th century B.C. / From the bottom of a well in the Nabû temple, Kuyunjik (Nineveh): B.M. excavations, 1904–05.

Opaque dark blue. Rounded top with convex shoulder curving to a tapering body; flattened base, on edge of which is a horizontally ribbed band in relief; underneath is a small cylindrical dowel-hole for fixing the shaft.

Ground and polished from a raw block of glass; one large fragment of side and base missing; surface dulled; streaky metal.

H, 0.06m. GD, 0.055m.

BIBLIOGRAPHY: R. Campbell Thompson, *The Nabu Temple*, p. 104.

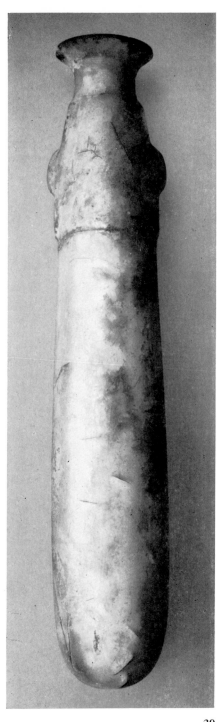

29

29. Alabastron

G.R. Dept. 69.6–24.16 / Late 7th to 6th century B.C. / From Pozzuoli (Puteoli), Italy / Given by the executors of Felix Slade (bought at Christie's, Castellani sale, 8 June 1869, lot 84).

Sea green. Tall, narrow-bodied alabastron; rim bevelled above, on inside; concave neck; angular shoulder; long, almost cylindrical body, widening slightly towards bottom; rounded base. Two unpierced, low, sharp-edged lugs forming imitation handles below shoulder. Inside of body cylindrical.

Ground and polished from a raw block of glass; probably rotary-ground within (as seems likely from comparison with a fragmentary parallel from Idalium, Cyprus—G.R. Dept. 73.3–20.182—where the interior shows grinding-marks); complete, broken and mended; slight pitting on surface and many short strain-cracks.

H, 0.21m. D rim, 0.034m. GD, 0.039m.

BIBLIOGRAPHY: von Saldern (1959a), p. 29, fig. 6 (in which he also illustrates the example from Cyprus); von Saldern (1959b), p. 4, fig. 9.

D. CASTING IN CLOSED OR OPEN MOULDS

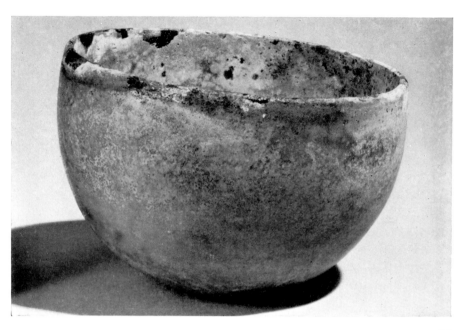

30

30. Hemispherical Bowl

W.A. Dept. 91521 (N734) / 8th to 7th century B.C. / From Nimrud, Room AB in N.W. Palace: A. H. Layard's excavations.

Green. Rounded rim; convex sides; flattened base (the flattening being off-centre, so that the vessel stands askew).

Cast in a two-piece mould; surfaces afterwards smoothed by polishing; intact; thick brownish weathering, with some pitting, especially at rim; contents-stains inside, and near top on outside of rim; remainder of outside dulled and milky on surface.

H varies, 0.053–0.07m. D, 0.098m.

BIBLIOGRAPHY: Layard (1853), p. 196 (one of his 'two entire glass bowls . . found in this chamber'); von Saldern (1959a), p. 28 and notes 19–20; von Saldern (1959b), p. 3. fig. 7 (colour).

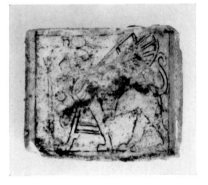

31

31. Inlay-plaque with Painted Sphinx

W.A. Dept. 134900 (1966.12–17.8) / 7th century B.C. / From Nimrud, Room SW 7 in Fort Shalmaneser (excav. no. ND7638): Brit. School of Archaeol. in Iraq excavations / Purchased.

Originally translucent, greenish–colourless, now appearing opaque white. Rectangular plaque, uniform in thickness; concave horizontally in front, the two side edges curving forward; top and bottom edges squared off, but side edges have acquired a frontal bevel; front surface smooth, back surface rough and with a ridge round its edge. Linear design in black paint showing a winged sphinx wearing *uraeus* disk and crown, and apron, walking left towards upright floral (lotus?) stem; traces of blue paint on sphinx's body.

Cast in a flat, one-piece mould and made concave thereafter by reheating; intact; completely devitrified to an opaque white limy consistency.

H, 0.033–0.035m. W (across concavity), 0.042m. Av. T, 0.002m.

BIBLIOGRAPHY: Mallowan (1966), p. 415, fig. 344, and A. von Saldern, *ibid*., p. 632, who states it is one of five similar plaques found in the same room.

32. Figurine of Astarte

W.A. Dept. 130076 (1939.6–13.76) / 14th or 13th century B.C. / From Atchana (anc. Alalakh), perhaps = excav. no. AT/39/66: Sir Leonard Woolley's excavations, 1939 / Purchased.

Originally translucent greenish–colourless, now appearing opaque white.

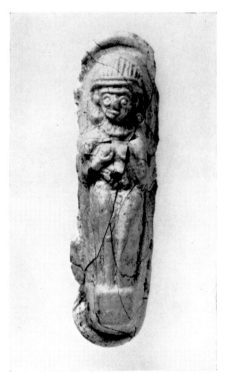

32

Plaque, flat behind and moulded in front in the form of a standing nude figure of the goddess Astarte holding her breasts; elaborate hair-style with side locks; indication of earrings and of a collar of beads; at navel a circular hollow, probably for a gold or gilded button (as occurs, e.g., on a north Syrian terracotta

figurine of Astarte of comparable date in the Ashmolean Museum, Oxford: *Liverpool Annals of Archaeol. and Anthrop.*, XXI (1934), 89ff., pl. xii, 1); behind the shoulders a horizontal piercing for suspension.

Cast in a one-piece mould, the back flattened by pressure; broken and mended, a few pieces missing; almost wholly devitrified on and near the surface to an opaque white limy consistency.

L, 0.085m. W, 0.023m. T, 0.016–0.018m.

BIBLIOGRAPHY: Woolley (1955), pp. 247, 302 and (for a similar piece) pl. lvi, *b*.

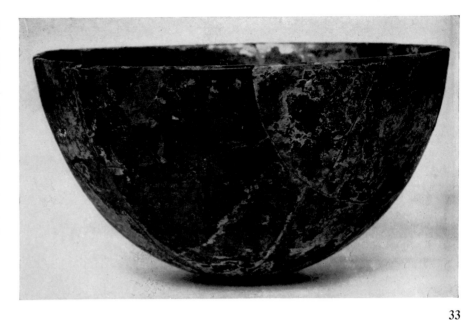

33

33. Hemispherical Bowl

G.R. Dept. 71.5-18.5 / Late 3rd century B.C. / From Canosa, Apulia, Italy / Bought with nine other vessels (including nos. 21, 35–8 in this catalogue) all found in one tomb / Given by the executors of Felix Slade.

Translucent dark blue. Plain rim, rounded at lip; hemispherical body with rounded base.

Cast in a two-piece mould, surfaces afterwards smoothed by polishing; broken and mended, some portions restored in plaster; black enamel-like film in part and much strain-cracking.

H, 0.071m. D, 0.129m.

BIBLIOGRAPHY: Unpublished. For a full discussion of this group of ten glasses see Harden (1968b).

34. Shallow Bowl with Cut Petal-design

G.R. Dept. 70.6–6.7 / 7th to 5th century B.C. / Given by the executors of Felix Slade (bought from E. Piot, Paris).

Greenish–colourless. Plain rim with rounded edge; concave sides with carination below; plain convex base. Deep broad cut groove at carination; below this, round the base, is a circular band of eight plain petals in high relief, alternating with eight grooved petals in low relief; centre of base undecorated.

Cast in a two-piece mould and finished by cutting and grinding; intact; dulled and much strain-cracking (the strains having a brown hue internally); some tiny bubbles and impurities.

H, 0.039m. D, 0.174m.

BIBLIOGRAPHY: von Saldern (1959a), p. 32, fig. 11; von Saldern (1959b), p. 4, fig. 12.

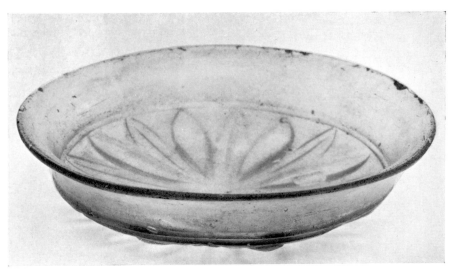

34

35. Shallow Dish

G.R. Dept. 71.5–18.8 / Late 3rd century B.C. / From Canosa, Apulia, Italy / Bought with nine other vessels (including nos. 21, 33, 36–8 in this catalogue) all found in one tomb / Given by the executors of Felix Slade.

Colourless with greenish tinge. Plain smooth-edged rim with two horizontal wheel-cuts flanking it on interior of vessel; concave sides; flattened, slightly concave base. The bowl has been painted and gilded on exterior. Only faint traces of this decoration remain, mainly in a border below the basal angle, with faint indications of a pattern (floral?) elsewhere, the remainder having disappeared with the film of weathering.

Cast in a two-piece mould, smoothed by cutting and grinding, then painted

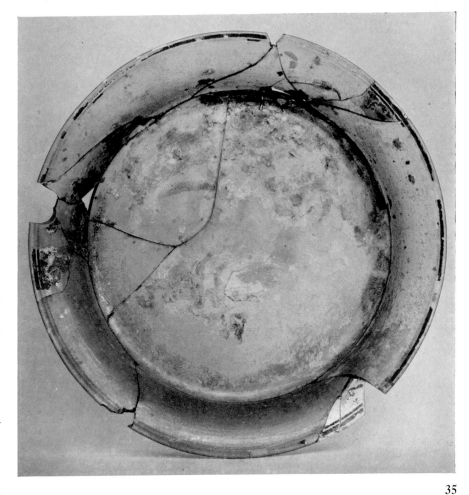

35

and gilded; broken and mended, some pieces missing; enamel-like film of weathering, almost all flaked away, except in places on bottom, leaving iridescent surface.

H, 0.045m. D, 0.276m.

BIBLIOGRAPHY: Unpublished. For a full discussion of this group of ten glasses see Harden (1968b).

36. Deep Bowl with Band of Bosses

G.R. Dept. 71.6–18.7 / Late 3rd century B.C. / From Canosa, Apulia, Italy / Bought with nine other vessels (including nos. 21, 33, 35, 37, 38 in this catalogue) all found in one tomb / Given by the executors of Felix Slade.

Greenish-colourless. Plain vertical rim, bevelled on inside; segmental body with slight carination; rounded base. At lip, outside, two narrow wheel-cut grooves flanking one broad one; below these, band of twenty almond-shaped raised bosses, H, 0.025m. W, 0.012m., and projecting 0.01m. from surface of bowl; below again, two narrow wheel-cut grooves. Centrally, underneath base, is a ten-petalled rosette, outside and around which, divided from it by two concentric wheel-cut grooves, is a band of six broad petals alternating with six narrower ones, partly lying under them, all twelve being longitudinally grooved.

Cast in a two-piece mould and finished by cutting and grinding; the bosses are in relief, remainder of design is intaglio. Broken and mended, some pieces missing; flaking, iridescent film.

H, 0.092m. D, 0.205m.

BIBLIOGRAPHY: Dillon (1907), pp. 47, 68; Deonna (1925), p. 17, fig. 4; Bartoccini (1935), p. 247; Thorpe (1938), p. 24, fig. 5; Wuilleumier (1939), p. 363; P. Demargne, *Fouilles de Xanthos*, I (1958), 69, note; von Saldern (1959a), p. 39, figs. 22–3; von Saldern (1959b), p. 6, fig. 17; Weinberg (1965), p. 33; Adriani (1967), p. 114, pl. viii, D. For a full discusssion of this group of ten glasses see Harden (1968b).

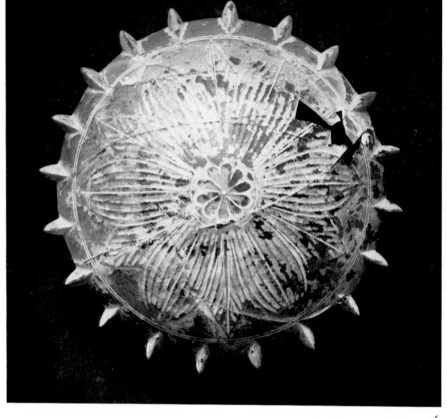

36

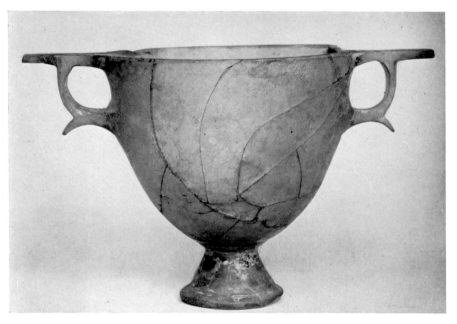

37

37. Cup on Tall Footstand with Wing Handles

G.R. Dept. 71.5–18.9 / Late 3rd century B.C. / From Canosa, Apulia, Italy / Bought with nine other vessels (including nos. 21, 33, 35, 36, 38 in this catalogue), all found in one tomb / Given by the executors of Felix Slade.

Colourless with greenish tinge. Almost flat rim with sharpish edges; half-ovoid body with convex sides; splayed footstand, concave below. Two wing handles with flat thumb-pieces above and curved finger-pieces below. Faintly convex mouldings at bottom of side and at edge of footstand.

Cast in a two-piece mould, probably as a thick blank with solid handles, and

E. MISCELLANEOUS

34. Shallow Bowl with Cut Petal-design

G.R. Dept. 70.6–6.7 / 7th to 5th century B.C. / Given by the executors of Felix Slade (bought from E. Piot, Paris).

Greenish–colourless. Plain rim with rounded edge; concave sides with carination below; plain convex base. Deep broad cut groove at carination; below this, round the base, is a circular band of eight plain petals in high relief, alternating with eight grooved petals in low relief; centre of base undecorated.

Cast in a two-piece mould and finished by cutting and grinding; intact; dulled and much strain-cracking (the strains having a brown hue internally); some tiny bubbles and impurities.

H, 0.039m. D, 0.174m.

BIBLIOGRAPHY: von Saldern (1959a), p. 32, fig. 11; von Saldern (1959b), p. 4, fig. 12.

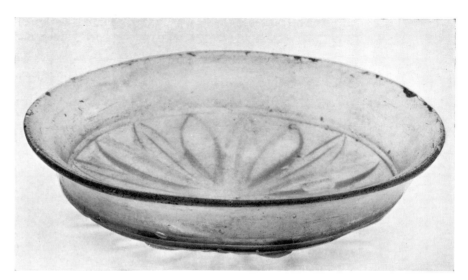

34

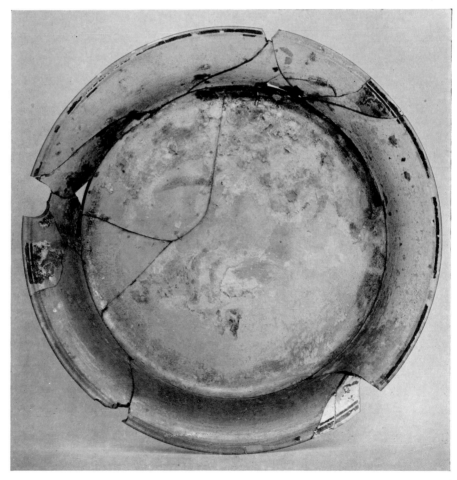

35. Shallow Dish

G.R. Dept. 71.5–18.8 / Late 3rd century B.C. / From Canosa, Apulia, Italy / Bought with nine other vessels (including nos. 21, 33, 36–8 in this catalogue) all found in one tomb / Given by the executors of Felix Slade.

Colourless with greenish tinge. Plain smooth-edged rim with two horizontal wheel-cuts flanking it on interior of vessel; concave sides; flattened, slightly concave base. The bowl has been painted and gilded on exterior. Only faint traces of this decoration remain, mainly in a border below the basal angle, with faint indications of a pattern (floral?) elsewhere, the remainder having disappeared with the film of weathering.

Cast in a two-piece mould, smoothed by cutting and grinding, then painted and gilded; broken and mended, some pieces missing; enamel-like film of weathering, almost all flaked away, except in places on bottom, leaving iridescent surface.

35

H, 0.045m. D, 0.276m.

BIBLIOGRAPHY: Unpublished. For a full discussion of this group of ten glasses see Harden (1968b).

36. Deep Bowl with Band of Bosses

G.R. Dept. 71.6–18.7 / Late 3rd century B.C. / From Canosa, Apulia, Italy / Bought with nine other vessels (including nos. 21, 33, 35, 37, 38 in this catalogue) all found in one tomb / Given by the executors of Felix Slade.

Greenish-colourless. Plain vertical rim, bevelled on inside; segmental body with slight carination; rounded base. At lip, outside, two narrow wheel-cut grooves flanking one broad one; below these, band of twenty almond-shaped raised bosses, H, 0.025m. W, 0.012m., and projecting 0.01m. from surface of bowl; below again, two narrow wheel-cut grooves. Centrally, underneath base, is a ten-petalled rosette, outside and around which, divided from it by two concentric wheel-cut grooves, is a band of six broad petals alternating with six narrower ones, partly lying under them, all twelve being longitudinally grooved.

Cast in a two-piece mould and finished by cutting and grinding; the bosses are in relief, remainder of design is intaglio. Broken and mended, some pieces missing; flaking, iridescent film.

H, 0.092m. D, 0.205m.

BIBLIOGRAPHY: Dillon (1907), pp. 47, 68; Deonna (1925), p. 17, fig. 4; Bartoccini (1935), p. 247; Thorpe (1938), p. 24, fig. 5; Wuilleumier (1939), p. 363; P. Demargne, *Fouilles de Xanthos*, I (1958), 69, note; von Saldern (1959a), p. 39, figs. 22–3; von Saldern (1959b), p. 6, fig. 17; Weinberg (1965), p. 33; Adriani (1967), p. 114, pl. viii, D. For a full discusssion of this group of ten glasses see Harden (1968b).

36

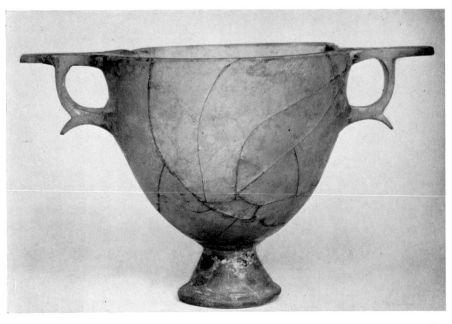

37

37. Cup on Tall Footstand with Wing Handles

G.R. Dept. 71.5–18.9 / Late 3rd century B.C. / From Canosa, Apulia, Italy / Bought with nine other vessels (including nos. 21, 33, 35, 36, 38 in this catalogue), all found in one tomb / Given by the executors of Felix Slade.

Colourless with greenish tinge. Almost flat rim with sharpish edges; half-ovoid body with convex sides; splayed footstand, concave below. Two wing handles with flat thumb-pieces above and curved finger-pieces below. Faintly convex mouldings at bottom of side and at edge of footstand.

Cast in a two-piece mould, probably as a thick blank with solid handles, and

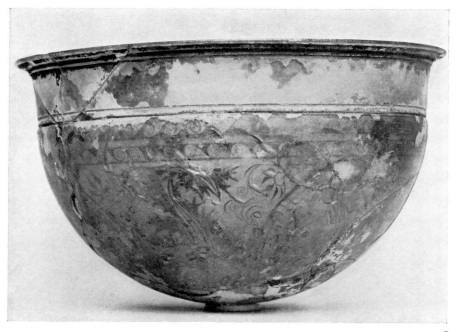

38

finished by cutting and grinding; broken and mended, some pieces missing; milkiness and iridescence inside and out.

H, 0.111m. D mouth (excluding handles), 0.109m.

BIBLIOGRAPHY: Dillon (1907), pp. 46, 68; Thorpe (1938), p. 14, fig. 3; Neuburg (1962), pl. 84; Oliver (1967), p. 31 (mention only). For a full discussion of this group of ten glasses see Harden (1968b).

38. Sandwich Gold-glass Bowl

G.R. Dept. 71.5–18.2 / Late 3rd century B.C. / From Canosa, Apulia, Italy / Bought with nine other vessels (including nos. 21, 33, 35–7 in this catalogue, and a companion sandwich gold-glass, no. 71.5–18.1), all found in one tomb / Given by the executors of Felix Slade.

Colourless with gilding. Rim outsplayed with rounded lip and horizontal wheel-cut grooves on inside and outside: body somewhat greater than a hemisphere with convex sides and rounded base.

Vessel formed in two layers, the outer one fitting over the inner one, but reaching only to a line 3.2cm. below rim, where its lip lies just below the lower of two horizontal wheel-cut grooves on the inner layer. Between the two layers, applied to the surface of the inner one, is a pattern in gold leaf: rising from an eight-petalled rosette at the centre of the base is a stylized design of four leaves of nymphaea caerulea alternating with four acanthus leaves, with highly complicated floral details filling and surrounding the leaves. Much of this decoration is based on the acanthus. Above and bordering this floral design, which covers most of the bowl, are two horizontal bands of wave-pattern, symmetrical with each other, but addorsed, the curls in the upper band being turned clockwise, those in the lower anticlockwise.

Both layers apparently cast in two-piece moulds and afterwards carefully cut, ground and polished to fit each other; the gilded decoration fashioned by cutting out the pattern from a layer of gold leaf applied to outside surface of inner layer; outer layer fixed to inner by gentle fusion, perhaps at its lip only. Broken and mended, one large fragment of rim and some other pieces missing, in

places differentially between the two layers, so that parts of one are extant without the corresponding parts of the other. Dulled and some iridescence inside and out.

H, 0.114m. D, 0.193m.

BIBLIOGRAPHY: Vopel (1899), pp. 77, 113, no. 487; Dalton (1901b), pp. 225ff., no. 23, pl. v; Dillon (1907), p. 45f.; Kisa (1908), p. 838 (brief mention only); Dalton (1911), p. 613, fig. 388 (with ascription to 3rd century A.D.); Deonna (1925), p. 17, fig. 5; Wuilleumier (1930), p. 29f., pl. x, 5; Bartoccini (1935), p. 247; Wuilleumier (1939), p. 363, pl. xxiv, 3; Rostovtzeff (1941), pp. 371f., 1408f. (note 165), pl. xliii, 2 (side view) and 3 (drawing of design); Jacobsthal (1944), p. 148 (where R. Zahn wrongly ascribes it to a tomb found in 1895); Honey (1946), p. 33; Harden (1956a), p. 342, pl. 25 B; von Saldern (1959a), p. 46, with coloured illustration as frontispiece and on cover of volume; von Saldern (1959b), p. 8, fig. 25; Schüler (1966), p. 48f., fig. 3; Forbes (1966), p. 148, fig. 25; Adriani (1967), pp. 114ff. For a full discussion of this group of ten glasses see Harden (1968b).

39. Fusiform Banded Alabastron

G.R. Dept. 51.3–31.9 / 2nd or 1st century B.C. / Bought at Sotheby's, 1851 (Dr. W. C. Neligan collection).

Translucent dark blue and colourless. Broad, horizontally-splayed 'disk' rim; slender cylindrical neck; elongated fusiform body with rounded butt-end. Built up of four parts, joined horizontally: (*a*) rim, neck and shoulder, (*b*) upper body, (*c*) middle body, (*d*) lower body; of these part (*c*) is colourless and the other three are dark blue.

Cast in a mould (?), but, if so, probably as a much thicker blank, and after release ground and polished to its present slender form; broken and mended, some parts restored in plaster; iridescent surface.

H, 0.193m. D mouth, 0.033m. GD body, 0.025m.

BIBLIOGRAPHY: Oliver (1967), p. 19f., fig. 11 (who illustrates a fragment of an alabastron in Nicosia Museum and a bowl in the Metropolitan Museum, N.Y., both of similar blue and white banded glass).

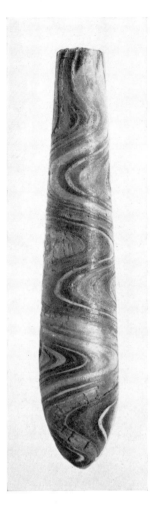

40

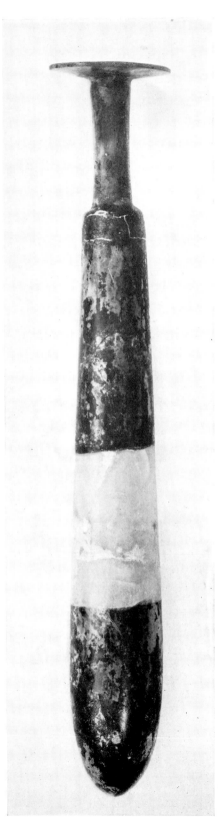

40. Fusiform Gold-band Alabastron

W.A. Dept.: B.M. Dept. cat. no. 95.6–2.1 / 2nd or 1st century B.C. / From Sidon / Bought from J. A. Durighello, Beirut.

Clear blue, opaque white, clear green and gilded bands; the last formed of a layer of gold foil (now shattered) between two colourless layers. Plain, ground rim; sides expand to greatest diameter near base and then contract to a rounded butt-end. The coloured bands form, between them, the complete vessel and are set in continuous vertical waves from rim to base.

Cast from separate sections on a core, then manipulated, on release, to a wavy pattern and finally perhaps cast a second time, before being finished by grinding and polishing; intact;[1] surface heavily pitted.

H, 0.112m. D rim, 0.012m. GD body, 0.022m.

BIBLIOGRAPHY: Unpublished. For gold-band glasses of this and other shapes (with a list of examples which excludes this piece) see Oliver (1967), pp. 20ff.

[1] Some of the gold-band alabastra possess a separate rim-and-neck piece which fits into the top of the body; perhaps, therefore, a rim-and-neck piece is missing from this example.

39

41. Bronze Brooch with Glass 'Runner'

G.R. Dept. 46.6–8.1 / Etruscan, mid–7th century B.C. / Given by the Marquis of Northampton.

Brooch made in one piece with triple-coiled spring and long pin, catch-plate missing. Bow decorated with a loose glass 'runner' of leech shape, opaque brown, with opaque yellow marvered trails combed two ways in feather pattern, the combing having produced longitudinal grooves. Some surface pitting, patches of light brown weathering.

L pin, 0.117m. L glass from tip to tip, 0.075m. GD glass, 0.024m.

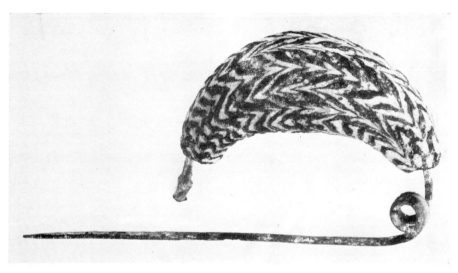

41

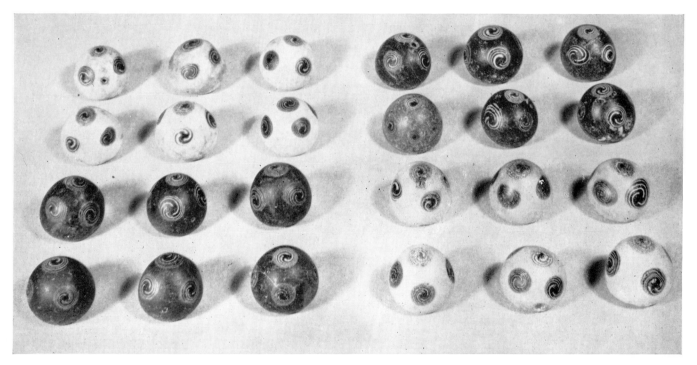

42

42. Set of Twenty-four Game-Pieces

B.M. Dept. 1967.2–2 / Late 1st century B.C. / Part of the rich grave-goods of an early-iron-age burial at Welwyn Garden City, Herts. / Given by Welwyn Garden City Development Corporation.

Twenty-four pieces in four groups of six, made respectively of opaque white, opaque blue, opaque yellow and trans-lucent light green; the 'eyes' are cane-sections showing interlocked curves (in two of the eyes only, a single spiral) of opaque white in a translucent dark green or wine-coloured ground. All the pieces except two are domed and slightly pointed at the apex, and considerably greater than a semicircle in section, with flattened base; the two exceptions have no apical point and in section are scarcely greater than a semicircle.

The cane-sections were applied to a marvered gathering; the whole was then reheated and worked in an open mould to produce the final form. All the pieces are intact and undamaged, though some contain hollow pock-marks and sandy inclusions; few bubbles.

H, varies from 0.02 to 0.022m. D, varies from 0.025 to 0.028m.

BIBLIOGRAPHY: Harden (1968c), pp. 14ff., fig. 10, and coloured frontispiece.

ROMAN GLASS

by K. S. Painter

The two most important developments in the history of glass from the 1st to the 4th century A.D. are the invention of the blowing technique and the spread of the manufacture and use of glass throughout the Roman Empire. The two developments are linked, for blowing changed glass from a luxury into a material of everyday use. Raw materials for large-scale production, however, were not available on many sites, and although some new centres were established fairly soon, the older centres such as Egypt and the Syrian coast retained their importance throughout the period.

The early Imperial period, approximately the 1st century A.D., is characterized generally by the predominance of finely coloured glass, often polychrome, with a great range in techniques and forms of decoration. In the middle Imperial period, the 2nd to 3rd centuries, the quantity of glass increased with a predominance of almost colourless glass, a great range of new shapes and types of decoration, and the almost exclusive use of the blowing technique. In the later Imperial period, the 4th and 5th centuries A.D., it might be expected that the increasing political instability would have been reflected in the glass industry, and indeed a greater differentiation from province to province can be detected. Nevertheless styles and technical knowledge continued to spread rapidly and some of the greatest achievements of the craft, as for example the openwork diatreta or cage cups, belong to this period.

The invention of blowing

Blowing was invented not long before the beginning of the Christian era, probably in Phoenicia on the Levant coast. Some of the glass-blowers from that area soon began to set up factories in the west and were making mould-blown glasses in Italy by the early 1st century A.D. The lidded box from Sidon (no. 59) is an example of the work of the eastern shops, as are presumably the one-handled cup from Cyprus by Ennion (no. 58) and the barrel beaker from Cyprus by Meges (no. 60). All but three, however, of Ennion's fourteen known cups come from the area round Venice or Aquileia or from sites in the Po valley and must have been produced in the Italian peninsula. It would not have been difficult for Ennion and his contemporaries to send workers to graft the new blowing technique on to the old hand-fashioning processes which the pre-Roman industry in the region or nearby had used for centuries to supply Etruria and the north. Examples of the work of this pre-Roman centre are to be seen in the Italic brooch (no. 41) and the scale-juglet (no. 16), and probably also in the outstanding set of playing pieces from Welwyn Garden City (no. 42). From the Alpine area the new Italian group spread northwards and westwards into Gaul, Germany and the Alpine provinces by A.D. 40–50. It has been very plausibly suggested, for example, that Ennion's north Italian shop set up a subsidiary, at Brugg (Vindonissa) in Switzerland or Lyon in France, which made cups similar in shape to that from Cyprus (no. 58), but without handles and with scenes of the arena or circus. A good example is the circus-beaker (no. 61) from Colchester. The vast majority with known provenience, about eighty, come from the Alpine, Gallic and Rhenish provinces and Britain. Only four come from Spain, two or three from Italy, and one or two, doubtfully, from the North African provinces.

The other main centre of ancient glass-working was Egypt. While the Syrian

workers were exploiting their new technique of blowing and were expanding their activities to west and north, the Egyptian workers continued to specialize in cutting, as on the outstanding Portland Vase (no. 57) and Bonus Eventus Plaque (no. 55), and also in mosaic and other fine coloured wares, and in the moulding technique which went with them. Mosaic glasses are some of the earliest of the period and there is of course no break between these and the pieces of the pre-Roman period. The Ptolemaic plaques from the 2nd-century A.D. site of Dendera (nos. 23, 24, 25), for example, together with the theatrical mask (no. 22), are of exactly the same family as the complete section of floral mosaic (no. 56) or the pre-Roman and Roman vessels in millefiori or thousand-flower technique, for example the 3rd-century B.C. dish from Canosa (no. 21) and the 1st- or 2nd-century A.D. jar from Tarquinia (no. 45). Other mosaic glasses used a marbled effect for decoration, such as can be seen on the pillar-moulded bowl from Radnage in Buckinghamshire (no. 51). Variegated pieces of glass, previously cooled, were reheated and then moulded as soon as they were in a liquid state. These vessels are closely related to the floral mosaic glasses, for in some cases disks with millefiori motifs were pressed into the reheated glass while it was still liquid. Finally, after cooling, the interiors and rims of the vessels were ground and polished.

Craftsmen in Egypt did not adopt the blowing technique for cheap ware until some time in the 2nd century A.D. at the earliest, as is shown by the evidence from various sites, particularly Karanis. Yet the Portland Vase (no. 57) was made both by cutting in the Egyptian cameo tradition and also by blowing. A solution of the problem may be found in the fact that great numbers of fine mosaic glasses have been found in Italy, especially in Rome. We cannot tell from the vessels themselves whether such mosaic pieces as the jar from Tarquinia (no. 45) or the bowl from Rome (no. 43) or the bowl from Vulci (no. 44) were made in Italy or were Egyptian exports; but fragments of all the main varieties of mosaic vessels occur throughout the western empire and are more common there and in Italy than in the east. It may well be, therefore, that the factories in the area of Rome and Campania were firms of Egyptian origin and that it was they who won the Italian and western markets with their 'Egyptian' products rather than firms in Egypt itself. The workshops in Egypt, that is to say, exported not only their wares but their workers, and it was in Italy that the Egyptians learnt the new Syrian technique, the Portland Vase being one of their finest achievements.

Parallel development in east and west

The spread of production further northwards from Italy is marked by the founding of the famous Cologne factories in the early 1st century A.D., while the north Gallic and Belgic factories were probably in full production by the 2nd century. The products of the western workshops include both mould-blown and free-blown work which is directly related to the products of the central and eastern empire. In any technique, *tours de force*, of course, such as the very large moulded box from near Rome (no. 49) or the free-blown flask with eight internal tubes (no. 125), are always the product of an individual craftsman; but even they cannot be divorced from earlier work and from their time and place of manufacture.

The relationship between western and eastern workshops is one of the

important facts demonstrated in the exhibition by such groups as the mould-blown pieces. Examples of the 1st century A.D. include not only the work of Ennion and his colleagues, discussed above, but the beaker from Syria (no. 62), the tall inscribed head-flask from Cyprus (no. 63) and the figured beaker from Cyzicus (no. 64). Direct mould-blown successors of these pieces in the east are the janiform head-vase (no. 76) and the bottle from Aleppo (no. 80). In the west these are paralleled by the fish-bottle, perhaps from Arles (no. 77), and by the bottle from Faversham made in the Gallic workshop of Frontinus by Felix (no. 79).

There was independent development, of course, in each area of glass-making both before and after A.D. 200, when Roman manufacture had spread to its full extent; but, as in the case of the mould-blown glasses, there was also continuous fertilization of each area from outside, and it is usually assumed that this was brought about by Syrian, and perhaps Egyptian, workers migrating to all other centres, eastern and western. The blue mould-blown shell-shaped flask (no. 65), for example, could have come from either end of the empire. This migration of workers must be the explanation of the continuing spread of new shapes and decorative patterns and the surprising similarity of forms and colours throughout the empire at any given time. Cologne, for example, supplied its customers with colourless vessels up to the early 3rd century and then switched to coloured wares, and the same pattern of production is demonstrated in the east by the evidence from Dura Europos and Karanis. Matching development is revealed equally by study of particular types of glasses, such as those with blobbed, snake-thread or painted decoration. The two 1st-century vessels in the exhibition with blobbed decoration are likely to have been made in northern Italy, even though one was found near Richborough (no. 70) and the other on one of the Aegean islands (no. 71). Later vessels using the same decorative technique but imitating jewelled cups must similarly have been obtainable at first from only a few sources, and the blue beaker blown into a silver case (no. 74) is perhaps an even earlier attempt to imitate a jewelled model; but the fashion caught on in the 3rd century, and by the beginning of the 4th century the Cologne and eastern workshops must have been in full parallel production of the many western examples on the one hand and on the other of eastern pieces like the bowl from Cyprus (no. 86) and the cone-beaker (no. 87). Glasses decorated with trailed threads can be found anywhere in the empire, whether in Germany (no. 113) or in Syria (e.g. no. 118), and snake-thread decoration marks a particular group within this type. Differences can be recognized between the snake-threads of the eastern shops, as on the vessel from Cyprus (no. 81), and the western snake-threads, as on the four pieces from Germany in the exhibition (nos. 82, 83, 84, 85). Snake-thread vessels seem, however, to have been contemporaneous with each other, wherever they were produced, just as painted vessels like those from Greece (no. 68) and Cyprus (no. 69) also found equally ready markets at both ends of the empire.

Products of particular areas

Yet, while it is true that there was parallel development throughout the empire, there were also marked differences of market fashions and workshop products. An example is the group of glasses with cut or engraved figured scenes. The

earliest glass of this type is a bowl with cupids riding a hippocamp and a griffin, found in a grave of the late 1st century A.D. on Siphnos in the Aegean (National Museum, Athens; Brock and Mackworth Young (1949)); but it is not until the later 2nd century that a school of such work can be recognized, namely the group of colourless bowls bearing mythological and genre scenes in facet-cutting helped out with 'diamond'-point engraving for the details, such as the Actaeon and Artemis Bowl from Leuna near Merseburg, Saxony (no. 94). Many of these bowls, like that from Leuna, have inscriptions in Greek characters giving the names of the personages depicted. The bowls are small, with plain rim smoothed by grinding, and vertical sides curving gently to a rounded or flattened base. The facet-cutting and the engraving are equally competent. A feature of the group which acts in general as its trademark is the curvilinear engraved band which nearly always appears just below the rim. This group is most probably of Egyptian manufacture. They are, moreover, not only the last glasses exported in any quantity from Egypt to the west but also the parent group from which all late-Roman cut and engraved glasses with figured scenes are descended. Surprisingly, however, the group had few successors in the east. Alexandrian cutting and engraving rapidly deteriorated in quality, and during the 3rd and 4th centuries workers there rarely attempted figured scenes. In the west, on the other hand, from some time in the 3rd century onwards a great quantity of figured cut or engraved glass begins to appear in Italy and in the neighbouring provinces. A recently defined Constantinian group, with free-hand flint-engraved decoration, not represented in the British Museum's collections, is that which includes the bowl found at Wint Hill in Somerset (Ashmolean Museum, Oxford; Harden (1960)). The group was made in a Rhenish workshop, almost certainly in Cologne. Another easily recognizable group has human-figure designs formed of straight and curved lines made with a wheel but without any faceting, of which examples in the exhibition are the bowl with dancing figures (no. 97) and the bowl with Attis (no. 98), both from Amiens, and the beaker from Cologne with Adam and Eve (no. 99). Other groups in this class of figured glasses are represented by the Apollo and Athena dish from Halicarnassus (no. 96), by the Pegasus and Bellerophon bowl (no. 95), and above all by the Lycurgus Cup (no. 100).

The eastern workshops may not have abandoned figured decoration altogether, for some later examples are known, particularly as imports to the west from the east; but in general the West Syrian–Egyptian workshops seem to have concentrated on geometric designs and to have dropped the earlier fine linear- and facet-cutting in favour of techniques which could be accomplished by speedier and less skilful workers. Of these later techniques it was wheel-abrading that most strictly imitated the fine facet style. The use of this technique for imitations of the fine facet style, with designs formed of curved lines, circles and ovals, took particular root in Egypt and perhaps in Syria too. Many of the examples found in the west must stem from that area. An example in the exhibition from Egypt itself is the one-handled jug with geometric decoration in friezes from Behnesa, Oxyrhynchus (no. 105).

Finds at Dura Europos have recently demonstrated that the vessels with simpler cut geometric designs can also be grouped in local styles and fashions. The earlier examples of the 1st and early 2nd centuries with very fine facet-cutting, such as the cups from Barnwell in Cambridgeshire (no. 101) or Curium in Cyprus (no. 102), probably stem from somewhere in West Syria or Egypt.

From this area they were exported to the rest of the empire, including East Syria; but later examples from Dura Europos show that, as the 2nd century proceeded, East Syrian artisans became steadily more familiar with the technique of glass-cutting and produced their own examples of vessels in this technique. There seems to have been continuity of manufacture in this East Syrian–Mesopotamian area from the early 2nd to the middle of the 3rd century throughout the life, that is, of Dura Europos, and then not only until the breakdown of the Sassanian empire in the 6th century (nos. 135–8) but into Islamic times (nos. 139–60).

Further west other areas were producing particular products of their own. Examples are painted vessels and gold-glass. It is probable, of course, that glass was given painted decoration, sometimes in combination with gilding, at almost all important centres; but fine work was being carried out in the Rhineland, and a series of cups with vivid scenes in fired pigments, found predominantly in Scandinavia and Free Germany, may have had a Rhenish origin. The most accomplished painted glasses, on the other hand, seem to have been eastern products, like the two in the exhibition (nos. 68 and 69). Some gold-glasses were decorated on their outside surface in the same way; but the term is generally used to refer to a group of early Christian glasses with gilded decoration between two layers of glass. The outer layer of glass is sometimes coloured, as on the glass from St. Severin's parish in Cologne (no. 88); but usually both layers of glass are colourless, as on the other gold-glasses in the exhibition (nos. 89–93). Gilding did not originate in this period, for gold foil was already being placed between two layers of clear glass in the Hellenistic period, the bowl from Canosa (no. 38) being a splendid example. The gilded glasses of the 3rd and 4th centuries A.D., however, are better known because the majority of them were found in the catacombs around Rome. The elaborate gilded scenes of most of these pieces were sealed between two layers of clear glass in the circular spaces defined by the base-rings of bowls. The use to which gilded bowls were originally put is not clear; but most have been found embedded in the walls of the catacombs, with the glass broken away to the edge of the medallion, and their manufacture can certainly be ascribed to a workshop in or near Rome.

The full range of the workshops of Italy, of which such vessels as the gilded glasses were but one group of products, has not yet been fully investigated or assessed; but Italy stood at the centre of the Roman Empire, mid-way between east and west, and not only the importance of the peninsula in the production of Roman glass but the finest achievement of the whole craft in this period is summed up in two glasses made in Italy, the Portland Vase and the Lycurgus Cup (nos. 57 and 100), which are also two of the finest objects in the whole of the Museum's collections. The one marks the invention of the blowing process, by which a minor luxury trade was turned into an industry of great economic and social importance, while the Lycurgus Cup was made some three to four centuries later by skilled and confident craftsmen whose products were major works of art.

A. MOULD-PRESSED

43. Mosaic Bowl

G.R. Dept. 70.9–1.1 / 1st century B.C. / Purchased at Rome / Presented by the executors of Felix Slade.

Polychrome hemispherical bowl in marbled ware, made up of sections of opaque white, clear purple and clear green, with no rim-band.

Mould-pressed, with the divisions between some of the sections clearly visible; broken and mended, but complete; dulled, with considerable pitting, the pitting shallow but extensive on the outside and less extensive but in some places deeper on the inside; some of the metal very bubbly.

H, 0.076m. D, 0.122m.

BIBLIOGRAPHY: Oliver (1967), p. 15.

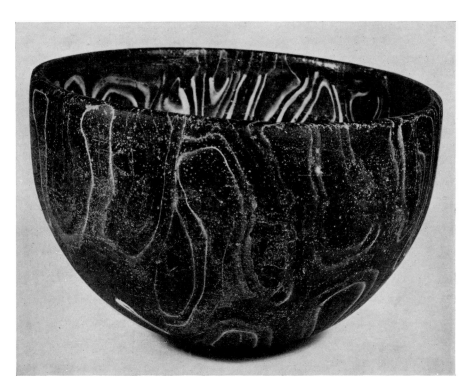

43

44. Mosaic Bowl

G.R. Dept. 73.8–20.420 / 1st century B.C. / From Vulci, Italy / Purchased.

Hemispherical bowl, all colours clear except the opaque white, made up of mosaic sections: (a) yellow spirals with white and blue centres in colourless, (b) monochrome slabs of opaque white, wine-coloured and amber. Border a spiral of blue with opaque white.

Mould-pressed; fire-polished outside, ground inside. Broken and mended; intact. Dulled and iridescent on one side of the exterior.

H, 0.06m. D, 0.127m.

Purchased from Signor Alessandro Castellani, Rome.

BIBLIOGRAPHY: Harden (1933), p. 424 and pl. II, fig. 4 (left).

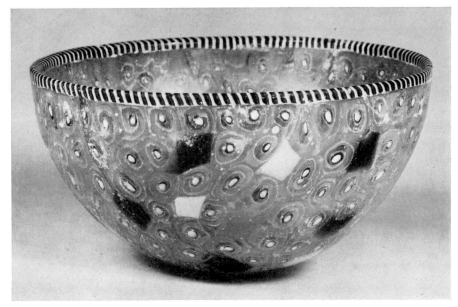

44

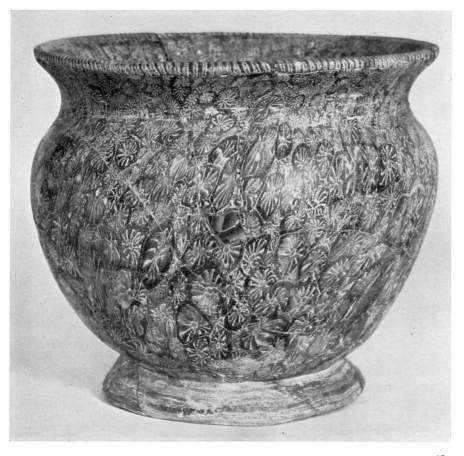

45. Mosaic Jar

G.R. Dept. 69.6–24.8 / Early 1st century A.D. / Found with a mirror at Tarquinia, Italy / Presented by the executors of Felix Slade.

Polychrome jar with everted rim, short neck, ovoid body and applied base-ring. Body made up of sections of floral rods as follows: (*a*) opaque white petals with opaque yellow and clear green centres in a clear purple ground, (*b*) the same in a clear blue ground, (*c*) opaque yellow petals with opaque white and clear blue centres in a clear green ground, (*d*) some stray fillings. Base-ring made up of stripes, all the colours as above.

Mould-pressed, base-ring apparently built up in coils; broken and mended, some filling, and a large piece of the rim restored; rough surface, pitting.

D (at mouth), 0.162m. H, 0.142m.

Formerly in the Castellani Collection.

Purchased from the sale at Christie and Manson, lot 52.

Register notes, 'Found at Corneto with a mirror'.

BIBLIOGRAPHY: Oliver (1967), pp. 15–16, fig. 4.

46. Mosaic Dish

G.R. Dept. 36.2–D.488: 1960.1–1.3 / Early 1st century A.D. / Purchased.

Shallow dish built up into mosaic consisting of white stripes, white coils, green backed with yellow, all set in a wine-coloured ground; rim a separate band of maroon and white stripes. Below rim two diametrically opposed suspension-holes.

Mould-pressed. The rim is a separately applied single strip of twisted maroon and white glass, with the junction between head and tail still visible. Intact; slight pitting in places on underside and also along junctions of mosaic on upper, internal surface; some bubbles and inclusions in metal.

D, 0.131m. H, 0.033m.

Purchased from the Durand Collection, February 1836.

BIBLIOGRAPHY: de Witte (1836), p. 356, no. 1507.

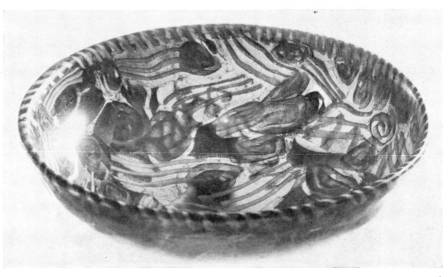

47. Bowl

G.R. Dept. ML 3188 / 2nd qtr. 1st century A.D. / Purchased / From Vaison, Vaucluse, France.

Emerald-green deep bowl, form Dragendorff 27.
 Mould-pressed; ground on both sides. Intact; enamelly film, flaking, leaving iridescent surface; pin-prick bubbles and black spots.

D, 0.128m. H, 0.055m.

From the collection bought from M. Léon Morel of Rheims (formerly of Châlons-sur-Marne) in two portions. April–May 1901.

47

48

48. Saucer

G.R. Dept. S 286 / 2nd qtr. 1st century A.D. / Bequeathed by Felix Slade, 1868.

Blue-green shallow saucer with wheel-cut concentric circles on under-side.
 Mould-pressed; ground all over. Intact, except for one tiny chip on rim; dulled; some black impurities.

H, 0.02m. D, 0.113m.

Formerly Roussel Collection.

BIBLIOGRAPHY: Nesbitt (1871), p. 47, no. 286.

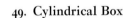

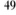
49

49. Cylindrical Box

G.R. Dept. 73.8–20.427 / 2nd qtr. 1st century A.D. / Found near Rome / Purchased.

Deep greenish-blue lidded box; lid convex with flanged edge and solid rounded knob, two raised circles near edge; box squat and cylindrical, slightly concave base with four raised circles, the minor ones with roll between, vertical sides with raised circles and roll at base.

Polished all over; box intact, lid broken and mended but complete; milky film inside, encrusted on exterior.

H (box), 0.118m. H (lid), 0.06m. D (box), 0.395m. D (lid), 0.405m.

Purchased from Alessandro Castellani, Rome. Described in the register as 'containing ashes'.

BIBLIOGRAPHY: Harden (1936), p. 282, n. 3.

50. Small Jar

G.R. Dept. 69.6–24.14 / 2nd qtr. 1st century A.D. / Found in the Greek Islands / Presented by the executors of Felix Slade.

Sea-green jar; rim cut and ground with rounded edge; constricted neck; ovoid body; concave base. Moulding at junction of neck and body; horizontal ribs at centre of body and 0.1cm. above base.

Ground and polished all over; intact; milky film, flaking and pitting.

H, 0.06m. D, 0.07m.

Former Castellani Collection. Purchased at the sale at Christie and Manson, lot 64.

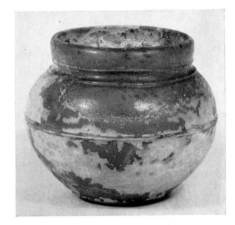
50

51. Pillar-moulded Bowl

B.M. Dept. 1923.6–5.1 / Mid-1st century A.D. / From Radnage, Buckinghamshire / Given by W. Gordon Ross.

Deep blue pillar-moulded bowl with opaque white marbling: twenty-two ribs run to near centre of base; base slightly hollowed.

Moulded and afterwards rotary- and

fire-polished. Intact, except for one hole in body; metal fair, some pin-prick bubbles and impurities.

H, 0.047m. D, 0.168m.

From a cremation burial in front of Two Shires Yew (donor's residence), Spriggs Alley, Chinnor Hill, Oxon., but actually in Radnage parish, Bucks.

BIBLIOGRAPHY: Skilbeck (1923); Harden (1947), p. 293; Thorpe (1961), p. 4 and pl. Ic; Brailsford (1964), p. 42 and pl. XI.

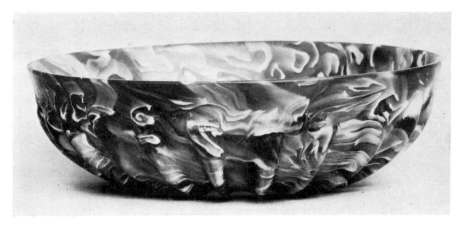

51

52. Pillar-moulded Bowl

G.R. Dept. 51.8–13.460 / Mid-1st century A.D. / From Vaison, Vaucluse, France / Purchased.

Light-green deep bowl with slightly splayed rim and concave base. Below plain band 2cm. wide thirty-one closely set ribs running over on to base; one wheel-cut at rim within, two more towards bottom of sides.

 Mould-pressed; ground smooth in interior and along the horizontal band at the top of the outer face; intact; flaky iridescence, pitted surface, one strain crack; some pin-prick bubbles and impurities.

D, 0.195m. H, 0.093m.

BIBLIOGRAPHY: Comarmond (1851), '460-patère ou casserole...trouvée à Vaison dans un ossuaire en marbre—en 1828...'

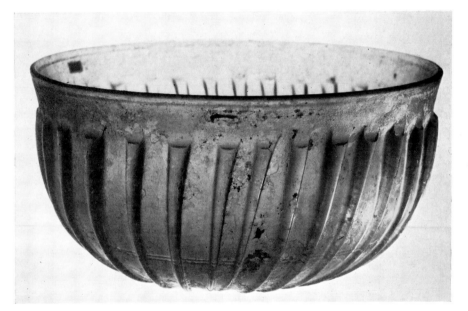

52

53. Boat

G.R. Dept. 69.6–24.20 / Mid-1st century A.D. / From Aquileia, Italy / Presented by the executors of Felix Slade.

Cobalt blue boat with raised stern; cut lines lead to the prow along the gunwale on each side; keel flattened.

 Ground all over, the stern modelled by cutting; intact; dulled, no iridescence, usage scratches; pin-prick bubbles and impurities.

L, 0.177m. H (at centre), 0.031m. H (greatest), 0.07m.

Formerly in the Castellani Collection; bought at Christie and Manson, lot 94.

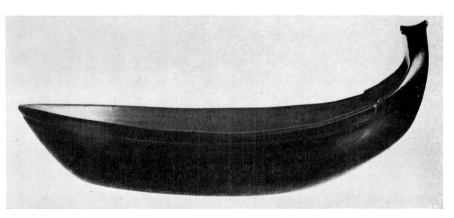

53

54. The Portland Vase Disk

G.R. Dept. Gem 4036 / Late 1st century
B.C. or early 1st century A.D. / Purchased
with the Portland Vase in 1945 with
funds bequeathed by James Rose Val-
lentin.

Flat disk of blue glass cased with opaque
white in which the design is cut, cameo-
fashion, in relief; groove 0.8–1cm. wide
and rounded in section cut on un-
decorated side; line incised round the
vertical edge in an attempt to give the
improvised base a moulded profile.

Relief: upper part of a young man
turned in profile to the right; he gazes
in front of him, and raises the forefinger
of his right hand towards his chin in a
gesture used in classical art to express
doubt or consternation; costume Asiatic;
short-sleeved tunic over a long-sleeved
undergarment, a billowing mantle fas-
tened at the throat by a circular brooch,
and a 'Phrygian' cap swathed in a
diaphanous scarf, one end of which hangs
down the cheek; above and behind him
the background is filled with foliage,
partly carved in the blue glass.

Broken and mended, complete except
for one chip about 1cm. long from under-
side of outside edge. No iridescence on
decorated surface; some pitting due to
exposure of bubbles in metal by cutting
of decoration; some iridescence remain-
ing on undecorated back, clearly cut
away by, and therefore earlier than, the
groove round the outside edge. Many
small bubbles and impurities.

D, 0.121–0.122m. T of blue, 0.004m.
T (greatest) of white, 0.001m.

The subject of the disk, which was
formerly the base of the Portland Vase
(no. 57), is related to that of the vase;
but the disk cannot be the vase's original
base: (a) the colours do not match, the
blue of the disk being much paler; (b)
though the disk is probably Augustan in
date or not much later, it is not by the
same hand as the frieze—the face, for
example, is quite differently modelled,
especially the area of the lips and nostrils,
and the pupil of the eye, blank on the
vase, is here indicated; (c) the disk has
been cut down from a larger composi-
tion, curtailing the figure and tree—no
doubt the complete plaque included the
three goddesses and Hermes; (d) the
groove on the undecorated back of the

54

disk is cut through iridescence, which
suggests that the disk was fitted to the
vase as a repair in comparatively recent
times.

A perplexed Asiatic youth is probably
Paris, the son of King Priam of Troy,
called upon to arbitrate between the rival
charms of Hera, Athena and Aphrodite.
At the wedding-feast of Peleus and
Thetis, Eris (Strife) had thrown among
the guests a golden apple inscribed 'For
the Fairest'; whereupon each of the three
goddesses claimed it for herself. As none
of the other Olympians dared intervene,
Zeus decided to refer it to Paris, the
most handsome of mortal men, at that
time still a simple herdsman on Mount
Ida. When Paris saw the goddesses ap-

proach, led by Hermes, and learnt what
was required of him, he was frightened
that, by choosing one, he would offend
the other two; but Hermes pointed out
that to disobey Zeus would be more
dangerous still, and so Paris agreed. Each
of the three competitors tried to bribe
their referee, Hera promising him royal
power and Athena martial success; but
Paris awarded the apple to Aphrodite,
who offered him the most beautiful
woman in the world for his wife. With
Aphrodite's help he seduced Helen, the
wife of King Menelaos of Sparta, and so
caused the Trojan War.

BIBLIOGRAPHY: see no. 57, The Port-
land Vase, below.

a patera, and the relief on the plaque may well be copied from this statue. There was also at Rome a statue of Bonus Eventus by Praxiteles (4th century B.C.; *v.* Pliny, *N.H.*, XXXVI, 4, 5); but we have no description of it. Bonus Eventus figures on the imperial coinage, and a temple dedicated to the god stood in the 9th region at Rome, near the baths of Agrippa (P. Victor, *de regionibus urbis*: 'Thermae Agrippae. Templum Boni Eventus'; Ammianus Marcellinus, XXIX, vi).

BIBLIOGRAPHY: Towneley Catalogue, p. 98; Taylor Combe (1818), engraving on title page and description; Müller (1835), p. 463, no. 381; Müller-Wieseler (1869), p. 61, no. 942; Daremberg et Saglio I (1877), p. 737, *s.v* Bonus Eventus; Wallace-Dunlop (1883), p. 182; Reinach (1912), p. 462, no. 5; Dillon (1907), p. 56.

55

55. Bonus Eventus Plaque

G.R. Dept. 1958.2–11.1 / 1st century A.D. / From Rome / Towneley Collection.

Square plaque, cobalt blue with yellowish-white flecks, with design in relief: a partly-draped youth, cut off part-way down thighs, facing right and seen in three-quarter view from behind, holds a patera in raised right hand and ears of corn in left; ends of cloak fall between arms in front, and down from left shoulder behind; in space to either side of head is inscribed BONO EVENTVI.

Moulded, with figure and objects heightened by cutting and engraved details; edges ground down, but no reason to suppose this was not done in antiquity. Broken and mended; four small patches of darker blue glass have been inserted: on right buttock; on left, lower, wrist; and two just above bottom right-hand corner of slab. No iridescence, some pitting of yellowish white flecks; some bubbles and impurities.

W, 0.18m. H, 0.18m. T (approx.), 0.009m.

Acquired for the Towneley Collection from the Museo Sabatini, Rome, before 1817.

The plaque is the upper slab of a relief made in two parts and is probably from a piece of furniture, perhaps from the triangular base of a large candelabrum as suggested by Taylor Combe. Bonus Eventus (Good Success) presided over agriculture (Varro, *de re rustica* I, 1, 6) and it was upon his favour that the abundance of the harvest was supposed to depend. A statue of him by Euphranor (4th century B.C.), preserved at Rome in the time of Pliny (A.D. 23/4–79; *N.H.* XXXIV, 19, 16), held corn, poppies and

56

56. Floral Mosaic Plaque

E. Dept. 29374: 97.5–11.90 / 1st–2nd century A.D. / Purchased in Egypt.

Rectangular plaque composed of many small cone-sections and strips of opaque colours from the range of white, yellow, green, brown, red and blue, set in transparent light blue; backing is mostly of red and black wavy strips.

Across the top are three yellow circles with white centres, the central one having eight white strips with yellow centres radiating above and a group of eight small white circles with yellow centres, probably buds, to either side and joined to it by yellow stalks; below, in the centre, three plants each with central yellow stalk and two yellow leaves, above which a five-petalled flower, green with yellow edges in side view and yellow with black spots in three-quarter-view from above; to either side, and at equal intervals of about 2.5cm. below, six small white flowers with yellow and red centres in three pairs; below the lotus-plants three yellow stems with green leaves, the outer of which have open quatrefoil flowers, the petals being red, white and then yellow in the centre; between the bottoms of the three yellow stems two closed flower-buds in the same colours, red at the tips, white in the centres, and yellow at the bases; below the three yellow stalks three yellow circles with white centres from which spring two yellow stalks, each with a group of eight white buds with yellow centres, this whole group resembling closely that at the top of the plaque.

Rectangle complete, one long edge being smooth and rounded, the other three rough. Much pitting of upper surface, particularly at junctions between sections; bottom surface wavy and un-polished, but bright; many small bubbles and impurities.

W, 0.063m. H, 0.094m. T, 0.004–0.005m.

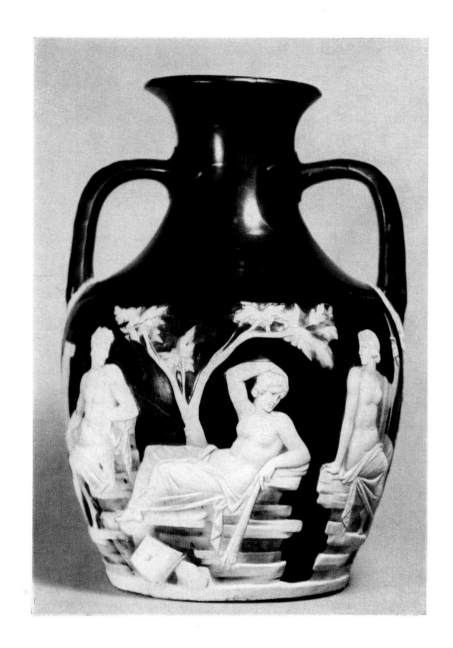

PLATE I

The Portland Vase. Late 1st century B.C. or early 1st century A.D. [57]

B. MOULD-BLOWN

77. The Portland Vase

G.R. Dept. Gem 4036 / Late 1st century B.C. or 1st century A.D. / Purchased in 1945 with funds bequeathed by James Rose Vallentin.

Amphora, cobalt-blue, cased with opaque white in which the design is cut cameo-fashion in relief. Rim rounded, with double wheel-cut groove on inside edge; everted mouth, below which neck curves smoothly out to carination of shoulder; bottom portion of body missing; a pair of handles from 3.5cm. below rim to shoulder, each vertically ridged on the outside and cut in V-shaped stepped sections.

Below the lower attachment of each handle is a head. The heads divide the figures of the frieze into two groups, one of four figures, the other of three:
Side a. Peleus moves to the right in front of a simple rustic shrine behind which grows a small-leaved shrub. The young man has either been lingering by the shrine or has just entered through the gateway. Eros, holding a bow in the left hand and a torch in the right, flies ahead of him, glancing backwards; and a woman sitting on a low rock in front of him turns and with her right arm clasps his at the elbow. The woman wears a mantle wrapped about her outstretched legs, and her left hand caresses a serpent-like creature which rises fawning towards her face. The last figure on this side is a bearded man, who stands, chin on hand, with his right foot on a rock at the base of a tree under which the woman sits. He too watches Peleus. Between him and the head of the adjacent handle grows another tree.
Side b. On the extreme left is a rectangular column surmounted by a square capital, beside which on a rock sits a young man with his head turned back. In the centre a half-draped girl reclines on the rock, with an inverted but still burning torch hanging from her left hand. On the ground at her feet lies a square block of stone with chamfered edges and a central slot, perhaps a fallen capital, and behind her is a plane-tree. On the right, on a separate, smaller, rock, a second half-draped woman rests on

her right hand, while in her left she holds a sceptre. The scene is closed by the head at the base of the handle and by the foliage of the plant which springs out from the base of the gateway on the other side of the vase.

Blown. Handles attached to white glass at shoulder, to blue glass at neck, with no junction visible at upper point. Grooved treatment of drapery and rocks suggests use of wheel, which is confirmed by depressions and marks of grinding round profiles of figures, inside neck and by handles; clear marks of rotary grinding on whole of inner surface of vessel. Elongated facet-shaped depression (matched by a bump on the interior) approximately 3cm. above the carination, 3cm. right of the handle and above the figure of Peleus, suggests use of grinding wheel to remove a flaw and perhaps indicates how far up the shoulder the white case came.

Broken and mended; base missing and edge roughly trimmed below white line 0.8cm. wide which forms base of figured frieze. There can be little doubt that the original base would have been made in one piece with the body; as a two-handled vessel or amphora the vase might have had a flat base with a moulded base-ring like that of the Auldjo Jug; but it is more likely, on the analogy of the closely related Blue Vase from Pompeii, that the body tapered downwards to a knob or point.

Slight iridescence in patches over most of interior; no iridescence observed on exterior; slight pitting on exterior, where pin-prick and elongated bubbles in metal have been exposed by the cameo-cutting of the surface. Many red streaks and tiny bubbles in the blue metal; both bubbles and streaks are very small at neck, becoming larger towards base, and all are elongated vertically; some tiny black flecks in the white, bubbles as in the blue; the vertical elongation of the bubbles suggests mould-blowing rather than free-blowing, which could have been expected to leave horizontal bubbles.

H, 0.245–0.248m. D (greatest), 0.177m. T (at bottom broken edge) of blue glass, 0.003m. T (at bottom broken edge) of white glass, 0.001m. D of mouth (external), 0.093m. H of handles, 0.086m. W of handles (at angle), 0.018m.

There is a story that the vase was discovered in 1582 in a sarcophagus on the Appian Way near Rome. This was not printed until 1697; but it was probably accepted by Girolamo Teti, who in 1642 was the first to record the vase, then in the Barberini Palace in Rome. Teti conjectures that the vase had originally been the cinerary urn of the Emperor Severus Alexander (d. A.D. 235) and that the scene on it had to do with his birth. There is no obvious reason for Teti to have suggested this unless he knew of the theory, conceived soon after the discovery, that the two marble figures on the lid of the sarcophagus are Julia Mammaea and her son Severus Alexander. The story, therefore, of the vase having come from the sarcophagus may reasonably be assumed to have been current as early as 1642, even though this does not necessarily mean that it is true.

The vase was purchased and brought to England by Sir William Hamilton, who sold it in 1785 to the Duchess of Portland. In 1810 the fourth Duke of Portland deposited it on loan in the British Museum where it remained until it was bought in 1945 with funds bequeathed by James Rose Vallentin.

The scene of the vase has been taken, though not without dispute, as illustrating the myth of Peleus and Thetis. The relationships of the characters, divine and mortal, are as follows,

Zeus and Poseidon both fell in love with the sea-goddess Thetis, daughter of Nereus and Doris; but Themis, the goddess of established order, prophesied that Thetis was destined to bear a son mightier than his father. Zeus and Poseidon therefore readily agreed that Thetis should be married to a mortal, and the choice fell on Peleus, son of Aiakos. In the most familiar version Thetis at first resisted Peleus' advances; but Peleus, helped by the advice of his friend, the Centaur Chiron, eventually forced her to submit, and the wedding was celebrated in Chiron's cave on

Mount Pelion in Thessaly. Yet the marriage was not a happy one, and after the birth of her son, Achilles, Thetis deserted her husband and returned to her native element. The version of the story given by the poet Catullus (*c.* 84–47 B.C.), however, is that, when the Argonauts sailed to fetch the Golden Fleece, the daughters of Nereus emerged from the waves to gaze with wonder on the first ship, and were thus themselves seen by mortal eyes for the first time. Among the Argonauts was Peleus, among the Nereids Thetis, and they fell in love with each other at first sight. At the end of the wedding celebrations the Fates sing: 'Never before has any house sheltered such loves, never before has love joined two lovers in such a harmonious bond as that which unites Thetis with Peleus, Peleus with Thetis.'

Haynes suggests that a romantic version of the myth, closely related to that of Catullus, must lie behind the frieze of the Portland Vase, which he interprets as one scene. Thetis, he says, carrying a torch to guide her through the night, has emerged from the sea on the coast of Thessaly and lain down on a rocky couch in her sanctuary. Peleus has been waiting for her and steps forward, emboldened not only by Eros, but by Thetis' own kin, for Haynes takes the sea-goddess who grasps Peleus by the arm to be either Doris, the mother of Thetis, or Tethys, her grandmother; the bearded sea-god accordingly either Nereus, the husband of Doris, or Oceanus, the husband of Tethys. Of the remaining pair of onlookers the stately seated woman, whom Haynes sees as watching Peleus across the whole width of the frieze, has been generally accepted as Aphrodite, while Haynes identifies the central figure on the second side as Thetis and the seated man at Thetis' feet as Aphrodite's husband, Ares. Menander the Rhetorician (3rd century A.D.) tells us that Peleus and Thetis shared with Dionysus and Ariadne the distinction of being the favourite themes for poems written to be recited at weddings. Haynes therefore takes the subject of the frieze to be the love of Peleus and Thetis for each other, symbolizing happy marriage, and suggests that the vase was designed to be an auspicious and commemorative wedding present.

Ashmole, on the other hand, sees the

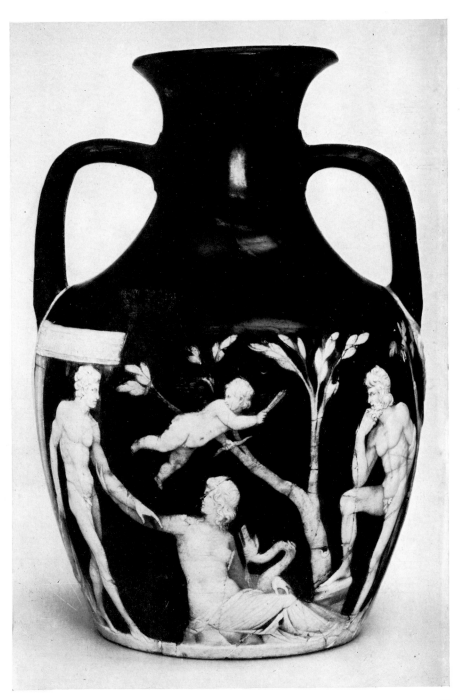

57

vase as having two separate but complementary scenes, separated by the handles and the heads at their bases. These heads have usually been thought to be Pan; but Ashmole takes them to be Oceanus. This would be appropriate to the myth of Peleus and Thetis, since Oceanus was both Thetis' grandfather and a symbol

of the triumph over death. Ashmole suggests that this is the theme of the whole vase, and further connects with it the handles, which he identifies with palm-fronds, a symbol in antiquity with the same significance. He takes the first scene to show first Peleus passing through the gateway through which the mortal

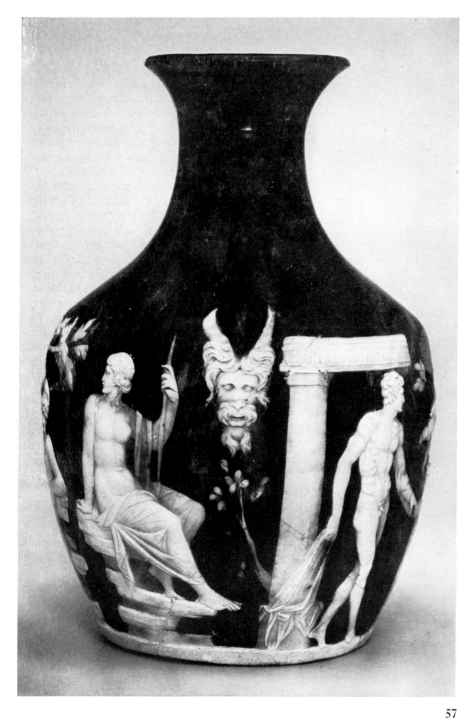

has just been talking, Ashmole suggests is Thetis' would-be lover Poseidon, who only thought better of the affair on learning that Thetis' son would be mightier than his father. The figures on the second scene are taken by Ashmole to be on islands in an oceanic setting: the first is Achilles, son of Peleus and Thetis, carried away after death by his mother to the White Island in the Euxine Sea, where his soul lived on. With Achilles on the island after death was Helen. The woman in the centre holds in her left hand an expiring torch, reversed, a symbol of death, and behind her is a plane, Helen's tree. The third figure on the second side is generally accepted as Aphrodite, and Ashmole explains her as looking back, from her island shrine of Paphos, over the cycle of events for which she was responsible, the Trojan story beginning with the union of Peleus and Thetis and ending with that of Achilles and Helen. This explanation gives a pattern in each scene of lover on the left, beloved in the centre and an Olympian deity on the right, and each scene shows the triumph over death under the gaze of Celestial Love, the one being the entry of mortal man (Peleus) into the world immortal, the other the apotheosis of perfect valour (Achilles) and perfect beauty (Helen).

BIBLIOGRAPHY: Walters (1926), no. 4036, pp. 376-8; Haynes (1964); Ashmole (1967); Haynes in Journal of Hellenic Studies (1968). For other interpretations see Haynes and Ashmole.

57

enters the world of the gods, as Peleus did when he married Thetis. He sees the position of Eros' wings as showing that Eros is turning towards us because they have arrived at their destination. The central figure, therefore, is likely to be Thetis, who turns towards Peleus and greets him by grasping his left arm with her right. The identification becomes more likely if there are references to some of what Ovid describes as the 'hundred forms' Thetis could assume at will: the sea-creature, which may be part of the young woman, the rocks beneath her and the tree by which she sits. The third figure, to whom the central young woman

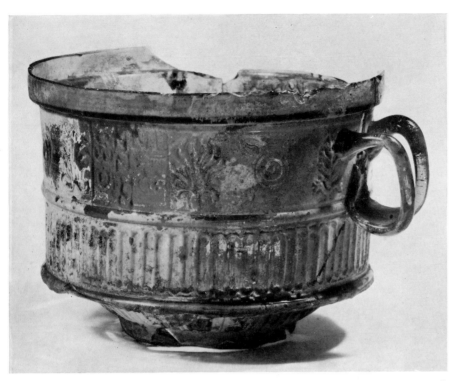

58

58. Cup by Ennion

G.R. Dept. 76.11–14.4 / 1st qtr. 1st century A.D. / From a tomb at Tremithus, Cyprus / Purchased.

Green one-handled cup; vertical sides; base not flat but concave with the vessel standing on a ridge. Decoration on sides in two friezes: (a) inscriptions, with palmettes, concentric circles, columns and a star between, (b) vertical flutes with rounded ends; bottom sloping with radiate gadroons; four raised concentric circles and a central dot on the underside of the base. Inscriptions in two parts of four lines each, enclosed in two rectangles: ENNIΩN ЕПOIHCEN and MNH⟨C⟩OH O ΑΓΟΡΑΖΩΝ.

The whole vessel blown in a bipartite mould; only one mould-mark visible, but clearly; the handle made of two parallel, vertical ropes of glass; the rim cut and ground. Broken and mended; incomplete. Enamel-like flaking; iridescent.

H, 0.097m. D, 0.135m.

Bought from General L. P. di Cesnola, 1876.

The find-spot is given in the register as:

'In a tomb at Tremithus, Cyprus'. Colonna–Ceccaldi gives Kythraea (Kytroi) as the find-spot, while, to judge from the name Locarna given in Kisa, Cesnola may somewhere have said that the vase came from Larnaka; but Kisa may simply have been confused by the location, 'Citium, Larnaka', given in the register for the first items in the acquisition-group (76.11–14.1, 2). Cesnola (1877), p. 424, mentions no find-spot.

BIBLIOGRAPHY: Maggiora-Vergano and Fabretti (1875), p. 104; Cesnola (1877), p. 424; Froehner (1879), p. 125, 6 g (inscription incorrectly quoted as ЕПOEI); Colonna–Ceccaldi (1882), p. 209; *IG*, XIV, 2410, 3; Conton (1906); Kisa (1908), pp. 714–5; Harden (1933), p. 424, fig. 7; Harden (1935), p. 165, A. Vases signed by Ennion, 1. One-handled Cups: (b).

59. Lidded Box

G.R. Dept. 93.10–16.1 / 1st half 1st century A.D. / From Sidon / Purchased.

Opaque white lidded box: round in section at top and bottom, octagonal in middle. On the lid is a frieze of eight palmettes facing outwards. Within this are three concentric circles and a dot, while outside there are two concentric circles. At the edge of the lid is a row of dots, below which are two raised horizontal circles. On the box there are eight panels with four separate designs, (a) Catherine wheel with a triangle above, (b) palmette, with the segment of a circle above, (c) circle and dot in a lozenge, (d) variant palmette, with the segment of a circle above. On the base is a frieze of overlapping leaves with six concentric circles and a dot inset.

Lid and box probably made in four-part moulds, rims cut and ground; intact; encrusted and some flaky weathering.

Box. D (rim), 0.051m. H, 0.065m. Lid. H, 0.026m. D, 0.061m. Total height, 0.085m.

Purchased from J. A. Durighello, Sidon.

BIBLIOGRAPHY: Dillon (1907), p. 57.

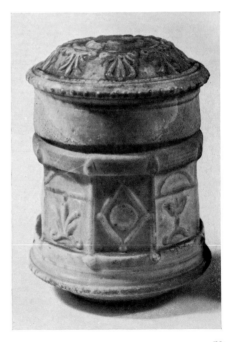

59

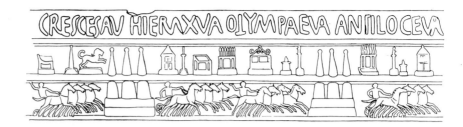

60. Beaker by Meges

G.R. Dept. 76.11–14.5 / 1st half 1st century A.D. / From a tomb at Maroni (Marium), near Amathus, Cyprus / Purchased.

Yellowish-green barrel beaker. Decoration contained by two raised lines above the zone, and by three raised lines below; two more raised lines 1cm. above base. Inscription ΜΕΓΗC ΕΠΟΗCΕΝ and ΜCΗCΘΗ Ο ΑΓΟΡΑCΑC in two parts of two lines each, separated by vertical palm-leaves, diametrically opposed; the theta and the omicrons and the sigmas all have dots within. Three raised concentric circles and a central dot on the under-side of the base.

The whole blown in a bipartite mould; rim cut and ground. Intact. Enamel-like pitting.

H, 0.087m. D (rim), 0.065m.
Bought from General L. P. di Cesnola, 1876.

BIBLIOGRAPHY: Maggiora-Vergano and Fabretti (1875), p. 104; Cesnola (1877), p. 424; Froehner (1879), p. 125, 9; Colonna-Ceccaldi (1882), p. 208; *IG*, XIV, 2410, 3; Kisa (1908), p. 708 (wrongly describing it as a two-handled cup); Harden (1935), p. 170, C. Vases signed by Meges, a.

61. Circus-Beaker

B.M. Dept. 70.2–24.3 / Mid-1st century A.D. / From Colchester / Presented by the executors of Felix Slade.

Olive-green cylindrical cup. Rim knocked off and ground; body divided into three friezes by three rolled ribs, below which body tapers to flat base standing on two more rolled ribs, which are concentric with a central hollow. Decoration in three zones, from the top: (*a*) Inscription, HIERAXVA OLYMPAEVA ANTILOCEVA CRESCESAV, (*b*) Circus objects, (*c*) four quadrigae; (*b*) and (*c*) are joined by two triple metae, extending over both.

Mould-blown. Chip off rim, otherwise intact. Dulled; incipient iridescence. Metal bubbly; many impurities and streaks in middle of a rolled rib.

H, 0.075–0.078m. D, 0.077m.

From the Pollexfen Collection. Found with a cremation-burial in the West Cemetery at Colchester. The inscription is interpreted as, 'Hierax va(le), Olympae va(le), Antiloce va(le). Cresces av(e)'. From the fact that Cresces is greeted with the word ave, in contrast to the farewell wished to the others, Hübner concludes that Cresces is the victor. Zangemeister and Kisa, however, regard CRESCESAV as a mistake for CRESCESVA.

BIBLIOGRAPHY: Keller (1863); Hübner (1873), no. 1273; Schuermans (1898); Kisa (1908), fig. 280 on p. 687, and p. 730; Smith (1922), p. 105 and fig. 124; Harden (1933), p. 425 and pl. III, fig. 6; Hull (1958), pp. 251 and 254, burial 109; Harden (1958); Berger (1960), pp. 64–5, no. 17, and pl. 9, fig. D (= Kisa, *op. cit.*, fig. 280); Hull (1963), p. 118, no. 109; Toynbee (1964), p. 378 and pl. LXXXVII a; Brailsford (1964), p. 44 and pl. XI.

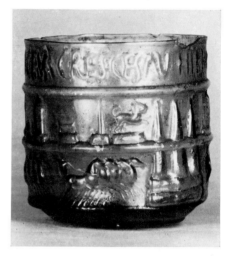

61

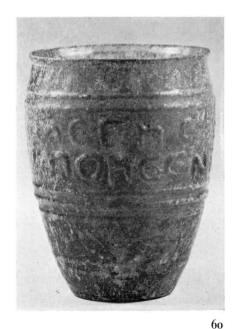

60

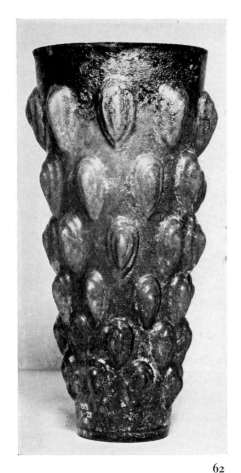

62

62. Beaker

G.R. Dept. 1913.5–22.18 / 2nd half 1st century A.D. / From Syria / Given by C. Fairfax Murray and W. Lockett Agnew.

Amber truncated conical vase with six rows of eight almond-shaped knobs and a raised horizontal rib 0.5cm. above the base.

Made in a tripartite mould, rim cut and ground; cracks, holes in one knob; enamel-like film on outside mostly flaked off and leaving an iridescent surface, the same on the inside but mostly not flaked off.

H, 0.208m. D (rim), 0.095m. D (base), 0.051m.

Collected in Syria by J. Durighello.

Compare the fragments from Vindonissa and parallels listed in Berger (1960), pp. 52–4, where the group is dated about A.D. 70–100.

63. Inscribed Head-flask

G.R. Dept. 76.11–14.3 / 1st century A.D. / Found in a tomb near Idalium, near the village of Potamia, Cyprus / Purchased.

Tall head-flask. At base of tall neck a slight constriction with roll-moulding below; main body in shape of male head with curly hair, between inscriptions above and below; upper inscription below the roll, on the front only ΕΥΓΕΝ; the lower inscription round the whole base, ΜΕΛΑΝΘ ΕΥΤΥΧΙ.

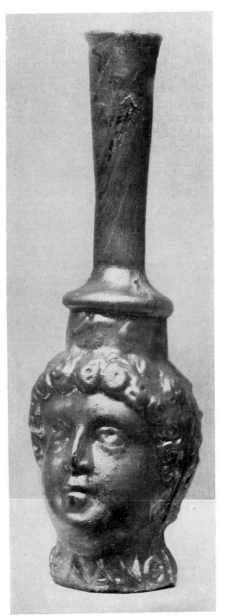

63

Mould-blown, with the mould-mark on the base very prominent; one hole and crack at the back of the head; highly iridescent and flaked, with rainbow colours; colour and quality of metal both uncertain because of the iridescence.

H, 0.198m. W (greatest), 0.07m.

Purchased from General L. P. di Cesnola, 1876.

BIBLIOGRAPHY: Cesnola (1877), p. 424; Froehner (1879), p. 125, 7; Colonna-Ceccaldi (1882), p. 209 (= *Rev. Arch.*, n.s. xxix (1875), 95), who quotes the inscription wrongly as ΕΥΤΕΝ; Kisa (1908), p. 707; Harden (1935), p. 183, Appendix A, 2; Neuberg (1949), pl. XVI, no. 56.

64. Figured Beaker

G.R. Dept. 78.10–20.1 / 1st century A.D. / Found in a tomb at Cyzicus, Turkey / Purchased.

Bluish-green conical beaker. Rim slightly inturned and cut and ground; flat base with two concentric ridges and central dot. Wheel incisions near rim. Below, four panels with gabled tops between columns of rough corinthian shape, each panel with single figure: (*a*) nude Mercury with caduceus in the right hand and purse in the left hand, (*b*) draped female carrying dead bird on pole across left shoulder and bow in right hand, (*c*) nude male carrying an animal upside-down in left arm, (*d*) female in short chiton carrying what may be an amphora across body in left arm, and a two-handled amphora at side in right hand.

High relief, mould-blown in a bipartite mould; intact; faint iridescence; good metal, some impurities.

64

H, 0.124m. D (rim), 0.062m. D (base), 0.044m.

Purchased from Titus Carabella, Constantinople, through Sir A. H. Layard. Found with an inhumation-burial accompanied by lacrimatories, a glass patera, a pottery lamp, a glass aryballos and an iron strigil in a tomb cut in the rock at Cyzicus. Carabella (p. 206) identifies the figures as, 'Hercule (il porte le lion de Némée), x...? Hermès Agoréos et (Diane?)'. For comparative pieces see Berger (1960), pp. 124–5 and pl. 8.

BIBLIOGRAPHY: Carabella (1879).

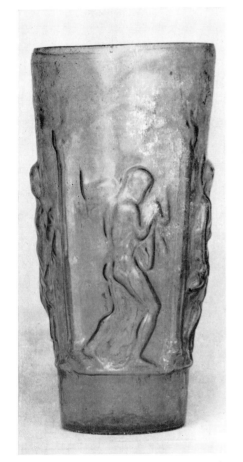

64

65. Two-handled Flask

G.R. Dept. 69.6–24.5 / 1st century A.D. / Presented by the executors of Felix Slade. Cobalt-blue amphorisk, with the body well modelled in the form of a bivalve shell. Rim outsplayed and folded in; neck cylindrical with constriction at base; two handles, circular in section.

Blown into a bipartite mould; intact; no weathering—what is on it now is probably modern faking; good metal, some bubbles.

H, 0.085m. D (greatest), 0.055m.

Formerly Castellani Collection. Purchased from the sale at Christie and Manson, lot 12.

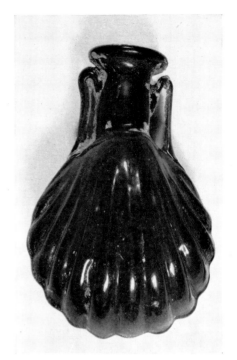

65

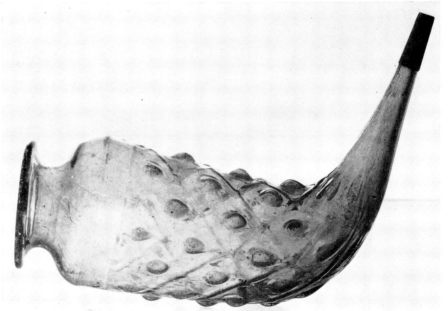

66

66. Drinking Horn

G.R. Dept. 72.7–26.1 / 1st century A.D. / Presented by the executors of Felix Slade.

Amber horn with rim at slight angle to body; body finished with angled nozzle. Rim folded over and in; below shoulder a flattened and sunk band forming the upper border to a pattern of seven rows of almond-shaped bosses in diamond-shaped squares.

Mould-blown in a tripartite mould; nozzle finished with a metal cap. Intact; no weathering; metal bubbly and uneven.

H, 0.17m. D (rim), 0.051m. L, 0.125m.

67. Rectangular Bottle

B.M. Dept. 1299–'70 / 1st or 2nd century A.D. / Found at Faversham, Kent / Bequeathed by William Gibbs.

Bluish green bottle; rim folded outwards, upwards and inwards; cylindrical neck with tooled constriction at base; body blown into rectangular mould; fifteen-ribbed flat drawn handle. On bottom four concentric circles in relief with central stamp of ligatured NE.

Intact; dulled, some contents-stain within; metal bubbly and streaky, but fair.

H, 0.2m. W, 0.11m. Capacity, 1260cc.

The Gibbs Bequest was transferred from the South Kensington Museum to the British Museum in 1895. Roach Smith says (introduction, p. iii), 'The Anglo-Saxon and other antiquities bequeathed by . . . Gibbs . . . were brought to light close to the town of Faversham chiefly during the formation of the London, Chatham and Dover Railway; and subsequently while excavations were being made for brick earth in land adjoining . . . We . . . are unable to group them . . . as they were originally disposed in the graves. They are all, both Saxon and Roman, from graves, the number of which indicate a cemetery of considerable extent . . .', and also (p. xxiv), '. . . The collection consists of specimens . . . for the most part found in graves in a locality adjacent to Faversham in Kent, known as the King's Field'.

BIBLIOGRAPHY: Roach Smith (1871); Charlesworth (1966), p. 40, Appendix II, no. 20.

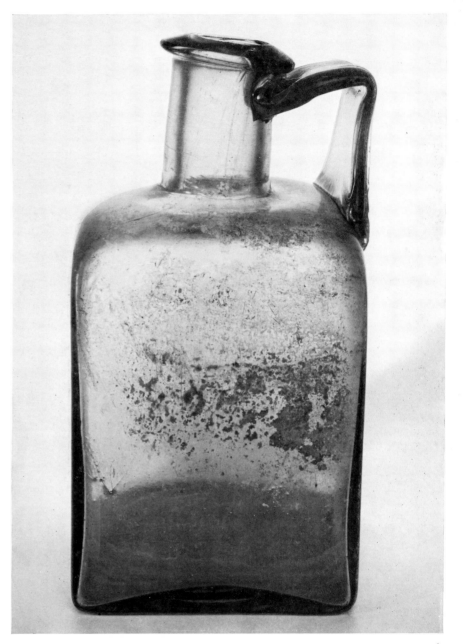

67

C. BLOWN

68. Bowl

G.R. Dept. 1905.11–7.2 / 2nd qtr. 1st
century A.D. / From Greece / Bought
from J. P. Lambros, Athens.

Yellowish-green painted bowl: rim
knocked off and ground; sides vertical
with slight convexity; bottom flattened.
Faint wheel-incised band below the rim;
painted design on the exterior, very ill-
preserved in places: a frieze shows a duck
prancing right towards a basket full of
flowers and with wreaths trailing over the
edge at each side, on the bottom an eight-
pointed star within a border of dots;
colours preserved are red, brown and
yellow.

 Broken and mended, some bits mis-
sing, some strain-cracks; blue enamel-
like film, mostly flaked off, on both sides,
leaving iridescent pitting; bubbly metal.

H, 0.07m. D (rim), 0.082m. D (greatest),
0.087m.

For dating see Harden (1947), p. 297.

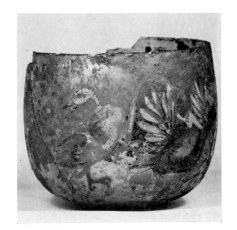

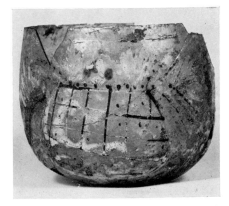

68

69. Bowl with Painted Lid

G.R. Dept. 88.11–12.1 / 2nd century
A.D. / Presented by the Committee of the
Cyprus Exploration Fund.

Pale greenish bowl with slight constric-
tion below mouth. Body globular, base
slightly concave, no decoration. Cover
has dished top, rim folded down and in;
trace of a winged figure in black outline,
moving right, looking left, with a bunch
of grapes in the left hand and a curved
object in the right, a tree fills the left of
the picture and three freely drawn zigzag
lines represent the ground below.

 Intact; enamel-like film, flaking off,
on bowl, cover encrusted.

D (cover), 0.075m. D (bowl at mouth),
0.065m. H (lowest), 0.061m. H (greatest),
0.068m.

BIBLIOGRAPHY: Harden (1936), p. 282,
n. 2; Dillon (1907), p. 47.

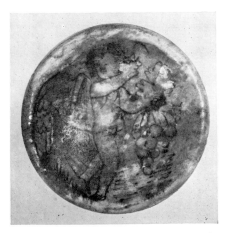

69

70. Oil-flask

B.M. Dept. 1932.3–14.1 / Mid-1st century A.D. / Found near Richborough, Kent / Purchased.

Dark-blue oil-flask with opaque white marvered blobs. Rim outsplayed and folded up and in, flattened on the bevel above; neck cylindrical with a constriction at the base; squat, globular body below with a rounded base offset—perhaps accidentally—near the bottom of the sides; two dolphin-like handles on the shoulder, not reaching to the neck.

Blown and marvered; intact; some dulling of the surface.

H, 0.09m. H of neck, 0.024m. D, 0.09m.

Purchased from B. W. Pearce of Sandwich. Probably found with a pottery cup (1932.3–11.1. Given by Mr. Pearce) on the East Kent light railway, south of Richborough. The cup is of samian, form 27, stamped IVSTI, c. A.D. 80–90. Made in north Italy—see Fremersdorf (1938).

BIBLIOGRAPHY: Smith (1933); Harden (1947), p. 296; Brailsford (1964), p. 44 and pl. XI.

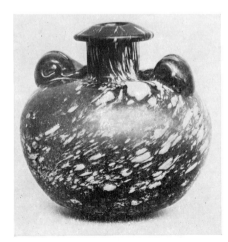

70

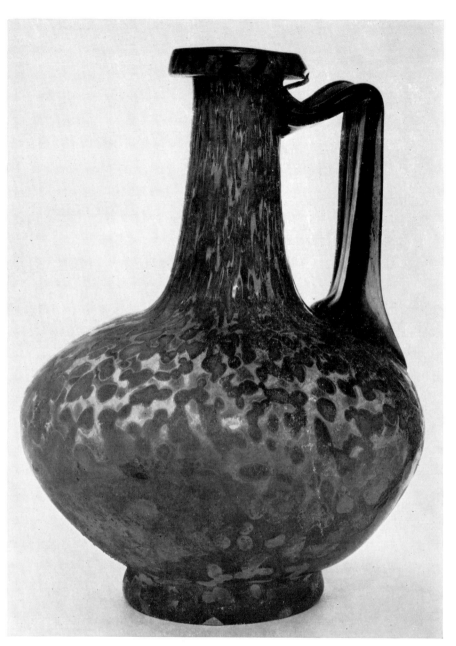

71

71. Jug

G.R. Dept. S 85 / Mid-1st century A.D. / Found on one of the Aegean islands / Bequeathed by Felix Slade, 1868.

Amber jug with opaque white blobbed decoration; rim folded down, over and in; cylindrical neck, expanding towards base; ovoid body with hollow concave base; three-ribbed handle. White blobs marvered all over body and neck, but only a few stray ones on base.

Intact except for one chip off lower edge of rim and upper tip of handle; dulled, one patch of encrustation; good metal, some impurities and bubbles.

H, 0.238m. D (rim), 0.055m. D (body), 0.178m.

Nesbitt (1871) notes, 'Found in one of the islands of the Archipelago, by M. Péretrié, French vice-consul for Syria'. Made in north Italy—see Fremersdorf (1938).

BIBLIOGRAPHY: Nesbitt (1871), pp. 16–17, no. 85, fig. 28; Harden (1947), p. 296; Haberey (1958), p. 191 and pl. 10.

72. Small Jar

G.R. Dept. 69.6–24.30 / Mid-1st century A.D. / From Pozzuoli, Italy / Presented by the executors of Felix Slade.

Iron-blue jar with opaque yellow spots and a very few opaque green ones. Rim folded out and down to base of concave neck; ovoid body; concave base with no pontil-mark. Spots in a band from just below the shoulder almost to the base.

 Blown; spots not marvered and therefore applied after blowing; intact; iridescent; metal good but with some tiny bubbles.

D (rim), 0.075m. H, 0.082m.

From the sale of the Castellani Collection at Christie and Manson, lot 119.

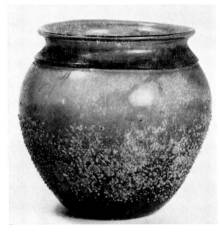

72

73. Handled Flagon

B.M. Dept. S 264 / 3rd qtr. 1st century A.D. / From Barnwell, Cambridgeshire / Bequeathed by Felix Slade, 1868.

Bluish-green flagon; rim outsplayed and folded up and in; cylindrical neck with constriction at base; inverted triangular body; concave base, no pontil-mark; from lip to shoulder angular handle, flat drawn with central rib, sides splayed at bottom and long un-nicked tail. Seventeen spiral ribs, probably tooled, on body from base of neck to near base; some of them accidentally nipt together near bottom during fashioning of base.

 Blown. Part of rim and neck missing, otherwise intact; brownish and white contents-weathering within, incipient iridescence outside; metal bubbly and streaky, some yellow streaks in handle.

H, 0.287–0.293m. H (neck), 0.12m. D (body), 0.133m.

Found in the cemetery at Barnwell, Cambridgeshire, with S 171.

BIBLIOGRAPHY: Nesbitt (1871), pp. 44–5, no. 264, fig. 64; Harden (1936), p. 233; Brailsford (1964), p. 44, no. 11 and pl. XII.

73

74. Beaker with Silver Case

G.R. Dept. 70.9–1.2 / 1st century A.D. / Found in Italy, probably at Brindisi / Presented by the executors of Felix Slade.

Cobalt blue beaker blown into a silver case which has eight rows of oval openings through which glass bulges; six more openings on the base and fifteen openings round the neck; plain ground rim, bulging sides and an almost flat base.

 Intact, part of the silver case chipped off; dulled.

H, 0.093m. D, 0.072m.

The register records, 'Purchased at Florence. On it is written "Brindisi 2° febr.° 1865" probably the locality where found'.

BIBLIOGRAPHY: Fremersdorf (1962), p. 57, pl. 115; Plenderleith (1962), p. 223 and pl. 29; Strong (1966), p. 13 and pl. 50 c.

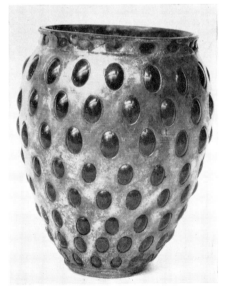

74

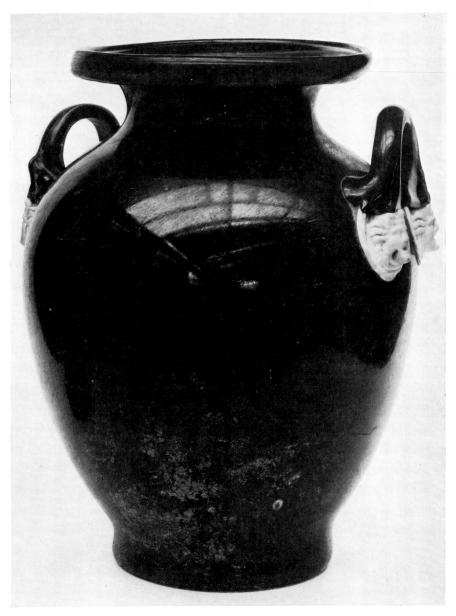

75. Two-handled Jar

G.R. Dept. WT 1122 / 1st century A.D. /
From Santelpidio, near the ancient
Atella, in Campania, Italy / Bequeathed
by Sir William Temple.

Wine-coloured jar with opaque white
masks and with white stripes on the
handles. Rim folded down, up and in;
concave neck; ovoid body with slight
inward curve above pushed-in concave
base; no pontil-mark or kick; strap
handles, circular in section, with two
white appliqué actors' masks under each,
probably tragic.

Blown; intact; incipient iridescence.

D, 0.192m. H, 0.248m.

One of the collection of antiquities be-
queathed in 1856 by Sir William Temple,
H.B.M. Minister at the Court of Naples.
'[The collection] is more fully described
in a Ms. catalogue made by R. Gargiulo'.
The entry in pencil against 1122 is
presumably quoting from Gargiulo's
catalogue, 'Santelpidio presso l'antica
atella', i.e. 'from Santelpidio, near the
ancient Atella'.

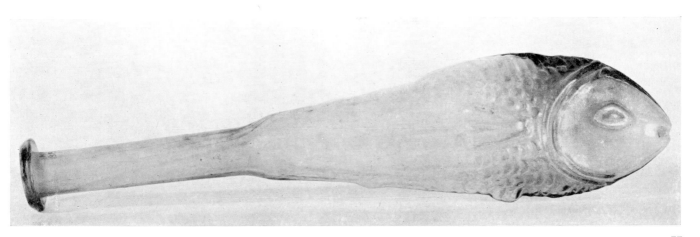

LATER ROMAN **A. MOULD BLOWN**

77. Fish-bottle

G.R. Dept. ML 3174 / 2nd–3rd century A.D. / Perhaps from Arles / Purchased.

Olive-green fish-bottle; rim turned down and then over and in; cylindrical neck; body in shape of a fish.

Blown in a bipartite mould; intact; dulling and iridescence in patches; some streaks and impurities.

H, 0.278m. W (greatest), 0.059m.

From the collection bought from M. Léon Morel of Rheims, formerly of Châlons-sur-Marne, April–May 1901. The register notes, 'Perhaps from Arles. See Morel—notes sur les découvertes etc. p. 1 and fig.'

76. Head-flask

W.A. Dept. 100659: 1905.5–13.8 / 2nd–3rd century A.D. / Purchased.

Olive-green janiform head-vase in form of small flask. Rim outsplayed and folded upward and inward; tallish neck with concave sides; body blown into two-piece mould in form of addorsed boys' faces, one serious, one smiling, the former perhaps representing the master, the latter the slave; base flat.

H, 0.065m. D (greatest), 0.035m.

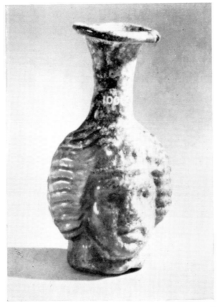

76

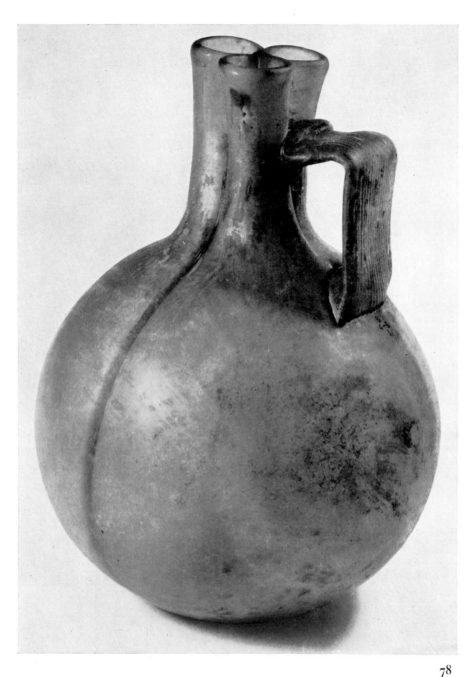

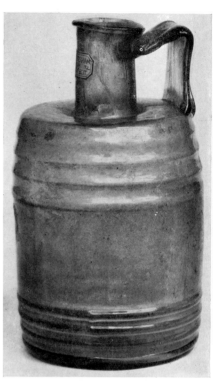

79

79. Barrel-jug by Felix

B.M. Dept. 1922.5–12.1 / 3rd century A.D. / From Faversham, Kent / Purchased.

Green one-handled bottle: rim outsplayed and folded up and in; cylindrical neck sunk into shoulder a little at base; below horizontal shoulder a slightly convex-sided body with group of four roll-ribs at top and bottom; at junction of body and base another roll rib and two more concentric ribs on the flat base; flat ten-ribbed sharply angular drawn handle from shoulder to below rim; between concentric ribs on base the inscription FELIX FECIT.

Blown into a bipartite mould; intact; iridescent contents-weathering within; iridescent outside; bubbly and streaky.

H, 0.148–0.153m. D, 0.085m. H (neck), 0.04m.

Found at Faversham, Kent, in 1878. Formerly in Sir Arthur Evans's Collection. Bought through Messrs. Spink and Son from the sale at Sotheby's, April, 1922.

BIBLIOGRAPHY: Brailsford (1964), p. 44.

78

78. Handled Triple Flask

G.R. Dept. 81.4–6.1 / Late 2nd or 3rd century A.D. / From Heraclion, Crete / Purchased.

Dull greenish triple bottle: rounded rims; cylindrical necks; globular bodies; flattened base; many-reeded handle.

Blown. Intact; dulled, some iridescence within.

H, 0.22m. D (of each bottle at rim), 0.026m.; (of body), 0.16m.

Purchased through Messrs. Rollin and Fenardent from sale at Sothebys, 29 March, 1881, lot 68. A bottle similar in construction sold in the sale of the Disch Collection at Cologne, no. 1541, 12–21 May, 1881, found at Mainz, pl. 130. For comparable examples at Trier, Bonn and Cologne see Morin–Jean (1913), p. 120, form 63.

BIBLIOGRAPHY: Clairmont (1963), p. 128, pl. XXXVIII.

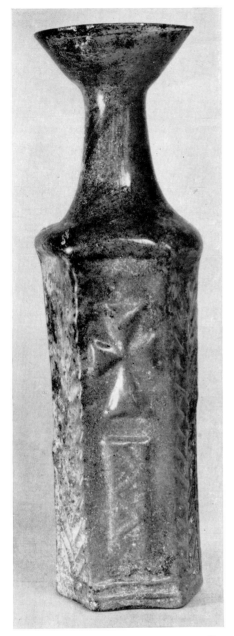

between two palms, and a monk or Christ between two panels of trellis.

Base hollow with pointed kick and pontil-mark. Intact; contents-weathering within, heavy enamel brown to black film outside with iridescence; metal bubbly and streaky.

H, 0.225m. H (body), 0.15m. D (rim), 0.063m. Greatest width of base, 0.065m.

Bought from Artin Sarkissian, Paris.

80

80. Hexagonal Bottle

B.M. Dept. 1911.5–13.1 / 4th–5th century A.D. / From Aleppo, Syria / Purchased.

Dull green hexagonal bottle: rim outsplayed and rounded; neck cylindrical but expands downwards to sloping shoulder; body blown into hexagonal mould. Decoration in the six panels shows a cross, on what may be an altar,

B. BLOWN

i. SNAKE-THREAD

81. Flask

G.R. Dept. 71.1–23.1 / Late 2nd century A.D. / From Idalium, Cyprus / Presented by the executors of Felix Slade.

Greenish flask: rounded rim; cylindrical neck, slightly funnel-shaped at the top; neck merges gradually into piriform body with greatest diameter near base; added base-coil; base concave below, with mark of pontil-rod. On the body three winding applied 'snake'-coils, all different, mainly flattened, each ending in a triangular head, and nicked one way or criss-cross.

Intact; blue enamel-like weathering

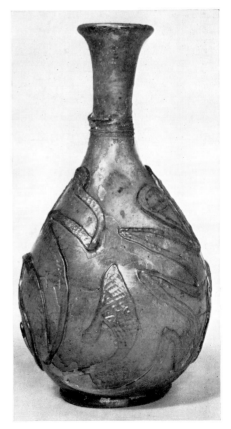

81

mostly flaked off, iridescent pitting all over.

H, 0.155m. D (rim), 0.03m. D (body), 0.081m.

Found by L. P. di Cesnola. Bought from the Cesnola collection at Sotheby and Wilkinson.

BIBLIOGRAPHY: Harden (1934), p. 50, no. 1; Harden (1956), p. 340 and fig. 316 (left).

82. Jug

G.R. Dept. 68.1–5.49 / Early 3rd century A.D. / From Urdingen, Germany / Presented by George Witt.

Colourless jug: rounded rim; pinched lip; funnel neck; ovoid body; tubular pushed-in base-ring; flat handle; pontil-mark and small kick in base. Four snake-trails on body, with varying numbers of central zigzags, alternately blue and yellow; small blue notched trail in handle.

Blown; broken and mended, one piece

of wax fill; some dulling; metal fair, some pin-prick bubbles.

D, 0.07m. H (excluding handle), 0.12m.

Found with 83 (below) and other objects in a stone coffin at Urdingen, near Düsseldorf, near the Roman Camp of Gelduba (Krefeld-Gellep) in 1861.

BIBLIOGRAPHY: Witt (1871).

83. Handled Bowl

G.R. Dept. 68.1–5.52 / Early 3rd century A.D. / From Urdingen, Germany / Presented by George Witt.

Greenish colourless shallow skillet: solid folded rim; tubular base-ring with pontil-mark in centre; handle twisted and drawn, nipt at end. Four snake-trails on outside, alternately blue and yellow.

Broken and mended, one side missing; dulled; fair, pin-prick bubbles.

H, 0.04m. D, 0.107m. Length of handle, 0.057m.

Found with 82 (above) and other objects in a stone coffin at Urdingen, near Düsseldorf, near the Roman camp of Gelduba (Krefeld-Gellep) in 1861.

BIBLIOGRAPHY: Witt (1871).

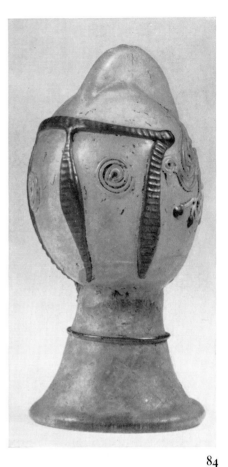

84

84. Pourer Flask

G.R. Dept. 81.6–24.2 / 3rd century A.D. / From St. Severin's parish, Cologne / Purchased.

Greenish–colourless helmet-flask in form of 'dropper', upside-down: rim outsplayed and folded up, in and down; funnel neck, widely cut in at base to very tiny opening; bulbous body, with crest of helmet on one side and underneath; pontil-mark on crest. Single blue trail on neck of vase; with side-whiskers and nose of nicked blue (snake-thread) between which coiled eyes of colourless with opaque white and blue pupils; on either side of face a bird, colourless, standing on a berried twig of opaque white with red berries and green twig and petals.

Intact; dulled and some strain-cracks; metal fair, some bubbles.

H, 0.102m. D (rim), 0.05m.

Bought through A. W. Franks from the sale of the Disch Collection at Cologne, 16 May, 1881, lot 1371. The only parallel is the helmet-flask found in a

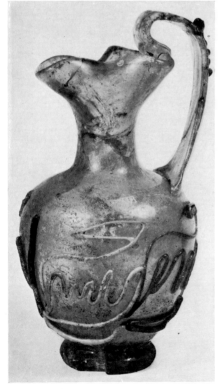

82

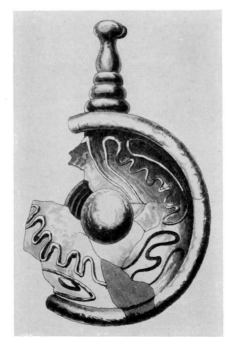

83

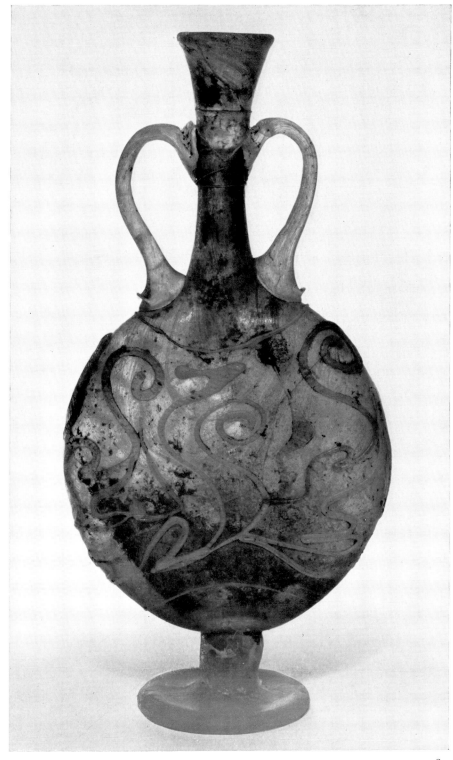

85. Flask

G.R. Dept. S 257 / 3rd century A.D. / From Cologne, perhaps from the Krefeld district / Bequeathed by Felix Slade, 1868.

Greenish–colourless flask; tall cylindrical neck; present rim rounded and outsplayed; flattened spherical body, on knob which originally topped a footstand; traces of junction of footstand remain at one side above modern restored base; two handles, circular in section, from middle of neck to base of neck. Opaque yellow spiral on neck, in middle, between handles; snake-thread nicked patterns, alternately blue and yellow in band round body flanked by single yellow trails top and bottom.

 Broken and mended: some alien pieces on body and base-knob and also at top of neck, where one green piece is certainly alien and rim portion, though right colour and weathering, may not belong either. Pitted in streaks, some strain-cracking.

H, 0.20m. W, 0.106 × 0.025m. D (neck), 0.03m.

The alien pieces on base-knob and at top of neck and the rim are shown in the drawing in Nesbitt (1871).

BIBLIOGRAPHY: Nesbitt (1871), pp. 42–3, no. 257, fig. 60; Harden (1933), p. 426 and pl. IV, fig. 11; Neuburg (1949), pl. XVII, no. 58; *Römer am Rhein* (1967), pp. 267–8, no. D 66.

85

grave in Cologne in the Luxemburgerstrasse (Fremersdorf (1961), p. 35 and pl. 45; Doppelfeld (1966), p. 56 and pl. 127; *Römer am Rhein* (1967), pp. 265–6, no. D. 55: Römisch–Germanisches Museum, Cologne, no. L 62).

BIBLIOGRAPHY: *BJ*, 36 (1864), pl. 3, 2; *BJ*, 71 (1881), pl. 7, no. 1371; Kisa (1908), pp. 250–1; Fremersdorf (1959), pl. 74; Fremersdorf (1961), p. 36, pl. 46; *Römer am Rhein* (1967), p. 265, no. D 54, and pl. 103.

86

86. Bowl

G.R. Dept. 71.10–4.2 / 4th century A.D. / From Cyprus / Given by the executors of Felix Slade.

Greenish–colourless segmental bowl with dark blue blobs; rim knocked off and ground, sides and body in one unbroken curve. One broad cut groove below rim; approximately 2.5cm. below the rim three groups of six blue blobs, marvered in, each between 0.5 and 1cm. in diameter, arranged in a flat-topped triangle; three large blue blobs, also marvered in, between the three groups, each between 2 and 2.5cm. in diameter.

Intact, some usage scratches on the centre of the base; incipient iridescence; good metal, a few bubbles.

H, 0.06m. D, 0.195m.

From the Cesnola Collection.

87. Beaker

W.A. Dept. 1965.4–14.1: 134638 / 4th century A.D. / Purchased.

Greenish cone-beaker, plain ground rim, bevelled to exterior; sides taper to very narrow flattened base. Two broad horizontal wheel-cuts near top above a band of twenty-two equal-sized transparent blue blobs; group of wheel incisions just below and a single wheel incision lower down body.

Intact; iridescent film, especially on one side.

H, 0.18m. D, 0.108m.

87

88. Bowl-fragments

B.M. Dept. 81.6–24.1: EC 629 / 2nd
half 4th century A.D. / From St. Severin's
parish, Cologne, Germany / Purchased.

Two portions of a colourless bowl, the
smaller consisting of three fragments,
the larger of four, with emerald-green
and blue blobs and with gold decoration
between the inner faces of the blobs and
the outer surface of the colourless bowl;
wheel-cut lines on the upper portions
suggest a bowl with incurving sides at the
top and a bottom rounded in an unbroken
curve. The pairs of wheel-cut lines are
0.5cm. apart, one pair on the smaller
portion, two pairs, 1.3cm. apart from
each other, on the larger portion.

The two portions are ornamented with
twenty-one medallions in gold, protected
at the back with blobs of emerald-green
and cobalt-blue glass. The medallions
are of two kinds, the larger, between 2
and 3cm. long, having figure subjects,
the smaller, between 0.5 and 1.5cm. long,
having eight-petalled stars or flowers.
They are arranged in concentric circles,
the smaller being placed in the spaces
between the larger. Of the four medal-
lions remaining from the outermost
circle one (green) represents Our Lord
or Moses with the rod of power, a second
(blue) Adam and Eve standing on either
side of the tree round which the serpent
is coiled, a third the sacrifice of Isaac,
the fourth a female, who may be Susan-
nah, wearing a long girded tunic with
clavi and standing in the attitude of an
orans between two trees. In the scene of
the sacrifice of Isaac, the boy lies nude
upon the ground to left with his hands
bound behind him; Abraham in the

centre, bearded and wearing a striped
tunic, with his left hand grasps Isaac
by the hair, with his right brandishes a
knife, his head inclined backwards to-
wards the arm of the Almighty, which
issues from heaven behind him; in the
right-hand corner stands the ram to
right also with its head turned back-
wards; in the upper part of the field
between Abraham's head and the knife
is the altar of sacrifice. The eight
remaining figured medallions illustrate
three subjects, the stories of Jonah,
Daniel, and the three children of Baby-
lon. To the first subject are devoted four
contiguous medallions: in the first
(green) is the ship occupied by four
men, above them a large dolphin; be-
neath this on the right (green) is the
monster swallowing the prophet, whose
legs project from its jaws; to the left of
this (blue) the monster vomits forth
Jonah on the shore; to the left again
(blue) Jonah is seen lying beneath the
gourd. Beyond the cycle of Jonah begins
that of Daniel, only two medallions of
which remain: on the lower (blue) is a
seated lion; on the higher (green) Daniel,
a nude youthful figure, stands in the
attitude of an *orans*. The two medallions
with the story of the three children are
both on the smaller portion of the bowl;
they are very similar, each representing
a youthful figure in oriental costume
standing in the attitude of an *orans* in the
midst of conventional flames; the pro-
tecting glass is in one case blue, in the
other green.

The blue and green blobs were pressed
in to the bowl from the outer side; the
gold seems to have been applied to the
bowl first, for the protecting blobs are
in some cases smaller than the design
and the gold can be seen unprotected on
the outer surface of the colourless bowl.
Each of the two portions of the bowl
broken and mended, the smaller consist-
ing of three fragments, the larger of four;
some incrustation, incipient iridescence,
slight pitting in places; fair metal with
some bubbles.

Greatest dimensions: 0.01m. (smaller
portion), 0.168m. (larger portion).

Found in the parish of St. Severin,
Cologne. Formerly in the Disch Collec-
tion. Purchased through A. W. Franks
from the sale of the Disch Collection at
Cologne, 16 May, 1881, lot 1357.

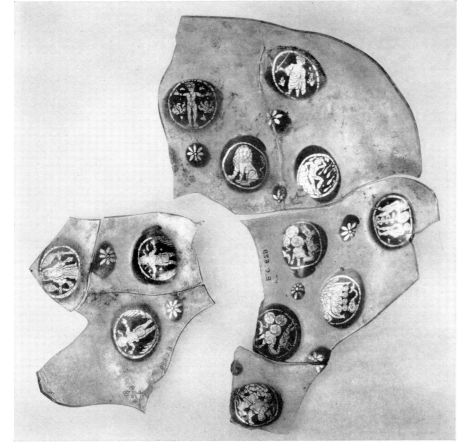

88

BIBLIOGRAPHY: *BJ*, 36 (1864), pp.
124ff. and pl. 3; *BJ*, 71 (1881), pp. 121–9,
no. 1357; Vopel (1899), no. 292; Dalton
(1901a), pp. 126–7, no. 629, pl. XXX;
Kisa (1908), p. 880 and figs. 365, 370;
Neuss (1933), figs. 10–11; Fremersdorf
(1956), pl. 2, 2; Morey (1959), pl. 30,
no. 349; Fremersdorf (1962), p. 34 and
pl. 48; Neuss (1964), fig. 21; *Frühchrist-
liches Köln* (1965), pp. 67f., no. 4, pls.
11–13; Doppelfeld (1966), p. 69 and pl.
168; Fremersdorf (1967), pp. 217–18,
pls. 300–3; *Römer am Rhein* (1967), p.
275, no. D. 102; Dillon (1907), pl. X, 1.

90

89. Bowl Fragment

B.M. Dept. 98.7-19.2: EC 603 / 4th
century A.D. / Probably from Rome /
Purchased.

89

Bottom of colourless bowl with parts of
thin transparent sides still remaining and
with disk of blue base beneath. The cen-
tral circle at the junction of the bottom
of the bowl and the blue base decorated
mainly in gold; a gladiator advancing to
left, holding a sword in his right hand
and a trident in his left; his loincloth is
of silver foil with indented edges, and his
belt is outlined and ornamented in red;
upper part of his body nude, but the left
arm is protected by padding bound with
thongs, and to the upper part of it is
fastened the galerus, a piece of defensive
armour. Across his body is a baldric,
perhaps part of the attachment of the
galerus, and his ankles are protected by
bound padding, rendered in silver foil;
behind, to the right, is a cippus on which
rests a windbag (*corycus*, or *follis pugi-
latorius*) used in practising boxing; on
the front of the cippus are two crossed
swords; round the field is the inscription
STRATONICAE BENE VICISTI VADE
AVRELIA (*Stratonice, bene vicisti, vade
in Aureliam*), and across the base PIE
ZESES.

Fragmentary, the lower, blue, glass
having been broken away to its junction
with the main bowl. Iridescent, milky
weathering, partly flaked off, over whole
of exterior; a few pin-prick bubbles in
colourless glass, many pin-prick bubbles
and impurities in blue glass.

GW, 0.089m. D of blue roundel, 0.054m.

Purchased through Messrs. Rollin and
Fenardent from the sale of the Tyskie-
wicz Collection, lot 103. Register notes,
'probably from Rome'.

BIBLIOGRAPHY: Lanciani (1884); *Cas-
tellani Catalogue* (1884), no. 428, fig. on
p. 62; Fröhner (1898), pl. viii, fig. 3;
Vopel (1899), no. 56; Dalton (1901a),
p. 118, no. 603, pl. XXVIII; Morey
(1959), p. 52, no. 302, and pl. XXIX;
for the inscription, *CIL*, XV, 7041;
Dillon (1907), p. 93.

90. Bowl-fragment

B.M. Dept. 63.7–27.3: EC 608 / 4th century A.D. / Purchased.

Bottom of a flat-bottomed bowl, slightly dished, broken away to the edge of the base. Decorated in gold with painted details: in the circular field are the half-figures of a husband and wife between whose heads is a small figure of Hercules standing on a disk about the level of their shoulders; the husband is beardless and wears a tunic with a red stripe on the right shoulder and over this the *toga contabulata*; the wife has her hair dressed in a succession of curls round the forehead and wears a *diadema* with what is probably a green gem in each of the lower corners near the ears, she is clothed in a mantle and has round her neck a broad collar ornamented with a row of rectangular green gems between two rows of smaller red stones and having a fringe of pear-shaped green pendants; the figure of Hercules stands to left and wears the lion's skin over his left shoulder pressing it against his body with his left arm, in his left hand he holds three globular objects coloured green, his club rests on his right shoulder; the group is enclosed in a circular inscription ORFITVS ET COSTANTIA IN NOMINE HERCVLIS, which is continued in smaller letters in the upper part of the field about the heads of the figures, ACERENTINO FELICES BIBATIS.

Bowl broken away to edge of central basal disk, base complete with rounded rim. Slight cloudy weathering on upper surface, partly flaked off; many pin-prick bubbles.
D, 0.104m. T, 0.004m.

Purchased from Signor Mosca, formerly in the collection of Count Matorozzi of Urbania.

BIBLIOGRAPHY: Vopel (1899), no. 133, p. 230, pl. i; Dalton (1901a), p. 119, no. 608 and pl. XXIX; Morey (1959), p. 54, no. 316, and pl. XXIX; for the inscription, *CIL*, XV, 7036; Dillon (1907), pl. X, 3.

91

91. Bowl-fragment

B.M. Dept. 63.7–27.6: EC 630 / 4th century A.D. / Purchased.

Greenish–colourless slightly dished base of a flat-bottomed bowl or dish, with slight trace of base-rim remaining at one side. Gold decoration: within a lozenge, itself contained in a square, a bust of Our Lord, beardless and youthful with hair cut across the forehead and falling in flowing curls upon the shoulders; He wears a tunic and a mantle fastened over the breast with a circular brooch; in the field on either side of the head is the inscription CRISTVS with five dots; within each of the angles of the outer square is a beardless bust clothed in a similar manner and flanked by two dots; beyond each side of the square is a triangle with the apex outwards, of which three remain.

The glass is made up of two sheets, the upper being 0.4cm. thick, the lower 0.1cm. thick. Incipient iridescence overall, enamel-like weathering between the two layers of glass at the top edge, some pitting on the lower surface, some usage scratches on the upper surface; metal fair, many bubbles and impurities in the under-layer of glass.

D, 0.09m. W, 0.077m.

Purchased from Signor Mosca, formerly in the collection of Count Matorozzi of Urbania.

BIBLIOGRAPHY: Torr (1898), fig. 2, p. 5; Vopel (1899), no. 297; Dalton (1901a), p. 127, no. 630 and pl. XXVIII; Morey (1959), p. 52, no. 305 and pl. XXIX.

92. Bowl-fragment

B.M. Dept. 63.7–27.9: EC 632 / 4th century A.D. / Purchased.

Greenish–colourless base, with base-ring, of a bowl or dish. The circular field is divided into two halves by a horizontal line; in the upper half stand four beardless figures in tunic and pallium holding rolls in their hands and separated by spirally fluted columns with foliated capitals connected by a festoon-like curtain; above is the inscription PIE ZESES; on either side of the three figures to the right are their names, PAVLVS, SVSTVS (Xystus) and LAVRENTEVS; the lower half contains three bearded half-figures, each in tunic and mantle, their heads bald above the forehead, with their names IPPOLITVS, CRISTVS, TIMOTEVS, in the field to the left of their heads; the lateral figures look towards the central person who is full-face and holds a roll in his hand; the space behind the head of St. Timothy is occupied by a roll.

Made up of two sheets, the upper being 0.3cm., the lower 0.1cm. thick; the outer edge of the lower sheet is folded down, up and in, to form the base-ring. Slight milky weathering with some iridescence, strain-cracks with enamel-like weathering in lower sheet; metal fair, many bubbles in lower sheet of glass.

W (greatest remaining), 0.098m. D (base-ring), 0.089m.

Purchased from Signor Mosca. Formerly in the collection of Count Matorozzi of Urbania.

92

Dalton notes (p. 128), 'It is difficult to suppose that the central figure in the lower division of this glass can be intended for any other person than Our Lord (though see Garucci, *Vetri*, expl. of pl. XVIII, fig. 2). But the type is very exceptional, being that usually adopted for apostles, especially for St. Paul. It has been suggested that *Cristus* is a mistake for *Calistus*'.

BIBLIOGRAPHY: Vopel (1899), no. 305; Dalton (1901a), pp. 127–8, pl. XXIX; Morey (1959), p. 57, no. 344, and pl. XXX; Dillon (1907), pl. X. 2.

93. Bowl-fragment

B.M. Dept. 63.7–27.12: EC 641 / 4th century A.D. / Purchased.

Greenish–colourless base of bowl or cup with part of base-ring. Within a plain circular border two beardless male busts in tunics and mantles folded over the breast and fastened with a circular brooch; in the field SVSTVS (Xystus) TIMOTEVS; between the heads a quatre-foil.

The fragment consists of two sheets of glass, each 0.2cm. thick; the edge of the lower is folded down, up and in to form the base-ring. Clipped round edges, strain-cracks, flaked on lower surface; milky weathering, iridescent in places, enamel-like weathering in places between upper and lower sheets and in strain-cracks in upper sheet; some pin-prick bubbles and impurities.

GW, 0.07m. D (base-ring), 0.065m.

Purchased from Signor Mosca. Formerly in the collection of Count Matorozzi of Urbania.

BIBLIOGRAPHY: Dalton (1901a), p. 129, no. 641, pl. XXVIII; Morey (1959), p. 54, no. 313, and pl. XXIX.

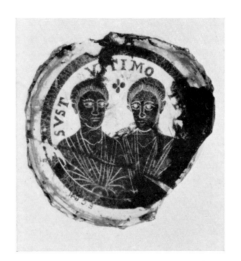

93

iv. WHEEL-CUT, FIGURED AND GEOMETRIC

94. Figured Bowl with Actaeon and Artemis

B.M. Dept. S 320 / 2nd century A.D. / From a grave at Leuna-Merseburg, Germany / Bequeathed by Felix Slade, 1868.

Buff–colourless bowl, rim knocked off and ground smooth, constriction in sides just below: sides curve gently thence to centre of base. Near rim one wheel-cut: then horizontal band of doodle incision; then another wheel-cut and below that the whole body is covered with finely-cut scene of Artemis and Actaeon, labelled AKTAIⲰN and APTEMIC, retrograde; fine facet-cutting with incised details; Artemis kneels up with dog beside her looking at Actaeon's head with horns growing reflected in water, stag to one side, Actaeon with stag's horns above, various sprays and trees in background.

Intact; some strain-cracks, especially at rim; incipient iridescence and milky and brown weathering; metal fair, some bubbles.

H, 0.063m. D, 0.12m.

Found in an inhumation-grave at Leuna, near Merseburg in Saxony, with other grave-goods including the bowl no. 103 (below). Probably made at Alexandria or at Antioch-on-the-Orontes.

The story of Artemis and Actaeon made famous by Ovid is that Actaeon came upon Artemis bathing and therefore naked. She flung water in his face, and by her power converted him into a stag, in which form he was run down and killed by his own hounds. Dawson (1944) has shown that artistically there are two versions of the myth. In one, which appears as early as the Classical period, Actaeon is attacked by dogs, with Artemis watching from nearby. A second version, known in Roman times, is the bath of Artemis, which belongs to a variation of the myth not current before 300 B.C. and, presumably, was first represented pictorially by Hellenistic artists. The Leuna bowl represents the bath of Artemis. The fragments of a similar bowl from Dura–Europos in Syria (*v.*

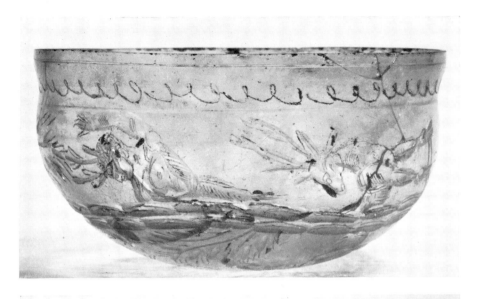

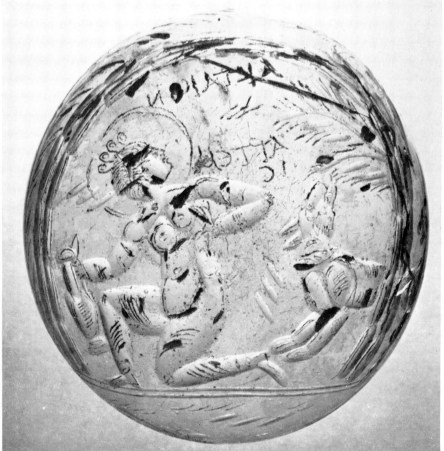

pieces. The only other fragments of Actaeon and Artemis bowls, from Castlesteads and the Isle of Wight, are too small to permit reconstruction of their scenes.

BIBLIOGRAPHY: *Anzeiger für Kunst der deutschen Vorzeit*, nr. 13 (1866), Sp. 116, nr. 24; Nesbitt (1871), pp. 57–8, no. 320, figs. 74 and 75; *BJ*, 64 (1878), p. 127; Kisa (1908), p. 660; Krüger, *Trierer Zeitschrift*, IV (1929), pp. 104ff., and figs. 4, 5; Harden (1933), p. 425 and pl. III, figs 8a, 8b; Harden (1936), p. 101; Fremersdorf (1951), p. 5, no. 5 and pl. 2.2 and 3; Eggers (1951), pl. 15, no. 215; Schulz (1953), pl. 33 and 34.2; Clairmont (1963), pp. 57–9; Fremersdorf (1967), p. 146 and pls. 187–9; *CIL*, XIII, 10036. 80.

94

Clairmont, pp. 57–9), favoured the earlier version, the scene of the death of Actaeon. In several Pompeian wall paintings, however, both versions were combined in the continuous narrative style (Third Pompeian Style—1st half 1st century A.D.), and the Leuna and Dura bowls therefore, made by the same craftsman, complement each other and are probably meant to be companion

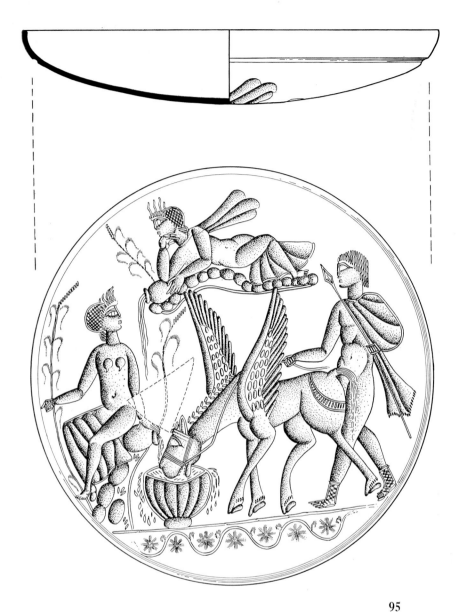

95

95. Figured Dish with Bellerophon and Pegasus

G.R. Dept. 1967.11–22.1 / Late 3rd or early 4th century A.D. / Find-place not known.

Ice-green shallow segmental bowl, rim ground smooth, rounded base. Deep-cut groove below rim. Remainder covered with design, in fine facet and linear cutting, of Bellerophon with Pegasus and two nymphs. Bellerophon, nude with cloak, stands to right, spear in left hand, Pegasus' reins in right hand. Pegasus in centre, standing and drinking out of a bowl on the ground. Above, a female figure reclining on rocks, nude with cloak, chin resting on right hand, left hand holding urn from which water pours down towards the bowl at the bottom of the picture. To left, female figure seated on rocks, between tall plants or young trees, nude with garment draped over one knee, left hand holding urn from which water pours into Pegasus' bowl. Water overflowing from the bowl splashes down from both sides to the ground which is represented by a straight line and a scroll below with flowers.

Broken and mended, with one triangular piece missing; the hole was previously mended with a piece of glass decorated with a thigh and a raised hand holding a thick baton. Enamel-like film, mainly flaked and leaving pitted surface.

H, 0.038m. D, 0.215m. T, 0.003m.

Pegasus, the winged horse, was born from the dying Medusa (Hesiod, *Theog.* 280). When he was drinking at the fountain Peirene he was caught and tamed by Bellerophon (Pausanias, 2.4.1), whom he helped to fight the Chimaera, the Amazons, and the Solymi (Hesiod, *Theog.* 325; Pindar, *Ol.* 13.86); but when Bellerophon attempted to fly to heaven Pegasus threw him. Pegasus was said to have stamped many famous springs out of the earth with his hoof, such as

Hippocrene on Mount Helicon and Peirene at Corinth. (Dio Chrys. *Orat.* XXXVI, 450M; Statius, *Theb.* iv, 6off.) There are, however, two springs at Corinth known as Peirene, one in the city and one in Acrocorinth, the citadel above the city. (Fowler, 1932, pp. 25–6; pp. 33–4). Blegen (in Broneer (1930), pp. 59–60) has shown, however, that, although the name Peirene occurs frequently in Greek authors, in no case before the time of Strabo (64/63 B.C.– A.D. 21) was it applied to the spring on Acrocorinth. In Greek mythology the lower spring alone was called Peirene.

After the restoration of Corinth by Caesar the local traditions, partly forgotten during the hundred years that had elapsed since the destruction of the city (see Pausanias, ii, 3, 6), were re-established; and the myths about Peirene were confused through a close association with the spring Hippocrene on Mt. Helicon, which also was connected with the Pegasus myth. Both were known as sources of poetic inspiration. In Roman times, through the influence of the Latin poets, Upper Peirene became the more important, and the Pegasus myth, which formerly had been connected with the

lower spring alone, was transferred to the spring on Acrocorinth. An explanation was then invented in the story that the upper and lower springs were in reality one, being connected by a subterranean channel (Strabo, viii, p. 379; Pausanias, ii, 5, 1). This tradition became firmly established through its acceptance by Strabo, and the scene on the glass dish described above is an illustration of this version, the upper female representing Upper Peirene, and the seated female representing Peirene in the city. No precise parallel is known to me; but there is obviously a close connection with the scenes on two complementary coins issued at Corinth in the time of Septimius Severus (A.D. 193–211), both of which show Acrocorinth, on the summit of which is the temple of Aphrodite. One shows Bellerophon watering Pegasus at the spring Peirene issuing from the foot of Acrocorinth. The other shows the fountain-nymph Peirene seated, pouring water from a vase, while before her Pegasus is drinking. (Head (1889), p. 86, nos. 653, 654). If the reverses of these two coins are taken as making up a single scene, then it may well be that the latter and the scene on the glass dish are derived from a single artistic source dating from Roman times, even though the coins draw attention to the temple on Acrocorinth and the glass dish to the spring of Upper Peirene.

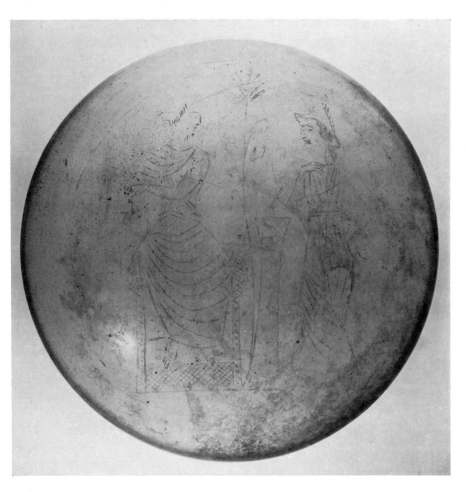

96. Figured Dish with Apollo and Athena

G.R. Dept. 87.1–8.1 / 4th century A.D. / From Budrum (Halicarnassus), Turkey / Purchased.

Green shallow dish: rim knocked off and ground, slightly bent in; rounded bottom. To left, Apollo seated in chair to front, holding lyre in right hand and playing with left; in centre a column; to right Athena, wearing crested helmet, leaning right elbow on pillar, left arm by side; in centre and outside each figure three plants; below, scalloping to indicate ground or water.

Figures drawn with wheel-cut lines, with internal shading by slight abrasion and no facets. Intact; dulled, usage scratches, some iridescence; bubbles and streaks.

H, 0.035m. D, 0.272m.

Bought from Rollin and Fenardent.

Athena is listening intently to Apollo, in a stance characteristic of Muses in late-Roman art (e.g. the right-hand figure on a 3rd-century sarcophagus at Rome, or others on a sarcophagus at Paris: M. Wagner, 'Muse' in *Enciclopedia dell'Arte Antica* (Rome, 1963), fig. 407 on p. 295 and fig. 401 on p. 290). The plants resemble water-plants, in view of which the scalloping at the bottom may be intended to represent a river. If so, the scene recalls the contest of Apollo with Marsyas, at the conclusion of which there sprang from the blood of Marsyas, or from the tears of his mourners, the river Marsyas, a tributary of the Maeander. In some, though not all, versions of the story Athena was one of the judges. On a sarcophagus in the Louvre several parts of the story of the contest are shown: among them Athena is to the left as one of the judges, Apollo is in the centre playing his lyre and being crowned by Victory, and Marsyas is at his feet as a river, holding a rush in his right hand and in his left an overturned pot with water flowing from it. (Daremberg et Saglio, *s.v.* Satyri, fig. 6138.) The scene on the dish could be extracted from a similar representation.

BIBLIOGRAPHY: Harden (1936), p. 68.

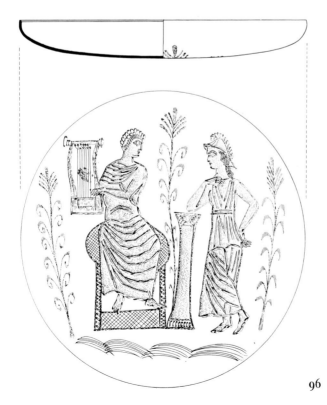

96

97. Figured Bowl with Dancing Figures

G.R. Dept. 86.5–12.3 / 4th century A.D. / From Amiens, France / Purchased.

Colourless hemispherical bowl, with ground and polished lip and slightly flattened base. Two circles at top; six dancing figures, alternately male and female, nude and clad, in frieze; on base a probably female bust within a wheel-incised circle; two small temples in field near top.

Fairly good linear cutting, impressionistic details, no facets. Broken and mended, one piece missing on rim; brown enamel-like film in parts, iridescence.

H, 0.082m. D, 0.191m.

Bought through Sir John Evans.

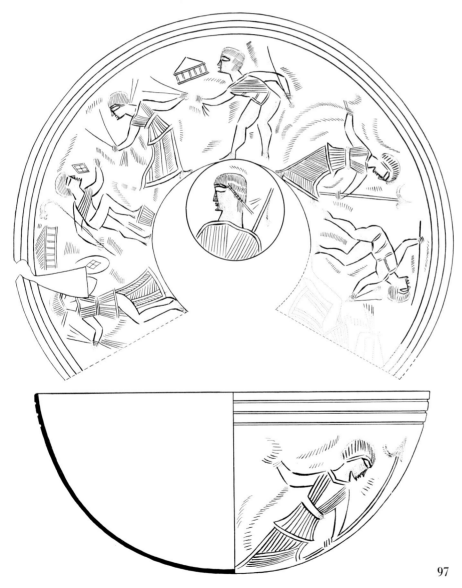

97

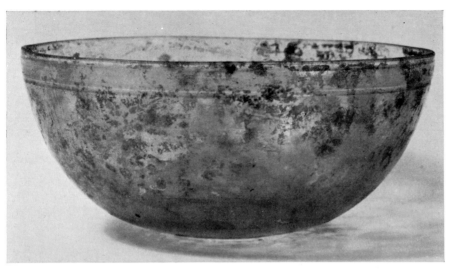

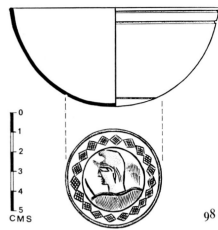

98

98. Figured Bowl with Attis

G.R. Dept. 86.5–12.6 / 4th century A.D. / From Amiens, France / Purchased.

Colourless segmental bowl: rim cut and ground, slight flattening on base. Two horizontal cuts at rim; on base, bust, probably of Attis, in Phrygian cap with crook over right shoulder and uncertain object in field over left shoulder, bordered by a band of wheel-incised lines; no facets.

Blown. Intact; brown film and iridescence in patches.

D, 0.11m. H, 0.047m.

Bought through Sir John Evans.

Attis was the youthful consort of Cybele, the great mother-goddess. In the Phrygian version of the myth the gods castrated the androgynous Agdistis; from the severed male parts an almond tree sprang and by its fruit Nona conceived Attis. Later Agdistis fell in love with him, and to prevent his marriage to another caused him to castrate himself. Agdistis is here clearly a doublet of Cybele. Like Adonis, Attis was fundamentally a vegetation god and the equinoctial spring festival centred about his death and resurrection. Under the Empire he was

invested with celestial attributes and became a solar deity, supreme, all-powerful, and sometimes it seems a surety of immortality to his initiates. (See *OCD*, *s.v.* 'Attis'.)

99

99. Figured Cup with Adam and Eve, Moses and Christ

B.M. Dept. 72.3–20.1: EC 652 / 4th century A.D. / Found at Cologne / Given by the executors of Felix Slade.

Buff–colourless cup: plain, ground rim; truncated conical body; slightly concave base; no pontil-mark. At rim one thick and one thin horizontal cut band: near base two medium ones. Between these three scenes: (*a*) Adam and Eve with serpent between, coiled round a tree; on Adam's left is a clothed figure (Our Lord?), (*b*) to left of this a clothed figure (Moses?), striking the rock, and (*c*) to left again, Christ raising Lazarus, to left of which a tree; no divisions between scenes, but sprays vertically between

Christ and Adam and between all other figures' heads, except where the serpent's tree and the other tree in any case reach to the top.

Top and bottom lines well made and polished: rest of cutting is 'etched' type, where the hollows have been left unpolished but are well enough made in themselves. Broken and mended, complete; encrustation on one side, inside and out, dulled and discoloured, incipient iridescence.

H, 0.128m. D (rim), 0.113 m. D (base), 0.045m.

BIBLIOGRAPHY: *BJ* (1878), p. 127, note 4; Dalton (1901), p. 131, no. 632; Fremersdorf (1967), pp. 185–6, pls. 264–5.

100. The Lycurgus Cup

B.M. Dept. 1958.12–2.1 / 4th century A.D. / Purchased with the aid of the National Art-Collections Fund.

SUMMARY: Cup with mainly open-work figured frieze, opaque green on surface but wine-coloured when viewed by transmitted light. Scene: death of Lycurgus, engulfed in a vine; at his feet the nymph Ambrosia; to right of Ambrosia, a satyr prepared to hurl a rock; to left of Lycurgus, Pan being egged on to attack the king by Dionysus, accompanied by his panther.

Bell-shaped cup with figured decoration, mainly openwork adhering to inner wall by small shanks or bridges left for the purpose by the glass-cutter. Rim partially broken away and obscured by modern metal addition of which one of two groups of three larger leaves masks a gap in the glass while the other does not. On the body four main figures (satyr, Lycurgus, Pan, Dionysus) have bodies hollowed out from behind on interior of cup with a certain amount of undercutting at edges, two smaller figures (Ambrosia, panther) each have a longitudinal boring closed at one end; other parts of figures and decoration carried out in openwork normal for cage-cups. Base of inner cup splays out into a foot-stand, itself in open-work, of four leaves, now fragmentary, which originally matched the set of four fragmentary leaves below the ring on which the figures stand; the two sets of four leaves must have been joined by a second open-work ring which formed the real base-ring of the vessel.

COLOUR: dull pea-green, even on the fractured edges, but a large patch of one side of the vase—the greater part of Lycurgus' body, the lower part of Ambrosia's legs, the top of the axe, and neighbouring portions of the vine, but not the contiguous portions of the inner cup—shows a surface-colour yellower than that of the rest of the vase, with a sharp junction between the two greens; in transmitted light, however, not green and opaque but wine-colour and transparent, or, where the yellower patch occurs, transparent amethystine purple.

DECORATION: frieze representing the death of King *Lycurgus* struggling in the grip of the vine. He stands towards the front, head and body frontal, legs in profile, completely naked except for the boots, which cover ankle, heel and most of the foot, leaving the toes exposed. His head and body form a diagonal line slanting across the vase from rim to base. The left leg is extended stiffly towards the spectator's right, while the right knee is bent; and the weight of the body is supported partly by the right leg and partly by the vine. The plant has already chained the king round the waist and thighs and is sending up branches to bind his wrists and arms. Lycurgus' arms are extended laterally on either side: the lowered right hand clutches at a vine branch, the palm of the raised left hand is opened outwards. The thick hair, the beard and the moustache are unkempt and wild. The face is anguished, with furrowed brow, staring eyes, and lips parted. Lycurgus' single-bladed axe has slipped from his grasp and is falling, the blade being visible behind the left foot. The vine-tree shoots up from two roots, one between the king's legs, the other (the lower part of its stem is broken away) to the left of him near the feet of *Ambrosia*, who is outstretched on the ground towards the right. She supports herself on her right arm and raises her left hand in supplication. She is naked save for a himation wrapped across her legs. Her hair is long and dishevelled; and her lips are parted in a cry. A large part of the vine on the left of Lycurgus,

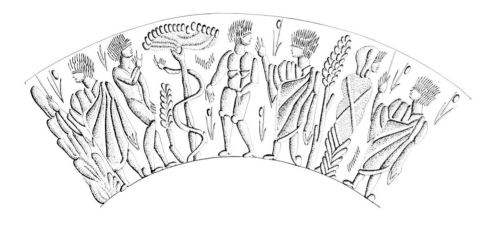

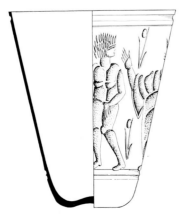

99

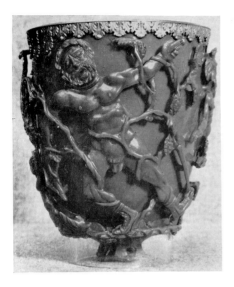
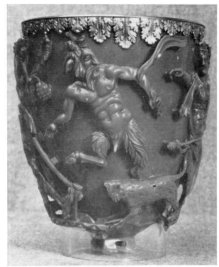
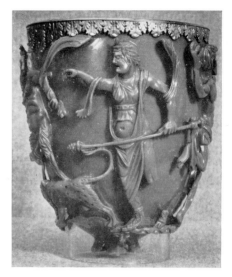

below the rim of the vase, is missing. On the left the scene closes with the standing figure of an open-mouthed *Satyr*, who faces to right. The head and legs are in profile, while the trunk is wrenched round to give a practically frontal view. He has a thick thatch of hair and pointed ears, wears a loin-cloth, and balances himself on tip-toe on his left leg, the right leg being kicked out behind him, at right angles to the body, to serve as a counterpoise, as he swings a mighty stone in his upraised right hand at the head of the helpless prisoner. In his left hand he grasps a notched pedum. Across the Satyr's right ankle falls the sash of the double-knobbed thyrsus, held by *Dionysus*, who stands back to back with him and terminates the scene on the right. The god holds himself erect and tense, his body turned three-quarters towards the left, while head and legs are in profile. The lower part of the left leg has been broken away. His agitation can be read in the tip-toe stance, the slightly forward bend of the whole figure, the outstretched right hand, with pointing fingers, the nervous grip of the left hand on thyrsus held horizontally across the abdomen, the gaping mouth, and the vehement upward and downward swing of the ends of the cloak. A scarf-like mitra is bound tightly round the head, secured by a knot over the left temple, and surmounted by a spray above the brow. Under his cloak he wears a diaphanous tunic, and his feet are shod in boots similar to those worn by Lycurgus.

The God is either abusing his victim, or shouting orders to his henchman, the horned and bearded *Pan*, who bounds through the air on his left towards the king. Pan's trunk and extended arms are frontal, head and legs in profile. Facing to right, he takes his cue from his leader. In his left hand he clutches his only garment, a twist of flying drapery. The smooth flesh offers an effective contrast to the animal shagginess of hair, moustache, beard and thighs. The ends of both horns have been snapped off. Below Pan stands to the left Dionysus' spotted *panther*, now bereft of its maw, with legs and body strained taut for the spring and sturdy, rope-like tail curled upwards, over its back, against one end of its master's thyrsus. A small hole was made in its back during the manufacture-process of grinding out the inside of the animal and cutting the figure out of the blank.

TECHNICAL DETAILS: Cut and ground from a thick-walled blank, which may have been mould-blown; decorated by cutting away on surface to leave open-work attached by bridges, usually elongated oval in section and mainly between 0.005 and 0.016m. long, by cutting hollows behind the satyr, Lycurgus, Pan and Dionysus, and by making longitudinal borings, closed at one end, behind Ambrosia and panther; whole vessel polished to a glossy finish, probably by fire-polishing as there are few traces of the grinding wheel extant, and none on the inner surface of the cup,

where one might expect to find them most easily. Weathering all absent, with no iridescence, pitting or cloudiness. Metal has many small bubbles and some impurities in form of dark specks. Analysis has shown that the glass is of the soda–lime–silica type; it contains, in addition, about $\frac{1}{2}$ per cent of manganese and minor constituents including gold to the extent of about 50 parts per million; the presence of the colloidal gold is probably the reason for the unusual optical properties of the glass, while the manganese probably contributes to the reddish purple body colour.

H (with metal rim), 0.165m. D of rim (outside), 0.132m. D of rim (inside), 0.122m. T of rim (with metal binding), 0.005m. T of glass at rim, just under 0.005m. D of central circle of external base of inner cup, 0.019 m. H of bowl (internal), 0.148m. H of inner bowl (external), about 0.153m. T of glass at base, about 0.005m. D of cup (external) at level of heads of Lycurgus and Dionysus, 0.141 m. H of bridges from outside of inner wall at level of heads of Lycurgus and Dionysus, about 0.005m. H. of bridges from outside of inner wall lower down, about 0.008m.

BIBLIOGRAPHY: Harden and Toynbee (1959); Harden (1963); Chirnside and Proffitt (1963).

The myth of Lycurgus, as in the latest version of the myth, followed by Nonnus in his *Dionysiaca*, *c.* A.D. 500, is as follows:

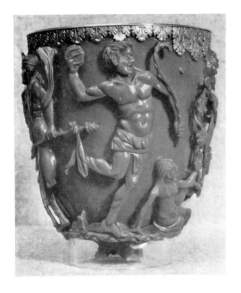

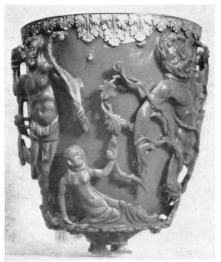

100

Lycurgus, King of the Thracian Edoni, a man of wild and violent temper, persecuted the Dionysiac thiasos and drove Dionysus into the sea with an axe. Encouraged by this success he rushed off into the forest to chase the Maenads. One of them, Ambrosia, in a fit of madness, snatched up a stone and hurled it at Lycurgus, knocking off his helmet. The king retaliated with a yet larger stone, thrusting it at the Maenad and seizing her round the waist, with a view to her capture. But Ambrosia stood her ground: Lycurgus failed in his attempt to smash her skull; and she eluded his grasp, praying to Mother Earth to save her. Earth heard her, opened a gulf, and received her into her embrace. As Ambrosia disappeared, she changed herself into a plant and became a vineshoot. She then coiled herself as a winding cord about the neck of the king and sought to strangle him with a throttling noose, armed for the fray with threatening clusters, as once with the thyrsus. Earth, to do favour to Dionysus, gave the plant a voice; and Ambrosia laughed aloud, mocking Lycurgus and swearing that she would vanquish him and choke him with the indissoluble bonds of her leaves. Whereupon Lycurgus was caught in the fetters of the vine, roaring defiance at Dionysus, but unable to escape; and his voice could find no passage through the smothering tendrils, while the Bacchic women thronged round to torment him.

The scene on the cup contains three successive moments in the episode, shown simultaneously. Ambrosia is still above ground, supplicating Mother Earth. But the vine into which she was changed has already sprouted into a spreading tree, in the branches of which Lycurgus is inextricably entangled; and the Dionysiac thiasos, here composed, not of Maenads, but of the god himself, his panther, a Pan, and a Satyr, has arrived and begun to exact its vengeance. The cup stands alone in combining with the cage-cup technique, not merely some decorative or genre motifs, but this brilliantly conceived and fully preserved episode from classical mythology.

101. Facet-cut Cup

B.M. Dept. S 171 / Last qtr. 1st or early 2nd century A.D. / From Barnwell, Cambridgeshire / Bequeathed by Felix Slade, 1868.

Greenish–colourless facet-cut cup; everted rim with moulding at edge, faintly S-shaped sides, splayed base-ring with hollowing below. On body, between offset lines, six rows of hexagonal facets in quincunx—top and bottom rows rounded and top row has a small U-shaped facet between each pair; circular facet in centre of base below.

Cut from solid block or blank. Chipped on base-ring, otherwise intact; dulled, no iridescence, a few tiny strain-cracks.

H, 0.09m. D, 0.097m.

Found with jug S 264 (see entry in Nesbitt (1871), pp. 44–5, no. 264), 'in a cemetery at Barnwell, near Cambridge'.

BIBLIOGRAPHY: Nesbitt (1871), pp. 28–9, fig. 38; Harden (1936), p. 139, n. 1; Berger (1960), p. 73; Clairmont (1963), p. 60, n. 141; Brailsford (1964), p. 42 and pl. XI.

101

102. Facet-cut Cup

G.R. Dept. 96.2–1.200. / Last qtr. 1st or early 2nd century A.D. / From Curium, Cyprus / From excavations conducted with funds bequeathed by Miss E. T. Turner.

Greenish–colourless facet-cut cup: rim ground and polished; sides faintly S-curved, tapering downwards; ring-base with central flat knob. Four bands of facets set closely in quincunx with raised horizontal lines above and below.

Cut and polished from a pre-moulded blank. Intact: dulled and pitted surface with some iridescence.

H, 0.095m D. (rim) 0.095m. D (base), 0.04m.

From tomb 114 at Curium; no. 1 as listed in Murray, Smith and Walters, their description being:
'Tomb 114—A large tomb (Roman), containing several sarcophagi and *niches*, with large quantities of glass.
 (1) Glass cup, like a tumbler, with sunk lozenge-pattern. Fig. 104.
 (2) Long bulb-shaped bottle of yellow glass. Fig. 103.
 (3) Marble colour-grinder in the form of a thumb, as from tomb 72.
 (4) Roman lamp with rosette, inscribed COPPINIS.
 (5) Lamp with pomegranate-plant and bird, as from tomb 62.
 (6) Ditto, plain.
 (7) Bronze mirror-case, the interior decorated with seven concentric

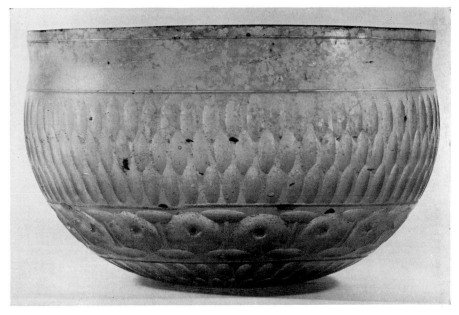

103

circles; near the edge is fixed an ivy-leaf, perhaps part of an ornamental hinge.'

BIBLIOGRAPHY: Murray, Smith and Walters (1900), p. 69, fig. 104, and p. 85; Harden (1936), p. 139 and fig. 3a; Vessberg (1952), p. 124; Clairmont (1963), p. 57, n. 119, and p. 60 and n. 140.

103. Facet-cut Bowl

B.M. Dept. S 321 / 2nd century A.D. / From a grave at Leuna-Merseburg, Germany / Bequeathed by Felix Slade, 1868.

Buff–colourless bowl: rim knocked off and ground smooth; constriction in sides just below; sides curve gently thence to centre of base in unbroken curve. Near rim one wheel-cut; 1.5cm. below, another; then three rows of vertical oval facets; then a wheel-cut and below a band of circles with central knobs in sunken relief; below this three more lines of oval facets and then a central 'boss' design of a circle with central knob in sunk relief, within a broad cut band.

Blown and cut. Intact: some strain-cracks, incipient iridescence and some patches of milky and brown weathering; metal good, but some bubbles.

H, 0.087m. D (rim), 0.142m.

Found with bowl 94 (above) and other objects in an inhumation-grave at Leuna, near Merseburg, Saxony.

BIBLIOGRAPHY: Nesbitt (1871), pp. 58–9, no. 321; Eggers (1951), pl. 15, no. 216; Schulz (1953), pl. 34.1; Fremersdorf (1967), p. 93 and pl. 77.

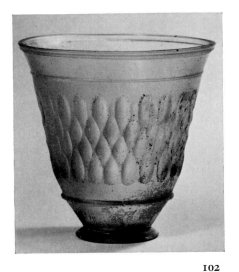

102

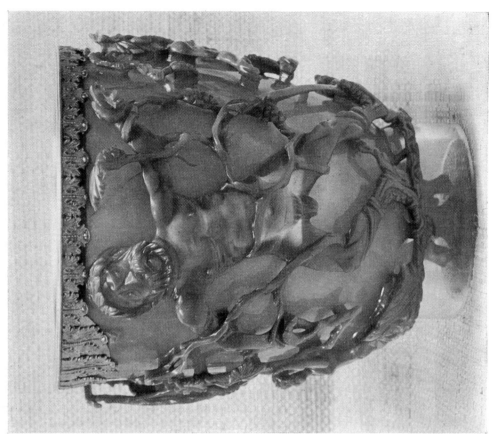

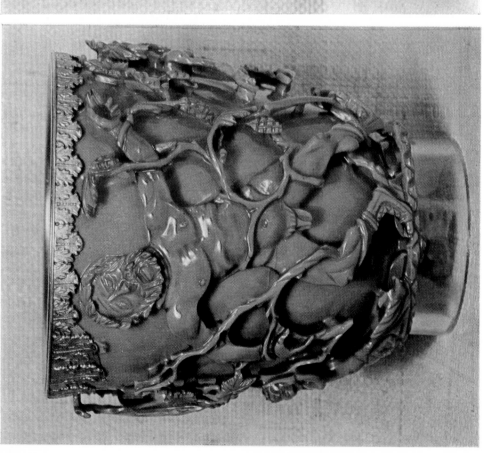

PLATE II: The Lycurgus Cup. 4th century A.D. [100]

104. Two-handled Bottle

G.R. Dept. 77.7–14.1 / 3rd century A.D. / From Nubia / Purchased.

Dolphin bottle of heavy Egyptian type; cupped and folded rim; short neck; no constriction at base; ovoid body; faintly concave base; no pontil-mark; two dolphin handles. Wheel-cut decoration of lines and facets from shoulder to base: six oval facets and eight short cuts, each approximately 1cm. long, above a continuous horizontal line round the shoulder; between this line and a line at the base a zone containing five circles with central oval facets, each circle being between 4.5 and 5cm. in diameter; each pair of circles separated by a circular facet at the top and a short vertical line at the bottom; flattened base defined by continuous circle, previously mentioned, and within the circle by four short horizontal lines outlining a square.

Intact; no weathering; metal bubbly.

H, 0.126m. D (rim), 0.065m. D, 0.107m.

Bought from Lord Garragh, who obtained it in Nubia as coming from the ruins of the temple at Maharraka, Nubia.

BIBLIOGRAPHY: Harden (1936), p. 253.

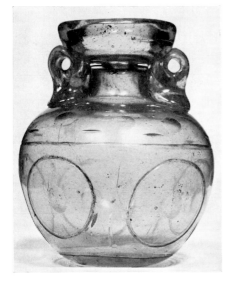

104

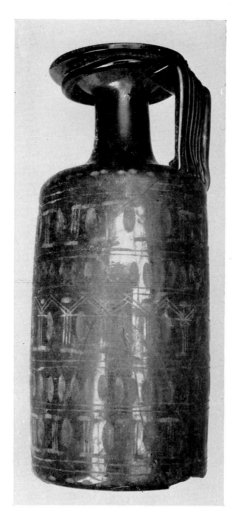

105

105. Large one-handled Jug

G.R. Dept. 1922.10–25.1 / 1st half 4th century A.D. / From Behnesa (Oxyrhynchus), Egypt / Purchased.

Dark yellowish–green one-handled cylindrical jug: rounded rim, outsplayed with strengthening trail below; cylindrical neck; cylindrical body; flattened, slightly concave base; seven-ribbed handle. Below a row of small facet-cuts on the shoulder five bands of wheel-cut and abraded designs bordered and separated by pairs of horizontal lines; second and fourth bands are rows of oval facet-cuts, set vertically; first and fifth bands are rows of fifteen triple strokes, lines above and below, alternating with vertically set oval facet-cuts; centre band resembles these, but each pair of triple strokes is capped by an inverted V, formed of double lines, giving an effect of arches, within each of which is a vertically set oval facet-cut.

Broken and mended, one or two pieces missing; dulled and usage scratches, a few patches of iridescence; bubbly and streaky, with impurities.

H, 0.315m. D (rim), 0.106m. D (body), 0.143m.

Bought from the British School of Archeology in Egypt through Professor Flinders Petrie. One of two bottles found in one tomb at Oxyrhynchus by Petrie in 1922, the other being a two-handled example, now in Cairo.

BIBLIOGRAPHY: Petrie (1925), p. 16, pl. xlv, 9 (the Cairo piece); Harden (1936), pp. 246ff.; Harden (1959), pp. 9–10.

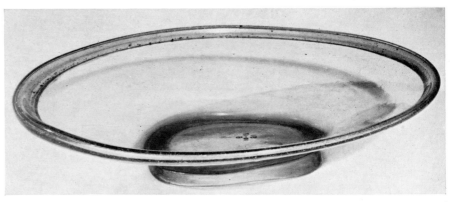

106

106. Oval Dish

G.R. Dept. 91.10–17.6 / 4th century A.D. / From Egypt / Purchased.

Greenish–colourless oval dish with slightly hollow rim and folded base-ring; no pontil-mark.

Blown and shaped. Intact, except for one long chip off the base-ring; traces of weathering now removed, one small patch of incrustation and very slight pitting; many bubbles, pin-pricks and impurities.

L, 0.237m. W, 0.17m. H, 0.054m.

Purchased from W. M. Flinders Petrie.

The register states, 'The oval dishes (91.10–17.6, 7, 8) are said by Dr. Fouquet (of Cairo) to be found with objects of the second century A.D.'

BIBLIOGRAPHY: Harden (1936), p. 47.

108

107. Cup on Foot

E. Dept. 64188: 1939.3–22.66 / 4th century A.D. / From Egypt / Given by P. E. Newberry.

Cobalt blue cup on foot: rim folded out and down; body slopes in sharply below rim to form flange, then slopes more gently downwards to stem, which is drawn out and then splayed into a broad stand at bottom with criss-cross tooling impressions; base slightly concave with pontil-mark below.

Blown. Internal cracks in one side; patches of enamel-like weathering, with some pitting, the rest quite clear; many pin-prick bubbles.

H, 0.069m. D, 0.129m.

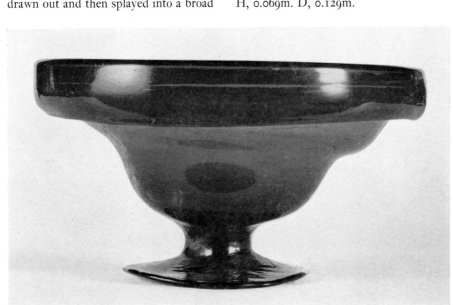

108. Handled Flagon

B.M. Dept. 83.12–13.319 / Late 1st or early 2nd century A.D. / From Bayford, Kent / Purchased.

Olive-green flagon: rim outsplayed and folded up and in; cylindrical neck with constriction at base; inverted piriform body with sharpish carination near bot-

107

tom; pushed-in, open base; no pontil-mark; two handles: (*a*) taller, flat drawn with central rib, sides splayed at base, central seven-notched tail; (*b*) smaller, oval drawn, with S-notched tail. Eighteen vertical optic-blown ribs on body from shoulder to near base.

Blown. Intact; dulled, some strains; metal poor, bubbly and streaky.

H, 0.232m. H (neck), 0.13m. D (body), 0.115m.

Bayford '186' with nos. 83.12–13.315–345 in grave 4 in Sneed, Dean and Co. brickyard north-east of Bayford Orchard, November 6, 1879. Purchased from George Payne Junior, F.S.A.

BIBLIOGRAPHY: Payne (1886), p. 2 no. V, and pl. facing p. 2; Oswald and Pryce (1920), pp. 193, 195, 197—for the samian from the burials; Smith (1922), p. 97; Wheeler (1932), p. 97; Brailsford (1964), p. 44 and pl. XI.

109

109. Handled Flagon

B.M. Dept. 83.12–13.295 / Late 2nd or early 3rd century A.D. / From Bayford, Kent / Purchased.

Bluish-green handled flagon: rim out-splayed and folded upwards and inwards; cylindrical neck expanding slightly downwards; sloping shoulder; piriform body; pushed-in, open base; no pontil-mark; on rim a strip of glass with four pinches at each end as strengthener for handle; handle flat drawn with outside ribs and bottom splays and a fine circular fold at top; twenty-six vertical ribs on shoulder, spreading up neck in parts, but not far down body.

Intact; incipient iridescent film; bubbly and many streaks and impurities.

H (to rim), 0.2–0.208m. D (greatest), 0.15m.

From the 3rd grave, discovered March 7, 1877. Purchased from George Payne, Jr., F.S.A., of Bayford, Kent.

BIBLIOGRAPHY: Payne (1877), p. 47, E, and pl. facing p. 48; Oswald and Pryce (1920), pp. 193, 195, 197—for the samian from the burials; Smith (1922), p. 86; Wheeler (1932), p. 97; Brailsford (1964), p. 44 and pl. XI.

110. Ribbed Bowl

B.M. Dept. 1312-'70 / 3rd century A.D. / From Faversham, Kent / Bequeathed by W. Gibbs.

Bluish-green bowl: rim folded out and down; sides flat with carination low down, whence sides flat to base-ring; pad base with some fastening marks and post mark. Twenty sloping ribs on sides and a further pair nipt together in middle. Ribs perhaps optic-blown.

Blown. Intact; dulled, incipient iridescence in places; metal bubbly and streaky, especially in one patch.

H, 0.085m. D, 0.192m.

From Faversham. Gibbs Collection. Paper label, 'G 1'. For the discovery of the cemetery see no. 67 (above).

BIBLIOGRAPHY: Roach Smith (1871) p. 19, no. 1312; Brailsford (1964), p. 42 and pl. XII.

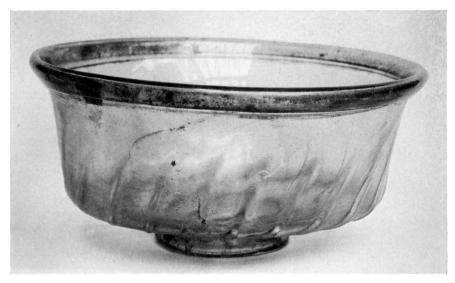

110

111. Jug with Chain Handle

B.M. Dept. 53.4-12.127 / 3rd century A.D. / From Colchester / Purchased.

Sea-green jug: rim outsplayed and rounded; neck expands downwards to body carination; nipt-out base-ring, solid; pointed kick and pontil-mark. Thick trail below rim, ending in a second twirl of very thin trail; vertical ribs on body, nipt diamondways before final blowing. Handle starts as two separate circular trails at shoulder, nipt together four times and then joined to make flat rim attachment, with upward fold.

Broken and mended, a few tiny chips missing; dulled, contents-stain and iridescence, strain-cracks.

H, 0.165m. D, 0.093m.

Found in digging Colchester Hospital. Purchased from R. Mantell.

BIBLIOGRAPHY: Harden (1956), p. 340 and pl. 27E.

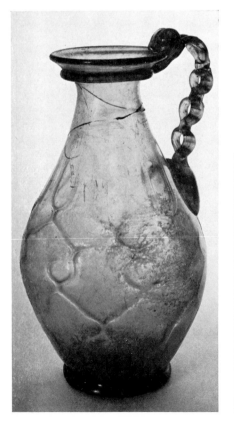

111

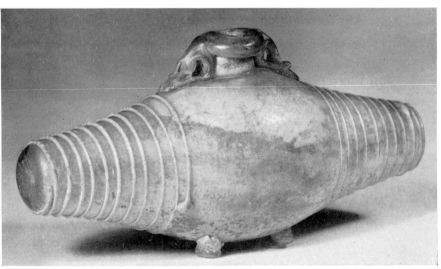

113

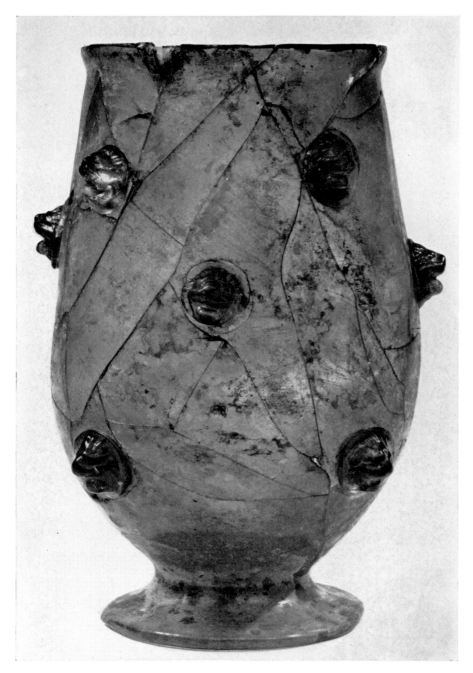

112

113. Barrel-flask

G.R. Dept. 81.6–26.1 / Late 2nd or early 3rd century A.D. / From Germany / Presented by A. W. Franks.

Colourless barrel-flask: rim folded over and in; two small dolphin handles; four solid coiled feet; ends flattened; no pontil-mark anywhere. Twelve opaque yellow trails, unmarvered at each end.
 Blown. Intact; milky iridescence.

H, 0.065m. L, 0.138m. D, 0.05m.

From the Disch Collection Sale, lot 1381.

For similar vessels see Fremersdorf (1961), pp. 32–3 and pls. 35–9, and Doppelfeld (1966), pl. 109.

114. Indented Beaker

G.R. Dept S 210 / 3rd century A.D. / Found at Cologne / Bequeathed by Felix Slade, 1868.

Colourless beaker: rim outsplayed and ground smooth; funnel neck; bulbous body with slope in to base; tubular

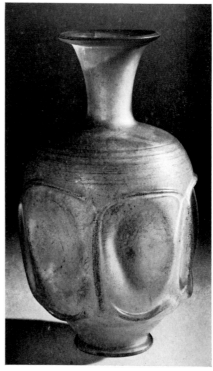

112. Large Beaker with Applied Lions' Heads

G.R. Dept. 77.5–7.2 / 4th century A.D. / From Reims, France / Given by Sir John Evans.

Green beaker: rim everted and ground on bevel; sides expand downwards; pad base with fashioning marks, kick and pontil-mark. Three rows of four lions' heads, applied, in quincunx.

Blown. Broken and mended, some pieces missing; milky and iridescent; many pin-prick bubbles.

H, 0.229m. D, 0.012m.

BIBLIOGRAPHY: Isings (1964)—describes a vessel from a 4th-century grave at Cuyk, on the Maas, Northern Brabant, Holland, to which the Reims piece is the closest parallel.

114

pushed-in base-ring. On shoulder three rough wheel-cut grooves; on body six vertical indents with ribbed borders, the horizontal parts at top and bottom being curved, the vertical ribs straight.

Ribs made with a tool and not moulded. Intact, strain-crack at lip; dulled, no weathering, incrustation or contents-stain within.

H, 0.15m. D (rim), 0.048m. D (body), 0.083m.

BIBLIOGRAPHY: Nesbitt (1871), p. 35, no. 210, fig. 49.

115. Handled Jug

G.R. Dept. 1940.3–7.1 / 4th century A.D. / From Andernach, Germany / Given by Miss S. Minet.

Greenish–colourless jug: outsplayed, rounded lip; horizontal strip, 0.5cm. wide, attached 2.7cm. below rim; long, convex neck expanding continuously from rim to body with sharply inturned shoulder; pontil-mark on base; attached base-ring; one prominent handle, with

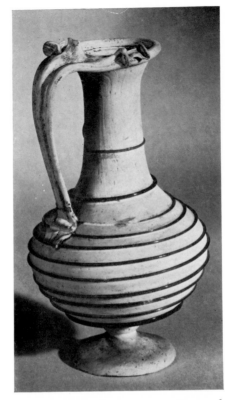

116

thickened outside edges, attached below horizontal ring near neck, and finished as a ribbon, 11cm. long, with eight horizontal striations, running down body.

Intact; iridescent, with some incrustation on neck and on lower body and base; iridescence and stain within; many pin-prick bubbles.

H, 0.252m. D (neck), 0.058m. D (greatest), 0.131m. L of handle, 0.175m.

Formerly in the collection of Sir John Evans. Labelled, 'Andernach, 1886'.

116. Handled Jug with Blue Trail

G.R. Dept. 87.6–13.8 / Late 3rd or early 4th century A.D. / From tombs at Nervia, near Bordighera, Italy / Purchased.

Opaque white jug: rim folded round and in; cylindrical neck; globular body; stemmed base; three-ribbed flat handle, splayed with two notches at either side

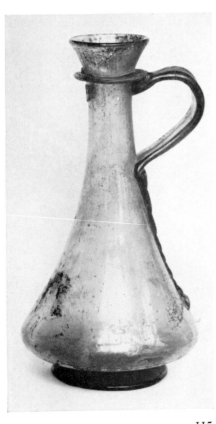

115

and central finial at top, one notch at bottom; clear blue spiral trail starting on neck and ending near stem.

Stem added as secondary piece, plain-cut at edge. Tip of central handle-finials broken away at top and bottom, some bits of trail missing; dulled, some pitting; metal fair, bubbly.

H, 0.15m. D (rim), 0.046m. D (body), 0.084m.

Purchased from J. A. Goodchild.

117. Large Handled Jug

G.R. Dept. 1900.10–15.1 / 4th century A.D. / From Syria / Purchased.

Greenish jug: lip outsplayed with thickened rim; neck expands downwards to continuous junction with body which is bulbous; stem thick and solid and drawn out from body; base splayed with moulded rim; ribbed handle from rim to body, splayed at rim attachment and with top also rising to point. One trail on upper side of base.

Broken and mended, virtually complete; dulled and incipient iridescence; metal good but streaky.

H (with handle), 0.45m. D (rim), 0.10m. D (body), 0.128m.

Bought from A. Decaristo.

118. Tall-necked Flask

G.R. Dept. 1913.5–22.108 / 4th or 5th century A.D. / From Syria / Given by Fairfax Murray and W. Lockett Agnew.

Greenish-yellow tall-necked flask: bell-shaped body with pushed-in, concave base with no pontil-mark; very tall neck with constriction at base, and with slight flare at top round which is an opaque, red-brown fourteen-spiral trail; the trail consists of three thick bands, divided by thin bands.

Intact; pitting and iridescence of fine golden colour.

H, 0.36m. D (rim), 0.03cm. D (body), 0.08cm.

Former Durighello Collection. Paper label on flask: '353'.

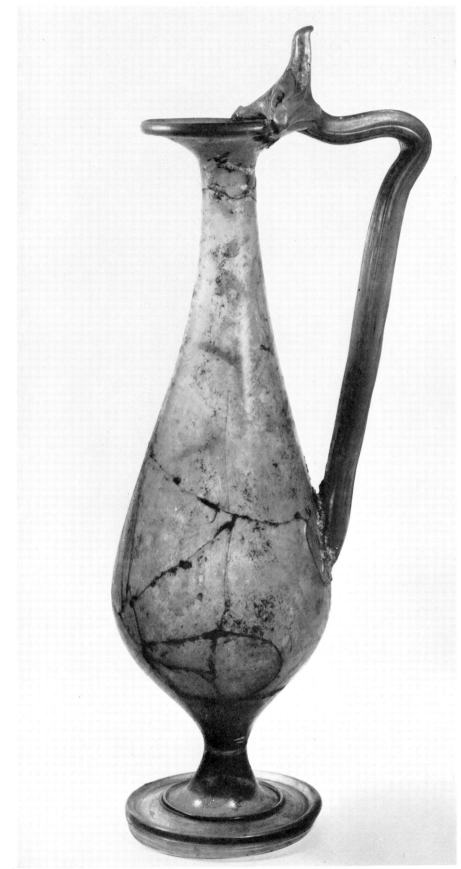

117

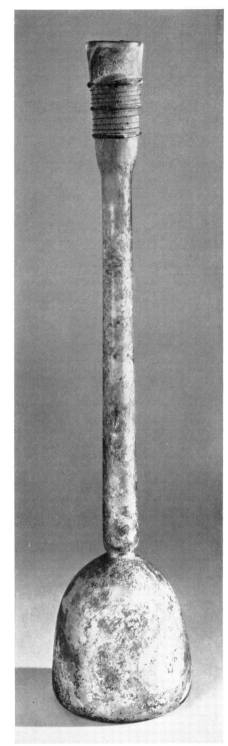

118

119. Handled Jug

G.R. Dept. 77.8–12.1 / 4th century A.D. / From Cyzicus, Turkey / Purchased.

Royal blue jug: rim outsplayed and folded back on to horizontal surface; ovoid body; pushed-in tubular base-ring, pontil-mark below; three-reeded handle.
 Blown, intact; dulled on one side of outer surface; very bubbly indeed.

H, 0.19m. D (rim), 0.08m. D (body), 0.126m.

Purchased through Messrs. Rollin and Fenardent from Calvert's sale, Sotheby's.

120. Handled Bowl

G.R. Dept. 77.8–12.2 / 4th century A.D. / From Cyzicus, Turkey / Purchased.

Bright blue shallow bowl: rim folded outwards and downwards; pushed-in base with pontil-mark; small 'krater' handles on sides.
 Blown; intact, except for one mended break; dulled on outer surface; very bubbly and some impurities.

D, 0.17m. H (lowest), 0.055m. H (greatest), 0.059m.

Purchased through Messrs. Rollin and Fenardent from Calvert's sale, Sotheby's.

121. Juglet

G.R. Dept. 77.8–12.3 / 4th century A.D. / From Cyzicus, Turkey / Purchased.

Opaque white and clear but streaky green juglet: rim folded out, up and in; cylindrical neck with constriction at base; piriform body; pushed-in tubular base-ring; no pontil-mark; faint pointed kick in base; marbled green and white circular handle.
 Blown; very thin outer casing of white glass, through which the green glass shows, particularly on the body and in one thin vertical irregular band; intact; slightly pitted on body of white casing.

D, 0.046m. H, 0.09m.

Purchased through Rollin and Fenardent from Calvert's Sale, Sotheby's.

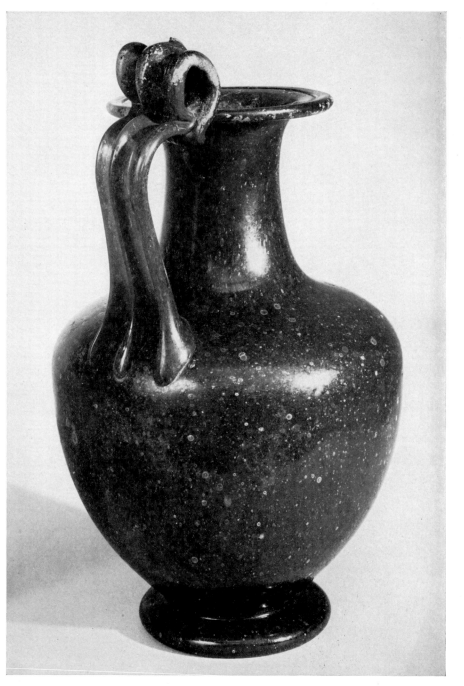

119

122. Jar with Green Hooks

G.R. Dept. 1906.5–22.3 / 3rd or 4th century A.D. / From the neighbourhood of Olbia, U.S.S.R. / Purchased.

Colourless jar: rounded rim; constricted neck; long ovoid body; concave base with pontil-mark. Eight emerald-green hooks on body, set zigzag in rows of four.
 Intact; white chalky contents-stain within, milky iridescence on outside with incrustation in area of hooks.

H, 0.119m. D (rim), 0.087m.

Bought from Messrs. Rollin and Fenardent.

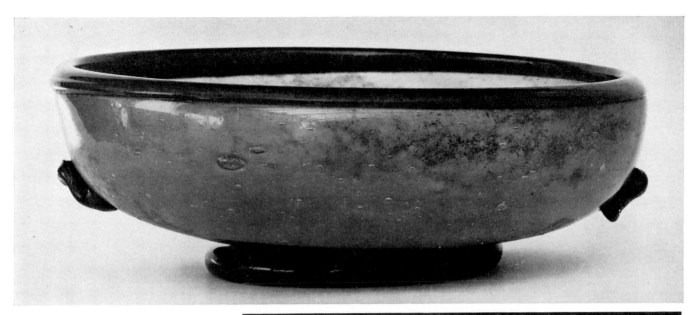

120

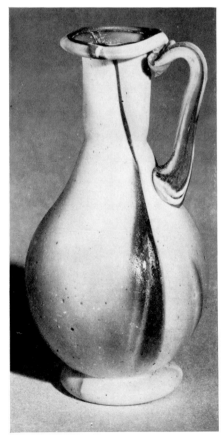

121

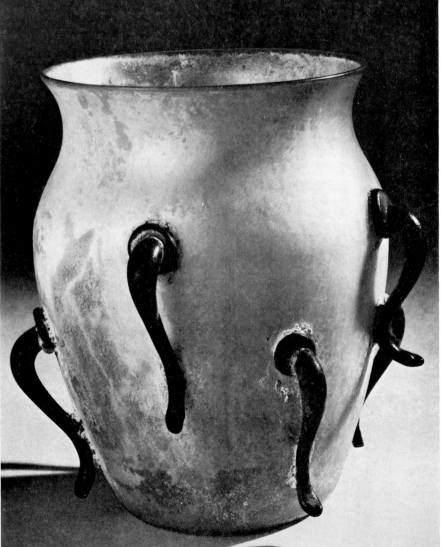

122

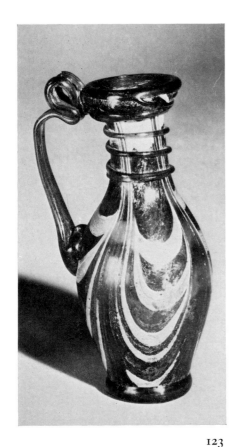

123

cylindrical neck; ovoid body; pushed-in splayed base with hollow fold and central knob; two-ribbed yellowish green handle from rim to shoulder. Turquoise twenty-four spiral trail from lip to base of neck.

Broken and mended, almost complete, some of trail missing; dulled and rough pitted surface, iridescence inside and out.

H, 0.269m. D (body), 0.128m.

A pencil note in the British and Medieval Department's copy of Nesbitt (1871) says, 'Fould Coll. 1497, pl. XXI'. This probably means the collection of Louis Fould and refers to the catalogue of his collection published by his son. For an ivory from Fould's collection see A. W. Franks in *Proceedings of the Society of Antiquaries of London*, 2nd series, vol. I (1859–61), p. 377.

BIBLIOGRAPHY: Nesbitt (1871), p. 39, no. 240, fig. 56; Harden (1936), p. 234 and note 1, and cf. *ibid.*, no. 722, pp. 234 and 243, and frontispiece and pl. XIX.

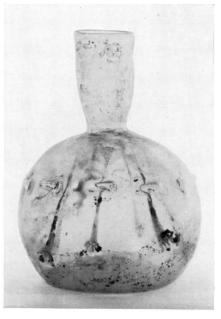

125

125. Flask with Internal Threads

G.R. Dept. 1952.5–1.1 / 4th or 5th century A.D. / Purchased.

Green flask: rounded rim; cylindrical neck, constricted at base; globular body; concave base, no pontil-mark. Eight tubes from near base of neck to bottom of body, inside, drawn out. Eleven horizontal nipt knobs at greatest diameter.

Intact; faint iridescence and contents-stains.

H, 0.115m. D (rim), 0.027m. D (body), 0.082m.

Bought from D. B. Harden.

123. Small Handled Jug

G.R. Dept. S 261 / 4th century A.D. / Bequeathed by Felix Slade, 1868.

Olive-blue jug: rim outsplayed; cylindrical neck expanding to elongated ovoid body; flattened base with green base-coil; pontil-mark; two-ribbed green handle from rim to shoulder. Marvered opaque white trails on body, combed upwards into festoons; six-spiral un-marvered green trail on lip and neck.

Intact; iridescent patches inside and out.

H, 0.098m. D (rim), 0.031m. D (body), 0.044m.

BIBLIOGRAPHY: Nesbitt (1871), p. 43, no. 261, fig. 61.

124. Handled Jug

G.R. Dept. S 240 / 4th century A.D. / Bequeathed by Felix Slade, 1868.

Greenish-yellow jug; rim rounded, lip outsplayed and pinched to trefoil shape;

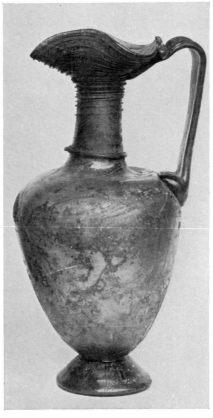

124

GLASS OF THE DARK AGES IN THE WEST

by D. B. Harden

The decline of the Roman empire in the west during the first half of the 5th century A.D. brought no change in the methods of making glass vessels, or in the ingredients of the batch, but there are very noticeable changes in shape and decoration, no doubt introduced, in part at least, to satisfy the tastes of the glass-makers' Teutonic customers.

All dark-age glass is blown, as was the great bulk of the glass used in the previous four centuries of Roman rule, and all of it is, like the Roman, of the soda–lime variety. The glass-makers in western Europe were still, apparently, able to obtain as alkali the soda-charged marine plant-ash from Mediterranean countries which their predecessors had used, and it was not until the end of the 1st millennium A.D. that western European glass-makers switched to potash glass, using as alkali the ashes of bracken and other woodland plants readily available locally, and manufacturing what is called 'forest glass', typical of the middle ages in the west.

However little change, therefore, took place in manufacturing processes, there is no doubt that, not long after A.D. 400, a considerable reduction occurred in the number of shapes and decorative techniques that the glass-makers employed.

The glasses found in pagan Anglo-Saxon graves in England of the 5th to the 7th centuries A.D. (excluding Roman survivals) can be divided into thirteen basic types (Harden (1956b), pp. 147ff.) and von Pfeffer's type series of Frankish glasses on the continent is similarly restricted in scope (von Pfeffer (1960), pp. 136ff., fig. 1); moreover, in the later centuries of the 1st millennium A.D., though the shapes may have become somewhat different, the types certainly do not increase in number.

The only Roman decorative methods that survived were trailing and mould-blowing: painting, gilding, cutting (in all its many varieties), indenting and decorative tooling cease; and even mould-blowing, though it survived, was used only for corrugated ribbing or other very simple patterns and not for the much more complicated modelling and figure-work so common in Roman times. Trailing, however, kept its place fully in the glass-makers' repertoire and continued to be employed with the same verve and dexterity which the Roman glass-maker commanded. A specific type of applied decoration, allied to trailing (since it was dropped on), the claw or prunt, which the Romans knew but made little use of, was strongly developed by the dark-age workers and brought forth what we may consider to be their finest products, the great series of claw-beakers which reached its zenith with such pieces as Castle Eden (no. 126) in the late 5th or early 6th century and lasted until at least the earlier 8th century, to which date some examples found in Scandinavia belong (Rademacher (1942), p. 290f.).

The nine glasses here exhibited, five found in England and four on the continent, have been chosen as typical of the best Teutonic glass-making. The finest of all, and also perhaps the earliest of the nine (except possibly the Bingerbrück horn, no. 132), for it belongs to the later 5th century, is the Kempston cone-beaker of limpid green glass with exquisitely symmetrical trailing (no. 127). About 20 examples of this variety of cone-beaker have been found in England, not all, of course, as superb in their execution as is this Kempston masterpiece.

In its technique the Castle Eden claw-beaker (no. 126) is perhaps in the same class as Kempston, and it is also little, if at all, later in date, but, though one of the best of its kind, it is stumpy and massive, without Kempston's grace and charm.

The three drinking-horns are worthy of note, since they represent three of

the four main types of glass drinking-horn found in Italy and the west between the 3rd and the 7th centuries A.D. (Evison (1955), pp. 171ff.). All three have knocked off and unworked rims, a peculiar lack of finish for what are presumably drinking-glasses: yet many late Roman beakers and bowls have similar rims and we can but infer that drinkers of the time did not object; for though the Rainham example, the roughest rim of all (no. 128), could, from its plain shape, have had a rim-binding of some other material, it is less likely that the others, on which the rims are everted, could have had one, and in any case none of the many rough-rimmed late Roman glasses has any extant trace of such a binding. The suggestion should probably, therefore, be discarded. The Bingerbrück horn (no. 132) is a late example of Evison's type II (4th–5th century); the Rainham horn (no. 128) belongs to her type III (late 5th–6th century); and the blue horn from Italy (no. 133) belongs to her type IV, a group from Lombardic graves in that country belonging to the late 6th and early 7th centuries A.D. No typological development from one type to another is postulated: they are just different varieties of horn, of different dates.

The decoration of thick trellis trailing on the shoulder of no. 133 leads on to the fine little dark-blue squat jar (no. 130), one of a pair from Broomfield, found with a burial group of the 7th century, which has a very similar trellis decoration. That both these glasses are blue is interesting. This colour seems to have been specially prevalent in the 7th century (Harden (1956b), p. 142, note 38).

The remaining three glasses exhibited also belong to the 7th century. Notice the great difference between the heavy, rather stumpy form of the cone-beaker from Gotland (no. 131) and the beautifully tall and slender Kempston example of two centuries earlier; notice, however, in contrast the far finer workmanship of the clear green Bungay pouch-bottle (no. 129) with its elegant and regular trailing. Indeed, all three of these 7th-century glasses are carefully made by a good craftsman and show that whoever produced them could, had he or his customers wished, have produced the far more refined shapes and designs of Roman times.

A. BRITISH

126. Claw-beaker

B.M. Dept. 1947.10–9.1 / Late 5th or early 6th century A.D. / From Castle Eden, Co. Durham (found in 1775 as the sole object accompanying a skeleton) / Given by the Hon. Mrs. Sclater-Booth.

Green; the trails at neck and base and on upper row of claws royal blue. Outsplayed rim, thickened by folding inward; body roughly cylindrical, though bulging where each claw is attached and tapering at bottom to a pushed-in basering with deep kick and remains of a cylindrical pontil-wad on under side. On neck a twenty-fold horizontal spiral trail running upward from drop-on at shoulder; at base an equivalent trail, sixteenfold, beginning from a drop-on at the top; between these trails, and added after them, since in places they overlap the trails, are two horizontal rows of large and dominant claws, five in each row, the tails of the upper row falling in between the heads of the lower one; on each claw a nicked vertical trail from top to bottom.

Blown; trails drawn on, base finished and vessel allowed to cool while held on blowpipe; heated blobs then applied, one by one, for each claw, which warmed part of the wall, enabling the claw to be blown hollow and drawn out into position with pincers; vessel then transferred to pontil, for finishing of rim; intact; one long internal crack across body (? a strain); some incipient iridescence; bubbly, with many streaks and impurities.

H, 0.19m. D rim, 0.095m.

BIBLIOGRAPHY: *Archaeologia*, XV (1806), 402, pl. 37, fig. 1; Surtees (1816), p. 44 and plate; Hodges (1905), p. 215, pl. opp. p. 216; Baldwin Brown (1915), p. 484, pl. 124; Fremersdorf (1933–34), pp. 21, 26, no. 58; Thorpe (1949), p. 59, pl. xi *b*; Harden (1956a), p. 340, fig. 317; Harden (1956b), pp. 139, 159, fig. 25 (group B, type II *b*, no. 1).

127. Cone-beaker

B.M. Dept. 91.6–24.1 / 2nd half of 5th century A.D. / From Kempston, Beds., 1863–64 (found in a grave with gold and garnet pendant, 120 beads, and bronze toilet set) / Bought from Miss Anne Scott.

Green. Outsplayed rim, rounded and thickened in flame; conical body tapering from underneath rim to base; base flattened with pontil-mark. On upper body a twenty-two-fold horizontal spiral trail running upward from drop-on at bottom; on lower body, reaching to base, a twelvefold continuous vertical looped trail.

Blown, with drawn-on trails; intact; incipient iridescence all over; bubbly and streaky metal.

H, 0.262m. D rim, 0.09m.

BIBLIOGRAPHY: Fitch (1864), p. 287, pl. i, no. 1; Roach Smith (1868), pp. 201ff., pl. xxxix, no. 1; de Baye (1893), p. 107, pl. xv, 2; Smith (1904), p. 181, col. pl. opp. p. 180, fig. 3; Dillon (1907), p. 113, pl. xvii, 1; Baldwin Brown (1915), p. 487; Smith (1923), p. 73f., fig. 54 *e*; Thorpe (1949), pp. 14f., 49f., pl. xiii *c*; Harden (1956b), pp. 140, 159, pl. xvi *d*, fig. 25 (group B, type III *a* i, no. 1).

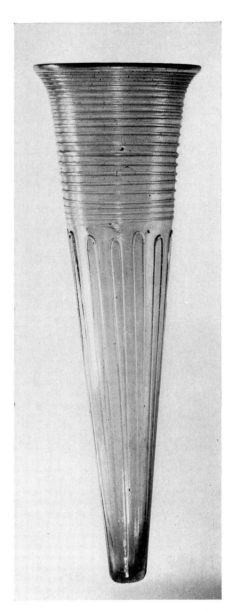

127

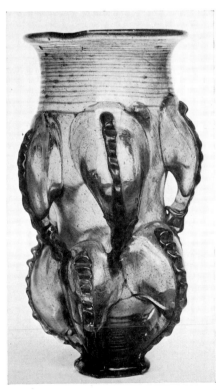

126

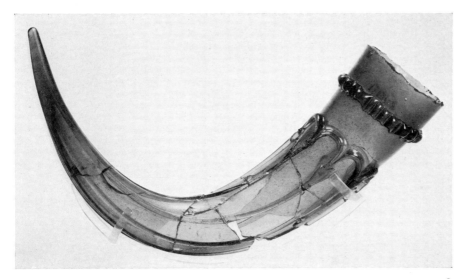

128

128. Drinking-horn

B.M. Dept. 1952.2–4.1 / Late 5th or 6th century A.D. / From Rainham, Essex (found in 1937 during gravel-working on site of a Saxon cemetery, where its twin—1952.2–5.1, given by Mr. J. C. Herington—was also found, though without proof that they were in same grave) / Given by Dagenham Borough Council through Mr. J. G. O'Leary.

Olive-green. Knocked-off rim, grozed at edge, but not smoothed; body blown as a cone and then bent, while warm, into shape of horn, with a simple angled bend in the middle and a further curve sideways nearer the tip; tip solid for a length of *c*. 7cm. Below lip a thick horizontal trail, nicked and with overlapping ends; below this another similar, not nicked, but combed downward to form an eight-fold festoon, from the bottom tips of which eight vertical trails, dropped on, have been drawn downwards to fade out towards tip of horn.

Blown; the trails applied at an intermediate stage, so that the vertical ones could be expanded downwards during final inflation; broken and mended, a large portion missing in middle as well as some smaller pieces elsewhere; surface dulled; very bubbly, some streaks and sandy and black impurities.

L across from tip to rim, 0.33m. D rim, 0.071m.

BIBLIOGRAPHY: von Pfeffer (1952), p. 160, fig. 3, no. 20; Evison (1955), pp. 159ff., esp. pp. 171, 175, 185–90, pls. lxiii *a*, lxix *a*, *d*; Harden (1956b), pp. 140, 161, pl. xvi *e*, fig. 25 (group B, type IV, no. 1).

129. Pouch-bottle

B.M. Dept. 54.10–23.1 / 7th century A.D. / From near Bungay, Suffolk / Bought from T. L. Crompton.

Clear pale green. Rim thickened and rounded in flame; neck concave, below which body expands to pouch shape with rounded bottom, pontil-mark over trailing on under side. Nine-fold horizontal spiral trail on neck and shoulder, starting from a drop-on at top; on lower body, reaching to centre of bottom, a seven-fold vertical 'merrythought' trail, five folds of which are continuous, but the remaining two are laid on independently, filling gaps between nos. 3 and 4 and nos. 4 and 5, and partly lying over no. 4; the lowest band of the upper trail lies over two of the tips of the 'merrythought'.

Blown, with drawn-on trails; intact; some dulling, contents-stain within on one side; bubbly, some impurities, and yellow streaks on rim.

H, 0.123m. D rim, 0.07m.

BIBLIOGRAPHY: Akerman (1855), p. 51, pl. xxv, 1; Smith (1923), p. 51, fig. 54 *b*; Thorpe (1949), p. 69; Harden (1956b), pp. 141, 163, pl. xviii *f*, fig. 25 (group B, type VII *a*, no. 1).

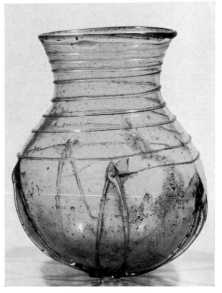

129

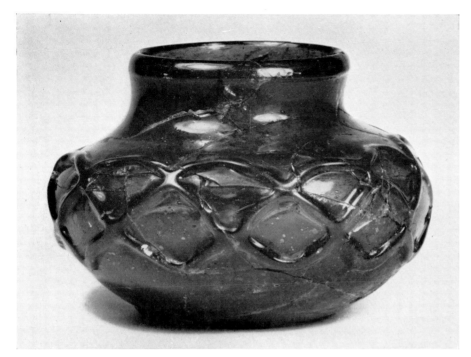

130. Squat Jar

B.M. Dept. 94.12–16.18 / 7th century A.D. / From Broomfield, Essex (part of contents of rich grave, partly found during gravel-working *c.* 1888 and partly during subsequent excavations in 1894. Other finds included another blue glass jar, 7th-century jewellery and a bronze pan) / Given by D. Christy.

Dark blue. Rounded rim, vertical, with external bevel, below which there is a slight rebate; short cylindrical neck; squat ovoid body; concave bottom with pointed kick and pontil-mark over trailing on under side. On upper body three horizontal trails combed into zigzags which join at the angles to form a trellis pattern; on bottom another trail combed inwards to form a four-petalled rosette.

Blown, with drawn-on trails; the unusually plain rim, with its rebate, may once have been covered by a gold or silver mounting; almost complete, but broken and mended; some brown filmy weathering on exterior; some strains; usage marks on bottom; very bubbly.

H, 0.073m. D rim, 0.063m. GD, 0.11m.

BIBLIOGRAPHY: *Proc. Soc. Antiq. London*, 2 ser. XV (1893–95), 250ff., fig. on p. 253; Smith (1903), p. 322, and col. pl., no. 19; Baldwin Brown (1915), pp. 485, 601f., pl. cxxvi, 2; Smith (1923), p. 63, fig. 54 *a*; Thorpe (1949), p. 66; Harden (1956b), pp. 141, 164, pl. xviii *j*, fig. 25 (group B, type VIII *a* iv, no. 1).

B. FOREIGN

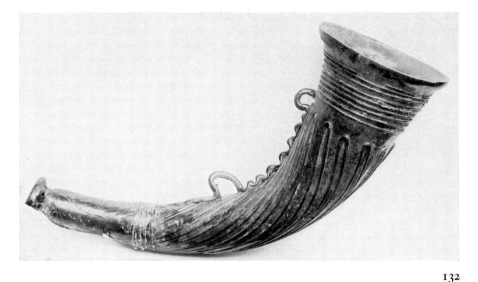

131. Cone-beaker

B.M. Dept. 1921.11-1.381 / 7th century A.D. / From Hablingbo, Gotland, Sweden / Bought (along with other items) from James Curle with the aid of a contribution from the National Art-Collections Fund.

Olive-green. Rim thickened by folding inward; sides taper downwards and bend sharply in to rounded bottom on which is an applied base-pad, flattened underneath on a marver, which covers the trails and also probably the pontil-mark. Two centimetres below rim a five-fold horizontal spiral trail, dropped on at bottom; 6cm. from rim and covered in one place by this spiral trailing, is a continuous trail of six vertical loops, which join together at the bottom, underneath the base-pad.

Blown, with drawn-on trails; complete, but broken in two horizontally across body and mended; surface dulled;

bubbles, some quite large, and some black impurities, especially at rim and in the trails.

H (uneven), 0.202-0.205m. D rim, 0.124m. D base-pad, 0.031m.

BIBLIOGRAPHY: Smith (1923), p. 167.

132. Drinking-horn

B.M. Dept. 73.5-2.212 / 5th century A.D. / From Bingerbrück, Germany (found in making railway, and collected by a Mr. Löb) / Given by the executors of Felix Slade.

Amber-yellow. Rim outsplayed, knocked off and not smoothed; body blown as a cone, circular in section, but bent into a curve while still warm so that the body, in the middle, has become oval in section; constriction at bottom, below which a flattened 'base-ring', pushed in to concavity below, with pontil-mark. Below rim a nine-fold horizontal spiral trail, dropped on at top; near base a six-fold ditto, also dropped on at top; between these a continuous sloping trail in fourteen loops, curving downwards to right, and fading out underneath the lower spiral trail (showing that the final inflation took place after these loops had been applied); on inside curve of body from upper to lower spiral trail is a handle-trail curled into two suspension loops and nicked into a wavy line between them and below the lower one.

Blown, with drawn-on trails; intact, save for chip out of base; iridescent

surface film on inside and outside; few bubbles, some streaks.

L across from tip to rim, 0.34m. D rim, 0.10-0.106m. Greatest and least diameter in middle of body, 0.065m. and 0.045m.

BIBLIOGRAPHY: Smith (1923), p. 157; von Jenny (1943), p. 70, no. 79 (right); von Pfeffer (1952), p. 160, fig. 3, no. 13; Evison (1955), pp. 172, 182, pl. lxix b, e; Kühn (1965), p. 255, pl. 130, no. 3. Both von Jenny and Kühn wrongly state that this vessel comes from Kent.

133. Drinking-horn

B.M. Dept. 87.1-8.2 / Late 6th or early 7th century A.D. / From Italy (found in a grave with a gilt radiate brooch and an S-shaped bird brooch, both set with garnets, a gold cross, two gold pendants and two greenish-blue glass amphorae with yellow, red and white opaque marvered blobs—nos. 87.1-8.3-9) / Bought from Rollin and Feuardent.

Royal blue; some of trailing in opaque white. Rim outsplayed, knocked off and not smoothed; body blown as a cone and bent into a curve while still warm, the inside of curve showing folds, such as are not noticeably present on nos. 128 and 132: end pointed, hollow within, and with faint pincer-mark outside. Six-fold thin opaque white horizontal spiral trail below rim, dropped on at bottom;

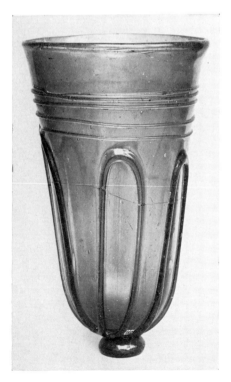

twenty-fold ditto on lower body, dropped on at point of horn; on shoulder three very thick royal blue horizontal trails, each separate and with its ends overlapping, the top one scalloped by combing downwards, the others combed two ways into zigzags, and all joining at the angles so formed to make a trellis pattern.

Blown, with drawn-on trails; one repaired break at rim, two chips out of rim and some of white trailing missing; some dulling on interior; full of bubbles.

L across from tip to rim, 0.23m. D rim, 0.072m.

BIBLIOGRAPHY: Smith (1923), p. 154, fig. 192 *e*; von Jenny (1943), p. 70, no. 79, fig. 79; Evison (1955), pp. 174, 187ff., pl. lxix *c, f*, fig. 8, no. 4; Kühn (1965), p. 255, pl. 130, no. 2. Both von Jenny and Kühn wrongly state that this vessel comes from Herpes, Charente.

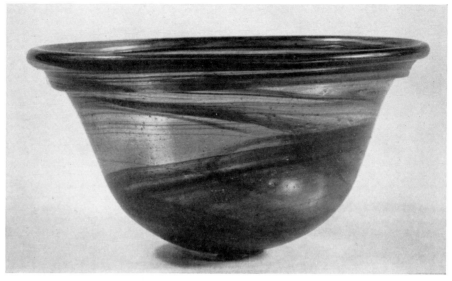

134

133

134. Palm-cup

B.M. Dept. ML 3989 / 7th century A.D. / From Rheims / Léon Morel collection, bought in 1901.

Green, streaked with red. Lip folded outwards and downwards to form a hollow, tubular rim; sides concave above, convex below, and thence curving inwards to a rounded bottom, on under side of which is the ring-mark left by a cylindrical pontil-wad. The red streaks clearly decorative, forming a spun spiraliform pattern.

Blown; intact; unweathered; very bubbly, one large sandy impurity on side and some black specks.

H. 0.065m. D rim, 0.126–0.13m.

PRE-ISLAMIC PERSIAN AND MESOPOTAMIAN, ISLAMIC AND CHINESE GLASS

by R. H. Pinder-Wilson

Judging from the Nimrud finds, a tradition of carving glass was already established by the 8th century B.C. in northern Mesopotamia. The tradition continued in the Achaemenian empire although there is no evidence that Persia shared in the industry.

After the collapse of the Achaemenian empire, glass production apparently ceased in Mesopotamia until its revival in the late Parthian period. The technique of glass-blowing was probably brought from Syria: and the rare pieces attributed to Mesopotamia are barely distinguishable from those of the latter country. Probably production was limited to unpretentious vessels for everyday use.

Luxury glass ware was revived in Persia and Mesopotamia under the Sassanian emperors. Techniques include mould-blowing, stamped and applied ornament and wheel-cutting. Most striking is the cut glass ware. Surviving examples are either facet or linear cut. The tall cylindrical flask (no. 136) is cut with concave facets like a honeycomb, a method of decoration already being practised in the Roman empire in the 1st and 2nd centuries A.D. The narrow beaker (no. 138) combines linear and facet cutting and was found in northern Persia where it may have been made. Its decoration includes typically Sassanian elements. Characteristic of Sassanian cut glass is the hemispherical bowl with concave cut facets; the glass is thick, well constituted and almost colourless (no. 137). Bowls of this type were exported to the East and to the West; among the finest are two which reached Japan in the 6th and 8th centuries respectively.

Some Sassanian glasses are coloured. In the Shosoin at Nara, Japan, there is a transparent green bowl of foliate form—a shape known in Sassanian metalwork—with incised designs of a boar's or fish's head and in the same repository there is a beaker of transparent blue glass with applied disks. In the Bibliothèque Nationale, Paris, the famous gold dish known as the Khusrau dish is set with mould pressed roundels with rosettes in relief; these are colourless, red and green. The large central roundel of rock crystal is carved in relief with the figure of a Sassanian monarch enthroned, possibly Khusrau I (A.D. 531–79). Judging from this last example the Sassanian craftsmen must have been skilled in carving hardstones and it would be surprising if relief carving on glass were not also practised in Persia or Mesopotamia. Up to the present no such vessel has survived.

The globular flask (no. 135) is an example of undecorated glass and belongs to the late Sassanian or early Islamic period. The material is characteristic of that of Persia and Mesopotamia but the form of the vessel occurs in an early 8th century context in Syria.

ISLAMIC GLASS

Glass-making was already a flourishing industry in those lands—Egypt, Syria, Mesopotamia and Persia—which in the course of the 7th century A.D. were conquered by the Arab armies under the banner of Islam. The seat of the Arab empire under the Umayyad dynasty (A.D. 661–750) was the former Byzantine

province of Syria. The few glass vessels excavated in Syria which can be associated with this period are objects for common use. They follow the forms inherited from the ancient world and transformed in the centuries immediately preceding Islam. Their new patrons seem not to have demanded novel styles from the glass-workers.

In A.D. 750 the Umayyad was replaced by the Abbasid dynasty who chose as their capital the city of Baghdad, an Islamic foundation. With the development of distinctively Islamic institutions, a unitary civilization was created thanks largely to the political unification of western Asia and the southern shores of the Mediterranean under a single ruler. It was in Mesopotamia that a distinctively Islamic decorative style was born; and in its creation and development the influence of Persia was paramount. For this reason, Islamic art produced to meet the tastes and requirements of a particular society did not exist earlier than the 8th century A.D.

A. Wheel-cut

The glass wares of Mesopotamia were famous in the 9th century A.D. and later: Baghdad and Basra in particular were noted for cut glass. No doubt the industry was stimulated by the demands of the Caliph and the court. The excavations at Samarra on the Tigris above Baghdad and the residence of the Abbasid Caliphs from A.D. 833 to 883 have revealed a notable series of glass vessels decorated in a wide variety of techniques including mould-blowing, facet, linear and relief cutting.

It would seem that there was a revival of the Sassanian tradition which may have suffered a temporary eclipse in the period of Arab domination. In the 9th and 10th centuries A.D. Persia underwent a veritable renaissance under the indigenous dynasty of the Samanids (A.D. 819–1004) whose principal cities were Nishapur in eastern Persia and Afrasiyab (Samarqand) in Transoxiana. Thanks to excavations at these two sites, it has become clear that Persia was producing cut glass ware, in every respect as fine as that of Mesopotamia, from the 9th century A.D.

The wheel-cut vessels (nos. 139–43) were all found in Persia and were probably made in east Persian workshops, possibly Nishapur. They form, too, a homogeneous group both as regards material and technique. The flask with oval facets carved on the body (no. 139) shows the continuity of the Sassanian tradition although the shape does not occur in the Sassanian period. A flask of similar shape but with a distinctive type of abstract ornament (no. 140) introduces a new feature. The style of cutting is the so-called 'bevelled' style adopted by the carvers and moulders of the wood and stucco decoration at Samarra. It is characterized by the absence of a second plane which would customarily supply the background to the decoration; and by the defining of the composition by means of outlines cut on a slant. The style spread from Mesopotamia to Persia, Egypt and north Africa: and its influence has been traced in stone, wood, crystal and glass carving.

The geometric decoration of the shallow dish (no. 141) consists of broad grooves with the section cut in the form of a U. This technique is modified in a more common group with linear cut decoration defined by lightly incised lines executed on the wheel and polished or left unpolished. The small ewer is of

markedly thinner glass and its decoration restricted to cross-hatching set in panels. The shape of the vessel—the beak spout, piriform body and handle with thumb-piece—is well known in metalwork of the Sassanian period and ultimately derives from Roman vessels of silver and gold dating from the 2nd century A.D.

The long-neck flask with globular body (no. 143) is an early example of a form that was to retain its popularity throughout the Islamic period. Noteworthy too is the scrolling ornament which was to exert a dominant influence on the mind of the Islamic artist.

The most remarkable group of early Islamic cut glass consists of vessels in which the surface is ground down leaving the ornament in relief. The technique was practised in Mesopotamia, Persia and Egypt and the glass-workers may have adopted it from the hardstone carvers of Persia and Mesopotamia. It is not known in which country the technique was first developed in the Islamic period. The earliest examples date from the 9th century A.D. In recent years important examples of this group have been found in Persia and two fine pieces are exhibited. The footed goblet (no. 145) shows a mastery of manipulation: the carving of its wafer-thin wall must have been an exacting task. While the heads and wings of the birds are in raised relief, the bodies are countersunk, only the outline being raised. The bowl (no. 146) is remarkable for the fine handling of the ornament so perfectly adapted to the convex wall which curves inwards to meet the diminutive raised foot. The notched outlining bands are characteristic of early Islamic relief ornament and the same feature is found in the great carved rock crystal vessels of Fatimid Egypt.

A few rare pieces of cameo cut glass have survived: fragments from Samarra and complete vessels from Egypt and Persia. The overlay is either green or blue. The flask (no. 148) is an outstanding example of Persian cameo cut glass. The green glass overlays are carved in the form of a hare, the articulation of the joints being cut away to reveal the colourless glass ground. The two overlays are offset by the incised 'fleur de lys' which fill the interspaces.

From the Museum's collection of early Islamic cut glass from Egypt, the flask (no. 144) is included in the exhibition. This was found in Syria and although the shape occurs in Persia where perhaps it originated, the material connects with Egyptian rather than with Persian workshops.

A problematic piece is the splendid beaker, one of the famous so-called 'Hedwig glasses' (no. 147). It has generally been held that these originated in Egypt in about the 12th century A.D. In 1960 fragments of a Hedwig glass were found in the course of excavations at Novogrudok, a town in White Russia between Minsk and Grodno where evidence of a glass manufactory came to light. B. Shelkovnikov of the Hermitage Museum, Leningrad, claims that these Hedwig glass fragments are similar to the waste glass from Novogrudok; and in a reconsideration of the Hedwig glasses would relate them to the art of the Kingdom of Kiev in the 12th century A.D. Admittedly there are no close parallels in shape, material and style of ornament in the Islamic world and a completely acceptable solution to the problem is awaited.

B. Applied decoration

Besides wheel-cutting, most of the techniques of surface manipulation were

known in the early Islamic world—mould-blowing and casting, stamped and pincered decoration and applied ornament. A fine example of the last is the hanging lamp (no. 149) which comes from Persia and is an early adumbration of the typical hanging mosque lamp current in the Muslim world in the 13th century and later.

C. Lustre painted

The glass-workers of the early Islamic period experimented in polychrome decoration of the surface. Opaque coloured glass vessels were made in Egypt and incrustation with glass of another colour—the so-called technique of 'combed' decoration—was practised in Syria continuously from pre-Islamic to late medieval times. An interesting and rare group is lustre-painted glass. The precise nature of the technique has not yet been established although there is good reason to connect it with the technique of lustre-painting on tin glazed pottery which was practised first in Mesopotamia in the 9th century A.D. The pigment is a film which, depending on the firing, is more or less lustrous and is imperceptible to the touch. There is, too, a variation in the colour—a few rare pieces are decorated in a polychrome palette—as well as in tone. It is now generally accepted that the technique was first practised in Egypt either in the late Byzantine or early Islamic period. It is possible too that it was known to the glassmakers of Syria but not, on our present evidence, to those of Persia or Mesopotamia. Our example (no. 150) is certainly of Egyptian origin and was found at Atfih on the Nile some forty miles south of Cairo. The ribbings of the vessel were obtained by its being blown in an 'optical' mould and the lustre-painting is a chestnut brown.

D. Gilded glass

The impact of the Seljuqs on Islamic culture was as profound as it was on politics. As patrons they gave an impetus to the artistic life of those countries where they and their successors were established. It was the Seljuq Atabeg, 'Imad al-Din Zangi, ruler of Mosul from 1127 and of northern Syria from 1130 until his death in 1146, who ordered the fragmentary flask (no. 151). The gilded decoration—not leaf gold but gold applied in suspension in a medium and fixed by firing—is remarkably vivid and fresh. This and a few other rare examples are thought to have been made at some centre in south-eastern Anatolia or northern Syria where the technique was probably introduced from Egypt. The style of decoration is that of the Seljuq art of Anatolia: and it is worth noting that at about the same period, a factory in Byzantine Corinth was producing vessels decorated in the same technique.

E. Enamelled and gilded glass

The decoration consists of opaque vitreous enamels and gilding, applied cold and fixed by firing: the decorative elements are invariably defined by red out-lines. Painting in fired pigments was practised in the ancient world both in the

Near East and in the West: the finest examples come from the former area but whether from Egypt or Syria has not yet been determined. The gilded and enamelled glasses for which the Near East was renowned in the 13th and 14th centuries was for the most part the product of Syria. These travelled as far afield as Egypt, Mesopotamia, China, Russia, Sweden and England. The earliest occurrence of the technique was towards the end of the 12th century in northern Syria, possibly Raqqa on the Euphrates where were produced glasses decorated with granulations of coloured enamel and gilded inscriptions. While the technique of enamelling was probably developed locally, that of gilding seems to have been introduced from Egypt.

The only Islamic glass with gilded and enamelled decoration to have been made outside Syria is the so-called 'Fustat' group produced in Egypt. The group is said to date from about A.D. 1270 to 1340; and the Museum possesses a single example.

C. J. Lamm has classified the gilded and enamelled glass of Syria on the basis of style and technique as follows:

(1) Raqqa group: about 1170–1270;
(2) Syro–Frankish group: about 1260–90. This consists of a few intact pieces, evidently the product of a single workshop, that of a certain Magister Aldrevandini and probably located in the Latin states;
(3) Aleppo group: about 1250–65;
(4) Damascus group: about 1250–1300;
(5) 'Chinese' group: about 1285–1400: So-called because of the 'chinoiserie' elements of decoration introduced into Syria as a result of the establishment of the Mongol dynasty in Persia and Mesopotamia.

The chronology of this classification is only relative and in the absence of positive archaeological evidence, the association of (1), (3) and (4) with these cities is based on historical factors of which the most significant is the devastation inflicted on Aleppo by the Mongols in A.D. 1260.

The finest and most important gilded and enamelled glass object in the Museum's collection is the pilgrim flask (no. 153). The enamels comprise no less than eight colours. The gilded scrolls with human and animal head terminals is a known theme in Islamic art and represents the Talking Tree which, according to the Islamic version of the Alexander legend, that hero consulted in the course of his adventures. Both this and the wonderfully depicted scenes of the hunt and feasting on the sides of the vessel occur in the inlaid silver and gold metal-work of Syria in the 13th century. According to Lamm's classification, the pilgrim flask is a product of the Aleppo workshops. The 'Chinese' group is well represented in the Museum's collections. Characteristic are the friezes of densely-packed flowers and birds rendered in thin red outlines in a calligraphic style (nos. 154, 155, 157 and 158). The overall design of Chinese lotus flowers and foliage in enamels on the mosque lamp (no. 159) is found in a number of lamps probably destined for the great madrasa built by Sultan Hasan b. Muhammad (1347–51 and 1354–61) in Cairo between 1356 and 1563. Many of the mosque lamps produced in Syria were made for Cairene mosques. The large lamp (no. 157) was made at the order of the Amir Shaikhu for the Takkiya (monastery) and Mausoleum which he founded in Cairo in 1345.

In 1400 Timur captured Damascus and carried off many of its skilled crafts-men, including glass-makers, to his capital, Samarqand. It is doubtful if the

Syrian glass industry survived the catastrophe for in the 15th century we have evidence of the Venetian workshops executing orders for enamelled glass mosque lamps for the Near East. Whether the Syrian glass-makers established a tradition of enamelling and gilding in Transoxiana or Persia where no such tradition had hitherto existed is not known. The evidence provided by the small dish of yellow glass (no. 160) suggests that there was such a tradition established. The gilded and enamelled figure of an angel is close in style to that of the Bukhara school of miniaturists of the middle of the 16th century. The glass too is without parallel in the Near East and there is reason to regard this as a late production of the glass-makers of Transoxiana.

GLASS FROM THE LATER ISLAMIC WORLD

There is little or no evidence for the manufacture of glass in Persia for some three centuries following the Mongol conquests. The industry was, however, revived in the reign of Shah Abbas the Great (1587–1628). According to Sir John Chardin the art was taught by an Italian—presumably from Murano. The industry must have flourished, for exports to India, Sumatra and Batavia are recorded in the 17th century. Unfortunately there is no satisfactory means of determining what are early pieces, for the industry has continued to the present with a remarkable consistency both in material and forms. In view of Chardin's information the resemblance to the forms of Venetian glass of the Renaissance and Baroque periods is not surprising.

According to Chardin glass was made everywhere in Persia but that of Shiraz was the best in quality since the best materials were available in that region. Isfahan, the Safavid capital, produced only glass of poor quality since the glass-makers merely melted down used material. Typical of the glass of Shiraz is the rose-water sprinkler (no. 161); its deep blue seems to have been the most favoured colour of the Shirazi glass-workers.

According to our present evidence glass-making was unknown in India before the Mughal period. Mughal miniatures of the late 16th century depict glass vessels placed in ornamental niches and resembling the Persian glasses of the period. These may of course be Persian imports mentioned by Chardin. In the 17th century Venetian or German glass was used in the imperial court and in the 18th century the English were manufacturing cut glass huqqa bases for export to the East Indies. This suggests that the output of the glass factories in India was not very considerable. Most of the fine glass which can with certainty be attributed to a native industry dates from the late 17th to the 19th century. The techniques of these pieces include wheel-cutting, gilding and enamelling and incrustation with jewels.

The two glasses exhibited are characteristic of the Mughal industry (nos. 162, 163). The poppy sprays in both vessels belong to the decorative repertory of the reign of Shah Jahan (1627–58) and later. Both may come from the same workshop.

CHINESE GLASS

Glass was manufactured in China as early as the late Chou period according to tomb finds which include decorative plaques and models of animals. In tombs of the 4th and 3rd centuries B.C. beads of Chinese origin have been found alongside beads imported from the West which they closely imitate, and are distinguished only by their constituents. In Han times glass was used as a substitute for burial jades.

There is evidence that Roman glass was imported by the Chinese and according to Chinese tradition glass was not manufactured in China before the 5th century A.D. when the secrets of glass-making were introduced by travellers from the West in A.D. 435. This presumably refers to the art of blowing. Unfortunately none of the surviving pieces can be confidently attributed to the T'ang period (618–907). Pictorial evidence, however, confirms the claim: a painting of the late 10th century in the Stein collection, British Museum, depicts a Bodhisattva holding a glass vessel in the form of a begging bowl: the shape of this vessel is globular and the rim is folded upwards and back. The regular green mottling may reproduce honeycomb-facet cutting of green tinged glass. In a painting at Tun-huang, probably of the 7th century A.D., a seated Buddha is depicted with groups of Bodhisattvas on either side. One of these holds in his right hand a glass bowl. A similar bowl was found in a 6th-century tomb in Ching-hsien, Hopei, but it has not been determined whether this bowl is of Chinese or of Western origin. The Stein painting, however, seems to provide evidence of a vessel of Chinese origin.

The small globular bowl (no. 164) is a shape which occurs in ceramics of the T'ang period. The vessel is blown and its material and weathering are remarkably like those of the moulded ornaments and votive objects which were made in this period, such as the figure of a standing Buddha (no. 165) and the lion of Buddhist type (no. 166). In the Museum's collections there is a hairpin, hollow blown, which is closely related to gold hairpins of the T'ang period.

Little is known of the glass industry in China during the Sung period (960–1279) or the Ming period (1368–1644) and it is not until the Ch'ing period (1644–1912) that we have explicit mention of glass-making. In 1680 a glass workshop was established in Peking under the patronage of the Emperor K'ang Hsi. The products of this factory included monochromes, cameo cut glass and clear or opaque glass painted with designs in translucent colours.

The early products of the factory suffered from a glass disease known as 'crizzling' which is a decay due to an excess of alkali in the composition of the glass. The flask of thick transparent blue glass with relief panels (no. 168) may belong to this period for it too is sticky to the touch, a sign of 'crizzling'. But in the 18th century this defect was overcome and the flask of opaque turquoise glass (no. 169) may well be a Palace product for it bears the mark of the Emperor Yung Cheng (1723–36).

On the whole the Chinese seem not to have appreciated glass as a material in its own right, rather regarding it as a substitute. This would account for their preoccupation with carving glass in an attempt to simulate hardstone carvings such as the vase imitating realgar (no. 167).

A. BLOWN

135. Flask

W.A. Dept. 132937 (1961.11-14.1) /
3rd-4th century A.D. / Persian (found in
Persia) / Purchased.

Dark green. Flattened rim bent inwards
to form a narrow aperture of only 1cm.
above a much broader neck diameter.
Short neck tapering downwards to a
sharp junction with body. Body squat,
base concave with pontil-mark. Body
spun in spiral formation including some
narrow streaks of opaque red providing
a decoration of sorts.

Intact; milky film all over, flaking
away and leaving iridescent surface.

H, 0.112m. D, 0.145m.

BIBLIOGRAPHY: *BMQ*. XXVI (1962-
3), p. 100; *JGS*, VI (1964), p. 157, no. 4.

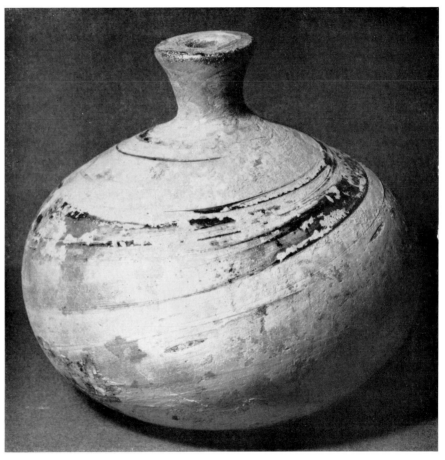

135

B. WHEEL-CUT DECORATION

136. Tubular Vessel with Cut Decoration

W.A. Dept. 91498A (821 in red: excavation no. N.833) / 5th-6th century A.D. / Mesopotamian or Persian / From upper levels of the excavations at Quyunjik (Nineveh).

Green. Cylindrical body; flattened base. Wheel-cut with honeycomb pattern of diamond facets all over body; base plain.

Top missing. Thick coating of enamel-like weathering all over, inside and outside (original green colour available at the break only).

H, as extant, 0.223m. D, 0.029m.

BIBLIOGRAPHY: Layard (1853), p. 596f.; Pinder-Wilson (1963), p. 34f. pl. XV(b).

137

137. Bowl with Cut Decoration

W.A. Dept. 134373 (1964.4-15.1) / 5th-6th century A.D. / Persian: said to have been found at Amlash / Purchased.

Greenish. Rounded rim; hemispherical body; rounded base. Exterior covered with large circular facets in quincunx; four horizontal bands on side with one large central facet on base, making the vessel stable.

Intact; flaking film and iridescence.

H, 0.075m. D, 0.103m.

138. Beaker with Cut Decoration

W.A. Dept. 132985 (1962.10-13.1) / 5th-6th century A.D. / Mesopotamian or Persian: said to have been found in Persia / Purchased.

Green. Plain rounded rim; almost cylindrical body curving to a rounded base. Linear and facet wheel-cutting all over body and base; at top a frieze of three rows of circular facets in quincunx formation; below this a frieze of nine arches on piers under one of which is a free-standing pillar; below this, these two friezes are repeated except that there are only eight arches; below again a frieze of five rows of circular facets as above with a single row of six larger circular facets below them, forming a circle within which is a central base facet.

Broken; some missing pieces restored in plastic. Roughened surface, some iridescence.

H, 0.213m. D, 0.063m.

BIBLIOGRAPHY: *BMQ*, XXVI (1962-63), p. 100; Pinder-Wilson (1963), p. 35f. pl. XV(a).

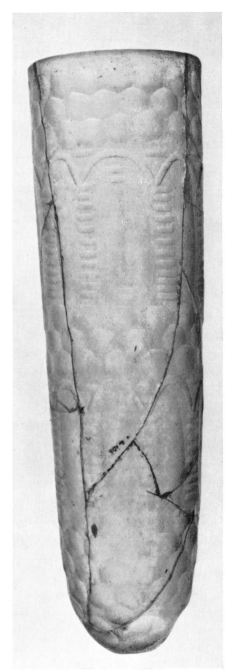

138

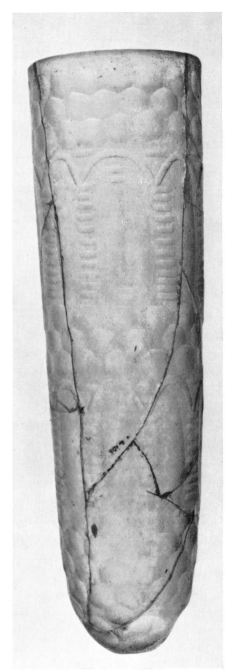

136

A. WHEEL-CUT
DECORATION

139. Flask

Or. Dept. 1959.2–18.1 / 9th century
A.D. / Persian: found in Persia / Pur-
chased.

Colourless with blue tinge. Rim cut
square; funnel neck on campanular body.
Seven facets between raised bands on
neck; two 'bevel' cut bands around
shoulder, five rows of oval concave facets
on body.
 Intact; patches of milky pitting
weathering; material good.

H, 0.15m. D, 0.085m.

BIBLIOGRAPHY: Pinder-Wilson (1963),
p. 36, pl. XVI(a).

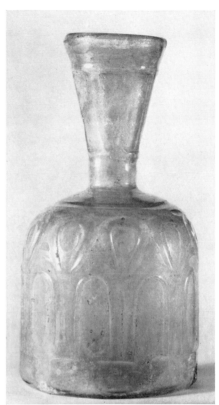

140

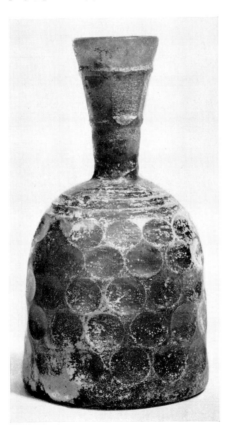

139

140. Flask

Or. Dept. 1959.2–18.2 / 9th century
A.D. / Persian: found in Persia / Pur-
chased.

Colourless. Rim cut square; funnel neck
on slightly curving shoulder; straight
sides to flat base with pontil-mark. Seven
faceted 'panels' around neck; 'bevel' cut
band around shoulder; on sides immedi-
ately below shoulder, two cut bands
interrupted by ten lentiloid figures each
concave within; below this, ten arcades
each with similar concavities; above base,
ten rectangular facets forming bases to
the columns of the arcades. On base,
four cut grooves forming a square around
pontil-mark.
 Intact; patches of milky pitting
weathering on inside and a few on
outside; material good.

H, 0.152m. D, 0.08m.

BIBLIOGRAPHY: Pinder-Wilson (1963),
p. 36f., pl. XVI(b).

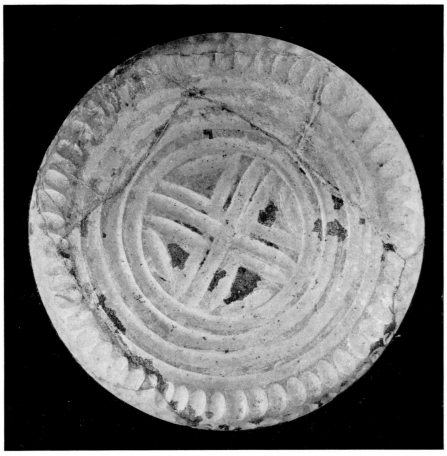

142. Ewer

Or. Dept. 1964.12–17.1 / 8th–10th century A.D. / Persian: found in Persia.

Colourless with greenish tinge. Polished rim on outsplayed mouth with 'beak' spout; piriform body; flat base. Handle attached to body and mouth. Cut linear decoration; on body, three panels of cross-hatchings and floral sprays in the interspaces. Handle cut to square section with 'arrow head' at base and three horizontal grooves half-way down its length; vertical thumb-piece in form of V-shaped crenellation. Pontil-mark ground down.

Multiple breaks and about one-fifth missing and now restored in plastic. Surface dulled; material good.

H, 0.157m.

141. Dish

Or. Dept. 1966.12–12.1 / 9th century A.D. / Persian: found in Persia / Purchased.

Colourless shallow dish. Rim cut square on inside and curving to outside. Side slightly cut back from rim curves inwards to flattish base. Decorated on outside only. On side: below rim a band of vertical concave ovals; on base: a band of similar concave ovals, three concentric grooves and in the central roundel grooves forming a cross; between each pair of arms a triangle in relief. Base slightly convex, the central roundel forming in fact the base.

Complete but nine fractures. Surface almost entirely iridescent except where flaking occurs; material good.

H, 0.027m. D, 0.155m.

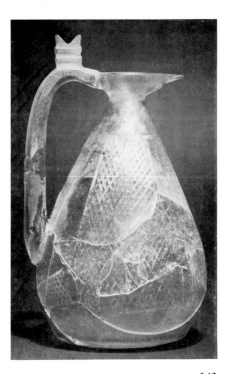

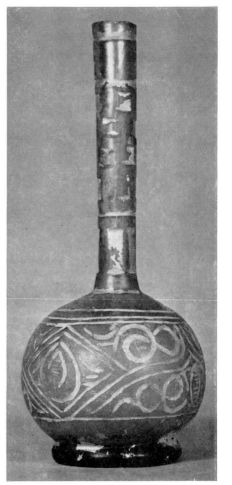

143. Flask

Or. Dept. 1913.10–9.1 / About 10th century A.D. / Persian: found at Sultanabad, Persia / Given by S. S. Bagge.

Colourless with green tinge. Neck, long and cylindrical; body spherical; flat base-ring. Cut linear and facet decoration; on neck: bands and facets; on body: scrolls and lanceolate leaves between diamond and ogival figures.

Intact; dulling and patches of iridescence.

H, 0.197m.

BIBLIOGRAPHY: Lamm (1930), Tafel 58, 16.

144. Flask

Or. Dept. 90.3–14.2 / 9th–10th century A.D. / Egyptian or Syrian: found in Syria / Purchased.

Colourless with yellow tinge. Horizontal rim; long neck widening to junction at shoulder of body; side of latter straight and pointing slightly inwards to flat base

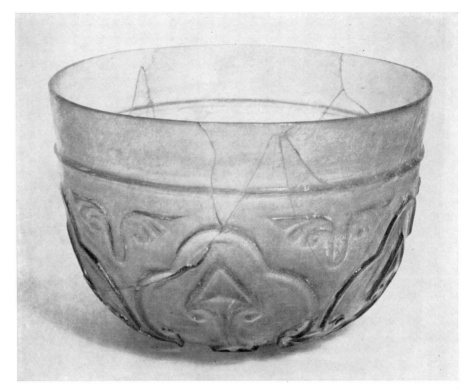

146

with slight kick and pontil-mark. Facet and linear cutting; long narrow facets between bands on neck; band at top of shoulder and below, a panel of palmette scrolling.

Intact; patches of milky pitting weathering; material good; few bubbles.

H, 0.23m.

BIBLIOGRAPHY: Lamm (1930), Tafel 58, 19.*

145. Goblet

Or. Dept. 1964.10–12.1 / 9th century A.D. / Persian: found in Persia / Purchased.
Colourless. Polished rim; sides very slightly concave tapering towards bottom where they curve inwards to join outsplayed base-ring. Wheel-cut decoration in relief on outside of bowl: three stylized birds processing to left, each with wings formed by a split palmette, all framed at top and bottom by a raised band.

Fractures and four small missing pieces restored in plastic. Frosting over entire surface. Material good with few bubbles.

H, 0.101m. D, 0.081m.

146. Bowl

Or. Dept. 1966.4–18.1 / 9th–10th century A.D. / Persian: found in Persia / Purchased.

Colourless with bluish tinge. Polished rim: side straight and then tapering

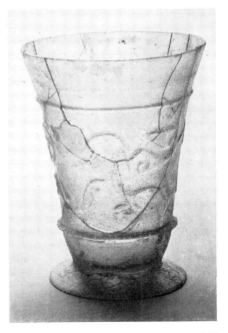

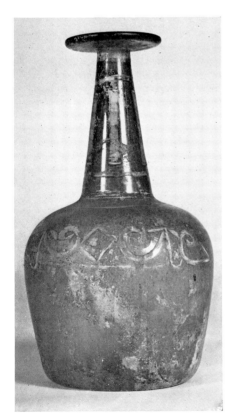

144

145

slightly inwards with a convex curve to a small raised disk, slightly concave, which serves as the base of the vessel. Wheel-cut decoration in relief on outside. Raised band below rim; between this and the foot, a frieze consisting of five trilobed arcades supported on leaves which point downwards; within each arcade a leaf pointing upwards with stem joined to a raised disk with raised boss in its centre; paired palmettes in the spandrels between the arcades. The raised outlining bands of the vegetal ornaments are 'notched'.

Multiple fractures and about one-fifth missing and restored in plastic. Surface condition of fragments vary; a few excellent, most dulled with small patches of milky weathering. Material good with few bubbles.

H, 0.092m. D, 0.148m. D (foot), 0.038m.

BIBLIOGRAPHY: *JGS*, IX (1967), p. 137, no. 19

147. Beaker (so-called Hedwig glass)

Or. Dept. 1959.4–14.1 / 12th century A.D. / Islamic / Purchased.

Colourless with smoky topaz tinge. Rounded rim; straight side slightly tapering to ring-base which is slightly concave with pronounced pontil-mark. Relief cut with linear elements: a lion and a griffon, each with a front paw raised, confronting an eagle with outstretched wings; opposite the latter, two paired palmettes placed one above the other. The edges of the raised areas either rise gradually from the ground or terminate in a sharply profiled edge. The ground has been sliced in a series of irregular facets, the top and bottom of the walls retaining the original thickness of the glass. Details, e.g. feathers of the eagle and griffon, lion's mane and veins of leaves are rendered by hatched or cross-hatched lines engraved in the glass.

Projecting foot-ring broken away at three points; condition of metal (average thickness 0.01m.) excellent; slightly bubbly.

H, 0.14m. D (top), 0.129m. D (bottom), 0.103m.

BIBLIOGRAPHY: *BMQ*, XXII (1960), pp. 43–5, pl. XVII; *JGS*, II (1960), p. 141, no. 18.

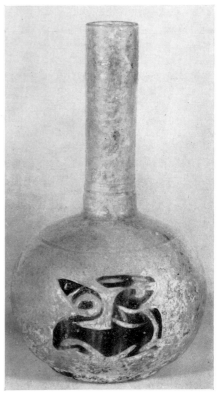

148

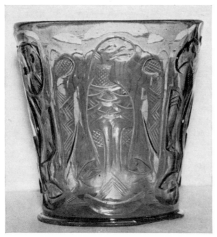

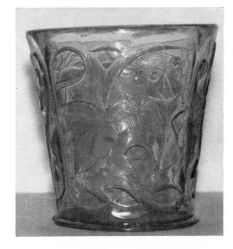

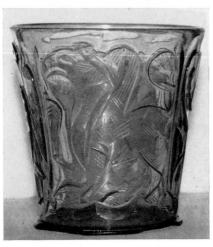

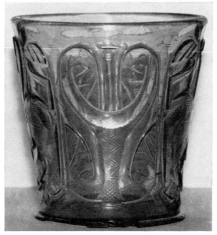

147

148. Flask with Cameo Decoration

Or. Dept. 1966.12–11.1 / 9th–10th century A.D. / Persian: found in Persia / Purchased.

Colourless. Rim ground square; long straight neck; spherical body; pad base. Linear cut and relief cut decoration. On neck, at base, two incised bands. On body at shoulder, incised band; below this, a hare carved in relief in an overlay of green glass, repeated; and between, a stylized lily reversed, also repeated.

Intact: small patches of iridescence on outside; large areas of opalescent iridescence and milky weathering on inside.

H, 0.15m.

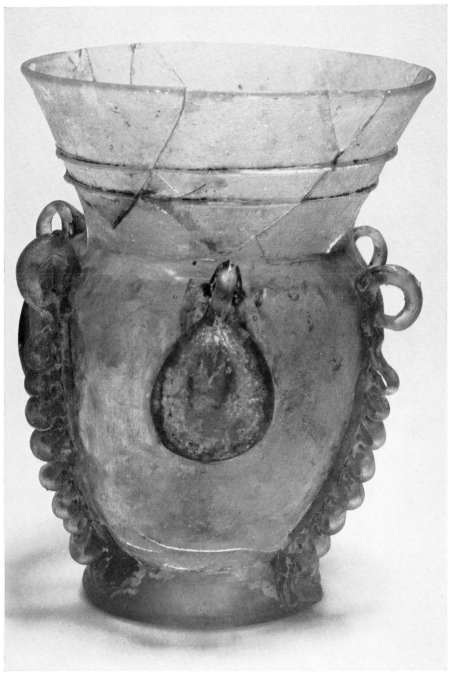

B. TRAILED DECORATION

149. Hanging Lamp

Or. Dept. 1964/12–17.2 / 8th–10th century A.D. / Persian: found in Persia / Purchased.

Colourless. Outsplayed mouth; narrow shoulder from which side curves gradually inwards to pushed-in base. Inside, cylindrical candle-holder attached to base (about 0.05m. in height). Two trailed threads around mouth; six coil handles for suspension on shoulder; from three of these, side-whisker tails with wavy contours reach to base and from the other three depend three lentiloid disks.

About two-fifths of mouth and two-thirds of body missing and restored; surface dulled; glass bubbly.

H, 0.142m. D (rim), 0.112m.

C. LUSTRE-PAINTED

150. Bowl

Or. Dept. 1902.5–17.2 / 12th century
A.D. / Egyptian: found at Atfih opposite
Wasta / Purchased.

Colourless with green tinge. Constriction
in side just below outsplayed rim from
which it curves inwards to rounded base:
vertical ribbings from below shoulder to
base. Painted on outside in brown lustre;
horizontal band below lip; frieze of
palmette scrolls between framing bands;
between ribbings, vertical stripes and
lanceolate leaves alternating.

 Intact; condition of glass excellent;
bubbly; blowing spirals.

H, 0.085m. D (rim), 0.109m.

BIBLIOGRAPHY: Lamm (1930), Tafel
37, 9.

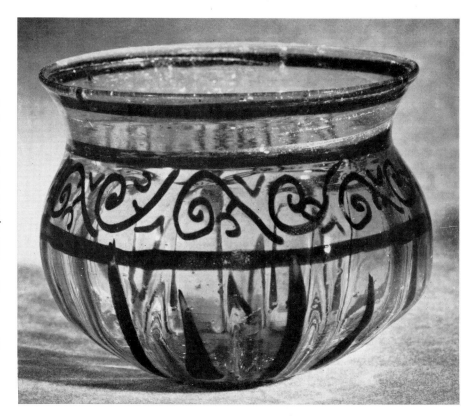

150

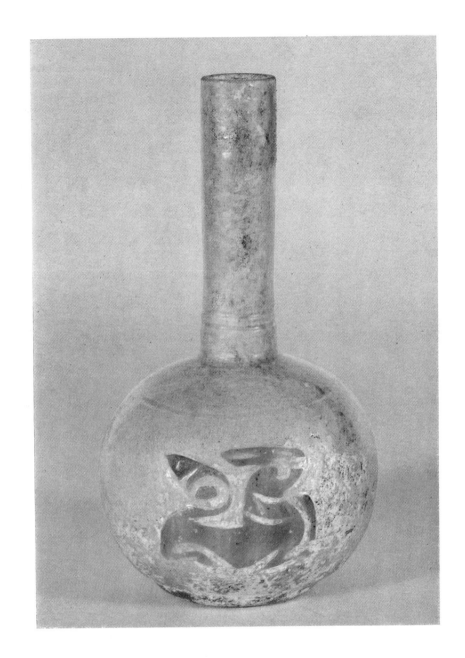

PLATE III

Flask with cameo-cut decoration. Persian. 9th century A.D. [148]

D. GILDED

151. Flask (fragmentary)

Or. Dept. 1906.7–19.1 / Between A.D. 1127 and 1146 / Syrian: found in Asia Minor / Purchased.

Colourless with yellow tinge. Neck missing; spherical body; flat base with pronounced kick and pontil-mark. Gilded decoration; the internal details are scratched. On body, around the middle, a band of Arabic inscribed in *naskh*; above this, a frieze consisting of a female dancer with one arm raised, the other grasping a castanet, and another female figure playing a harp (?). Judging from the two incomplete fragments, each figure was placed between a stylized pomegranate tree. Below the inscribed band, a frieze consisting of an eagle with outstretched wings, its head either to right or left, between pomegranate trees similar to those in the upper register.

Fragmentary; about one-quarter of the lower part and three-quarters of the upper part of the body are missing. Condition of glass good; many bubbles and imperfections.

H (extant), 0.132m. D, 0.163m.

Inscription: probably in the name of 'Imad al-Din Zangi, Atabeg of Mosul and Aleppo (A.D. 1127–46).

BIBLIOGRAPHY: Lamm (1930), Tafel 42, 4; L. A. Mayer, 'A Glass bottle of the Atābak Zangi', *Iraq*, VI (1939), p. 101f. and fig. 1, who argues convincingly in attributing the inscription to the reign of Zangi I; Basil Gray, 'Gold painted glass under the Seljuqs', *Atti del Secondo Congresso Internazionale di Arte Turca*, Naples, 1965, pp. 144ff., pl. LXXIV, figs. 1a–b.

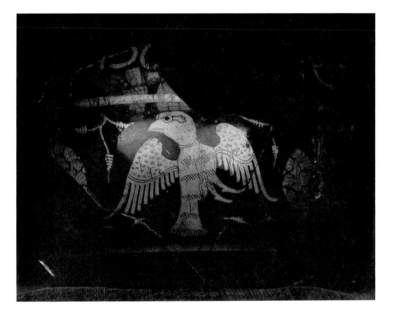
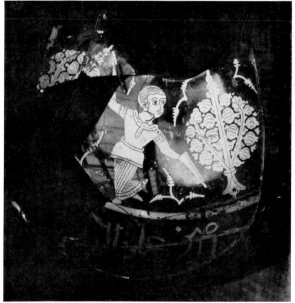

151

E. ENAMELLED AND GILDED GLASS

152. Beaker

Or. Dept. 79.5–22.68 / About A.D. 1250 / Syrian: found at Quft (Koptos) in Upper Egypt / Purchased.

Colourless with amber tinge. Outsplayed mouth; side tapering slightly to pad base; pontil-mark. Outside decorated with fishes and eels of which the outlines and inner details are painted in red and each gilded overall.

Intact; condition of glass good; blowing spirals and bubbles.

H, 0.11m. D (rim), 0.071m.

BIBLIOGRAPHY: Lamm (1930), Tafel 138, 1.

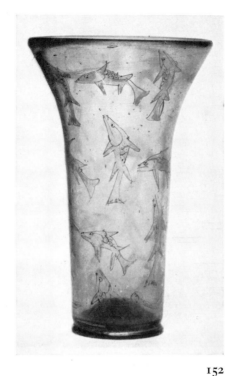

152

153. Pilgrim Flask

Or. Dept. 69.1–20.3 / About A.D. 1250–60 / Syrian / From a collection in Wurzburg / Presented by the executors of Felix Slade.

Colourless with brownish-yellow tinge. Low neck on body which is piriform with one side hemispherical and the other flat; two loop handles joining neck and shoulder. Kick in base; prominent pontil-mark. Painted in blue, three shades of red, green, yellow, white and black enamels and gilding.

On flat side of body: within a circle an eight-pointed star, the arms outlined in blue; on a gilded scrolling ground; within the star, a circle with long lanceolate leaves radiating from the circumference to the centre, gilded.

On the front: within a six-lobed cartouche and surrounded by gilded scrolls with terminals in the form of human and animal heads, two polylobed cartouches interlaced, outlined in broad red bands and with gilded arabesque scrolls within.

On left side: above a roundel containing a seated female figure playing the harp on a blue ground, a horseman thrusting with spear, accompanied by a hound; a hare between the horse's feet; herons, one red, the other blue, flying overhead. The horse is bay; the saddle red, green and gold. The rider is dressed in cloth of gold, with white hose and blue hat; around his neck a blue scarf blown by the wind.

On right side: above a roundel containing a seated male figure drinking, a horseman thrusting a spear, with animals as on left side. To the top left, a flowering tree. The horse is white; the rider dressed in cloth of gold, with green lining, turban of red and white stuff, black hose. The saddle is red and gold.

Intact; much of the gilding in the lower areas of the vessel has worn away.

H, 0.23m. W (max.), 0.213m.

BIBLIOGRAPHY: Lamm (1930), Tafel 126, 18.

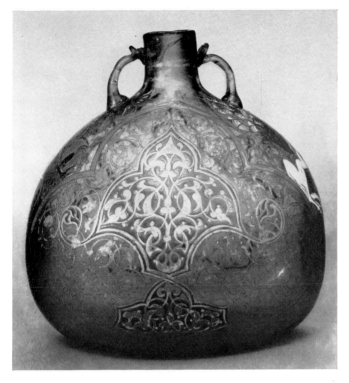

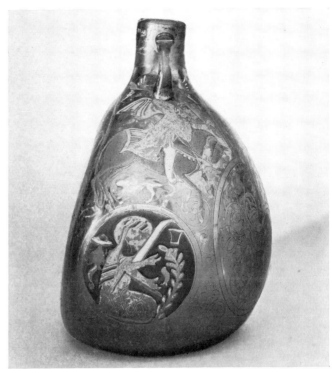

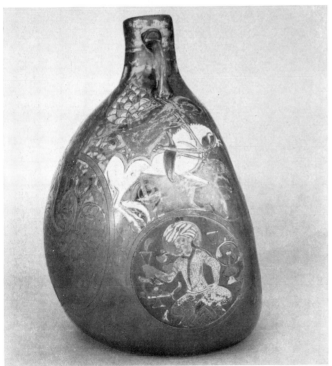

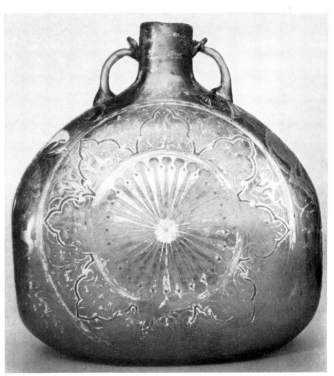

153

154. Footed Bowl

Or. Dept. 1924.1–25.1 / Early 14th century A.D. / Syrian: acquired in China / Given by Mrs. Spier in memory of her husband Julius Spier through the National Art-Collections Fund.

Colourless with brownish-yellow tinge. Thickened and rounded rim; side curves outwards and inwards to stem which is decorated with a trail of similar glass drawn in waves around its middle. Outsplayed foot with outward folded rim. Painted in blue, red, green, yellow and white enamels and gilding.

On side: between friezes of floral scrolling reserved in gold on blue, a band of Arabic inscribed in *naskh* script in blue against spiral leaf scrolls in white, red and green interrupted at four points by a roundel containing a lotus reserved in blue and a circular framing band of *naskh* in gold.

On under-side of body: four roundels each with a lotus painted in red, green and white on a ground of gold scrolls; scrolling arabesques in upper and lower borders and in the spaces between the roundels.

At top and bottom of stem: bands of pseudo-Arabic characters in green.

On upper face of foot: phoenixes, flowers and foliage, all outlined in red only.

Intact; blowing spirals prominent; many bubbles; faint slanting impressions; pontil-mark.

H, 0.293m. D (mouth), 0.165m. D (max.), 0.293m.

BIBLIOGRAPHY: *National Art-Collections Fund, Twenty-First Annual Report*, 1924 (London, 1925), p. 31, no. 472, with facing photographic reproduction.

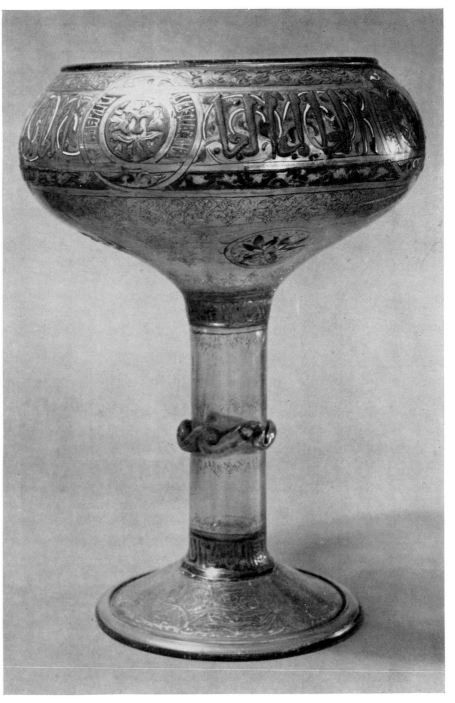

154

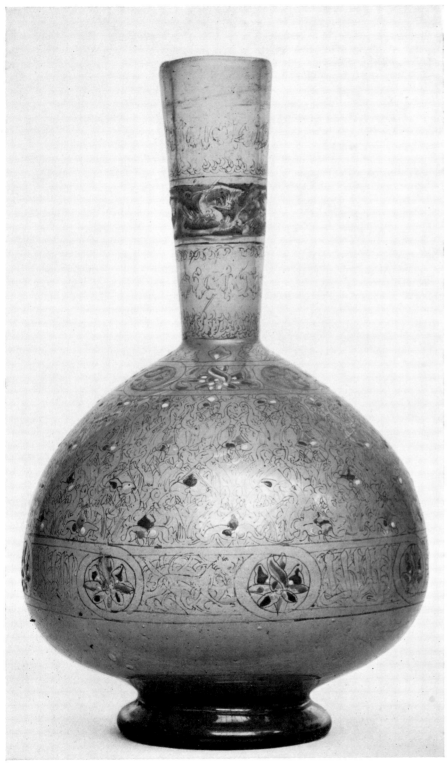

155

155. Flask

Or. Dept. S 334 / About A.D. 1330–40 /
Syrian: obtained at Naples / Bequeathed
by Felix Slade.

Colourless with brownish-yellow tinge.
Long neck, slightly funnel-shaped; piri-
form body; pushed-in base-ring. Painted
in blue, green, red, yellow and white
enamels and gilding.

On neck: around middle, a band of
birds and flowers in red outlines on a
blue ground; above and below, bands of
indeterminate ornament in red outlines.

On body: below shoulder, within a
roundel a 'lion passant' repeated three
times, lotus flowers in interspaces; a
lower band of eight lotus flowers each in
a roundel and in the inter-spaces, the
word al-'alim (the Wise) inscribed in
naskh and a feline creature walking to
right. Between these two bands, arranged
in three registers, paired birds (herons?)
in red outlines, against floral scrolls, the
buds of which are painted in white, blue
and gold.

Intact; slight surface dulling; blowing
spirals; elongated and spiral bubbles
both in and on the surface of the glass;
pontil-mark on base.

H, 0.275m. D (max), 0.175m.

BIBLIOGRAPHY: Nesbitt (1871), p. 62f.
pl. IX; Lamm (1930), Tafel 180, 3.

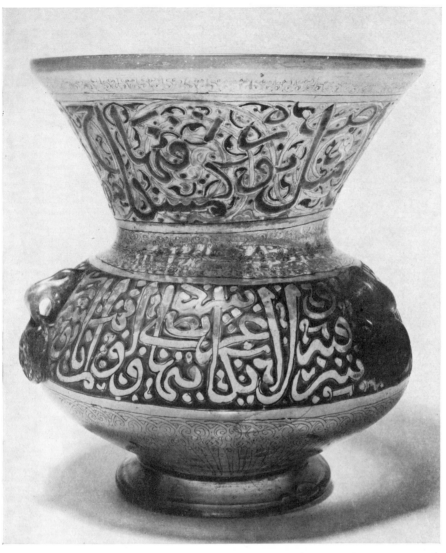

gilded and outlined in red, on a blue ground.

On each of the disks below the suspension rings, gilded *naskh* on a blue ground.

Lower face of body: palmette border with long lanceolate leaves pointing to the base like wheel spokes, in gold.

Intact; metal full of bubbles and impurities; the green and yellow enamels very faint.

H, 0.247m.

Inscriptions: on neck and body: Qur'an, XXIV, 35; on suspension ring disks, dedicatory for the mosque of the mausoleum of the wazir (sāḥib) Taqī al-Dīn.

BIBLIOGRAPHY: Lamm (1930), I, p. 427, no. 4.

156

156. Mosque Lamp

Or. Dept. 75.7–17.1 / About A.D. 1300–40 / Syrian: found in Damascus / Given by A. W. Franks.

Colourless with faint yellowish tinge. Rounded rim; outsplayed neck; side slopes outward and then sharply inward to low foot with pushed-in base which has pronounced kick and pontil-mark. Three suspension rings trailed on upper part of body, each with a thick pendant disk. Painted on outside in blue, red, white, green and yellow enamels and gilding.

On neck: wide band of *naskh* in blue on a scrolling ground in blue, red, green, yellow and white; above, a palmette border gilded with red outlines.

At junction of neck and body: a band of interlacings and knots framed above and below by palmette borders similar to that below the rim.

Upper face of body: band of *naskh*

157. Mosque Lamp

Or. Dept. S 333 / Middle 14th century
A.D. / Syrian / Bequeathed by Felix
Slade.

Colourless with yellowish tinge; six sus-
pension rings trailed on body; low
pushed-in base. Painted on outside in
red, blue, black, white, green and yellow
enamels and gilding.

On neck: band of *naskh* in blue on a
scrolling ground interrupted at three
points by a blazon: upper field red, on a
self-coloured middle field a red cup,
lower field black—within a circular band
of floral scrolling. Around base of neck,
outlined in red only, a procession of
flying birds interrupted by roundels con-
taining alternately a lily and a floral
arabesque.

On upper face of body: broad band of
naskh on a scrolling ground reserved in
blue.

On lower face of body: three blazons
with framing bands of scrolling reserved
in blue alternating with three roundels
of arabesque scrolls reserved in blue;
lotus blossoms in interspaces.

Intact; many bubbles and impurities;
patches of surface dulling on inside of
neck. Green and yellow enamels badly
fired.

H, 0.35m.

Inscriptions: on neck, Qur'an, XXIV, 35,
opening; on body: dedicatory for Saif
al-Dīn Shaikhu 'l-'Umari, a prominent
Mamluk amir (died A.D. 1357).

BIBLIOGRAPHY: Nesbitt (1871), p. 61f.
pl. VIII; Lamm (1930), p. 451, no. 92;
Mayer (1933), p. 204, no. 5.

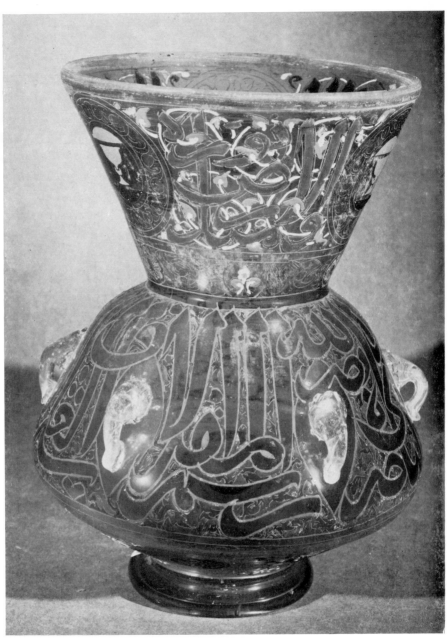

157

158. Mosque Lamp

Or. Dept. 69.6–24.1 / About A.D. 1330–45 / Syrian / From the collection of Lord Ashburton; and exhibited South Kensington Loan Exhibition, 1862 / Presented by the executors of Felix Slade.

Colourless with yellowish tinge. Six suspension rings trailed on body; tall splayed foot. Painted in red, blue, white, yellow and green enamels and gilding.

On neck: between borders of flying birds in scrolls outlined in red only, a broad band of *naskh* in blue on a scrolling ground of white and red, interrupted at three points by a blazon: a pointed shield, on red field, a gold eagle above a gold cup.

On upper face of body: around shoulder, a border of cusped arcades each containing a palmette scroll and in the spandrels flying birds on a scrolling ground. Below, a broad band of *naskh* and scrolling in gold on a blue ground.

On lower face of body: blazon (three times) lotus blossom reserved in blue (three times); arabesque scrolls in interspaces. Below, a border of flowers.

On foot: band of *naskh* between floral borders.

Intact; slight dulling of inside surface; blowing spirals especially on neck; green and yellow enamels deteriorated.

H, 0.33m.

Inscriptions: on neck: Qur'ān XXIV, 35; on body: dedicatory for Saif al-Dīn Tuquztamur al-Hamawī, an important amir of Sultan Muḥammad b. Qalāūn (died A.D. 1345); on foot: al-'alim (the Wise), repeated.

BIBLIOGRAPHY: Lamm (1930), p. 445; Mayer (1933), p. 236, nos. 2 and 3.

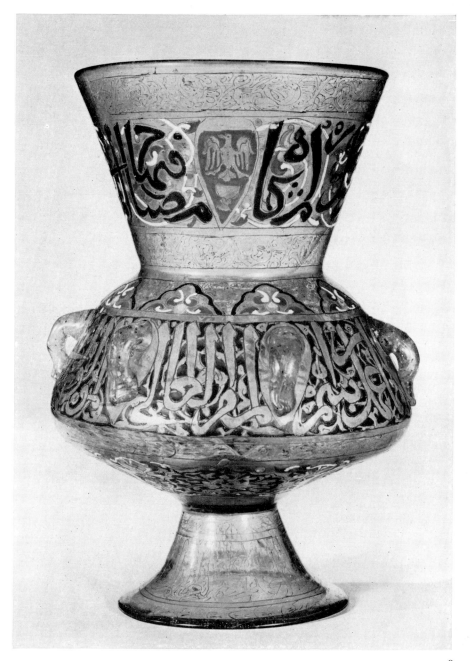

158

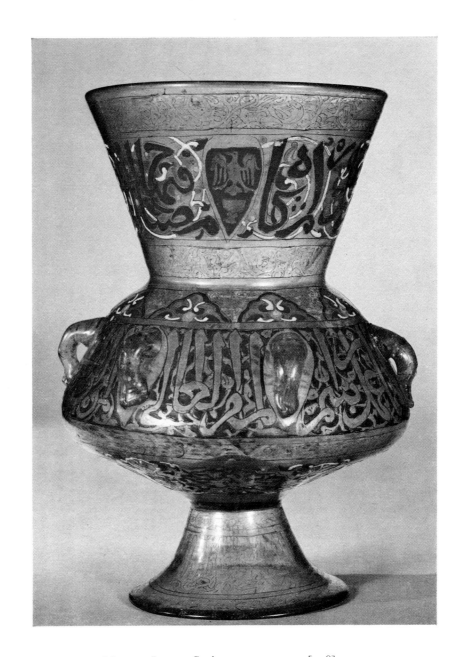

PLATE IV: Mosque Lamp. Syrian. A.D. 1330-45 [158]

159. Mosque Lamp

Or. Dept. 81.9–9.3 / About A.D. 1350 /
Syrian / Presented by A. W. Franks.

Colourless. Rounded rim; high out-
splayed neck; six suspension rings on
body; tall splayed foot: pronounced
pontil-mark. Painted in blue, red, white
and green enamels. Neck, body and foot
decorated all over with lotus blossoms
and foliage. Three roundels on neck and
three on under-side of body, each con-
taining an arabesque in red, blue, white
and green.

Fractures on neck; one small piece
below rim missing and restored in plas-
tic. Surface dulling; many bubbles and
impurities. Green enamel badly deterior-
ated and barely visible.

H, 0.38m.

BIBLIOGRAPHY: Lamm (1933), I, p.
454, no. 11.

159

160

160. Dish

Or. Dept. 89.5–7.11 / 16th century A.D. / Persia or Transoxiana / Presented by A. W. Franks.

Brownish-yellow glass. Rounded rim from which side curves inward to rounded base. Painted on inside with cobalt, turquoise, red, white and black enamels and gilding. Below rim, a floral scroll between bands, gilded with red outlines. In centre a winged angel (*parī*) holding a flask in one hand and a stemmed goblet in the other.

Intact; bubbles and minute fissures in and on the surface.

D, 0.142m.

BIBLIOGRAPHY: Lamm (1933), Tafel 182, no. 12; A. U. Pope and P. Ackerman, *A Survey of Persian Art* (London, 1939), VI, pl. 1449A; Zaky M. Hassan, *Atlas of Moslem Decorative Arts* (in Arabic) (Cairo, 1956), p. 259, fig. 766.

161

GLASS FROM THE LATER ISLAMIC WORLD

A. PERSIA

161. Sprinkler

Or. Dept. 90.5–17.9 / 17th–18th century A.D. / Persian / Given by A. W. Franks.

Blue. Mouth with long pouring lip drawn upwards; long neck, spirally ribbed, descends sideways and then vertically to spherical body; tubular base-ring. Ribbing obtained apparently by twisting. Pontil-mark.

Intact; condition excellent; many small bubbles.

H, 0.388m.

162

B. INDIA

162. Huqqa Bowl, Gilded

Or. Dept. 1961.10–16.1 / About A.D. 1700 / Indian / Bequeathed by Louis C. G. Clarke.

Green. Low funnel neck with wide projecting collar; spherical body: pontil-mark on centre of shallow kick in base. Gilded decoration; on neck, four poppy sprays; on body, six flowering poppy plants framed above by a border of scrolling flowers between chevron bands and an outer edge of triangular lappets; and below by a scrolling border enclosed by two plain bands.

Intact; small bubbles and imperfections render the glass translucent rather than transparent.

H, 0.191m.

BIBLIOGRAPHY: *BMQ*, XXV (1962), pp. 91–4, pl. XXXVII.

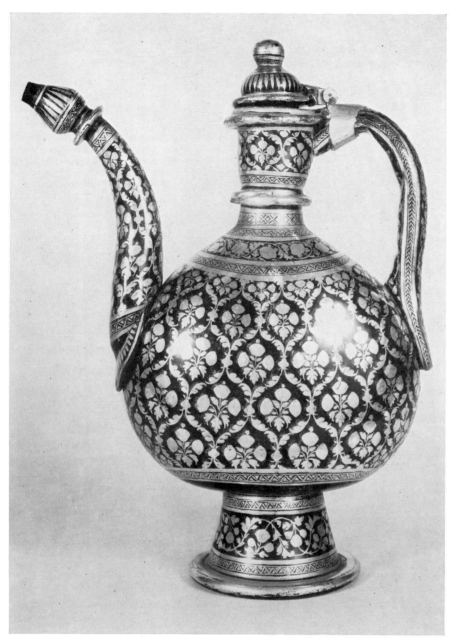

163. Ewer, Gilded

Or. Dept. S 343 / 18th century A.D. / Indian / Bequeathed by Felix Slade, 1868.

Blue. Flattened piriform body; rounded collar at base of neck and another just below rim; dome-shaped lid with ball finial; curved handle joined to top of neck and to body; opposite, a curved spout tapering to a collar above which is the pouring mouth in the form of a bud. High base with true ring. Gilded decoration. On body, a spray of three poppies framed by acanthus leaves arranged in diaper on body, neck and spout; chevron bands and floral scrolls on neck and shoulder, foot, handle and spout. The lid is secured to handle by a metal tongue which swivels on a pin attached to handle by a metal collar.

Intact; small bubbles in glass which tends to opaque.

H, 0.28m.

BIBLIOGRAPHY: Nesbitt (1871), p. 64, pl. XI.

163

164

164. Bowl

Or. Dept. 1940.12–4.108 / 7th century A.D. / Presented by Mrs. B. Z. Seligman from the collection of Professor C. G. Seligman.

Green. Rounded rim; side curves convexly to bottom which has slight kick and pontil-mark. Multiple breaks and a few small pieces missing restored in plaster; opaque greyish-white weathering flaked off in a few places.

H, 0.055m.

165

165. Standing Buddha

Or. Dept. 1938.5–24.285 / About 10th century A.D. / Formerly Eumorfopoulos Collection / Purchased.

Green. Standing figure of the Buddha; front in relief, back plain and flat. Standing on a double lotus, head surrounded by flame halo (*vesika*); right hand holding robe at shoulder height; left hand holding water vessel (*kamandalu*). Top of halo and small part of drapery below left hand missing: almost entirely coated with creamy enamel-like weathering except where this has flaked off on back of halo and on parts of drapery.

Cast in mould.

H (extant), 0.055m.

BIBLIOGRAPHY: R. Soame Jenyns, *Chinese Arts*, *The Minor Arts*, II (London, 1965), no. 72, facing p. 132.

166

166. Lion

Or. Dept. 1938.5–24.301 / 9th century A.D. / Formerly Eumorfopoulos Collection / Purchased.

Colourless. Crouching lion (*shihtzu*) head facing to side; tail curled forwards along back; brocade ball underneath right front paw.
 Small portion of rear missing: surface dulling, patches of whitish weathering. Cast in mould.

L, 0.05m.

B. MING AND CHING PERIODS

167

167. Vase

Or. Dept. SL 1696 / Late 17th to early 18th century A.D. / Sloane Collection.

Opaque and partly translucent, red with mottling of various shades of yellow. Hexagonal in section; slightly flaring neck with rounded collar where straight side slopes outwards and then curves to pad base, flat and also hexagonal in section.
Mould-blown.
Intact; minute surface fissures and pittings.

H, 0.162m.

BIBLIOGRAPHY: R. Soame Jenyns, *Chinese Art, The Minor Arts*, II (London, 1965), no. 81, facing p. 144.

168. Flask, Mould-blown

Or. Dept. 1938.5–24.742 / Late 17th to early 18th century A.D. / Formerly Eumorfopoulos Collection / Purchased.

Translucent indigo. Rim ground square; flaring mouth with three ribbed bands; straight neck slightly funnel shaped; ovoid body; three ribbed bands around base which is flat; pontil-mark ground down. Moulded decoration on body, four rectangular panels, each enclosing a peach.
Intact; crizzling over almost entire surface; patches of silvery grey weathering. Glass is very thick.

H, 0.328m.

BIBLIOGRAPHY: *International Exhibition of Chinese Art, Royal Academy of Arts, London*, 1935–6, no. 2759; R. Soame Jenyns, *Chinese Arts, The Minor Arts*, II (London, 1965), no. 80, facing p. 143.

168

169

169. Flask

Or. Dept. 88.5–15.4 / A.D. 1723–36 / Presented by A. W. Franks.

Opaque turquoise. Rim ground square; long straight neck; body slightly ovoid; pad base with outsplayed profile.
Intact; minute pittings and fissures on surface.

H, 0.222m.

Incised on base, reign mark of Yung Cheng (A.D. 1723–36).

GLASS IN EUROPE FROM THE MIDDLE AGES TO 1862

by Hugh Tait

For this exhibition, a maximum of 100 objects of European glass was agreed upon—a total far too small to embrace the entire chronological story of glass-making throughout Europe from medieval times, but a perfect number with which to 'highlight' the excellence of the best, to underline the imperfections of the poorer, and to convey clearly the five main ways by which the glass-maker sought to alter the appearance and the character of his glass-ware.

Clear glass

All the objects in the first group (nos. 170–92) are made of a clear glass, to which neither gilding, enamelling, nor engraving has been added. Not in every case is the clear glass a truly colourless glass; among the 'primitive' glasses (nos. 170–80), the tinge of brown, grey or green in the glass appears to be due to chemical imperfections rather than to a deliberate intention to create a coloured glass by a scientific recipe. However, the widespread appreciation of the beauties of these tints in the glass throughout the Rhineland, Germany and the Netherlands caused the glass-houses to continue to make vessels in this early primitive *Waldglas* (or 'forest-glass') long after the means of decolourizing it were widely known. Indeed, the Rhenish glass-house that produced, for example, the strange blue-green for a *stangenglas* (no. 175, and cover) soon after 1500 may be suspected of deliberately preferring the green metal and perhaps even of enhancing its tonal strength.

The appeal of these 'primitive' late medieval and Renaissance glasses from Northern Europe lies not only in the subtle tints of the glass but in the unexpected shapes—and occasionally the austere beauty of their proportions and lines. To describe these early 'primitive' glasses (nos. 170–80) as 'undecorated' would, however, be totally misleading, for many are embellished with decorative patterns and ornamental motifs, but all these enrichments are executed without using a different type of glass or a different medium, such as gold or enamelled painting. Perhaps the most complicated of the ten examples in this exhibition is the *stangenglas* (no. 175, and cover) in which the interior is as elaborately 'ornamented' as the exterior.

Very little, indeed, is known about the history of these forest glass-houses of Germany, Bohemia, the Southern Netherlands and England (the Weald of Kent and Sussex), and only very rarely can the productions of a particular locality be identified. This problem is made more difficult by the constant need for fresh sources of wood fuel which caused the forest glass-makers to move on to new areas at frequent intervals. Differences in colour and quality of the glass will, therefore, occur within the productions of a single glass-house in the same period for a variety of purely fortuitous reasons and the absence of documentary pieces of known origin makes the task of classification in this field almost impossible.

In Venice, however, where glass-making had been continuously practised since the end of the 10th century, the Renaissance brought a stimulus that initiated a period of intense development for the Venetian glass industry.

In 1291, the Venetian glass-houses were transferred across the Lagoon to the island of Murano as a safety precaution. During the following 150 years their products included vessel glass but there is a distressing lack of evidence as to its variety or quality and it is generally assumed to have been restricted to

long-neck carafes for wine, jugs with handles and beaker-shaped tumblers for the table. By about 1400, however, the glass industry took on a new life, perfecting a glass material which nearly approached the clarity of a fine geological rock-crystal. Alongside this achievement (often referred to as Venetian *cristallo*—see no. 181), the Venetians discovered the secret of coloured glasses—blue, white, green and purple and turquoise—and, perhaps most important, how to decorate their glass with coloured enamels and rich gilding, using the designs and patterns that were currently popular in the other fields of the decorative arts. Glass rapidly became an important item in the Venetian export trade and the secrets of its making were jealously guarded. Any glass-maker who left the Venetian state was condemned to death *in absentia*, as a traitor. There were privileges to compensate for this restriction on liberty and in consequence the Muranese enjoyed a more democratic system of local government than the Venetians.

One technique, which the Renaissance glass-makers of Murano developed to an incredibly skilful art, was to incorporate opaque-white threads into the substance of their material and work it into patterns of ever-increasing intricacy. This type of glass is called *latticino* or in its most complex forms, *vetro-de-trina*, or lace-glass (nos. 183 and 230). During the late 16th century, glass-makers in Germany, Bohemia, the Netherlands, Spain and England copied Venetian methods and techniques of glass-making as well as the shapes and decorative idioms of the Venetians. Throughout the period of the late 16th and 17th centuries, each of these countries developed its own version in the *façon de Venise*, and, with time and the strong influence of local glass-blowers, the pure Venetian inspiration diminished and a distinctive regional character gave an individual interpretation to the general style. In Germany, the popular tall cylindrical form, or *stangenglas*, was not only made of the clear Venetian *cristallo* glass (no. 222) but was, for example, decorated with bands of *latticino* (no. 182), whilst in the Southern Netherlands, a jug of typical late medieval form was made entirely of broad bands of opaque-white glass (no. 186). The Northern glass-blower's application of coloured glass for the purely ornamental details of a highly individual character can be seen on a *cristallo* goblet of basically Venetian form (no. 185).

After 200 years of domination by Venetian glass, European taste began to react and both in Germany and England an alternative was evolved. In both countries a new type of glass was invented which surpassed the rather horny Venetian soda-lime *cristallo*; in Germany, it was achieved by introducing lime to stabilize the purified potash-glass and the resultant solid clear glass was ideal for wheel-engraving (nos. 243–8); in England, it was achieved by using lead-oxide (nos. 189–92, 241–2 249). By the 18th century the Venetian supremacy in the field of glass-vessel production was vanquished and English glass-making for the first time in history began to occupy a dominant role in the world.

The invention of lead-glass, successfully brought to fruition by George Ravenscroft in London about 1675–76, enabled a very heavy glass with great powers of light refraction to be produced. One of Ravenscroft's earliest lead-glasses to have survived—a serving bottle—can be seen in this exhibition (no. 189) and in 1677 the wholesale price (*not* the retail price) for this pint bottle was 2s. 6d. (which in present-day monetary terms would be appreciably more). The new heavy lead-glass required different handling; the old elegant Venetian shapes were totally unsuitable and so simple sturdy forms became *de rigueur*. But the climate in England (and probably everywhere north of the Alps) was

undoubtedly ripe for a change: in a series of letters written a few years earlier (1667–72), a London glass-seller, John Greene, requested his Venetian supplier, a certain Allesio Morelli, to send glasses of sober forms and 'white sound Meltall'. John Greene even included drawings of the simple forms that he wished the glasses to be made in and these survive with his correspondence in the Department of Manuscripts of the Museum (Sloane MS. 857), a selection of which is illustrated in this exhibition. The monumental simplicity of English lead-glass at the end of the century cannot be demonstrated more effectively than by the giant goblet, which the Circle of Glass Collectors presented to the Museum in 1949 in memory of their founder, John Maunsell Bacon (no. 192).

*Extract from letter dated 'London, September 17, 1669' from John Greene to 'Seni*er *Alleisio Morelli', of Venice*

'. . . parcell redij to send by the first good free ship, then send us 2 or 3 chests or what you can get redij and lett the plaine glasses (as in the Margent) be first made in a redijness for them wee want most espesallj, and also we desire now that noe Looking Glasses be packt in the bottoms of the chests of drinking Glasses, but wee woud have them verij carefully packt in one or two strong Cases as you shall see most Convenient for securitj from danger of Breakidge with the box of false pearle neck Laces with them, and Sr further we desire you to send us Two facterijs, and in one of them to nominate and prize those 18: glasses of 2/4½ silke and those 24 glasses of 14 or 14½ Inches . . .'

SLOANE MS. 857 (*Dept. of Manuscripts*).

Glass with gold decoration

The second group of glasses (nos. 193–204) illustrates the different ways in which the glass-makers sought to enrich the appeal of their products by the application of gold. The gilding of Venetian glasses of the Renaissance has a singularly delicate, granular, almost dust-like, quality, which creates such a beautifully subtle impression that it can effectively provide the sole medium of decoration (no. 194). The Antwerp glass-houses, working in the Venetian style, imitated this technique so successfully that it is difficult to make any distinction in quality, but in many cases the gilding is restricted to a few decorative motifs, like satyr-heads or lion-masks (nos. 196–8), or simply to the rims and the applied circuits (no. 195). The Venetians used this delicate gilding as a ground for the exquisite lettering of an inscription; the letters are simply erased through the gilding (no. 193). The same technique, combined with enamelling, is found on French Renaissance glass (no. 214), which may possibly be the work of an itinerant Venetian glass-worker. In Venice the subtle combination of a sparing use of enamelling and this delicate gilding was extremely popular during the early Renaissance (nos. 209–10) and spread north to Germany (nos. 222–3). The

Venetians also favoured the joint use of bands of *latticino* and granular gilding (nos. 199 and 230)—a partnership which the Venetian glass-maker, Giacomo Verzelini, brought to Elizabethan England (no. 231).

The use of 'unfired'—and hence, easily damaged—gilding at the important glass-house established at Hall (in the Tyrol) in 1534 was misguided (no. 252). Although frequently executed on beautifully coloured glass—and integrated with finely engraved designs—the gilding on few examples has survived in a sufficiently good state to convey the original splendour of these ambitious pieces. The same regrettable error was made by a Netherlandish glass-maker working in the Italianate manner towards the end of the 16th century (no. 253). However, when this gilding is used to delineate the intricate diamond-engraved patterns (no. 232), the effect is most rewarding—and far more lasting.

During the 17th century, relatively few glasses were decorated with gilding; not until the 18th century was the use of gold on glass to return to fashion and find new modes of expression. One technique, the so-called *Zwischengoldgläser*, re-employed a technique essentially similar to that used in the Early Christian glass of the Roman catacombs. This revival (nos. 200–1) seems to have been concentrated in Bohemia at one or two workshops and to have flourished from about 1730 to 1760. In these glasses, the gold-leaf was applied and engraved on the outside of a glass, which had been ground with great precision to enable an outer glass to fit over it 'skin-tight'. The weakness of the technique lay in the need for perfect precision resulting in an airtight fit. Few examples are entirely free of faults on this score. Occasionally, silver-leaf was also used (no. 201) and the addition of ruby or green lacquer occurs on some of the later and more elaborate examples. Towards the end of the century, Johann Joseph Mildner, of Gutenbrunn in Lower Austria, produced an effective variant of the technique (no. 269), cutting away an oval in the outer wall of the glass and inserting a glass medallion, on the reverse of which is the design in gold (or silver).

The Germans during the 18th century favoured the use of gold to decorate their glasses but only very rarely, for special court commissions, was gold applied to the surface of the glass in relief (no. 202). For obvious reasons, constant handling of such a glass would quickly spoil its glory and the highly burnished fired gilding of the Potsdam glass-houses patronized by the Electors of Brandenburg was far more practical and rather more spectacular (no. 203). Frequently the wheel-engraved decoration of the Potsdam glasses is gilded and the overall effect is often little short of ostentatious.

By contrast, the application of gilding to the wheel-engraved decoration on the products of the contemporary Spanish Royal glass-house, at the Palace of La Granja de San Ildefonso, is delicate and elegant (no. 204). There is, however, little about these glasses from La Granja that is truly Spanish, for the factory was staffed by foreign workmen and inspired by foreign styles.

Glass with enamelled decoration

Theophilus, writing in the early 12th century, makes it clear that the technique of enamelling on glass was practised in Europe in his day. Speaking of 'the various colours of opaque glass', Theophilus says: 'One also comes across various small vessels of the same colours, which the French—who are most skilled in this work—collect'. In the following two sections, Theophilus described

how 'the Greeks also make from these blue stones [mosaic tesserae] precious goblets for drinking, embellishing them with gold' and how they 'then take the white, red and green glass, which are used for enamels, and carefully grind each one separately with water on a porphyry stone. With them, they paint small flowers and scrolls and other small things they want, in varied work, between the circles and scrolls, and a border around the rim. This, being moderately thick, they fire in a furnace in the above way. They also make goblets from purple or pale blue, and bowls with moderately wide necks, decorating them round with threads of white glass, and fixing handles of the same glass on them. They also give variety to their different works with other colours as they please'.

However, examples of this work have yet to be identified; only a small group of enamelled glasses, of the same type as the Aldrevandini Beaker (no. 205), has survived. They seem to date from the late 13th or 14th century but whether made in Syria or in Europe has yet to be firmly established.

Not until the middle of the 15th century is there any reliable evidence of European enamelled glass and one of the earliest pieces is in this exhibition (no. 206). Significantly, the enamelling is executed on a sapphire blue glass— not a clear glass. Of far greater competence, the enamelling on an emerald green goblet (no. 207) and on a rare turquoise-blue goblet (no. 208) indicate that, by the end of the 15th century, Venetian craftsmanship in this difficult medium had reached a remarkably high level. By the beginning of the 16th century, coloured glass had given way to clear glass, even for enamelled decoration, despite the fact that it was far better suited to the purpose (no. 213) and the fashion spread to France (no. 214) and Spain (no. 215). In Bohemia and Germany, enamelled clear glass became immensely popular (nos. 219–24) and a group of glasses, which may be of Bohemian or Southern Netherlandish origin, are among the most attractive (no. 216). In the latter group, the use of cobalt blue glass was retained (nos. 217–18) and acts as a vibrant ground for the brilliant enamelled decoration.

In Venice, enamelling on glass passed out of fashion by the end of the 16th century, if not before, but remained a favourite form of embellishment in Germany until the second half of the 18th century. In Nürnberg, for example, a gifted artist, Johann Schaper, who had been trained to paint on domestic window glass, developed (no. 225) a technique of painting on vessels in black (*schwartzlot*), whilst others went on to use red enamel (nos. 226–7). By the 18th century, the *schwartzlot* technique had been brought to a most sophisticated skill in Silesia and Bohemia (no. 228) and many coloured tints were added to the background including patches of yellow stain, produced (as in window glass) with an oxide of silver (no. 229).

At this point, in the middle of the 18th century, enamelling on glass takes on a different character, for it becomes avowedly an imitation of porcelain and is, therefore, to be discussed under the heading of 'opaque-white glass' (nos. 263–8).

Glass with diamond-engraved decoration

Engraving on the surface of a glass vessel with a diamond-point was a technique practised in Italy from the middle of the 16th century (nos. 230, 234) but soon

after became far more popular on glass of Venetian type made in other countries, particularly in the Tyrol (nos. 232 and 252), in England (nos. 231, 233 and 239) and the Netherlands (nos. 235–8). In Holland, during the 17th century, diamond-engraving was especially fashionable as a pastime among amateurs, many of whom were remarkably gifted and skilful (no. 240).

A technique of stippling with the diamond-point came into vogue in Holland during the second quarter of the 18th century and again a number of amateur artists developed this art to the full (nos. 241–2). No doubt suggested by the mezzotint, this technique produced the design on the glass by gently striking the surface with the diamond-point and so grouping the dots ('stipples') that they gradually represent the highlights of the scene or subject depicted. In most, if not all, cases, the glasses used by the Dutch stipple-engravers were of English origin, for the English lead-glass was ideal for this immensely subtle skill.

Glass with wheel-engraved decoration

The technique of wheel-engraved decoration, executed with such consummate skill by Renaissance artists on rock-crystal and other hard stones, demanded a considerable degree of thickness and solidity in the glass. When Bohemia and Germany achieved its new potash-lime glass in the early 17th century, Caspar Lehmann, the Imperial Court Glass and Hardstone Engraver to the Emperor Rudolph II at Prague, figured prominently as the greatest exponent of the new craft. On his death in 1622, his patent was taken over by Georg Schwandhart, the Elder, who founded a brilliant school of wheel-engraving on glass in Nürnberg (no. 243), which continued to flourish until the 18th century.

Among the most prominent Nürnberg engravers are Herman Schwinger (no. 244) and Georg Friedrich Killinger (no. 245), but some less readily recognized engravers of this school may be responsible for the decoration on two ruby glasses in this exhibition (nos. 258–9).

The quality of the engraving at the Brandenburg glass-house in Potsdam was equally high, though no school was founded by its leader, Gottfried Spiller. The Queen Sophia Charlotte Goblet (no. 257) was engraved at Potsdam between 1701 and 1705 and adequately conveys the major characteristics of this Prussian workshop, not far from Berlin.

At the Elector of Saxony's court in Dresden, an accomplished workshop of wheel-engraving was active before the commencement of the 18th century (no. 246) and had much in common with the Silesian and Bohemian schools of engraving (nos. 247–8).

Wheel-engraving on glass became popular in Holland by the beginning of the 18th century and the most prominent engraver there was Jacob Sang (no. 249), a 'Saxon', who worked in Amsterdam and was almost certainly related to Andreas Friedrich Sang, Court engraver at Weimar, whose son Johann Heinrich Balthaser was Court engraver at Brunswick.

No French 17th- or 18th-century school of wheel-engravers on glass existed, but in the middle of the 19th century the French glass industry was transformed and secured for the first time a pre-eminence in the field of glass-making. In consequence, one immensely skilful example, produced by the Clichy factory for the 1862 International Exhibition held in London, is included (no. 250).

Coloured glass

This small group (nos. 251–9), which excludes those coloured glasses with enamelled decoration (nos. 206–8, 217–8), had to be gathered together to solve the peculiar problem of lighting for display.

At the same time, this grouping serves to emphasize the relatively small range of colours deliberately created by glass-makers in Europe from the 15th to 18th centuries. There is no suggestion that, in this small exhibition of 100 pieces, any attempt at comprehensiveness was possible and, indeed, no specimen of the Venetian 'marbled' glass of the 15th century or French 'pebbled' glass of the 17th century, for example, could be included from the Museum's rich collection. Nevertheless, the tendency in Europe has been to concentrate on the production of colourless glass, even if the next stage has been to cover its surface with decoration of one kind or another.

The Venetians in the Renaissance were able to produce glorious rich colours, particularly blue, green and turquoise (nos. 206–8) and even so-called *millefiori* glass, in imitation of the ancient Roman glass, though the Venetians achieved the effect by embedding the sections of the rod bearing the flower-like patterns in clear glass (no. 251). The Italians took their skill to Hall (in the Tyrol) (no. 252) and to the Netherlands (nos. 253 and 254).

In the seventeenth century, using their different recipes for making glass, the French and the Nürnberg glass-makers introduced a blue colour (nos. 255–6) with very different results. The talented chemist, Johann Kunckel, who directed the new glass-works at Potsdam from 1679, was famous for his discovery of making ruby glass with gold chloride (nos. 258–9) but he is known to have made glass of other colours (no. 257).

Opaque-white glass

Chinese porcelain was known in Italy in the 15th century, if not before, and, indeed, a serious attempt to produce porcelain was made in Florence between 1575 and 1587. Opaque-white glass was undoubtedly made in Venice in the manner of porcelain before 1500 and some rare examples survive (no. 260). During the 17th century, few attempts to make a pure white glass seem to have been made north of the Alps, and examples of an opaline or bluish-white glass (nos. 261–2), almost certainly of German origin, are equally rare before 1700.

With the universal admiration of porcelain throughout the 18th century, opaque-white glass with enamelled decoration executed in slavish imitation of porcelain became immensely popular in Venice (nos. 264–5), in Germany and Bohemia (nos. 263 and 268), and in England (nos. 266–7).

By the end of the 18th century this fashion, which forced upon glass a complete denial of its fundamental nature, its translucency, had fortunately died and glass could return to a truer role.

NOTE: All the items in this section (nos. 170–269) are from the Department of British & Medieval Antiquities. A different form of catalogue entry has been used for this later material, none of which has been excavated.

A. CLEAR GLASS

170. Cup

So-called 'Maigelein', of simple form, with sides tapering outwards until near rim; the base with a high kick. Green glass of the primitive forest glass-house type; mould-blown in a pattern of nodular spirals, the upper edge left free.

H, 6cm. D, 7.5cm.

Reg. no. 75, 3–5, 2.

Probably Rhineland, 15th century / Found at Frankfurt-on-the-Main in 1872 / Presented by John Evans, Esq., F.R.S., 1875.

BIBLIOGRAPHY: Rademacher (1933), p. 94f., pl. 22–4; E. Schenk zu Schweinsberg, *Führer durch das Bischöfliche Diözesan-Museum zu Limburg an der Lahn*, Limburg (1962), no. 64, p. 9, pl. 12; Klesse (1963), no. 67–9; Bremen (1964), pp. 227–37, figs. 56–67; R. Chambon and F. Courtoy, 'Verres de la fin du Moyen Âge et de la Renaissance aux Musées de Namur', *Annales de la Société archéologique de Namur*, xlvi, no. 4, p. 109, pl. Id.

170

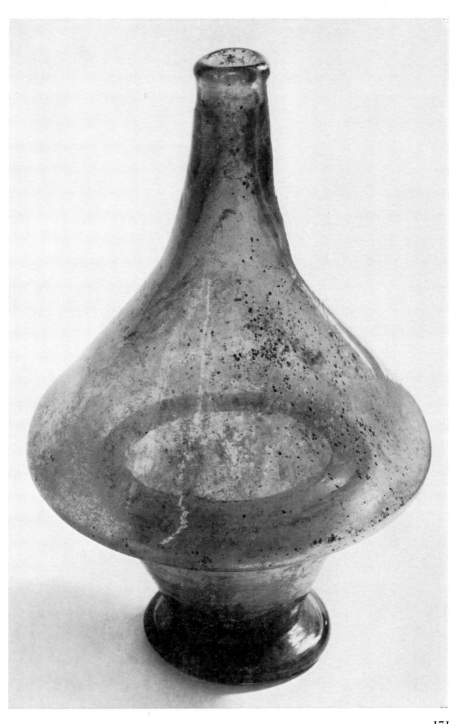

171

171. Bottle

Double conical form; thick yellow-green glass of the primitive forest glass-house type.

H, 17.9cm.

Reg. no. 73, 5–2, 214.

Probably Rhineland, late 15th century /

Found in building a railway near Bingerbrück, Rhenish Prussia / Presented by the executors of the late Felix Slade, Esq., F.S.A., 1873.

BIBLIOGRAPHY: Rademacher (1933), p. 71f., pl. 16; Klesse (1963), no. 59; Bremen (1964), pp. 346–7; Klesse (1965), no. 34, p. 100, pl. 34.

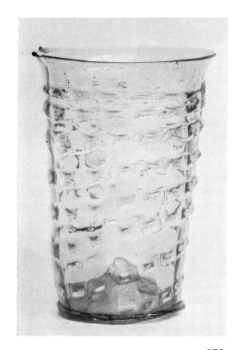

172

172. Beaker

With slightly everted rim, high kick in base and an applied foot-ring; rose-greyish glass of the primitive forest glass-house type. The base and sides ornamented with an uneven chequered, spiral-trail.

H, 9.6cm.

Reg. no. 1958, 5–3, 1.

Probably Southern Netherlands, mid-16th century / Said to have been found about 1800 bricked up in the wall of a house in Culross, Scotland / Part-gift of R. H. A. Adams, Esq., 1958.

BIBLIOGRAPHY: Tait (1967), p. 94f., figs. 2–3.

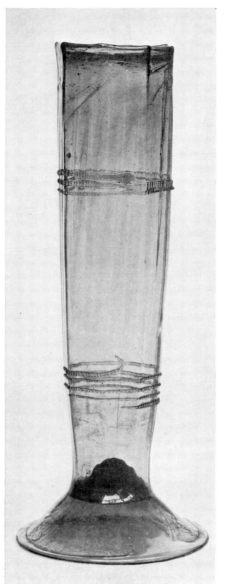

173

173. 'Stangenglas'

Tall, cylindrical, very slightly tapered, becoming octagonal and vertically ribbed in the upper part; ornamented with two spiral bands of milled glass thread, the upper comprising two and one-half circuits and the lower four circuits; on a short spreading foot. The glass, amber-green in tint, is of the primitive forest glass-house type.

H, 20.5cm.

Reg. no. 69, 1–20, 6.
Probably Southern Netherlands, 16th century / Presented by the executors of the late Felix Slade, Esq., F.S.A., 1869.

BIBLIOGRAPHY: Hartshorne (1897), p. 68, fig. 101; Schmidt (1926), no. 39, p. 18; Kestner-Museums (1957), no. 33, p. 52, pl. 11; Klesse (1963), no. 110; Bremen (1964), no. 108a, p. 7; A. E. Liederwald, *Niederländische Glassformen des 17. Jahrhunderts* (dissertation), Freiburg-am-Breisgau (1964), p. 81f.; Tait (1967), p. 95, fig. 2.

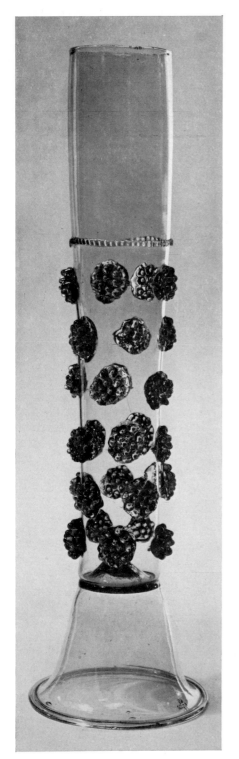

174. 'Stangenglas'

Green glass of the primitive forest glass-house type; tall cylindrical form tapering slightly, ornamented with six horizontal rows of raspberry prunts beneath a single milled ring and above a high bell-shaped foot-base with folded rim; each row consists of five prunts arranged in a diagonal alinement.

H, 28.8cm.

Reg. no. 69, 1–20, 14.

Southern Netherlands or Rhineland, late 16th or early 17th century / Presented by the executors of the late Felix Slade, Esq., F.S.A., 1869.

BIBLIOGRAPHY: Bremen (1964), no. 105, p. 282, pl. 105; B. de Neeve, 'Decorative Arts Department at the Boymans-van Beuningen Museum', *Apollo*, lxxxvi, no. 65 (July, 1967), p. 26f., fig. 1.

NOTE: A very similar specimen complete with a cover is preserved in the Victoria and Albert Museum (Reg. no. 5320–1901), and is published in W. A. Thorpe, 'The Aesthetics of Flint', *Apollo Annual*, 1948, p. 83, fig. II.

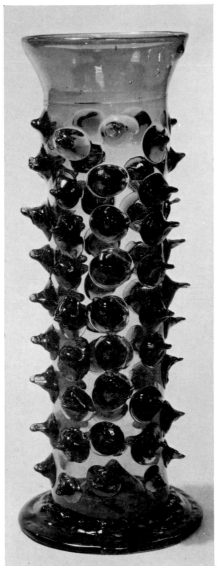

175. 'Stangenglas'

Tall cylindrical vessel on a pierced foot. Externally, the bowl decorated with eight vertical rows each of nine prunts below a thin thread circuit. Internally, there are eight rows of seven prunts. The glass, dark blue-green, is of the primitive forest glass-house type.

H, 26cm. D, 8.1cm.

Reg. no. S 875.

Probably Rhineland, early 16th century / Bequeathed by Felix Slade, Esq., F.S.A., 1868.

BIBLIOGRAPHY: Nesbitt (1871), p. 148, fig. 244; Rademacher (1933), p. 121, pl. 51b; A. E. Liederwald, *Niederländische Glasformen des 17. Jahrhunderts* (dissertation), Freiburg-am-Breisgau (1964), p. 79.

174

175

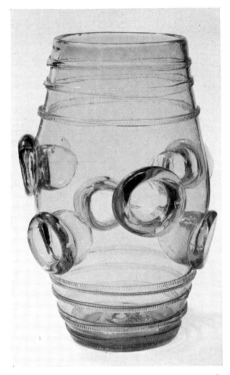

176

176. Drinking Vessel

Green glass, barrel-shaped with six finger grips arranged horizontally in two rows around the middle with three circuits of milled threading above and four below.

H, 20cm.

Reg. no. 70, 2–24, 8.

Germany or Netherlands, 17th century / Presented by the executors of the late Felix Slade, Esq., F.S.A., 1870.

BIBLIOGRAPHY: Buckley (1939), no. 335, pl. 111; *Strauss, Exhibition* (1955), no. 95, p. 40; Corning Museum (1958), no. 54, p. 62; Schrijver (1961), pl. 12c; Klesse (1963), nos. 115–19.

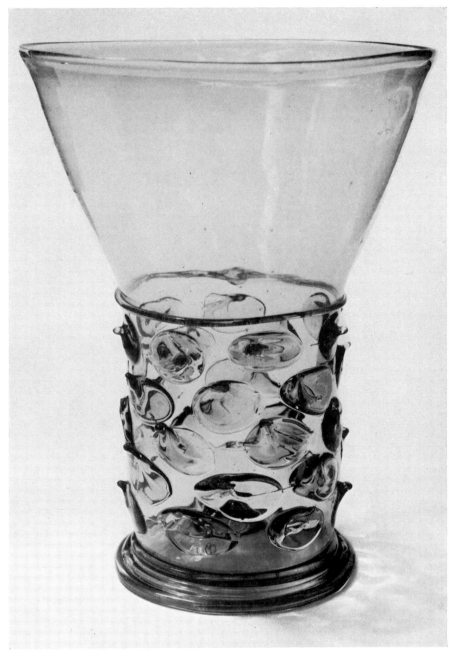

177

177. 'Berkemeyer'

A green glass conical bowl continuing into a cylindrical stem on a short coil-wound foot; the stem ornamented with five staggered horizontal rows, each of seven prunts, beneath a thread circuit at the junction of bowl and stem.

H, 20.7cm. D, 16cm.

Reg. no. 69, 1–20, 7.

Netherlands or Rhineland, 16th–17th century / Presented by the executors of the late Felix Slade, Esq., F.S.A., 1869.

BIBLIOGRAPHY: Buckley (1939), no. 344, p. 113, *Catalogus van nord- en zuidnederlands glas*, Gemeentemuseum den Haag (1962), no. 60, p. 43; R. Chambon and F. Courtoy, 'Verres de la fin du Moyen Âge et de la Renaissance aux Musées de Namur', *Annales de la Société archéologique de Namur*, xlvi, no. 15, p. 115, pl. IVd; Klesse (1963), nos. 87, 99; Bremen (1964), pp. 320ff.

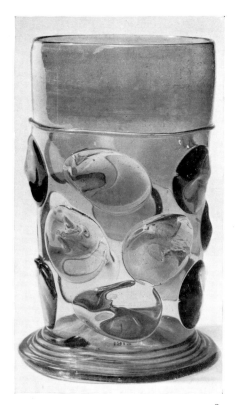

178

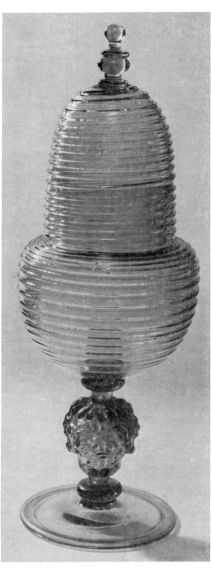

179

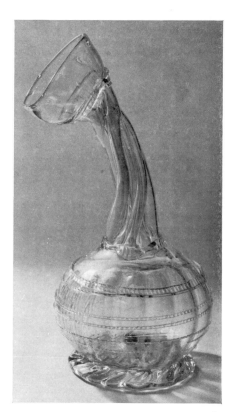

180

178. Beaker

On a low coil-wound foot, a cylindrical body of green glass enriched with three staggered horizontal rows, each consisting of three flattened prunts, below a thread circuit; above the thread circuit, a diamond-point inscription in Dutch: 'Onz Ouders over hondert jaer, Die maeckten deze Back wel klaer. 1648.' (Our ancestors, about a hundred years ago, made this vessel. 1648.)

H, 15cm. D, 8.5cm.

Reg. no. 1912, 11–6, 1.

Rhineland or Netherlands, first half of the 16th century / Purchased, 1912.

BIBLIOGRAPHY: Rademacher (1933), pls. 43c, 45d; R. Chambon and F. Courtoy, 'Verres de la fin du Moyen Âge et de la Renaissance aux Musées de Namur', *Annales de la Société archéologique de Namur*, xlvi, no. 16, p. 115, pl. Va; *Sotheby and Co. Sale Catalogue*, 10 November, 1938, lot 87, formerly in the Wurfbain Collection, Rheden, near Arnhem, Holland; Bremen (1964), no. 107, p. 285.

179. Covered Goblet

Most unusual acorn-like shape; the globular portion of the bowl is coil-wound, as is the beehive-shaped cover; a lion-mask stem and plain foot with a narrow fold; the whole grey in tint.

H, 23.5cm.

Reg. no. 80, 6–17, 6.

Netherlands, late 16th–early 17th century / Sale of E. W. Cooke, R.A., Christies, 15 June, 1880, lot 64 / Purchased, 1880.

BIBLIOGRAPHY: C. Jackson, *History of English Plate*, II, London (1911), p. 662, fig. 871; Hugh Tait, 'The Stapleford Gold Acorn Cup', *BMQ*, xxi, no. 2 (1957), p. 51, pl. xv.

NOTES: The acorn shape seems to be a reflection of forms used in metalwork and may be compared to the Stapleford Gold Acorn Cup and the Westbury Cup, both of English origin.

180. 'Kuttrolf'

Vertically ribbed globular body of colourless glass on a frilled foot. The body ornamented with an encircling milled spiral-thread of six circuits. Neck of four tubes around a central tube, twisted and bent, terminating in a triangular mouthpiece.

H, 20cm.

Reg. no. 1925, 2–18, 3.

Germany, 17th century / Purchased, 1925.

BIBLIOGRAPHY: Rademacher (1933), p. 60f.; Klesse (1963), nos. 112–14; Bremen (1964), p. 357; Klesse (1965), no. 54, p. 112, pl. 54.

181. 'NEF' EWER

Colourless glass; bowl in form of boat with a spout forming a prow; stem consists of a large ribbed knop above a wide trumpet-shaped foot. The decoration of the bowl consists of a spiral of twelve clear glass thread circuits, which extend half-way up the side, over which are applied four small blue, strawberry prunts and a clear glass boss in the centre on either side, the centre of which bears a satyr's mask in relief; a fifth blue strawberry prunt is applied to the base of the spout; pincered lattice work of blue and clear glass forms the 'rigging' or superstructure of the nef, both forward and aft, the latter surmounted by a dolphin with eyes and fins in pale blue glass.

H. 34.3 cm.

Reg. No.: 55, 12–1, 197.

Venice, attributed to Ermonia Vivarini, 16th century. / Purchased at the Sale of the Coll. of Ralph Bernal, M.P. in 1855.

BIBLIOGRAPHY: Bernal Collection (1857), p. 328, No. 3299; Chambon (1955), p. 311, Pl. VI, Pl. O, a; Gasparetto (1958), p. 96, Pl. 72; Mariacher (1961), p. 32f., pl. 50.

NOTES: The creation of particularly grand objects for the table in the form of a ship was a late Medieval invention and a number of examples in silver-gilt ranging from 15th-18th centuries have survived. The form has earned them the designation, *nef*—see C. C. Oman, *Medieval Silver Nefs* (1963).

A glass vessel of very similar design was presented to the Emperor Charles V (1500-1558), when he visited the glasshouses of Beauwelz, near Mons (Belgium) in 1549 but only survives in the form of a sketch within the pages of the introduction to the *Catalogue Colinet* of 1555; in the *Journal d'Amand Colinet* under the year of 1574, there is a sketch of another similar example. There is good evidence, therefore, that among the glass in the *façon de Venise*, which was made at Colinet's glasshouse at Beauwelz in the 16th century, glass *nefs* of the Venetian type were made, though probably only as special commissions.

182. 'STANGENGLAS'

Cylindrical, clear glass with a slight grey tinge; the high foot striped with plain bands of opaque-white glass; the lower part of the body ornamented with applied vertical opaque-white ribs above which are two applied horizontal bands of *latticino*, each bordered by a thin opaque-white thread circuit.

H, 30.2cm.

Reg. no. 1855, 12–1, 154.

Germany, late 16th century / Purchased at sale of collection of Ralph Bernal, M.P., in 1855.

BIBLIOGRAPHY: Bernal Collection (1857), p. 301, no. 2942; Schmidt (1914), no. 16, p. 12; Schmidt (1926), no. 16, p. 12.

NOTES: The term, *latticino*, is used to denote a technique by which 'threads' of

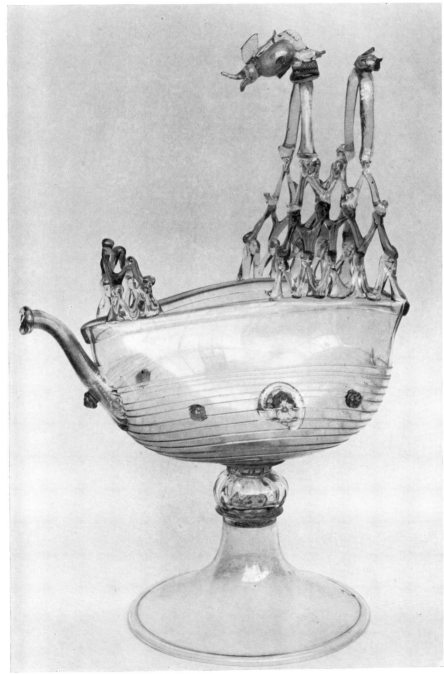

181

opaque-white glass are embedded in the clear glass and formed into intricate patterns. This technique was especially popular among the Venetian glass-makers and the more complex designs were called *vetro de trina* or lace-glass.

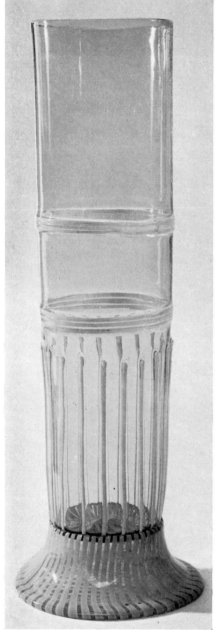

182

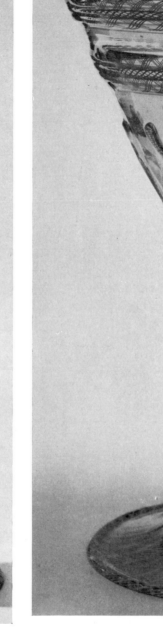

183

183. Goblet

Colourless glass having a funnel-shaped bowl, resting on a knop and bell-foot; below the rim, two raised horizontal bands of *latticino*; beneath, six elongated vertical loops forming a network in applied *latticino* canes. The knop and foot are executed in the intricate *latticino* technique called *vetro de trina* or lace-glass.

H, 24cm. D, 15.6cm.

Reg. no. S 637.

Venice or S. Netherlands (*façon de Venise*), late 16th century / Bequeathed by Felix Slade, Esq., F.S.A., 1868.

BIBLIOGRAPHY: Nesbitt (1871), p. 114.

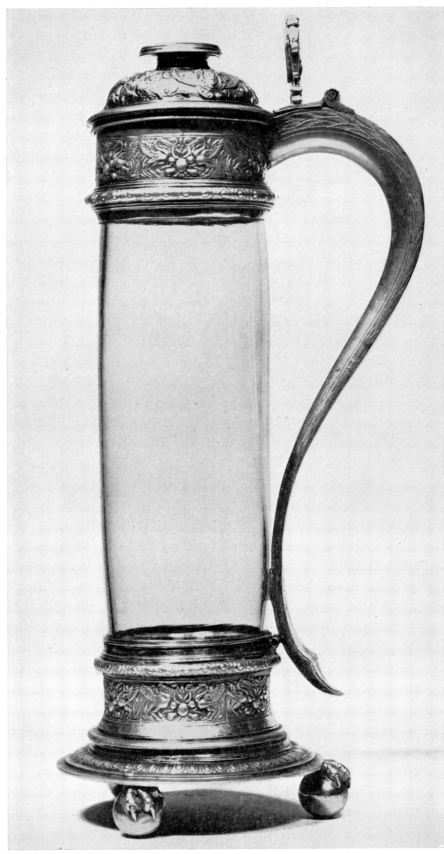

a standing figure of Justice. The mounts at top and bottom are ornamented with repetitions of oblong stamps with pairs of cranes fighting; three ball-and-claw-feet; beneath the foot is engraved a lily.

H, 21.3cm.

Reg. no. Æ. 3134.

Probably Verzelini's glass-house in London, about 1575 / Formerly in the Collection of Mr. Arthur Maitland Wilson, Stowlangtoft Hall, Suffolk / Franks Bequest, 1897.

BIBLIOGRAPHY: Sir Hercules Read and A. Tonnochy, *Catalogue of the Silver Plate . . . bequeathed to the British Museum by Sir Augustus Wollaston Franks, K.C.B.,* (1928), no. 25, p. 11, pl. XVII; Hartshorne (1897), p. 164, pl. 26; C. Jackson, *History of English Plate,* vol. II, London (1911), p. 777, fig. 1010; Hugh Tait, The 'Stonyhurst' Salt, *Apollo,* lxxix (April, 1964), pp. 270f., fig. 15.

NOTES: William Cecil (1520/1–98), created 1st Lord Burghley 1571, installed a Knight of the Garter in 1572, Lord High Treasurer and Chief Minister of Queen Elizabeth I, 1572–98.

The enamelled coat of arms on the cover is encircled by the Garter and consequently dates from after 1572. The Frenchman, Jean Carré, who was granted a Royal licence to manufacture glass in England in 1567, was buried at Alfold, in the Weald, on 25 May 1572; he is unlikely to be the author of this piece.

The Venetian glassmaker, Jacopo Verzelini (1522–1606), is thought to have arrived in England from Antwerp in 1571 or soon after, but was not granted a royal privilege for glassmaking until 15 December, 1575. In the following year he was granted papers of denization and remained in England until his death in 1606.

The glass tube may have been a very early piece made by Verzelini to demonstrate his craft to Lord Burghley and may, therefore, date from the period 1572–75.

The final form of the piece resembles contemporary tall narrow tankards of silver and hard stone. Rock-crystal, cut into cylindrical form, was a popular material for use in secular silver plate and this version in glass may have been made by Verzelini to rival these more traditional pieces.

187

188. Beaker

Mould-blown, clear glass with pale greyish tinge and filled with bubbles; of octagonal form tapering inwards to a circular base; three loops applied to the middle of the sides, each decorated with a small glass ring (one missing). Lower half of the sides of the vessel ornamented with an arcade of four arches under which are represented: (i) a male and female figure holding hands, (ii) a sun face, (iii) a rampant horse, and (iv) three fleurs-de-lys (the arms of France). Two rows of horizontal ribbing below the rim.

H, 7.2cm. D, 6.5cm.

Reg. no. 71, 6–16, 10.

Probably made by Bernard Perrot at Orléans, France, late 17th century / Presented by the executors of the late Felix Slade, Esq., F.S.A., in 1871.

BIBLIOGRAPHY: J. Barrelet, *La Verrerie en France*, Paris (1953), pp. 75–6, 81f., pl. XLIc.

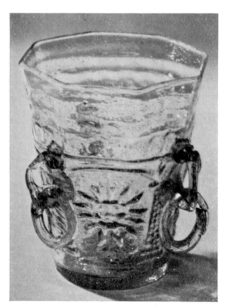

188

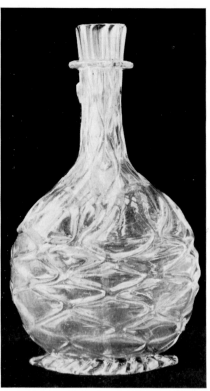

189

189. Serving Bottle

Colourless lead-glass; flattened globular body with a slender neck. On the neck 'nipt diamond waies' and on the body similar decoration on a 'second gather'. On an applied, oval pincered foot-ring. Round the neck is an applied collar, below which is an applied seal on which is represented a moulded inverted raven's head.

H, 20.8cm.

Reg. no. O.A. 110.

George Ravenscroft's glass-house at Henley-on-Thames or at the Savoy, London, about 1677–80; later provenance uncertain.

BIBLIOGRAPHY: Buckley (1925), p. 26f., pl. III, fig. B; Thorpe (1929), p. 166ff., p. 133, pl. X.

NOTES: In May, 1677 the raven's head seal was adopted by George Ravenscroft to distinguish the products of his glass-houses.

On 29 May, 1677, an agreement between George Ravenscroft and the Glass Sellers' Company included a list of types of glasses and the prices at which they were to be sold to the Company—not the retail prices:

Quart bottles all over nipt diamond waies . . . 16 oz . . . 4s. od.
Pint bottles of the same sort . . . 10 ozs . . . 2s. 6d.

The British Museum decanter holds 0.9 of a pint and weighs 11 oz., and clearly is identifiable with the 'pint bottles all over nipt diamond waies' described in the list.

190. Decanter-jug and Stopper

Colourless lead-glass, body sloping outwards from a pincered foot; with 'nipt diamond waies' around base and chain circuit below the shoulder; conical neck with vermicular collar; handle with a single rib and the lower terminal folded back and waved; hollow cover, with a long conical stopper, decorated with

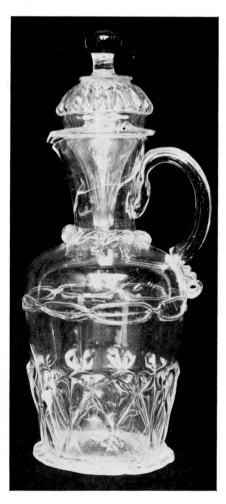

190

184

185. Goblet

Colourless glass, having a funnel-shaped bowl, ornamented with projecting bossed ribs at the lower end, and a spiral-thread running to within an inch of the rim. The stem is a complicated design, composed of a pair of greenish-blue scrolls at right angles to a pair of clear-glass scrolls forming a heart-shape; above the lower knop, three equidistant scrolls terminate in strawberry bosses.

H, 24.3cm.

Reg. no. S 487.

Perhaps Belgium or Netherlands, late 16th century / Bequeathed by Felix Slade, Esq., F.S.A., 1868.

BIBLIOGRAPHY: Nesbitt (1871), p. 90, fig. 140.

184. Horn

Colourless glass, with two applied rings for suspension, each flanked by a crimped thread circuit; a plain narrow band at the wide end, below which is scratched in diamond-point: '1595 21 *Julet*', together with an unintelligible inscription in French. A second diamond-scratched inscription in the middle of the vessel reads: *Nicoles Coels at beu icy à la santé de PDB*'. At the narrow end of the horn, a silver bell and mount with the legend:

QVI × TIENT × Y × BOIT ×
× *A* × 1599 ×

L, 31.5cm.

Reg. no. 55, 12–1, 153.

Probably Southern Netherlands, end of the 16th century. / Purchased at sale of collection of Ralph Bernal, M.P., 1855.

BIBLIOGRAPHY: Bernal Collection (1857), p. 300f., no. 2937; F. Hudig, 'Cristalleyne Drinkhorns', *Oud-Holland*, Aflevering no. 6, pp. 1–5 (with illustrations); Buckley (1929), p. 15, pl. 9; van Gelder (1955), p. 27, pl. XV; Chambon (1955), p. 314, pl. XIII; Klesse (1963), no. 163.

NOTES: A similar piece, also bearing diamond-engraved inscriptions, one of which is dated '8 Febr. 1590' and refers to Renier Cant, ten times Burgomeister of Amsterdam, is preserved in the Rijksmuseum, Amsterdam.

A slightly different piece, decorated with the diamond-engraved portrait of Prince Maurits of Orange-Nassau, is inscribed: 'Mauritius Prins van Oranjien. 1616' (now in Prinsenhof, Delft).

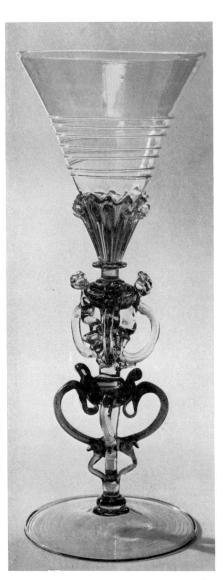

185

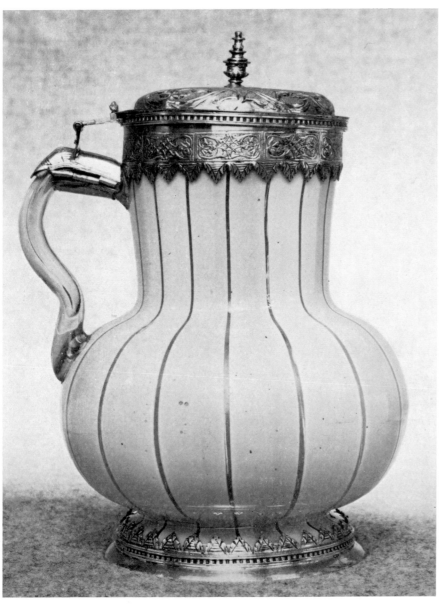

item listed in Queen Elizabeth's Inventory of 1559, repeated in the Inventory of 1574:

'Item oone white glasse with strakes downeright garnishid with silver and guilt with a faulling lidde chasid, sitting ther vpon a boy with a dagger in thone hande and a shilde in thother: poiz with the glass x oz. quart.'

An extant jug of identical glass and shape with silver-gilt mounts bearing London hallmarks for 1546 and the enamelled coat of arms of Sir William Parr, uncle of King Henry VIII's sixth wife, formerly in the Horace Walpole collection at Strawberry Hill, was acquired by the London Museum in 1967.

The shape of both glass jugs is not found among the glass normally ascribed to the Venetian workshops but is a very common form in pottery in north-west Europe in the late 15th–16th centuries. The form is also known in English silver of the mid-16th century. The origin of these two glass jugs is, therefore, probably northern European—not Venetian.

These two glass jugs are the only surviving complete specimens of Continental glass in the *façon de Venise* which can be shown to have reached England before the middle of the 16th century. That both Queen Elizabeth and Sir William Parr possessed examples of this Venetian-type glass specially mounted in silver-gilt may be regarded as evidence of the rarity of such pieces and the esteem in which they were held.

186

186. Jug

With broad vertical bands of opaque white having very narrow lines of clear glass between them; silver-gilt mounts are hallmarked: London, 1548–9.

H, 15cm.

Reg. no. Æ 3133.

Probably Netherlands, first half of the 16th century / Franks Bequest, 1897.

BIBLIOGRAPHY: Sir Hercules Read and A. B. Tonnochy, *Catalogue of the Silver Plate Medieval and later Bequeathed to the British Museum by Sir Augustus Wollaston Franks, K.C.B.*, London (1928), no. 24, p. 10, pl. xvi; *Exhibition of the Royal House of Tudor*, held at the New Gallery, Regent Street, London, 1890, no. 835; C. Jackson, *English Goldsmiths and their Marks*, 2nd edn., London (1921), p. 96 (1548–49); A. J. Collins, *Jewels and Plate of Queen Elizabeth I, the Inventory of 1574*, London (1955), no. 850, p. 437; P. Fox-Robinson, 'The Parr Pot', *Burlington Magazine*, cx (January, 1968), p. 45, fig. 59.

NOTES: This piece is very similar to an

187. Lord Burghley's Tankard

A tube of colourless glass, mounted in silver-gilt. The glass tube is open at both ends and tapers inwards slightly at top and bottom.

The lid is embossed with three masks on wing-like cartouches, with swags of fruit and birds between; in the centre a disk standing free containing a circular medallion enamelled with the arms of Lord Burghley on a crimson ground within a garter; thumb-piece in the form of an escutcheon, having on the inner side an enamelled shield with Lord Burghley's crest; on the outer a vase of flowers; ogee-shaped handle engraved on the flat outer side with linear scrolls and

gadrooning and having a finial with a single knob.

H, 28.3cm.

Reg. no. 1946, 10–11, 1.

English, Ravenscroft period, about 1680–85 / Given by Lady Lister, 1946.

BIBLIOGRAPHY: Thorpe (1929), pls. XVIII, XX; *Circle of Glass Collectors Commemorative Exhibition Catalogue*, Victoria and Albert Museum (1962), no. 121, pl. VIB, lent by the Ashmolean Museum, Oxford; Hugh Tait, 'A Review of Post-Medieval European Glass Acquired since the Outbreak of the Second World War', *BMQ*, xxvii (1963), no. 1–2, p. 31f., pl. XIVa; J. Hayes, *The Garton Collection of English Table Glass*, London Museum, H.M.S.O. (1965), pl. 5; *European Glass*, The Toledo Museum of Art, p. 16 with illustration.

191. Covered Tankard

Colourless lead-glass, partly ribbed ogee cover terminating in ornate finial surmounted by a swan on a crown(?). Later wheel-engraved decoration on the body consists of a swan with the inscription: 'PETER CHRETIEN Novr. the 4, 1789'. Enclosed in the base above the foot, a silver coin of 1709.

H, 35.8cm. (with cover).

Reg. no. 1917, 6–5, 1.

English, early 18th century / Bequeathed by Miss Caroline Chretien, 1917.

NOTE: A similar specimen, but with spout and B-shaped handle repeating the swan finial motif on the cover, was lent to *The International Art Treasures Exhibition* held at the Victoria and Albert Museum, 2 March–29 April, 1962, Cat. no. 515, pl. 277; exhibitor: Howard Phillips, London.

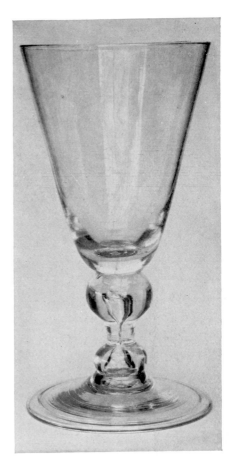

192

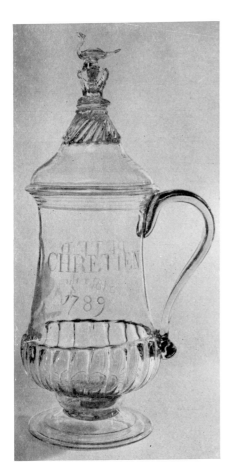

191

191

192. Giant Goblet

Colourless lead-glass, with round funnel bowl on stem composed of two knops, each enclosing an air bubble and supported on a wide folded foot.

H, 30.5cm.

Reg. no. 1949, 4–1, 1.

English, about 1690–1700 / Formerly in the collection of Arthur Kay, Edinburgh / Given by the Circle of Glass Collectors in memory of their founder, John Maunsell Bacon (1866–1948).

BIBLIOGRAPHY: W. King, 'An English Glass Goblet in the British Museum', *Apollo*, xlix (1949), p. 131 and illustration; Hugh Tait, 'Review of Post Medieval European Glass Acquired since the Outbreak of the Second World War', *BMQ*, xxvii (1963), nos. 1–2, p. 32, pl. XIVb.

NOTE: The Circle of Glass Collectors was founded on 27 May, 1937.

B. GLASS WITH GOLD DECORATION

193. Bowl

Colourless glass, having an everted lip, below which is a gilt band with dentillations on its lower edge; the inscription, 'AMOR.VIDVE.FELIX', in fine lettering, is erased through the granular gilding. The lower portion of the bowl has heavy ribbing below a thread circuit, and a high kick in the base; the bowl rests on an applied foot-ring.

D, 15.2cm.

Reg. no. 91, 2–24, 7.

Venetian, early 16th century / Purchased in 1891 at the sale of the Hailstone Collection, lot 463.

BIBLIOGRAPHY: Honey (1946), p. 62, pl. 32c.

NOTE: A similar specimen was recorded in Lord Muncaster's possession in the late 19th century.

194. Goblet

Colourless glass; wide oviform bowl on short stem and narrow foot; granular gilt bands on rims of foot and bowl; the lower portion of the bowl and the knop sprinkled with granular gilding.

H, 12.3cm. D, 9.7cm.

Reg. no. 71, 6–16, 6.

Venice or Southern Netherlands (*façon de Venise*), 16th century / Presented by the executors of the late Felix Slade, Esq., F.S.A., 1871.

BIBLIOGRAPHY: *Trois Millénaires* (1958), p. 139, no. 299.

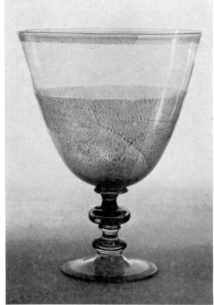

194

195

195. 'Roemer'

Colourless glass; funnel-shaped bowl with granular gilt rim opening into a cylindrical stem; below a milled gilt thread circuit, the stem is ornamented with three bosses with satyr-heads, separated by groups of six prunts, each set with an applied turquoise-blue 'pearl'.

H, 10.7cm.

Reg. no. S 497.

Southern Netherlands, probably Antwerp, second half of the 16th century / Bequeathed by Felix Slade, Esq., F.S.A., 1868.

BIBLIOGRAPHY: Nesbitt (1871), p. 92; A. Barr, 'Verrerie des Flandres, fabrication Anversoise', *La Revue Belge d'Archéologie et d'Histoire de l'Art*, 1938, no. 3, pl. IV (ii), VII (13), IX (15); Chambon (1955), pl. X, no. 38 and pl. IX, no. 36; *Trois Millénaires* (1958), no. 302.

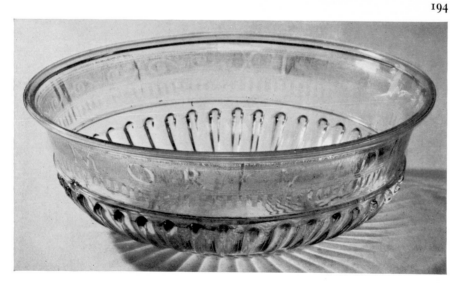

193

196. Large Beaker

Ice-glass; cylindrical form, with everted rim, tapering slightly inwards to base; the middle of the body is ornamented with three large gilt lion-masks, having intermediate prunts, two with a turquoise-blue and one with a dark blue 'pearl'. The foot-ring is milled.

H, 20.9cm.

Reg. no. S 700.

Southern Netherlands, probably Antwerp, second half of the 16th century / Formerly in the Bernal Collection / Bequeathed by Felix Slade, Esq., F.S.A., 1868.

BIBLIOGRAPHY: Bernal Collection (1857), p. 290, no. 2804; Nesbitt (1871), p. 123; Chambon (1955), p. 313, pl. IX, no. 34; Schlosser (1956), pl. 61; *Trois Millénaires* (1958), no. 373.

NOTE: 'Ice-glass' is created by plunging the hot glass into water for a moment and immediately re-heating it. The roughened frozen surface appearance became popular in Venice in the 16th century and spread to Northern Europe, where it remained in vogue into the 17th century.

197

196

197. Tazza

Colourless glass, with a saucer-shaped bowl, on stem composed of three scroll brackets, each decorated with two gilt strawberry prunts with applied turquoise-blue 'pearls', beneath which is a gilt knop of lions' heads and a small foot; the rims of the foot and the bowl have narrow bands of granular gilding.

H, 15.9cm. D, 15.9cm.

Reg. no. S 476.

Southern Netherlands, probably Antwerp, second half of the 16th century / Debruge-Duménil collection (before 1838); Prince P. Soltykoff collection (before 1861) / Bequeathed by Felix Slade, Esq., F.S.A., 1868.

BIBLIOGRAPHY: J. Labarte, *Description des Objets d'art dans la collection Debruge-Duménil* Paris (1847), no. 1230; *Hotel Drouot, Paris, sale catalogue of collection of Prince Soltykoff*, April, 1861, lot 815; Nesbitt (1871), p. 88, fig. 134.

198

198. Goblet

Colourless glass, having a thistle-shaped bowl ornamented with an applied band on the shoulder below which three gilt medallions with satyr-heads, separated by prunts with turquoise-blue 'pearls'; the stem has a large tapering knop composed of gilt lions' heads. The surface of the bowl is decorated with a moulded stylized pattern, reminiscent of a bunch of grapes or a pine-cone.

H, 21cm.

Reg. no. S 561.

Southern Netherlands, probably Antwerp, second half of the 16th century / Bequeathed by Felix Slade, Esq., F.S.A., 1868.

BIBLIOGRAPHY: Nesbitt (1871), p. 103, fig. 165; Chambon (1955), no. 27, p. 312, pl. VIII; *Trois Millénaires* (1958), no. 407.

NOTE: The moulded stylized pattern occurs in silver-plate of the late 16th century—see C. H. Read, *The Waddesdon Bequest*, London (1902), no. 103.

199. Covered Goblet

Colourless glass; thistle-shaped, ornamented at shoulder by two horizontal bands of *latticino* glass, each bordered by a thin opaque white thread circuit; between the two bands, granular gilding; short stem and flat ribbed foot sprinkled with granular gilding. From the centre of the interior of the bowl, an ovoid enamelled in blue and painted with two fish. The cover, low-domed and ornamented with two bands of *latticino* glass.

H, 21.4cm.

Reg. no. 1855, 12-1, 151.

Façon de Venise, probably Southern Netherlands, late 16th century / Purchased at sale of Collection of Ralph Bernal, M.P., in 1855.

199

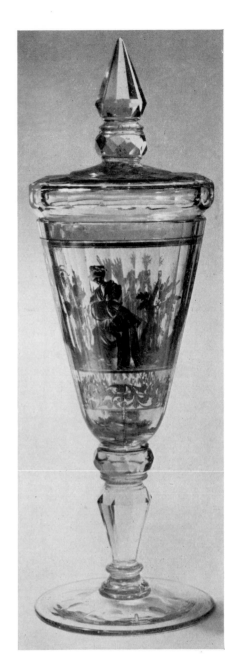

200

BIBLIOGRAPHY: Bernal Collection (1857), p. 300, no. 2930; Chambon (1955), no. 29, p. 312, pl. VIII—illustrates a similarly shaped goblet; A.-M. Berryer, *La Verrerie ancienne aux Musées Royaux d'Histoire*, Brussels (1957), p. 22, pl. X.

NOTE: The motif of bands of *latticino* glass bordered by thin opaque white thread circuits with traces of gilding was brought to England by Verzelini in the last quarter of the 16th century—see no. 231.

C. GLASS WITH ENAMELLED DECORATION

205. Beaker

Thin colourless glass, containing many bubbles and black specks; cylindrical, with an applied foot-ring, the sides flaring outwards towards the upper rim and having a high kick in the base.

Decoration consists of the application of enamelled colours on both sides of the glass and is confined between one broad band at the top and one narrow band at the bottom. The upper band contains the inscription, in white enamel on the outer face: '+MAGISTER· ALDREVAN-DIN· ME· FECI(T)'. Above and below the lettering, a narrow strip of yellow bordered by a thin red line on either side.

The main area of decoration consists of three shields alternating with sprays of foliage. The shields display the following heraldic devices:

(*a*) three stags' horns in fesse, azure;
(*b*) three keys in fesse, gules;
(*c*) per fesse, argent and sable, in chief a bar.

Both (*a*) and (*b*) are on yellow and white grounds, respectively, which are enamelled on the inner face of the glass. The white outlines of the three shields and the surrounding frame of white dots

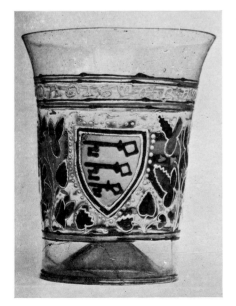

205

are on the outer face. The enamelled black of the third shield is on the inner face; and the narrow frame of red enamel surrounding each shield is executed on the inner face of the glass.

The foliage consists of white enamelled stalks on the outer face, heart-shaped and trefoil leaves, with serrated outlines in white enamel on the outer surface; the leaves painted in blue, red and green on the inner face. Between the leaves are scattered white and red enamelled short squiggles, on the outer face.

H, 13.0cm.

Reg. no. 76, 11–4, 3.

Attributed to a Syro-Frankish workshop, about 1260–90 / Formerly in the collection of R. Gedon, Munich / Purchased in 1876.

BIBLIOGRAPHY: E. Dillon, *Glass*, London (1907), p. 176f.; C. H. Read, 'On a Saracenic Goblet of Enamelled Glass of Medieval Date', *Archaeologia*, lviii (1902) p. 224f., figs. 6, 7; C. Lamm, *Oriental Glass of Medieval Date Found in Sweden and the Early History of Lustre Painting*, Stockholm (1941), p. 83f.; W. Honey, *Glass, A Handbook*, London (1946), p. 46f.; A. Gasparetto, *Il Vetro di Murano*, Venice (1958), p. 33, fig. 16; J. M. Cook, 'Notes and News; A Fragment of Medieval Glass From London', *Medieval Archaeology*, ii (1958), p. 176f.; W. Pfeiffer, 'Magister Aldrevandin me fecit', *Verhandlungen des Historischen Vereins für Oberpfalz und Regensburg*, cvi (1966), p. 206f.

NOTES: (1) According to Sir C. Hercules Read, 'Max Rosenheim has narrowed the search of the original owner to the province of Suabia, to which two out of the three coats belong. The coat with the three stags' horns belongs, with variations of colours, to no less than six towns in Suabia, as well as to the family of Landtau; a second, that of the three keys, to the family of Spet of the same district.'

(2) Of 'Magister Aldrevandin(i)', nothing is known. The name, Aldrebrandini (and several close variants), is commonly found in early Tuscan archives, especially in Florence. The use of 'Magister' may indicate that he was not the actual craftsman who made this enamelled beaker but the gentleman who commissioned it to be made.

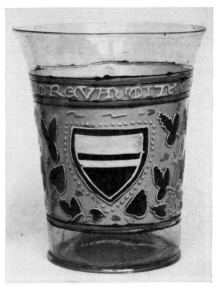

205

(3) This beaker is one of three perfectly preserved examples of a group of some twenty-five enamelled pieces, which have been tentatively attributed to a Syro-Frankish workshop active in the second half of the 13th century. The remaining twenty-two items are fragmentary, having been excavated or dug up by chance. The fragments of a glass beaker recently found at Regensburg are the closest in design to this Aldrevandini beaker.

(4) The origin and date of this group have yet to be firmly established. The known provenance of the twenty-five examples shows no consistent geographical distribution, fragments having been found over an area ranging from England in the west, Sweden in the north, to the Caucasus in the east and Egypt (Fostat) in the south, but none has as yet been found in Syria.

The tone of the glass itself is held to be more akin to that of glass of definite Syrian origin and the technique of enamelling on both the inner and the outer surfaces of the vessels appears to be a well-authenticated Syrian practice. The traditional dating of this group to the late 13th century has been suggested by a parallelism between these glasses and Syrian glasses of the second half of the 13th century.

However, the enamel decoration incorporating Latin inscriptions, an Italian family-name, and several heraldic coats-of-arms of European, probably Swabian,

origin, has been regarded as evidence that these glasses were manufactured in Europe, either in Venice or the Rhineland, by makers who had been trained or had worked in Syria. Furthermore, the proportions of the Aldrevandini beaker are more squat than is usual in Syrian glasses of this form and may be indicative of a European origin.

At present, no example of this type of enamelled glass can be shown to have definitely originated in Europe, though Theophilus, writing in the early 12th century, provides convincing evidence that the technique was practised in Europe in his day.

(5) The results of a recent scientific examination of this beaker, some fragments of a similar beaker found at Restormel Castle, Cornwall (Reg. no. 1943, 4–2, 3) and a fragment of Syrian glass (Reg. no. 1900, 6–21, 29) revealed no differences of any real significance.

(6) In this connection, mention should be made of the grave doubts which are now entertained concerning the genuineness of the well-known 'Hope' glass in the British Museum (Reg. no. 94, 8–4, 1). The enamelled decoration on this glass is wholly religious (Virgin and Child, two attendant angels, and St. Peter and St. Paul); both in this respect and in its form, this glass was unique within the group of twenty-five specimens. The form of the inscription on this glass gives rise to doubts about its authenticity but principally the quality of the metal of the glass and palette of the enamelled decoration provide the strongest grounds for suspecting the age and origin of the glass. For these reasons, this glass has been omitted from this exhibition.

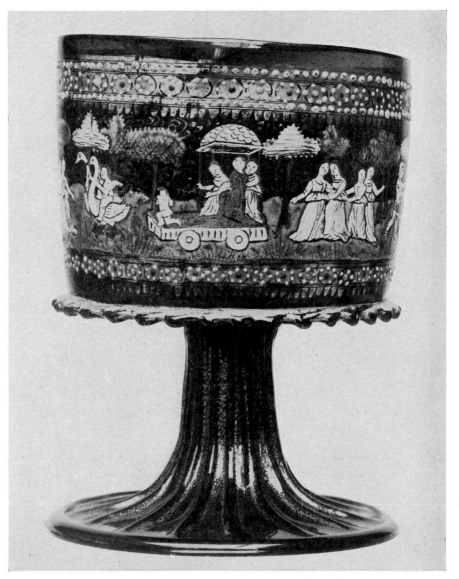

206

206. Standing Cup

Sapphire blue, having a stem and expanding foot with raised ribs and sprinkled with granular gilding. The bowl is cylindrical, with a notched applied ring at its base, and surrounded by two jewelled and gilt bands between which is represented a procession of figures, with a background of clipped trees, all executed in enamels of various colours, heightened with gold. The principal subjects of the design represent, on one side, Venus seated in a fish-shaped car, preceded by Hymen holding a torch, after which comes a Centaur bearing a youthful figure and grasping the hand of a cavalier, armed *cap-à-pié* in the fashion of the early part of the fifteenth century; on the opposite side is another triumphal car, in which are seated three figures under a canopy. It is preceded by two putti mounted on a pair of geese. This composition is separated from the scene on the reverse by groups of standing women.

H, 16.5cm. D, 12.5cm.

Reg. no. S 363.

Venice, mid-15th century / Sold for 180 francs by M. Lhérie (in early 19th century); Debruge-Duménil collection (before 1838); Prince P. Soltykoff collection (before 1861) / Bequeathed by Felix Slade, Esq., F.S.A., 1868.

BIBLIOGRAPHY: J. Labarte, *Histoire des Arts Industriels* (1800), pl. cxxxiii; J. Labarte, *Description des objets d'art dans la collection Debruge-Duménil*, Paris (1847), no. 1269; *Hotel Drouot, Paris, Sale catalogue of collection of Prince Soltykoff*, April 1861, lot 808; Nesbitt (1871), p. 70, pl. XIII; Gasparetto (1958), p. 81f., pl. 27; Mariacher (1961), p. 24f., pl. 25.

NOTE: The quality of both the drawing and the enamelling of the figures is inept and may indicate an early date. Comparison with the enamelled figures on the two goblets (nos. 207 and 208) demonstrates a marked inferiority in the artistic ability of the enameller of this piece.

207. Goblet

Rich emerald-green glass; a fluted stem and knop, on a spreading foot with raised ribs, enriched with granular gilding. The bowl is ornamented with two portrait medallions surmounted with garlands supported by cupids: (i) a lady, with auburn hair, with a bouquet; her dress is of a brown colour, relieved by blue across the chest, and has white puffed sleeves; (ii) a gentleman in the costume of the 15th century, accompanied by a scroll bearing the motto 'AMOR.VOL.FEE' (love requires faith).

H, 22.3cm. D, 10.5cm.

Reg. no. S 361.

Venice, second half of the 15th century / Purchased in Italy for 172 francs (in early 19th century); Debruge-Duménil collection (before 1838); Prince P. Soltykoff collection (before 1861) / Bequeathed by Felix Slade, Esq., F.S.A., 1868.

BIBLIOGRAPHY: J. Labarte, *Histoire des Arts Industriels* (1800), pl. CXXXIV; J. Labarte, *La Collection Debruge-Duménil*, Paris (1847), no. 1274; *Hotel Drouot, Paris, Sale catalogue of collection of Prince Soltykoff*, April 1861, lot 809; Nesbitt (1871), p. 68, pl. XII; Gasparetto (1958), p. 82f., pl. 25; Mariacher (1961), p. 24f., pl. 23.

NOTE: On grounds of style, the two profile portraits indicate a date about 1480,

which is consistent with the style of the other decorative features, including the putti. The quality of the enamelling on this example is exceptionally high.

208. Goblet

Even opaque turquoise-blue glass; ogee-shaped bowl and ribbed foot with a stem of lapis-lazuli blue; the base of the bowl, the upper and lower edges of the foot have applied circuits of opaque white glass. The bowl is enamelled and gilded with scale pattern; on opposite sides, medallions enclose: (i) a gentleman and a lady, half-length, and (ii) a similar subject but with a quadruped (? deer couchant), in the foreground; both scenes are framed by a narrow band of gilding studded with white enamel. Vestiges of scale-like ornament in red enamel on the foot remain.

H, 18.9cm. D, 12.3cm.

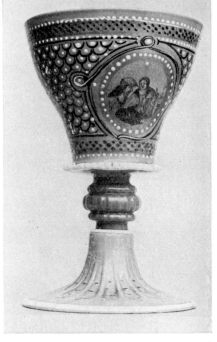

208

Reg. no. Waddesdon Bequest, Cat. no. 55.

Venice, late 15th century / Bequeathed by Baron Ferdinand Rothschild, 1898.

BIBLIOGRAPHY: A. Nesbitt, *Glass Vessels in the South Kensington Museum*, London (1878), p. 48, no. 4319/1858; Sir Hercules Read, *The Waddesdon Bequest, Catalogue*, 1st edn. (1899), p. 26, pl. XV; *The Waddesdon Bequest*, Catalogue, 2nd edn. (1927), p. 12; *Straus Exhibition* (1955), nos. 86 and 87, p. 37 (for shape and style of decoration); 'The Fairfax Cup', *The Connoisseur*, cxliii, no. 575 (February, 1959), p. 32, with illustration in colour; Honey (1946), pp. 57, 60.

NOTES: Only two other 15th-century Venetian glasses made of this turquoise-blue glass are known, the 'Fairfax Cup' and a tazza, both in the Victoria and Albert Museum. Unlike the 'Fairfax Cup', this goblet does not change to a deep amethyst-red colour by transmitted light. The quality of the enamelled figure drawing on the 'Fairfax Cup' is far more primitive and may be indicative of an earlier date. On grounds of style, the half-length scenes on this goblet can be dated to about 1500.

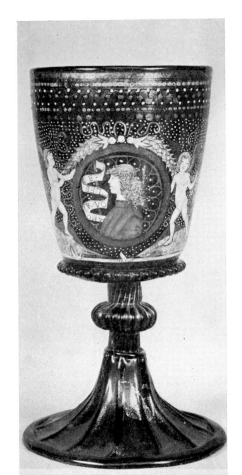

207

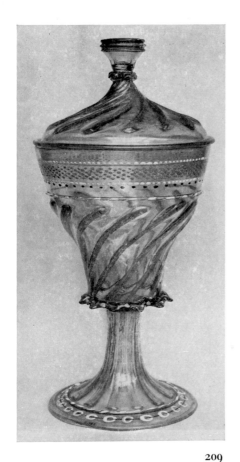

209

Reg. no. S 362.

Venice, second half of the 15th century / Exhibition of the Art Treasures of the United Kingdom, Manchester, 1857 / Bequeathed by Felix Slade, Esq., F.S.A., 1868.

BIBLIOGRAPHY: A. W. Franks, 'Vitreous Art', *Art Treasures of the United Kingdom*, London (1858), p. 8; *Le Cabinet de L'Amateur*, no. 3, May, 1861; Nesbitt (1871), p. 68, fig. 81; Gerspach (1885), p. 139, fig. 63.

210. Bowl

Large, deep bowl in colourless glass. The upper part is decorated with a deep band of scales or feather pattern in gold with raised enamel dots; the lower part is ribbed with diagonal gadroons; the foot is ribbed.

H, 16.5cm. D, 27.5cm.

Reg. no. S 938.

Venice, second half of the 15th century / Bequeathed by Felix Slade, Esq., F.S.A., 1868.

BIBLIOGRAPHY: Nesbitt (1871), p. 163, fig. 84; Kestner-Museum (1957), no. 1, p. 46, pl. 2.

211. Covered Cup

Enamelled opalescent glass; supported on a high trumpet foot, the bowl has a flattened globular form, repeated in the cover, which has a flat top with a raised rim. On the side of the bowl, a flat curved handle, with a rolled-over end. The surface decoration consists mainly of scale pattern in white and coloured enamel with gilding. On the lid two enamelled coats of arms and the date '1518': the arms of Scharff and Hörlin, patricians of Nürnberg and Augsburg, respectively.

H, 15.5cm.

Reg. no. Waddesdon Bequest, Cat. no. 59.

Attributed to Venice, but perhaps made in southern Germany, 1518 / Bequeathed by Baron Ferdinand Rothschild, 1898.

BIBLIOGRAPHY: Sir Hercules Read, *The Waddesdon Bequest*, 1st edn. (1899),

209. Large Standing Cup and Cover

Colourless glass; the bowl is ornamented with wrythen gilt ribs; above these is an applied thread circuit enamelled in white and blue, a row of red dots, and a marginal pearl-edged band of gilt imbrications, each containing a central blue enamel dot. The cover has similar ribs, and is surmounted with a flat-headed knop, on which is still visible, encircled with a blue ring, a partially defaced shield of arms, of an early form, which seems to have been quarterly, 1 and 4 arg. a cross gu., 2 and 3, or a bend gu., any minor charges are now invisible.

Around the base of the cup is a denticulated rim edged with red enamel, and having gilt points with large blue enamel dots between them. The stem has vertical gilt ribs, and around the foot is a raised ring of glass decorated with intertwined stripes of white and blue enamel, below which is a band of opaque white rings strung together by a red cord.

H, 42.1cm. D, at mouth of bowl, 19.7cm.

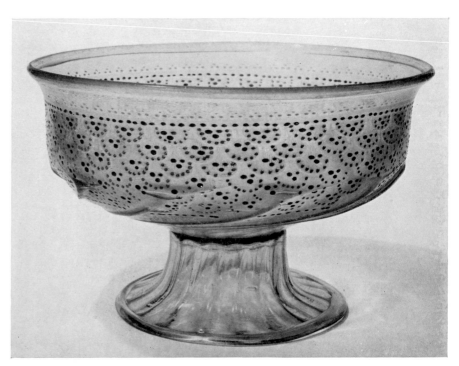

210

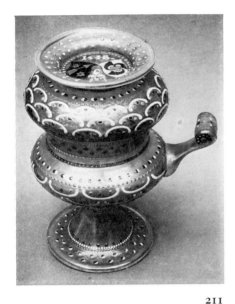

211

212. Cup

Colourless glass; supported on a trumpet foot; the lower part of the bowl is globular and heavily ribbed with a single short curled handle with narrow ribbing; the upper part of the bowl opens outwards in a trumpet form and has four enamelled coats of arms:

 (1) gu. a demi bull ar. horned and hoofed or (Stortzing),

 (2) gu. a bifid plant ar. growing out of three hillocks or (Söll von Aichberg),

 (3) or a sceptre head in bend sa. (probably Reich von Reichenstein),

 (4) gu. a greyhound's head couped ar. collared sa. ringed or. (Rost).

Below the rim, a band of scale pattern executed in enamels and gilding with a white beaded border on either side.

H, 15.6cm.

Reg. no. S 831.

Attributed to Venice, but possibly made in the Tyrol or southern Germany, early 16th century / Bequeathed by Felix Slade, Esq., F.S.A., 1868.

BIBLIOGRAPHY: Nesbitt (1871), p. 138, fig. 233; von Saldern (1965), p. 34.

NOTES: An identical cup was formerly in the Sigmaringen Museum, see R. Schmidt, 'Die Venezianischen Emailgläser', *Jahrbuch der preussischen Kunstsammlungen*, xxxii (1911), p. 283, fig. 15.

The form combines the main features of a Northern European handled cup of the 15th–16th century, as in no. 211, with the Venetian goblet; extant examples are very rare.

p. 27, pl. XV; *The Waddesdon Bequest*, Catalogue, 2nd edn. (1927), p. 13; Gasparetto (1958), p. 86, pl. 50; von Saldern (1965), p. 35.

NOTES: An identical specimen, also dated '1518', was formerly in the Lanna Collection, *Sammlung . . . Lanna*, Prague (1911), no. 708, pl. 59.

The form, known in German as a *Doppelscheuer*, is found in silver, crystal and wood (called 'covered mazers') throughout Northern Europe in the 15th–16th centuries. For an early example in German glass, see Schmidt (1922), p. 147, fig. 76 and Rademacher (1933), p. 124f., pl. 56. For other examples in Venetian glass, see Schmidt, (1922), p. 88, fig. 51.

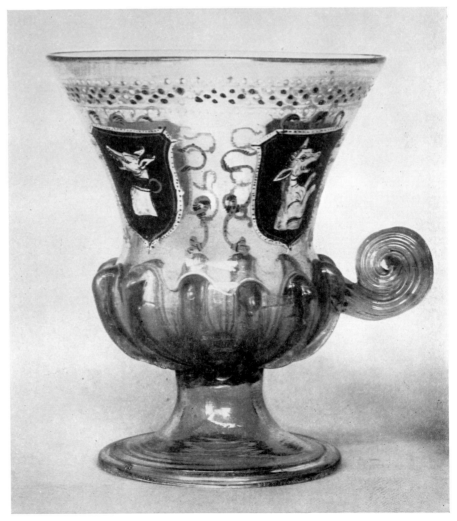

212

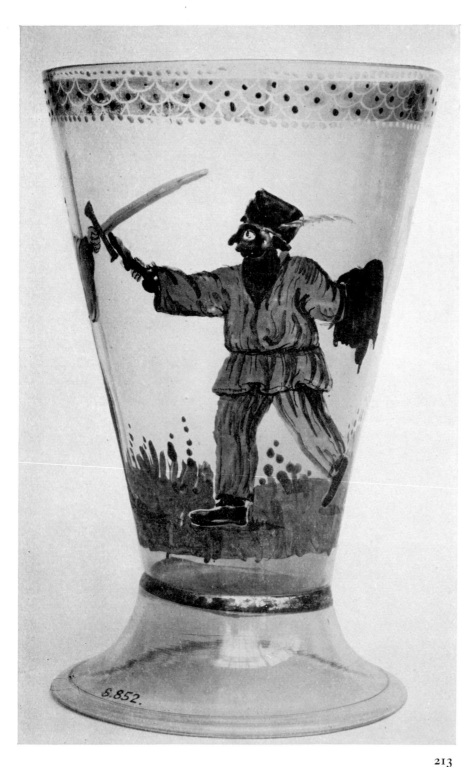

narrow grassy strip, painted in bright yellow and green. A narrow gilt band decorates the foot where it joins the bowl.

H, 19.2cm. D, 12.2cm.

Reg. no. S 852.

Venetian, late 16th century / Bequeathed by Felix Slade, Esq., F.S.A., 1868.

BIBLIOGRAPHY: Nesbitt (1871), p. 142, fig. 237; W. King, 'Eine Gruppe Emaillierter Venetianer Gläser im Britischen Museum', *Pantheon*, October, 1929, p. 475, fig. 8; Gasparetto (1958), pl. 91; Hugh Tait, *'The Commedia dell'Arte in Glass and Porcelain'*, *Apollo*, lxxviii (October, 1963), p. 261f., figs. 1–3.

NOTE: Very similar goblets, but enamelled with coats of arms of German and Austrian families are attributed to glasshouses in southern Germany; see von Saldern (1965), p. 48, figs. 31, 33.

214. Goblet

Colourless horny glass; enamelled and gilt; the bowl funnel-shaped with a flat base, resting on a bulb-shaped stem and a conical foot. The bowl is divided into three compartments:

(1) a gentleman in the costume of the period, with blue hose, a slashed red doublet, and puffed breeches, wearing a sword and blue hat with a feather, and holding some red flowers; before him is a white scroll inscribed 'IE SVIS A VOVS';

(2) a lady holding a heart, surmounted by an orb; on a scroll in front of her is inscribed MŌ CVEVR AVES;

(3) a white goat, attempting to drink out of a narrow-necked vase, forming together the rebus, *BOUC eau*. Above, a gilt band with pearled edging on which the following inscription has been erased through the gilding: 'IE.SVIS.A VOVS. IEHAN. BOVCAV. ET. ANTOYNETTE. BOVC.' (the space not admitting of the completion of the second name). On the exterior of the base of the bowl are enamelled stiff white scrolls.

H, 16.2cm. D, 13.5cm.

Reg. no. S 824.

France, mid-16th century / Formerly in

213

213. Goblet

Colourless glass; conical bowl on a low trumpet-shaped foot with folded edge; beneath a band of gilt and enamelled scale-pattern, three enamelled male figures in masquerading costumes, probably the three chief 'Masks', or characters, from the *Commedia dell'Arte*; Pantaloon, holding a sword, fights with Harlequin, clutching a cut-down stick, and the Doctor, with both arms extended, tries to make peace. The figures are set on a

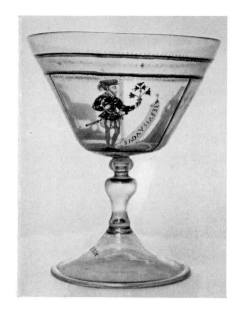

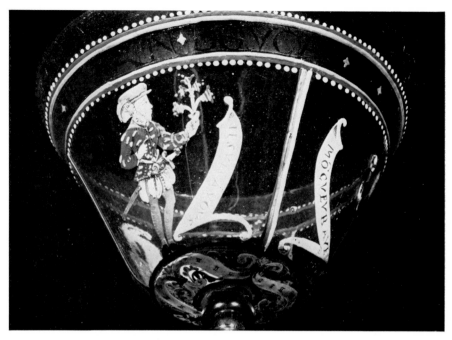

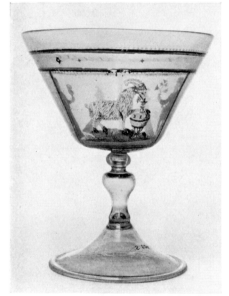

214

the collection of J. Huyvetter, of Ghent, Belgium / Bequeathed by Felix Slade, Esq., F.S.A., 1868.

BIBLIOGRAPHY: Nesbitt (1871), p. 136, pl. XX; Gerspach (1885), p. 210, fig. 96; Hartshorne (1897), p. 92, fig. 122; Barrelet (1953), pp. 72–3, pl. XXXIX; Chambon (1955), p. 84, footnote 2; Schlosser (1956), pl. 67; Recent Important Acquisitions, *JGS* (1961), III, p. 140, no. 21.

NOTES: Although a few similarly enamelled French glasses have survived, it is impossible to determine whether they are the work of Italian craftsmen, who are recorded in various provincial centres, or of French glass-workers.

Chambon has made the suggestion that this goblet could have been made in Belgium, partly because it belonged to a collector in Ghent, whose acquisitions had been purchased in Belgium in the first half of the 19th century, and partly because the name 'Boucau' is to be found in old Flemish records. He states that in 1529 a 'Jehan Boucau' is listed as a land-owner at Beauwelz, near Mons, Belgium.

214

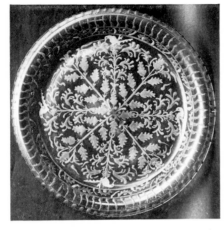

215

215. Plate

Colourless glass; enamelled cruciform pattern of green oak(?) leaves; in each quadrant a spray of green and yellow foliage surmounted by a grey bird. The raised rim decorated in green flamelike shapes with a band of formal ornament which includes touches of blue enamel.

D, 18.2cm.

Reg. no. 69, 6–24, 62.

Spain, probably Barcelona, second half of the 16th century / Formerly Castellani collection / Presented by the executors of the late Felix Slade, Esq., F.S.A., 1869.

BIBLIOGRAPHY: J. Gudiol Ricart, *Los Vidros Catalanes*, Barcelona (1941), pl. 49B; Frothingham (1963), p. 37, pl. 9B.

216. Mug

Colourless glass; on neck, between two applied threads and two vertical 'pearled' panels, a female bust and the date '1577'. The upper neck ornamented with a gilt band much worn away and circuits of beading. The body enamelled with a stag pursued by two dogs separated by a tree and two lilies-of-the-valley and the date, '1577'.

H, 16.4cm. (without pewter cover).

Reg. no. 78, 12–30, 294.

Attributed to Bohemia or to the Southern Netherlands, 1577 / Bequeathed by John Henderson, Esq., F.S.A.

BIBLIOGRAPHY: A. Baar, 'Verrerie des Flandres, Fabrication Anversoise', *Revue Belge d'Archéologie et d'Histoire de l'Art*, 1938 no. 3, p. 236f., pl. XIII, 69B; A.-M. Berryer, 'Enrichissement du Département de la Verrerie en 1953', *Bull. des Musées Royaux d'Art et d'Histoire*, 1954, p. 48f.; Chambon (1955), p. 92f., pl. XX; von Saldern (1965), pp. 173ff.; Tait (1967), p. 110f.

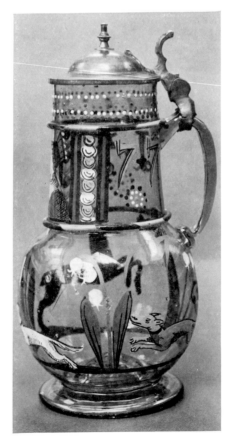

216

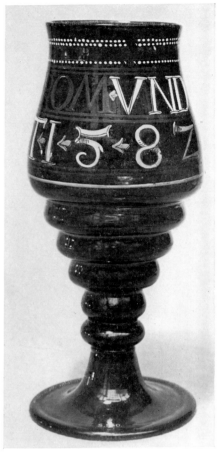

217

217. Goblet

Cobalt-blue glass; lower portion of the bowl tapering inwards in a series of four bulbous rings, below which a knop and trumpet foot; beneath the rim a gilded band with beading, and encircling the bowl an inscription in large letters, each word being a different colour (either white, yellow-green, yellow or blue): 'SEI. ALZEIT. FROM VND. FVRCHTE. GOT. 1582' (Be always pious and fear God).

H, 24.1cm.

Reg. no. S 850.

Attributed to Bohemia or to Southern Netherlands, 1582 / Bequeathed by Felix Slade, Esq., F.S.A., 1868.

BIBLIOGRAPHY: Nesbitt (1871), p. 141; Jantzen (1960), no. 50, p. 22, pl. 22; von Saldern (1965), pp. 169, 171, 250f., pls. 5, 6, and fig. 302; Düsseldorf-Kunstmuseum (1966), no. 167, p. 63; Tait (1967), pp. 110f.

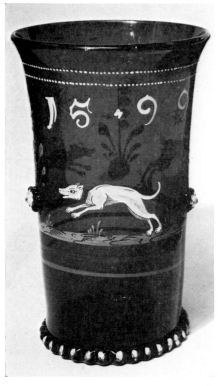

218

NOTES: This eccentric form of glass is to be found in: (*a*) *Latticino* glass attributed to Venice, see I. Schlosser, *Venezianer Gläser*, Österreichisches Museum für Angewandte Kunst, Vienna (1951), pl 34, and Klesse (1963), no. 179.

(*b*) *Latticino* glass attributed to the Southern Netherlands, see Chambon (1955), pl. XIV, nos. 46, 47, 48.

218. Beaker

Dark blue glass; everted rim and slightly tapering sides, with applied milled footring, highlighted with white enamel; below the rim, a gilt band edged with pearling; the middle register divided by three applied prunts, from two of which lilies-of-the-valley grow, into three compartments:

(1) a hound with the date '1599', above;
(2) a hound with star pattern above;
(3) a stag.

Below, two enamelled narrow bands, one of red and one of blue.

H, 17cm.

Reg. no. 73, 3–29, 8.

Attributed to Bohemia or to Southern Netherlands, 1599 / Presented by the executors of the late Felix Slade, Esq., F.S.A., 1873.

BIBLIOGRAPHY: A. Baar, 'Verrerie des Flandres, Fabrication Anversoise', *Revue Belge d'Archéologie et d'Histoire de l'Art*, 1938, no. 3, p. 236f., pl. XIII, 68B; A.-M. Berryer, 'Enrichissement du Département de la Verrerie en 1953'. *Bull. des Musées Royaux d'Art et d'Histoire*, 1954, p. 48f., fig. 18; Chambon (1955), p. 92f., pl. XIX; von Saldern (1965), p. 165, pl. 173, fig. 296; Tait (1967), pp. 110ff.

219. 'Humpen'

Clear glass with a slight greyish tinge; below the rim, a band of gilt scale-ornament with green dots bordered by simple beading in white and blue, and, immediately beneath, the inscription: 'DAS HAILIG.ROMISCH.REICH.MIT. SAMPT.SEINIEN.GELIDERN.1571'.

The body enamelled with the double-headed eagle of the Holy Roman Empire in black with the details executed in blue and superimposed a crucifix, the cross depicted in green. On the wings, the fifty-six shields which represent an idealized version of the constituent parts of the Holy Roman Empire; the top horizontal row on the left listing the ecclesiastical electors and, on the right, the secular electors. The remaining twelve groups are read vertically and are identified by a ribbon at the bottom of the column. On the reverse of the humpen, a representation of the Brazen Serpent.

H, 26.8cm.

Reg. no. S 836.

Probably Bohemia, 1571 / Bequeathed by Felix Slade, Esq., F.S.A., 1868.

BIBLIOGRAPHY: Nesbitt (1871), p. 139; Kestner-Museum (1957), no. 51, p. 55, pl. 14; von Saldern (1965), p. 51.

NOTE: This specimen is the earliest dated example of a humpen with this form of decoration, known in German as a 'Reichsadler Humpen'.

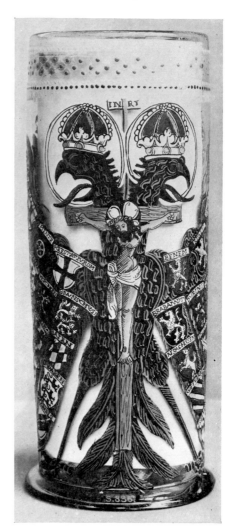

219

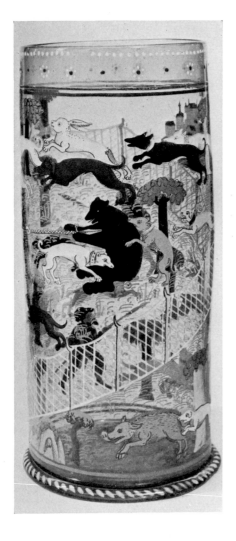
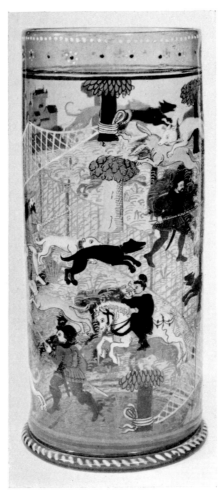
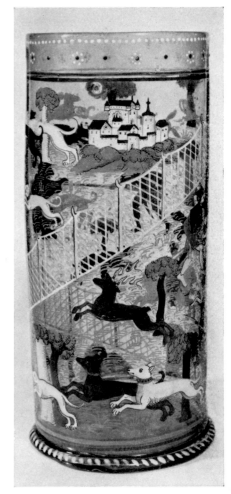

220. 'Humpen'

Clear glass, slightly greyish in tint; applied foot-ring. Below rim a gilded band with rosettes and beads; the remainder of the cylindrical body enamelled with a hunt scene, in which a net is arranged spirally around the vessel; at the top, a castle or hunting lodge; a boar, stag, bear and two rabbits hunted by hounds; four hunters are represented, two with spears, one spearing a bear and one on horseback blowing a horn.

H, 26.2cm.

Reg. no. 1903, 6–18, 1.

Attributed to Bohemia, late 16th century / Purchased from Miss Ann Drewry, Elmfield, Cleethorpes, Lincs., 1903.

BIBLIOGRAPHY: von Saldern (1965), p. 113f., pl. 55, figs. 164, 168.

221. 'Humpen'

Clear glass with greenish tinge; foot-ring made from same gather. On the obverse, Martin Queck, holding a goblet. Above his arm the date, '1678'. On either side of his legs, the three children who died are depicted in white surplices with crosses above their heads. To his left, his four sons; on the reverse, his wife, Catharina, and to her left, two daughters, Margaretha and Eva.

In the empty spaces, stars, flowers and inscriptions; the grass strip bordered by three lines with a hatched edge. Below the rim, a gilt band bordered by white lines and hatching.

H, 17cm.

Reg. no. S 844.

Germany, probably Thuringia, 1678 / Bequeathed by Felix Slade, Esq., F.S.A., 1868.

BIBLIOGRAPHY: Nesbitt (1871), p. 140, fig. 235; H. Kühnert, 'Identifikation einiger Thuringischer Gläser des 17. Jahrhunderts', *Glastechnische Berichte*, 10. Jahrg., Heft 9 (1932), p. 494f.; H. Kühnert, 'Ursprungsnachweis einiger Thüringischer Emailgläser an der zweiten Hälfte des 17. Jahrhunderts', *Jahrbuch der Staatlichen Museen Heidecksburg Rudolstadt*, 1961, p. 40f., pl. 4a, 6; von Saldern (1965), pp. 139ff., 193, 195, n. 391.

NOTES: Martin Queck (1626–94), son of Wolf Queck (died 1664), a forester in the service of the Prince of Saxe-Coburg, and Dorothea (née Hanickel, 1592–1672). Martin followed the same calling as his father. He married, in 1654, Catharina, daughter of another forester, Georg König, and they lived, with their family of nine children (three of whom died), at Steinach, Thuringia.

222. 'Stangenglas'

Colourless glass; tall narrow cylindrical body; ornamented with a coat-of-arms twice repeated, viz., tiercé per chevron or and sa., in base a plough-share ppr.; the crest: two horns, the dexter or, the sinister sa., from each of which issue three feathers counterchanged. Below the rim, a gilt and pearled scale-pattern band; a plain gilt band at junction of bowl and base.

H, 38.3cm.

Reg. no. S 839.

Germany, or possibly Venice; about 1580 / Formerly in the collection of Ralph Bernal, Esq., M.P. / Bequeathed by Felix Slade, Esq., F.S.A., 1868.

BIBLIOGRAPHY: Bernal Collection (1857), p. 311, no. 3080; Nesbitt (1871), p. 139; R. Schmidt, 'Die venezianischen Emailgläser des XV., und XVI. Jahrhunderts', *Jahrbuch der k. Preussischen Kunstsammlungen*, xxxii (1911), p. 249f.; W. King, 'Eine Gruppe emaillierter venetianer Gläser im Britischen Museum', *Pantheon*, iv (1929), p. 475, fig. 7; von Saldern (1965), p. 125f.; Tait, (1967), p. 108f., figs. 30, 31.

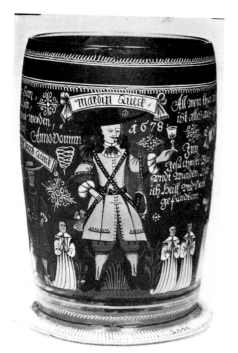

221

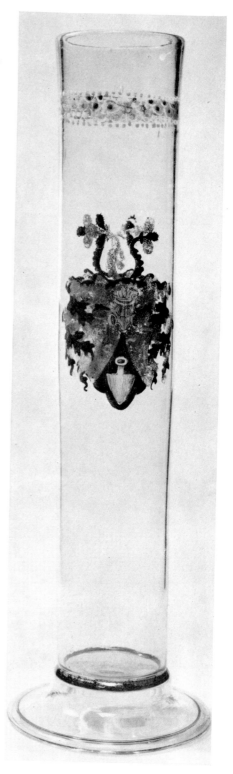

222

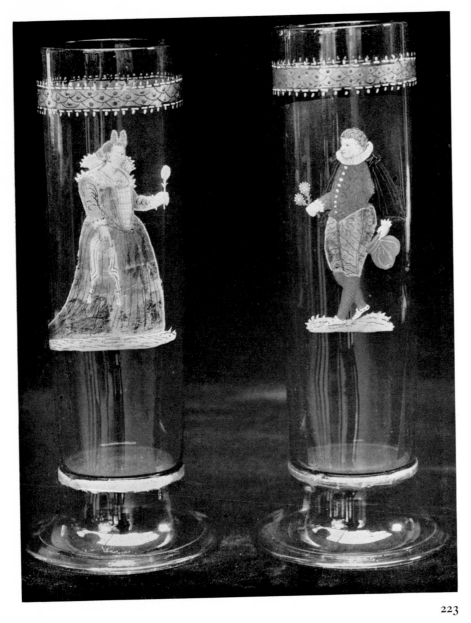

NOTES: Jacob Praun married Clara von Roming in 1589. The Praun family, well-known merchants of Nürnberg, had at this time their head office in Bologna. The costume and head-dress of Clara Praun are said to show strong Venetian influence.

224. 'Passglas'

Coloured glass, with five milled applied rings, between which, painted in grisaille, is a triumphal procession with figures on horseback and on foot; below the procession, the inscription: 'Churfürstlich Bayrisches Frewden-Fest, Bey den Vorgangnen Tauff-Ceremonien des Durchleuchtigsten Fürsten und herrn,

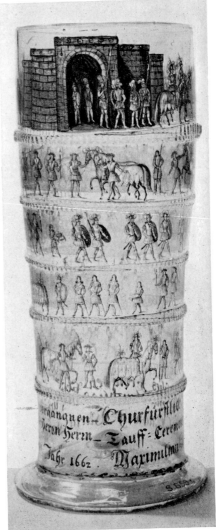

223

223. Pair of 'Stangengläser'

Colourless glass; below the rim, a border of gilt imbrications edged with pearl dots, beneath which, on one glass, is an enamelled figure of a standing man holding two flowers; on the reverse, two coats-of-arms (Praun and von Roming), below which in gold, 'JACOB PRAUN'. On the other glass, Jacob Praun's wife, Clara, in a gold dress with white muff, holding a flower; on the reverse, two coats-of-arms and inscription as on the companion glass.

H, 28.5cm. (S 845) and 28cm. (S 846).

Reg. no. S 845 and S 846.

Germany, or possibly Venice, probably 1589 / Formerly in the collection of Ralph Bernal, Esq., M.P. / Bequeathed by Felix Slade, Esq., F.S.A., 1868.

BIBLIOGRAPHY: Bernal Collection (1857), p. 327, no. 3290; p. 293, no. 2853; Nesbitt (1871), p. 141, pl. XXII; R. Schmidt, 'Die venezianischen Emailgläser des XV. und XVI. Jahrhunderts', *Jahrbuch der k. Preussischen Kunstsammlungen*, xxxii (1911), p. 249f.; W. King, 'Eine Gruppe emaillierter venetianer Gläser im Britischen Museum', *Pantheon*, iv. (1929), p. 374, figs. 2, 2a; von Saldern (1965), pp. 79f., 125f.

224

Herrn Maximilian Emanuel Ludwig Maria Joseph, In Jahr 1662'. (The solemn rejoicing of the Electorate of Bavaria on the occurrence of the baptismal ceremonies of the most illustrious prince and Lord the Lord Maximilian Emanuel Louis Mary Joseph, in the year 1662.)

H, 22.6cm.

Reg. no. S 859.

Germany, third quarter of the 17th century / Formerly in the collection of Ralph Bernal, Esq., M.P. / Bequeathed by Felix Slade, Esq., F.S.A., 1868.

BIBLIOGRAPHY: *Bernal Collection* (1857), p. 325, no. 3264; Nesbitt (1871),

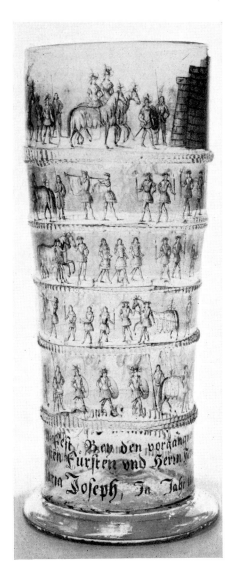

224

p. 143, fig. 239; Buckley (1939), no. 361, pl. 123; Kestner-Museum (1957), no. 39, p. 53, pl. 12; Bremen (1964), no. 108, pp. 286–7; Klesse (1963), no. 252, p. 120; Klesse (1965), no. 136, p. 165.

NOTES: Maximilian Emanuel (1662–1726) became Elector of Bavaria in 1679. In 1692 he was appointed Governor of the Netherlands. Defeated at Blenheim in 1704, his dominions were restored to him in 1714.

225. Footed Beaker

Cylindrical beaker with flat bottom on three hollow, ribbed, bun-feet. Decoration in *schwartzlot*: on the front, a circular medallion frame inscribed, 'IOANNES GEORGIUS: ELECTOR SAXONIAE', enclosing portrait of John George II of Saxony, signed JS (in monogram); on the reverse, an enamelled black wreath, surrounding a small circular concave 'window' of wheel-engraved polished glass.

H, 8.2cm.

Reg. no. 91, 2–24, 12.

Nürnberg, probably decorated about 1660–70 by Johann Schaper / Formerly in the Hailstone collection / Purchased, 1891.

BIBLIOGRAPHY: Schmidt (1922), p. 215f.; T. Hampe, 'Das Altnürnberger Kunstglas und seine Meister', *Neujahrsblätter der Gesellschaft für fränkische Kunstgeschichte*, XIV (1919), p. 7; G. Pazaurek, *Deutsche Fayence und Porzellan Hausmaler*, i, Leipzig (1925), p. 1f.; *Sale Catalogue of the Collection of Viktor Schick, of Prague*, Sotheby & Co., 4 May, 1939, lot 63.

NOTES: Johann Schaper (1631–70), enameller, who was trained as a decorator of domestic window glass and later worked in *schwartzlot*, a technique employing black, sometimes using highlights of gold and red. Few details of his career are recorded: from 1655, he was working in Nürnberg; in 1664, he was in Ratisbon.

(2) John George II, Elector of Saxony (1613–80), became Elector in 1656.

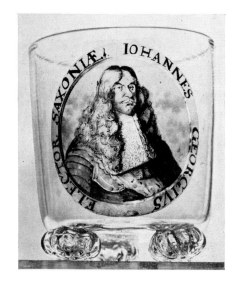

225

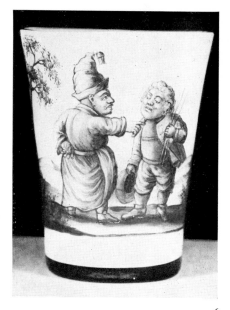

226

226. Tumbler

Colourless glass, enamelled in red with two pairs of so-called 'Callot' figures and a tree.

H, 11.8cm.

Reg. no. 1938, 11–2, 3.

Probably Nürnberg, about 1720 / Formerly in the Schiftan Collection, Vienna/ Purchased, 1938.

BIBLIOGRAPHY: 439. *Kunstauktion . . . Kostbare Gläser (Shiftan) Dorotheum*, Vienna, 27–9 February, 1936, p. 13, fig. 52b; Rijksmuseum, Amsterdam,

International Tentoonstelling van Oude Kunst, 1936, no. 708; Sotheby's, *Sale Catalogue, 10 Nov. 1938*, lot 124, and illustration, W. King, 'Three German Glasses', *BMQ*, XIII (1938–39), p. 38f., pl. XVIb.

NOTE: The figures are adapted from two engravings, representing March and November, in a series of illustrations of the months in '*Il Calotto resuscitato; oder Neu eingerichtes Zwerchen Cabinett*, one version of which was published in Amsterdam by Wilhelmus Koning in 1716.

227. Bottle

Colourless glass; conical, twelve-sided faceted at the shoulder, with the bottom cut in a roundel with radiating rays. The whole painted in red with Chinese figures, floral scrolls, birds, and a spider.

H, 13.3cm.

Reg. no. 88, 12–22, 1.

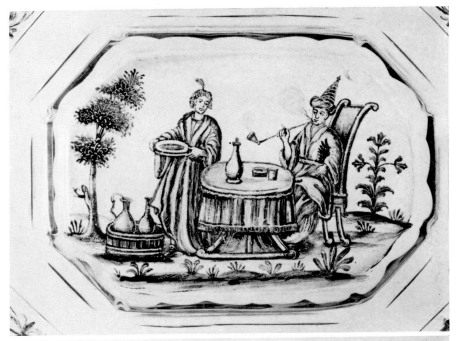

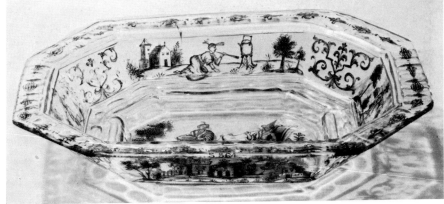

228

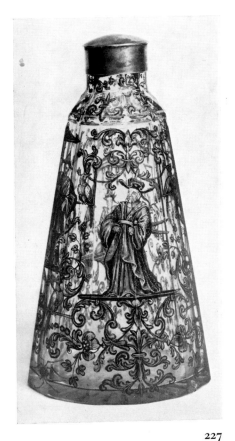

227

Silesia or Bohemia; decoration attributed to Ignatz Preissler, second quarter of the 18th century / Purchased, 1888.

BIBLIOGRAPHY: Jantzen (1960), no. 70, p. 28, pl. 31; Klesse (1965), no. 145, p. 169; G. Pazaurek, *Deutsche Fayence und Porzellan Hausmaler*, i, Leipzig (1925), pp. 209f., 248f.

NOTES: Ignatz Presisler (born 1676), enameller, son of Daniel Preissler (1636–1733); worked at Kronstadt in Bohemia in the service of Count Franz Karl Liebsteinsky von Kolowrat from 1729 to 1739.

The attribution of this type of decoration on glass to Preissler can only be made tentatively in the absence of a group of signed works.

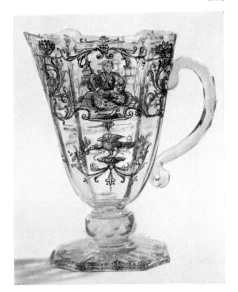

228

228. Ewer and Basin

Colourless glass. The ewer: octagonal bowl on a faceted knop and flat octagonal foot; enamelled on one side with an oriental building framed by scroll-work and on the other with an oriental figure holding a sceptre and seated on a cushion, also framed by scroll-work; a border of alternating quatrefoils and fleurs-de-lys around edge of foot. All the decoration is executed in black and picked out in gold (*schwartzlot* technique).

The basin has similar mouldings and decoration. The rim with fleurs-de-lys and quatrefoils; on the sides, a figure with an ocelot, a figure blowing on a fire, a figure carrying a basket and a bundle, and a landscape; in the centre, two oriental figures in a landscape, one seated at a table smoking a pipe, the other, perhaps a servant, standing and holding a dish.

H, 12cm. (ewer); H, 44cm. L, 22.6cm. (basin).

Reg. no. S 863 and S 864.

Silesia or Bohemia; decoration attributed to Ignatz Preissler, second quarter of the 18th century / Bequeathed by Felix Slade, Esq., F.S.A., 1868.

BIBLIOGRAPHY: Nesbitt (1871), p. 145; G. Pazaurek, *Deutsche Fayence und Porzellan Hausmaler*, i, Leipzig, (1925) pp. 209f., 248f.

NOTE: For the attribution of this type of decoration to Preissler, see preceding entry (no. 227).

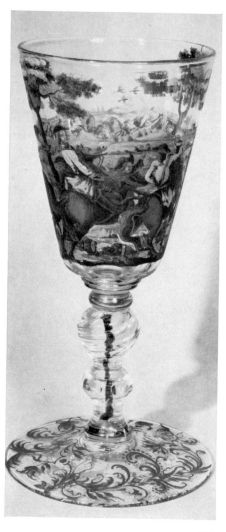

229

229. Goblet

Colourless glass; on the conical bowl, a landscape scene with fighting horsemen in the foreground, the figures being principally executed in grisaille, with lilac, blue and green accessories. The distant background is bluish in tone; and the trees in the foreground are in grisaille, with bright green lights intermingled with a little dull green. Portions of the figures and other parts of the scene are heightened by small patches of yellow stain, produced as in window glass with an oxide of silver. The stem consists of a bright orange flattened bulb, immediately beneath the bowl; a ruby cord extends from it through the centre of the large spirally ribbed bulb into the faceted smaller bulb beneath. The foot is painted with sprays of foliage.

H, 21.8cm.

Reg. no. S 860.

Bohemia, about 1740 / Bequeathed by Felix Slade, Esq., F.S.A., 1868.

BIBLIOGRAPHY: Nesbitt (1871), p. 144, fig. 240.

NOTE: The whole execution is that of a painter of domestic window glass, and produces but little effect at a distance.

D. GLASS DECORATED WITH THE DIAMOND POINT

230. Plate

Colourless glass; a deep centre and a broad rim; ornamented with two bands of granular gilding and bordered on either side by *latticino* network which, in the case of the outer band, includes blue threads. Between these two bands, dragons, birds confronting a mask, and crossed Papal Keys are engraved with the diamond-point; similarly engraved, scallops around the rim.

D, 27.5cm.

Reg. no. S 607.

Venice, middle of the 16th century / Bequeathed by Felix Slade, Esq., F.S.A., 1868.

BIBLIOGRAPHY: Buckley (1929), p. 17, pl. 18; Nesbitt (1871), p. 109f., fig. 184; Honey (1946), p. 63; *Trois Millénaires* (1958), no. 579, p. 209; Gasparetto (1958), pls. 79, 83; Klesse (1963), no. 169, p. 92.

NOTES: Two similarly decorated plates have the coat of arms of Pope Pius IV (1559–66) in the central area of the plate and it is possible that this plate was originally ornamented with armorial bearings in gold.

Another similar plate, also in the Slade Collection (no. S 606), has two concentric bands of diamond-engraved ornament but no bands of *latticino* glass—only the thin opaque-white threads.

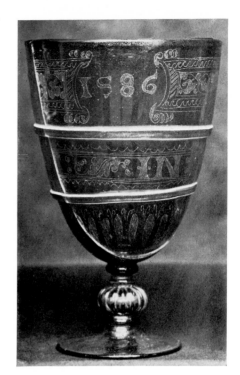

231

231. Goblet

Colourless glass, ovoid bowl on a ribbed knop and plain foot. The bowl divided into three registers by two gilded applied bands, each bordered by a thin opaque white thread circuit. Diamond-engraved in the upper register the initials 'GS' united by a love-knot (appearing twice) and the date '1586', each separated by a foliate panel; in the middle register, 'IN: GOD: IS: AL: MI: TRUST:'; in the bottom register and on the foot, simple scroll and gadroon decoration. A narrow band of gilding decorates the rim; the knop is also lightly gilt.

H, 13cm.

Reg. no. 95, 6–3, 17.

Attributed to the London glass-house of Jacopo Verzelini (1522–1606), situated in Broad Street; said to be engraved by Anthonye de Lysle, a Frenchman resident in London / Presented by Sir A. W. Franks, 1895.

BIBLIOGRAPHY: W. A. Thorpe, 'The Lisley Group of Elizabethan Glasses', *The Connoisseur*, cxxii, no. 510 (December, 1948), p. 110f.; W. A. Thorpe, 'An historic Verzelini Glass', *Burlington Magazine*, lxvii (1935), p. 150f.—for

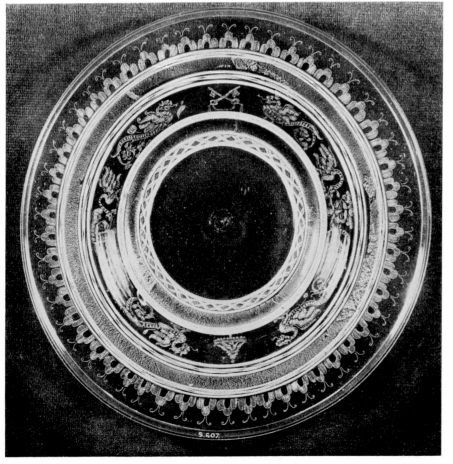

230

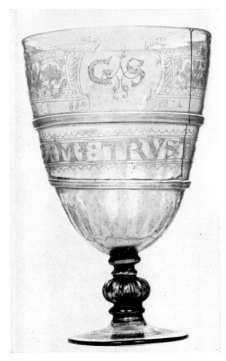

231

with the Worshipful Company of Pewterers, he may have used the Company's motto to decorate these glasses, but it must be stressed that contemporary Dutch and German diamond-engraved glasses bear similar, indeed identical, pious inscriptions written in the native tongue of the locality.

Of the eight items in this group, this glass is the only one to combine gilding with diamond-engraved decoration. A ninth glass firmly attributed to Verzelini and Anthonye de Lysle, the '*Wenyfrid Geares 1590*' goblet, now in a private collection in New York, is elaborately decorated with heraldic devices and inscriptions, entirely executed in gilding.

A most significant feature of the British Museum's specimen dated 1586, which appears on none of the other eight glasses, is the use of gilded bands of applied glass bordered on either side by a thin opaque-white thread. This motif is not uncommon on Continental glasses of the period, some of which are normally attributed to Venice (see no. 230), others to the Southern Netherlands (see no. 199) and some to Germany (see no. 182).

documentation on Anthonye de Lysle's presence in London; W. A. Thorpe, 'A newly discovered Verzelini Glass', *Burlington Magazine*, lvi (1930), p. 256f.; Buckley (1929); Hartshorne (1897), pp. 164–5, pl. 27.

NOTES: Jacopo Verzelini, a Venetian, was in 1586 (the date on this glass) the only person in England allowed to make glasses in the *façon de Venise* under a Royal Patent granted on 15 December, 1575. He retired in 1592 to his estate at Downe, Kent, but he died at his London house near the glass-works on 20 January, 1606.

Only eight glasses, all diamond-engraved in a similar manner and incorporating a date, are extant and can be attributed with some certainty to Verzelini; the dates range from 1577 to 1586.

The motto, 'IN: GOD: IS: MI: TRUST:' occurs on one other glass within this tiny group of eight, the goblet dated 1583 and inscribed with the initials, 'KY', and a merchant's mark (now in the Corning Museum, New York). Since two glasses bearing different initials have the same legend, it may be concluded that the motto was not used as a personal device. Thorpe has suggested that, because of Anthonye de Lysle's close connections

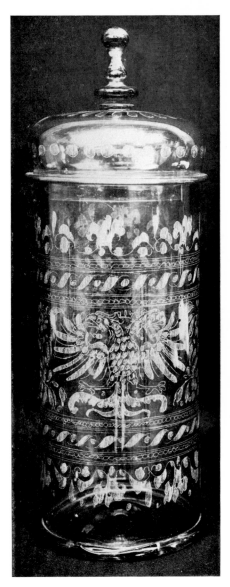

232

232. Covered 'Humpen'

So-called 'Willkomm', of colourless glass with greyish tinge, cylindrical, with low kick in base, and an applied foot-ring. The diamond-engraved decoration is gilded: two double-headed eagles separated by foliage with floral borders and bands of conventional ornament. Domed cover more simply ornamented with a band of circles and a radiating pattern centring on the finial with its gilt knop.

H, 36.4cm.

Reg. no. 81, 6–26, 7.

Germany, or Austrian Tyrol, second half of the 16th century / Formerly in the Disch Collection / Presented by A. W. Franks, Esq., 1881.

BIBLIOGRAPHY: H. Zedinek, 'Die Glashütte zu Hall in Tirol', *Altes Kunsthandwerk*, i, no. 3 (1927), p. 98f.; Buckley (1929), pl. 26f.; Honey (1946), p. 64f., pl. 33A; A.-M. Berryer, 'Enrichissement du Département de la Verrerie en 1953', *Bulletin des Musées Royaux d'Art et d'Histoire*, 1954, pp. 41–8, figs. 10–14; E. Egg, 'Die Glashütten zu Hall und Innsbruck im 16. Jahrhundert', *Tiroler Wirtschaftsstudien*, XV (1962).

233. Goblet

Clear glass with a slight greenish tinge, long funnel bowl on a hollow cushion-shaped knop and a trumpet foot. The bowl engraved with the diamond-point with two stylized symmetrical floral bouquets, with insects, including bees, a grasshopper, a beetle and an ant; bordered above and below by a formal ornamental band. Foot engraved with simple hearts and scrolls.

H, 27.1cm.

Reg. no. 91, 2–24, 8.

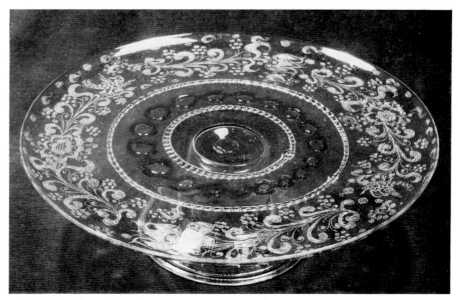

234

Façon de Venise, perhaps England, late 16th century / Formerly in the Hailstone collection / Purchased, 1891.

BIBLIOGRAPHY: Buckley (1929); Honey (1946), p. 62f.; E. Egg, 'Die Glashutten zu Hall und Innsbruck im 16. Jahrhundert', *Tiroler Wirtschaftsstudien*, XV (1962).

NOTES: The form is unusual and yet most happily proportioned—for a similar form in 'ice-glass', see Klesse (1963), no. 187; see also Düsseldorf-Kunstmuseum (1966), no. 225. There is an overall quality about this glass which may be seen as closely resembling the known products of Verzelini's glass-house in London in the late 16th century.

234. Tazza

Colourless glass, flat but with the rim slightly upturned, resting on a low trumpet-shaped foot decorated with a thread circuit. In the centre of the dish, two milled thread circuits enclose a chain motif in blue glass. The outer area ornamented with a floral wreath with two birds, engraved with the diamond-point.

D, 26.9cm. H, 7.8cm.

Reg. no. S 544.

Venice, early 17th century / Bequeathed by Felix Slade, Esq., F.S.A., 1868.

BIBLIOGRAPHY: Nesbitt (1871), p. 100, fig. 159; Frothingham (1963), p. 40, pl. 11A–B; Kestner-Museum (1957), no. 17, p. 49, pl. 6; J. Gudiol Ricart, *Monumenta Cataloniae*, III, *Los Vidrios Catalanes*, Barcelona (1941), pl. 77; Boesen (1960), nos. 11, 97 and 98; Klesse (1965), no. 83, p. 135.

NOTE: The attribution of this type of glass, with its distinctive combination of the chain motif in blue glass and the floral sprays and birds engraved with the diamond-point, to a Spanish workshop centred at Barcelona has yet to be proved; the more traditional attribution to Venice has been repeated here.

235. 'Roemer'

Green glass, spherical bowl opening into a cylindrical stem with two staggered horizontal rows of four large raspberry prunts and high kick supported on a coil-wound foot. A serrated thread circuit at the junction between bowl and stem and another plain, between stem and foot. The bowl engraved with the diamond-point with the half-length figure of a young man holding a baton and, in flowing script, the inscription: 'Noch Leeft Orange' (Still lives Orange).

H, 13.2cm.

Reg. no. 69, 1–20, 10.

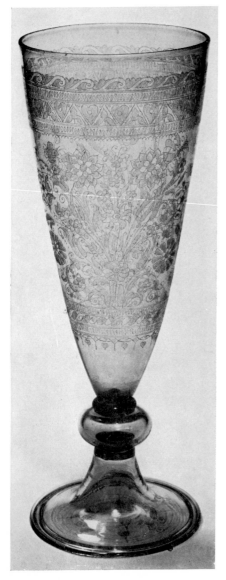

233

Holland, second quarter of the 17th century / Presented by the executors of the late Felix Slade, Esq., F.S.A., 1869.

BIBLIOGRAPHY: Hartshorne (1897), p. 66f., pl. 14; The Hague Gemeente Museum (1962), nos. 67–72, 104, pp. 47, 63.

NOTES: The engraving almost certainly depicts William II of Orange (1626–50), who in 1641 married Mary, Princess Royal of England and eldest daughter of Charles I, and whose son, the future William III of England, was born shortly after his death in 1650.

The inscription on this glass would suggest that this glass was decorated in 1650 to commemorate the death of William II and the perpetuation of the House of Orange with the birth of the Prince.

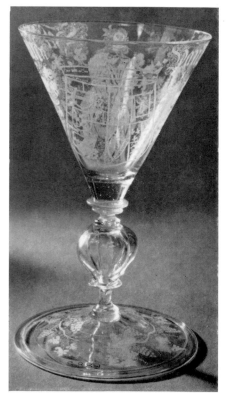

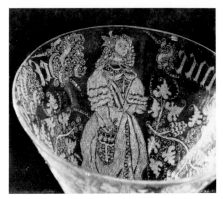

236

236. Goblet

Slightly smoky glass; funnel-shaped bowl on a stem with quatrefoil bulb above a foot with a folded rim. Both bowl and foot engraved with the diamond-point: on one side of the bowl, the figure of a lady in contemporary costume, above which is a highly ornate inscription: '*Het Welfaren Van De Princes*' (To the welfare of the Princess); on the opposite side, a shield surmounted with a coronet, bearing the arms of Orange and England impaled; vine branches decorate the intermediate spaces and the foot.

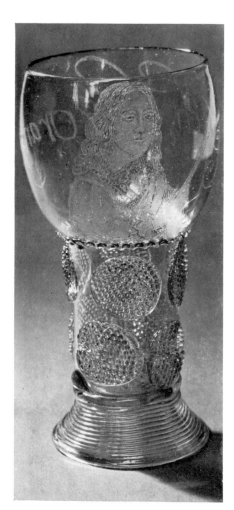

235

H, 16.1cm.

Reg. no. S 889.

Netherlands, probably decorated in 1657–58 / Bequeathed by Felix Slade, Esq., F.S.A., 1868.

BIBLIOGRAPHY: Nesbitt (1871), p. 153f., fig. 249.

NOTES: The engraving almost certainly depicts Mary, Princess Royal of England and Princess of Orange (1631–60), eldest daughter of Charles I and Henrietta Maria. Celebrated for her beauty and her intelligence, she was married to William of Orange in 1641, when she was nine and he was fifteen years old. Nine years later, soon after her young husband's death, she gave birth to a son, the future William III of England. In 1651, Princess Mary was by decree made tutrix of her son but the States refused to instate the prince in the honours enjoyed by his father. In August, 1658, Princess Mary, who had attained her full majority in November of the previous year, was acknowledged by the Parliament of Orange as sole Regent for her son, according to the terms of her husband's will. But, although she lived just long enough to share in her brother's triumphal Restoration to the throne of England, the last two years of her life were marred by the strong opposition to her Regency by factions in Holland.

This glass could, therefore, have been engraved in Holland at any date after the marriage in 1641. The wording of the inscription does not suggest that it was executed at the time of the birth of the prince in 1650. In consequence, the most probable date is 1657–58, when, having attained her full majority, Princess Mary was acknowledged sole Regent for her son.

The engraving is reminiscent of the work of Willem Mooleyser, but there is no evidence that he was active as early as 1658 in the field of glass-engraving.

A recent scientific examination of this glass in the Research Laboratory of the British Museum indicates that it is an alkaline glass with some lead content.

237. Flute

Colourless glass, tall conical bowl on short stem with hollow inverted baluster. Bowl and foot engraved with the diamond-point: on the foot, three flower-sprays, and, at the top of the bowl on one side, is the coat-of-arms of the Prince of Orange, below which is an eagle; on the other side, a full-length figure of a man in military attire (cuirasse, boots, etc.), below which is a parrot. The lower part of the bowl is closely covered with a spiral of floral ornament which commences above a narrow band of flowers and leaves.

H, 38.5cm.

Reg. no. S 894.

Holland, second quarter of the 17th century; perhaps engraved by Cristoffel Jansz Meyer / Bequeathed by Felix Slade, Esq., F.S.A., 1868.

BIBLIOGRAPHY: Nesbitt (1871), p. 156, fig. 255; Hudig (1926), p. 9f.; Buckley (1939), nos. 368–70, pls. 124–8; Honey (1946), p. 130f., pl. 36; M. A. Heukens-feldt-Jansen, 'Noord-Nederlandsch Glas van 16ᵉ en 17ᵉ eeuw', *Historia Maandblad voor Geschiedenis en Kunstgeschiedenis*, November, 1945, pp. 241–50; A. M. Berryer, 'Enrichissement du Département de la Verrerie en 1953', *Bull. des Musées Royaux d'Art et D'Histoire*, 1954, pp. 32–7, fig. 4; van Gelder (1955), p. 28f., pl. XX(5), 6; Hague Gemeente Museum (1962), p. 63, no. 103, p. 72, no. 122.

NOTES: The engraving almost certainly depicts Frederick-Henry, Prince of Orange (1584–1647), who became Stadt-holder of the United Provinces in 1625. A successful and prudent general, he is depicted on this glass holding his baton and clad in his military attire. The glass and its engraved decoration probably date from the early forties.

For undecorated flute glasses of similar form, see Hague Gemeente Museum (1962), p. 29, nos. 25–8.

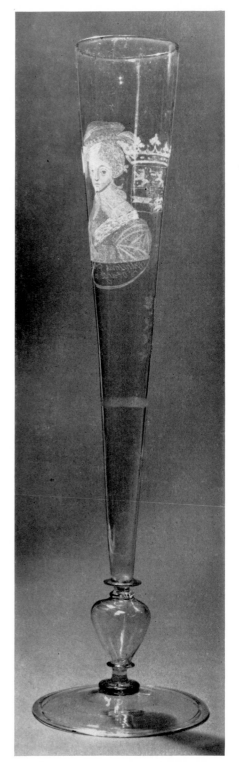

238

238. Flute

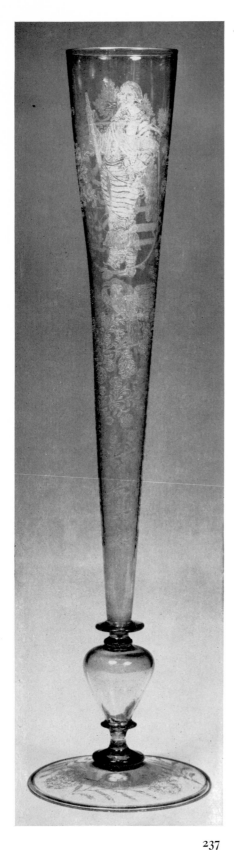

237

Colourless glass; tall conical body on short stem composed of a hollow inverted baluster between two collars ('*mereses*') on a folded foot. The bowl engraved with the diamond-point: on one side, a half-length portrait of a very young boy, wearing a plumed hat and holding a baton; on the other side, the coat-of-arms of the House of Orange, beneath

which a sapling grows from a belt of grass. Beneath the half-length portrait, the inscription: 'Wilhelmus Prince d'Orange, etc.'

H, 40.1cm.

Reg. no. 72, 12–1, 12.

Holland, mid-17th century / Presented by the executors of the late Felix Slade, Esq., F.S.A., 1872.

BIBLIOGRAPHY: Hudig (1926), p. 9f.; Buckley (1939), nos. 368–70, Pls. 124–8; Honey (1946), p. 130f., pl. 36; van Gelder (1955), p. 28f., pls. XX (3); R. J. Charleston, 'Dutch Decoration of English Glass', *Trans. of Soc. of Glass Technology*, 1957, XLI, pp. 229ff., fig. 4; Hague Gemeente Museum (1962), p. 63, no. 103; p. 72, no. 122.

NOTES: The engraving is said to depict the future William III of England (born 15 November, 1650), as a young boy. His father, William II, Prince of Orange (born 1626; died 1650) and Stadtholder (1647–50), married Mary, Princess Royal of England, in 1641.

239. 'Roemer'

Colourless glass and of very unusual shape; cylindrical stem decorated with three staggered horizontal rows of four gilded strawberry prunts and a gilded milled thread circuit opening into a spherical bowl and supported on a trumpet-shaped foot. Bowl, stem and foot are engraved with the diamond-point. On the bowl, four medallions containing half-length emblematic figures representing the four Seasons: Spring—a female holding a shepherd's crook and flowers with hair garlanded with flowers; Summer—a female holding a bowl containing fruits of the harvest, her hair festooned with wheat and flowers; Autumn—a young man with a garland of vine leaves in his hair and holding a footed beaker of wine; Winter—an old man warmly dressed and warming his hands over a brazier, with carrots, gourds, etc. on his head. Around the rim and in the spandrels between the medallions, a vine stem with a bird and a rabbit. On the stem, a wreath containing the initials ' H ' and on the other
 W E
side, the date: 'August the 18th, 1663'.

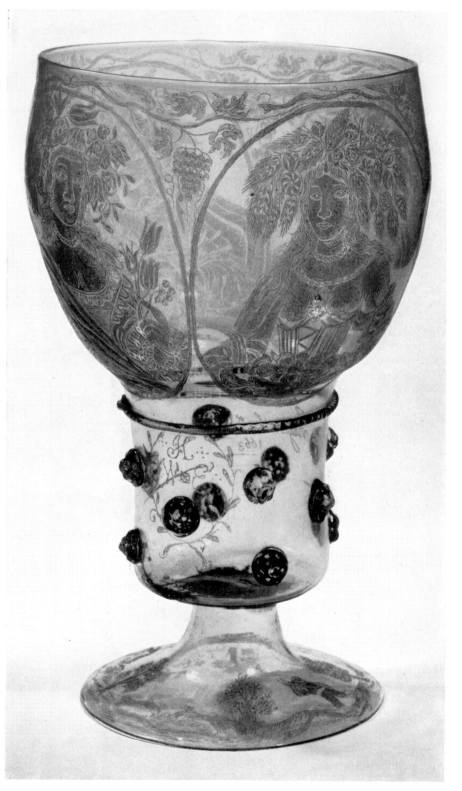

239

171

Around the foot, a stag pursued by a hunter and two hounds through a landscape including trees, a windmill and a horse and cart.

H, 22.5cm.

Reg. no. 1895, 6–12, 1.

Probably English (the Duke of Buckingham's glass-house at Greenwich), about 1660–63 / Purchased, 1895.

BIBLIOGRAPHY: Hartshorne (1897), p. 223, pl. 28; Hudig (1926), pp. 8ff.; Thorpe (1929), pp. 100ff., pl. VII (i); R. J. Charleston, 'Dutch Decoration of English Glass', *Trans. of Soc. of Glass Technology*, 1957, XLI, p. 232, fig. 6.

NOTES: The engraving is executed in the Netherlandish manner but may be the work of an Englishman, although it is clearly not by the same hand as the 1663 Royal Oak goblet (now in U.S.A.), the only comparable piece with English connections to have survived.

No other glass of this form is known and, though it is basically a roemer shape, this variant is unlikely to have been made in Holland.

240. Covered Goblet

Colourless glass; conical bowl over a stem of two ribbed hollow inverted balusters with applied ear-shaped wings supported on a foot with folded rim; domed cover with finial similar to stem; cover and lower part of bowl have applied dotted rib ornament. Diamond-engraved inscription on the cover:
''T WELVAREN VAN HET' (The prosperity of the)
and on the bowl, midst calligraphic flourishes, the inscription:
'VADERLAND' (Fatherland),
repeated once in reverse.

H, 36.5cm.

Reg. no. 73, 12–4, 1.

Netherlands, mid-17th century; engraved by Willem van Heemskerk or a follower / Purchased, 1873.

BIBLIOGRAPHY: van Gelder (1955), p. 29f., pls. XXIII, XXIV; Hague Gemeente Museum (1962), nos. 109–16, p. 67f.; Klesse (1965), no. 98, p. 143.

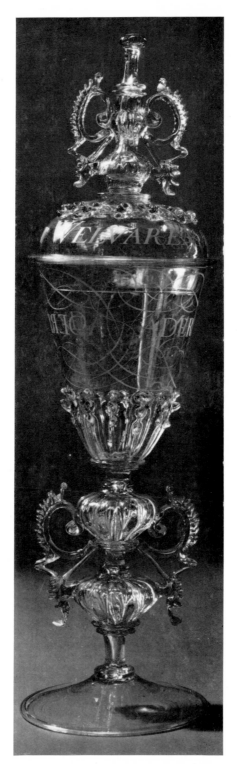

240

NOTES: About the middle of the 17th century, wheel-engraving began to be practised in the Netherlands, but it was not until the end of the century that diamond-engraving gave place to the wheel-engraved decoration.

Willem Jacobsz van Heemskerk (born 1613; died 1692), a cloth merchant of Leiden, was also a poet and a dramatist, but his skill as an amateur glass engraver with the diamond-point was scarcely rivalled, especially in this calligraphic style.

241. Goblet

Colourless glass, with oviform bowl, resting on a stem enclosing ornamental air bubbles. The bowl is almost entirely decorated with stipple engraving; Bacchus on a barrel, surrounded by satyrs, bacchantes, fauns, and goats, etc., grouped in a clearing of a wood; on the side of a large stone tomb or monument beneath a tree, an inscription (engraved with the diamond-point):

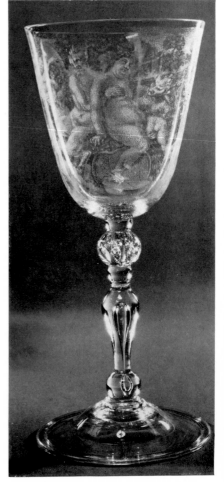

241

Het druiven bloet,
Dat lieflyk zoet,
Noemt Salomon een spotter.
Die't gulzig drinkt,
En brast'en klint,
Wort vroeg benooit 'en zotter.
 F. Greenwood Ft.

(The juice of the grape, that delightful sweet thing, Solomon calls a mocker; he who drinks greedily, revels and toasts, will quickly become befuddled and sillier.
 F. Greenwood made it)

H, 24.2cm.

Reg. no. S 903.

English, perhaps Newcastle-upon-Tyne. Engraved in Holland (at Dordrecht) by Francis Greenwood about 1750 / Bequeathed by Felix Slade, Esq., F.S.A., 1868.

BIBLIOGRAPHY: Nesbitt (1871), p. 158, fig. 258; Hudig (1926), pp. 15ff.; W. Buckley, *Notes on Frans Greenwood*, London (1930), pp. 11, 15, no. 24, pl. 28; Honey (1946), pp. 10, 132–3; van Gelder (1955), p. 32, pl. XXX; R. J. Charleston, 'Dutch Decoration of English Glass', *Trans. of Soc. of Glass Technology*, 1957, XLI, p. 240f.

NOTE: Francis Greenwood, born in 1680 in Rotterdam, was of English descent and in 1726 became a civil servant in Dordrecht, where he died in 1761. Greenwood is credited with the invention of stipple engraving on glass in 1722.

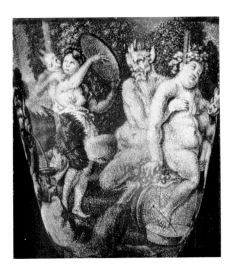

241

242. Goblet

Colourless glass; round funnel bowl continuing into a solid stem; base of bowl and stem cut in ovals and facets giving the effect of a many-petalled flower when viewed through the bottom of the bowl. One side of bowl, stipple-engraved with two female figures, one holding a scroll inscribed (with the diamond-point): 'Werken van het Genootschap K.W.D.A.V.' (Works of the Society, K.W.D.A.V.). On the reverse side of the bowl, executed with the diamond-point, festoon and the inscription:

Zy, die Seraphs kan bekooren,
Tygers naar heur toon doet hooren;
Wen ze een's ORPHEUS Lier besnaart,
Leer' den Mensch hoe Eng'len zingen;
Tot zyn zang, in hooger' kringen,
Zich met dien der Eng'len paart.

(She, who can enchant the Seraphs, who can make tigers listen to her songs; When she plucks the lyre of an Orpheus, Teach Man how Angels sing; Until his song in higher spheres, Unites with that of the Angels.)

On the foot, the diamond-engraved inscription:

'Aan het Genoodschap: KUNST WORDT DOOR ARBEID VERKREGEN; bÿ deszelfs Vÿfentwintig-Jaarig feest, op XI—Slaghtmaand, 1791.
 De Medebestuurders.'

(To the Society: *Art is achieved by Work*, on its twenty-fifth anniversary, on 11 November, 1791.
 The Committee.)

H, 18.5cm.

Reg. no. 69, 1–20, 16.

English, probably Newcastle-upon-Tyne; stipple-engraving, attributed to David Wolff, of the Hague; dated 1791 / Presented by the executors of the late Felix Slade, Esq., F.S.A., 1869.

BIBLIOGRAPHY: Hudig (1926), p. 20, figs. H and J; W. Buckley, *D. Wolff and the Glasses that He Engraved*, London (1935); Honey (1946), p. 135; van Gelder (1955), p. 33f., pls. XXXI–XXXII; R. J. Charleston, 'Dutch Decoration of English Glass', *Trans. of Soc. of Glass Technology*, 1957, XLI, p. 241.

NOTE: This Society met in Leyden.

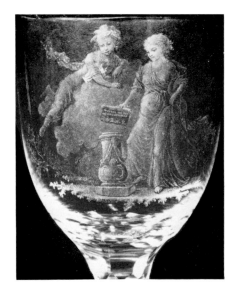

242

E. GLASS WITH WHEEL-ENGRAVED DECORATION

243. Covered Jar

Colourless but 'crizzling' glass, of cylindrical form on a foot-ring; wheel-engraved decoration consists of:

(*a*) around the bowl, three medallions separated by symmetrical foliage scrolls with birds, fruit, masks and musical

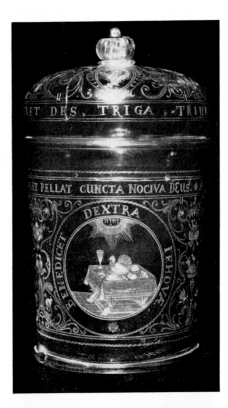

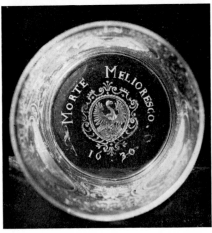

243

instruments enclosing the following scenes:

(1) Bellona, the Goddess of War, being dismissed by the Goddess of Peace, with the inscription: 'PROCUL HINC BELLONA FACESSE'.

(2) Noah's Ark with the dove of peace and inscription: 'ADSIT PAX AUREA RURSUM'.

(3) Covered table with turkey and beaker inscribed: 'BENEDICET DEXTRA IEHOVAE'. Below the rim, the inscription: 'AUTOREM, POSSESSORES, EX HOCQUE BIBENTES PROTEGAT ET PELLAT CUNCTA NOCIVA DEUS';

(*b*) on cover, between symmetrical inhabited scrolls, the arms of three Nürnberg families: Imhoff, Pömer and Kötzler, with the inscription: 'NESTORIS HAEC ANNOS SUPERET DES, TRIGA, TRIUNE'. On base, in trailwork, a Phoenix over flames, the date '1630' and inscription: 'MQRTE MELIORESCO'. The knop on the cover is a later replacement and has touches of gilding.

H, 18.2cm.

Reg. no. 1938, 11–1, 1.

Nürnberg; engraved by George Schwanhardt, the Elder (1601–67); dated 1630 / Purchased, 1938.

BIBLIOGRAPHY: E. G. Troche, 'Neue Jugendwerke von Georg Schwanhardt D.Ä.', *Pantheon*, XXV (1940), p. 138f.; Willi Meyer-Heisig (1963), no. 6, pp. 29, 74.

NOTES: The decoration on this piece relates to the Thirty Years' War (1618–48). George Schwanhardt, the Elder, was the foremost pupil of Caspar Lehmann (*c.* 1570–1622), the first great wheel-engraver of glass. Schwanhardt returned to Nürnberg on the death of Lehmann, and his two sons and three of his daughters carried on the art of glass engraving.

244. Goblet

Colourless glass; round funnel bowl on a long stem composed of a hollow knop and inverted baluster separated by pairs of mereses on a flat foot with rim folded under. Wheel-engraved decoration, on foot, comprises laurel leaf and berry circuit; on the bowl, two bacchanalian scenes:

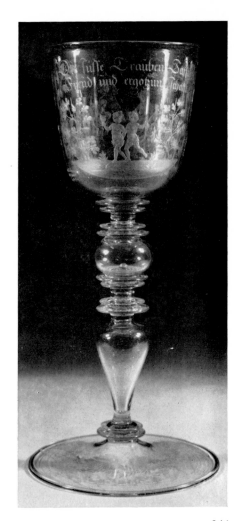

244

(1) two boys, one with a wine glass and one with grapes, flanked by two grape vines and superscribed:

> Der süsse Trauben Safft
> Freud und ergötzung schafft.

(Sweet grape-juice supplies mirth and bliss.)

(2) Bacchus seated on a wine barrel, Ceres reclining on sheaves of corn holding a cornucopia and attended by two putti, the whole framed by vine stems. Signed, on the lower part of the bowl, with the diamond-point:

> Herman Schwinger
> Cristall schneider
> zu Nürnberg.

H. 27.8cm.

Reg. no. S 883.

Nürnberg; engraved about 1665 by

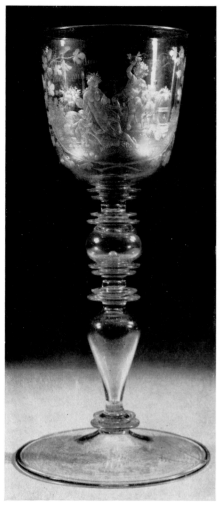

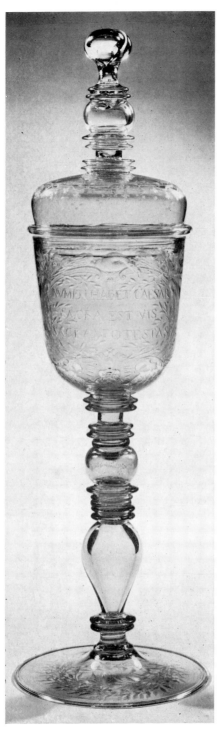

244

245

Herman Schwinger (1640–83) / Bequeathed by Felix Slade, Esq., F.S.A., 1868.

BIBLIOGRAPHY: Nesbitt (1871), p. 150; Meyer-Heisig (1963), p. 55, no. 82.

NOTE: Herman Schwinger (1640–83) was one of the gifted glass-engravers of the Nürnberg school.

245. Covered Goblet

Colourless glass; round funnel bowl on long stem composed of a hollow knop and inverted baluster separated by groups of mereses on a flat foot with rim folded under. On one side of the bowl, wheel-engraved decoration comprising an altar on which are placed the orb, sceptre, sword and the Ottonian crown of the Holy Roman Empire (the imperial

insignia), with a radiant sun above, and enclosed by a foliate wreath and eagles; on the other side of the bowl, the inscription:

'NVMEN HABET CAESAR
SACRA EST VIS
SACRA POTESTAS'

The foot, engraved with a circuit of simple foliage, bears the signature: 'Killinger fec. Norib.' (executed with the diamond-point). A ring of scroll work is engraved on the cover.

H, 27.6cm. (without cover).

Reg. no. 88, 12–14, 4.

Nürnberg; first quarter of the 18th century; engraved by Georg Friedrich Killinger / Formerly in the Morgan Collection / Purchased, 1888.

BIBLIOGRAPHY: Meyer-Heisig (1963), pp. 67ff., nos. 184–217.

NOTES: This goblet is not included in Erich Meyer-Heisig's comprehensive list of known works by Killinger—probably because this piece has not been published before.

The cover does not seem to belong to this goblet, although it fits well.

246. Covered Goblet

Colourless glass; thistle-shaped bowl, the base cut in facets and ovals, on a faceted inverted baluster stem; domed cover with faceted finial decorated wheel-engraved foliage scrolls; the foot similarly ornamented. The body of the bowl, on one side wheel-engraved with the monogram 'AR' beneath a royal crown; on the other side, the Royal Coat of Arms of England, as borne by Queen Anne (1665–1714) and the motto: 'SEMPER EADEM'.

H, 30.1cm.

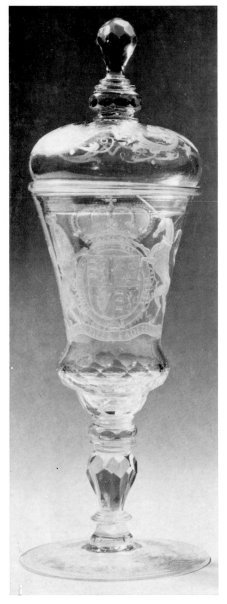

246

247. Goblet

Colourless glass; the round funnel bowl cut in long panels on a stem composed of a faceted knop and inverted baluster. The bowl and foot profusely decorated with wheel-engraved ornament: on three sides of the bowl, between bands of ornament, a panoramic view of London, framed by caryatides, above which the arms of England, Scotland and Ireland, with an unidentified coat of arms on the fourth side. Foot engraved with ornament similar to that on the bowl but tinted grey.

H, 22.3cm.

Reg. no. 1942, 7–9, 1.

Silesia, early 18th century / Purchased, 1942.

BIBLIOGRAPHY: Kestner-Museum (1957), p. 79, no. 148; Hugh Tait, 'A Review of Post Medieval European Glass Acquired since the Outbreak of the Second World War', *BMQ* (1963–64), XXVII, nos. 1–2, pp. 30–1, pl. XI (a); O. Drahotova, 'The Circle of the Master of the So-Called Koula's Beaker', *Bohemian Glass*, vol. XX, (June 1965), pp. 29–32.

NOTES: The panoramic view of London engraved on this goblet seems closest to Visscher's famous long view of 'London from St. Catherine's in the East to the Palace of Westminster', which is dated 1616, but there is one notable difference.

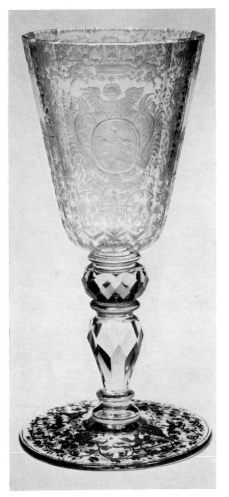

247

247

Reg. no. 1965, 4–5, 1.

Saxony; engraved in Dresden between 1707 and 1714 / Purchased, 1965.

BIBLIOGRAPHY: Bremen (1964), p. 407, no. 224; Kestner-Museum (1957), no. 136, p. 76.

NOTES: The version of the Royal Arms on this goblet is the one used by Queen Anne from the time of the Act of Union with Scotland, namely 1707, until the end of her reign in 1714.

The motto, 'Semper Eadem', was used by Queen Anne in preference to 'Dieu et Mon Droit'.

The monogram, 'AR', stands, therefore, for Anna Regina, and no doubt this glass, the only one of its kind known to survive, was a special presentation gift, perhaps by the Elector of Saxony's ambassador to the court of St. James's in London.

The tower over the crossing of old St. Paul's is depicted by Visscher with a flat roof, whereas the Silesian glass-engraver has given it a sloping gable roof, a feature which it appears, in fact, to have possessed by the mid-17th century.

248. Shell-shaped Cup

Colourless glass, with deep cuttings forming a series of bold projecting compartments, the curved surfaces of which are minutely engraved with figures, scrolls and other ornaments. The faceted stem supported on a polygonal foot.

H, 13.5cm.

Reg. no. S 881.

Silesia, 1730–40 / Bequeathed by Felix Slade, Esq., F.S.A., 1868.

BIBLIOGRAPHY: Nesbitt (1871), p. 149, fig. 246; Düsseldorf-Kunstmuseum (1966), p. 118, no. 362.

NOTE: Perhaps intended for use as a sweetmeat dish.

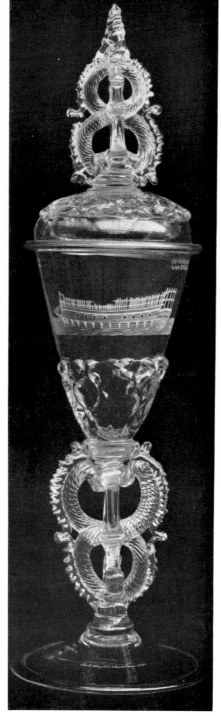

249

249. Covered Goblet

Lead glass. Round funnel bowl with 'nipt diamond waies' around the base on a figure-of-eight stem with pincered frills supported on a folded foot. The domed cover ornamented with 'nipt diamond

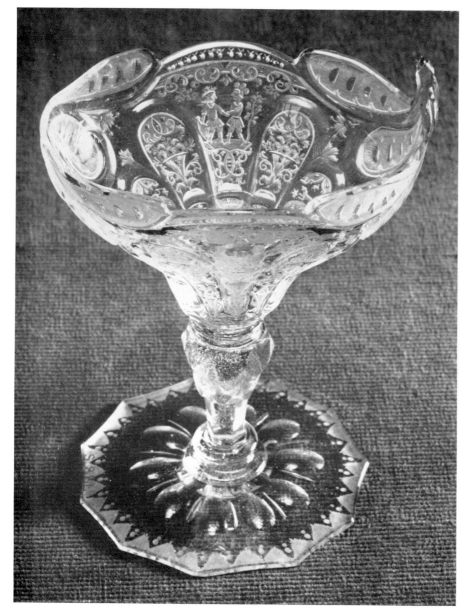

248

waies' and a finial like the stem. The bowl wheel-engraved with a ship on the stocks named VELZEN, and an inscription:

OP HET HONDERDSTE SCHIP, GENAEMD VELZEN DOOR MR WILLEM THEUNISZ BLOK TEN DIENST VAN D'E: O,I. COMPAGNIE VOLBOUWD, DEN 30 IUNŸ 1757 VAN DE WERF TE WATER GELOOPEN.
HET SCHIP SPREEKT.
KOMT KONSTEN AEREN HIER, AEN'T Ÿ,
DE BAES VAN INDIESCH-MAET-SCHAPPY
DEN GROOTEN BLOK, DIE NOOD U ALLEN,
EN VRAEGD EEN IEDERS WELGE-VALLEN?
ZIET M'EERST RONDOM, DAN BINNEN BOORD,
'K BEN VELZEN, DAT ELKS OOG BE-KOORD:
HET HONDERDSTE VAN'S MANS GEBOUWEN,
WIE STAROOGD NIET, OP'T BLŸDE AENSCHOUWEN
VAN MŸN VOLMAEKTEN STROOK EN ZWIER?
DIE TIMM'REN LEEREN WIL, LEER' HIER!

G.B.

On the occasion of the hundredth ship, named the *Velzen*, built by Master Willem Theunisz Blok, in the service of the Honourable East India Company, launched at the yard on 30 June, 1757.
 The Ship speaks.
Come Artists here, to the IJ,
The Master of the India Company,
The Great Blok, invites you all
And asks all of you what will you have?
First look all around me and then inside,
I am *Velzen*, that enchants every eye:
The hundredth ship this man has built,
Who is not amazed and happy, looking at my perfect shape and line?
He, who wants to learn shipbuilding, let him learn here!

G.B.

Engraved in diamond-point on the base: Jacob Sang, Fec.: Amsterdam 1757.

H, 49.5cm.

Reg. no. 69, 1–20, 17.

English, about 1700. Engraved in Holland by Jacob Sang in 1757 / Presented by the executors of the late Felix Slade, Esq., F.S.A., 1869.

BIBLIOGRAPHY: Sir H. Hercules Read, 'Two Anglo-Venetian Glasses', *Burlington Magazine*, xlviii (1926), p. 186f., pl. B.; Thorpe (1929), pl. XXX (1); G. E. Pazaurek, 'Die Glasschneiderfamilie Sang', *Der Wanderer* (1930), pp. 1–11; R. J. Charleston, 'Dutch Decoration of English Glass', *Trans. of Soc. of Glass Technology* (1957), XLI, p. 241f.; R. J. Charleston, 'English Glass in the Reserve Collections at the Rijksmuseum', *The Connoisseur*, clx (1965), p. 238, figs. 2 and 3.

NOTES: A similar glass, with identical stem, is in the Donald Beves collection, in the Fitzwilliam Museum, Cambridge; however, the elaborate finial of the cover does not repeat the motif of the stem, as on the British Museum's example, nor has the Beves goblet been engraved—

see 'English Glass in the Collection of Mr. Donald H. Beves', *The Connoisseur* (June, 1960), pp. 32–7, fig. 9.

The *Velzen* was named after a village near Amsterdam; she made several voyages to the Indies and sailed for the last time from the Texel in 1771.

Willem Theuniszoon Blok was born in 1684 and became the chief shipwright to the Dutch East India Company.

250. Tazza

Colourless glass, with a bowl of very open conical form, on an inverted baluster stem. The bowl is expertly wheel-engraved with arabesque patterns, intermingled with filaments, which terminate in clear spots; a similar decoration may be observed on the foot and bulb of stem.

H, 16cm. D, 18.3cm.

Reg. no. S 829.

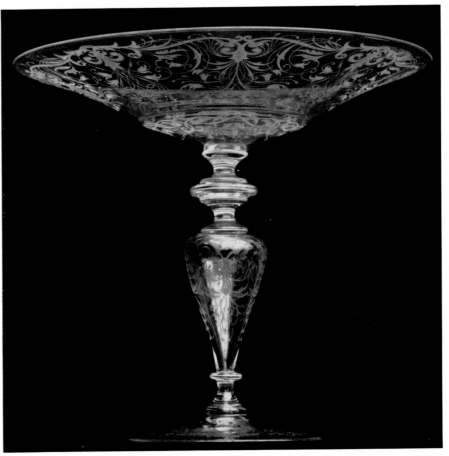

250

France; made at Clichy-la-Garenne near Paris in 1862 / The International Exhibition of 1862 (held in London)—exhibited by M. Maës, one of the founders of the Clichy glassworks in 1844 / Bequeathed by Felix Slade, Esq., F.S.A. 1868.

BIBLIOGRAPHY: Nesbitt (1871), p. 137; Barrelet (1953), pp. 123ff.

NOTE: The presence of this piece in the Slade Collection is explained in Nesbitt's Catalogue in the following terms: '*It was selected as one of the best examples of engraving on glass in the Exhibition, and this must be the excuse for introducing so modern a specimen into this catalogue.*'

F. COLOURED GLASS

251. Miniature Ewer

(One of a pair) of *millefiori* clear glass; the flattened globular body is heavily ribbed, and opens into a narrow bulbous neck; a small handle is joined to the shoulder of the vessel and touches the bulge of the neck.

Silver-gilt mounts comprise a hinged cover with baluster knop, a thumb-piece with mask, four caryatid scroll feet and four vertical straps encompassing the body, one of which divides to pass on either side of the handle.

H, 12.6cm.

Reg. no. S 799.

Venice, 16th century / Debruge-Duménil collection (before 1838); Prince P. Soltykoff collection (before 1861) / Bequeathed by Felix Slade, Esq., F.S.A., 1868.

BIBLIOGRAPHY: J. Labarte, *La Collection Debruge-Duménil*, Paris (1847), pp. 355–6, p. 708, nos. 1366–7, *Hotel Drouot, Paris, Sale Catalogue of collection of Prince Soltykoff*, April 1861, lot 784, p. 195; Nesbitt (1871), p. 134, nos. 799–800, colour pl. XVIII (2); Schmidt (1922), pp. 87–9, fig. 51; Haevernick (1961), p. 132, pl. 52(1); Düsseldorf Museum (1966), p. 81, nos. 221–2.

NOTE: The so-called *millefiori* glass made in Venice in the 16th century is inspired by the ancient Roman *millefiori* glass, but, apparently, the Venetian process differed from the Roman although a similar effect was produced—see Honey (1946), pp. 23f. and 57.

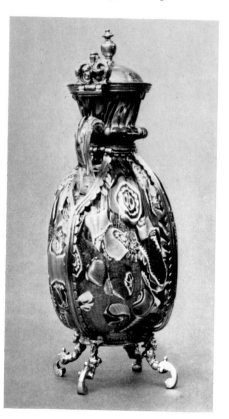 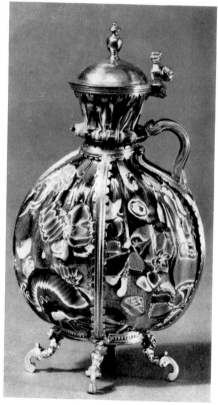

251

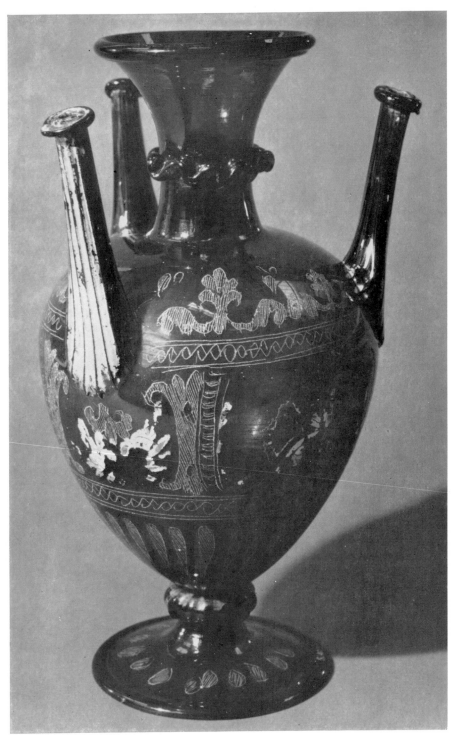

252. Large 'Bouquetière'

Dark blue glass, having an oviform body and concaving neck expanding at the mouth, and encircled with a wavy fillet; three almost vertical tubes rise, equidistant, from the shoulder of the body; the stem comprises a compressed fluted bulb above a conical foot. The vertical tubes are gilt, and traces of elaborate gilt patterns are perceptible round the whole of the body, combined with diamond-engraved frames and scrolls of an elaborate character.

H, 20.2cm.

Reg. no. S 405.

Attributed to Hall (in the Tyrol), second half of the 16th century / Bequeathed by Felix Slade, Esq., F.S.A., 1868.

BIBLIOGRAPHY: Nesbitt (1871), p. 80; H. Zedinek, 'Die Glashütte zu Hall in Tirol', *Alter Kunsthandwerk*, i, no. 3 (1927), pp. 98ff.; Buckley (1929), p. 17, pls. 24–5; Buckley (1939), nos. 177, 211, pls. 40, 53; Honey (1946), p. 64, pl. 33B; Gasparetto (1958), pls. 82, 85; Mariacher (1961), pls. 52–3; E. Egg, 'Die Glashütten zu Hall und Innsbruck im 16. Jahrhundert', *Tiroler Wirtschaftsstudien*, XV (1962).

NOTE: The form is probably derived from the Spanish *almorrata* or sprinkler— for 16th–18th-century glass examples made in Spain, see J. Gudiol Ricart, *Los Vidrios Catalanes* (Barcelona, 1941), nos. 68, 104–5.

252

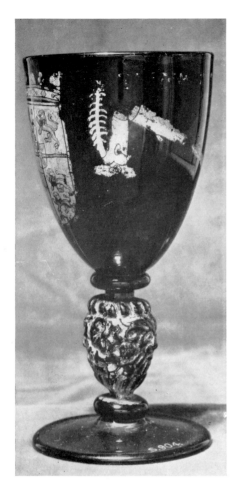

253

Netherlands; late 16th or early 17th century / Presented by John Henderson, Esq., to Felix Slade / Bequeathed by Felix Slade, Esq., F.S.A., 1868.

BIBLIOGRAPHY: Nesbitt (1871), p. 158; E. Frhr. Schenk zu Schweinsberg, 'Ein Mundglas aus dem Hause Oranien-Nassau', *Pantheon* (1967), pp. 281–3, Figs. 1–5.

NOTES: This goblet appears to have been made for Prince Maurice of Orange

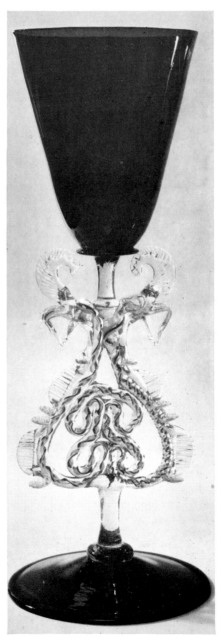

254

253. Goblet

Emerald-green glass, with a baluster stem ornamented with masks in relief, and partially gilt. On the bowl are the following devices, executed in gilding:

(i) the arms of Nassau–Orange under a coronet, probably for Philip William, Prince of Orange, died 1618;

(ii) the arms of Nassau, as borne by Maurice, Prince of Orange, died in 1625;

(iii) and between them, a tree cut down and a new stem is springing from its root, the personal device of Prince Maurice; above and near the rim, the motto: 'TANDEM FIT SVRCVLVS ARBOR' (The sucker at length becomes a tree)— this motto was adopted by Prince Maurice in order to indicate his intention to follow in his father's footsteps.

H, 16.8cm.

Reg. no. S 904.

(1567–1625). He was the son of Prince William of Nassau, styled the Great, by a second marriage. He was a renowned general, became Stadtholder in 1584 and inherited the title of Prince of Orange in 1618, when his half-brother, Prince Philip William, died. In 1621 he renewed the war against the Spaniards and died in 1625. The goblet appears to date from after 1584 and probably before 1610.

254. Goblet

The bowl and foot of purple glass; round-funnel bowl over a convoluted stem of colourless rods enclosing twisted opaque white, blue and red threads with clear cresting pinchings around the edge, on a short stem and plain foot with narrow edge folded under.

H, 29cm.

Reg. no. S 587.

Netherlands or Germany, early 17th century / Bequeathed by Felix Slade, Esq., F.S.A., 1868.

BIBLIOGRAPHY: Nesbitt (1871), p. 106, fig. 181; Klesse (1963), p. 110, nos. 222, 224.

NOTE: For the late 19th-century copies of this type of goblet, which were made at Ehrenfeld, near Cologne, see Klesse (1963), p. 186, nos. 441–3, pls. 18–19.

255. The 'Amiens Chalice'

Vase, of thick blue glass, with two handles; expanding tip opening out of a globular fluted body on a fluted, bell-shaped foot; the two handles are of particularly bold and massive form and grooved to create the impression of twisted rope.

H, 16cm. W (between handles), 24cm.

G.R. Reg. no. 1865, 1–3, 50.

Perhaps France, late 17th century / Said to have been found near Amiens, 'the ancient Samarobriva'; formerly in the Pourtalès collection, Paris / Purchased, 1865.

BIBLIOGRAPHY: *Catalogue des Objets d'Art de feu M. Le Comte de Pourtalès-Gorgier et dont la vente aura lieu en son hôtel*, rue Tronchet no. 7, 6 Février 1865 et jours suivants, no. 1401. Nesbitt

(1871), p. 55, fig. 72; Dalton (1901a), p. 132, no. 658; Kisa (1908), pp. 890ff.; Schmidt (1922); A. E. A. Werner, 'Problems in the Conservation of Glass', *Annales du 1er Congrès des Journées Internationales du Verre*, Liège (1959), pp. 189ff., fig. 50.

NOTES: Only one comparable piece (Slade Collection, no. 318) is known to have survived, but it has no provenance and has lost both its handles.

Both pieces have suffered equally from a process of decomposition, known as 'crizzling'. This defect is said not to occur among ancient Roman glass and has led scholars to doubt the previous attribution of the 'Amiens Chalice' to the 5th century A.D. The absence of comparable archaeological material from classical contexts has served to strengthen these doubts.

The recent scientific examinations, carried out in the British Museum's Research Laboratory, have shown that both the 'Amiens Chalice' and its Slade Collection companion piece have an almost identical chemical make-up, with a high potash content and a low lead content.

If the date of manufacture is considered to be post-classical, then it seems unlikely, on stylistic grounds, to be earlier than the 17th century. Similarly, there seems to be little evidence to support an attribution to Venice or Germany.

One glass, the so-called 'Savoy Vase', bears very close affinities with the 'Amiens Chalice'. Formerly in the collection of Mr. Henry Brown (see *Glass Notes*, compiled by Arthur Churchill, Ltd. (December, 1946), VI, p. 28, fig.

XII), sold at Sotheby & Co. (29 July, 1947, lot 200, Colour Plate Frontispiece) and now in the Toledo Museum of Art. This 'Savoy Vase' is made of heavily 'crizzled' blue glass and has two handles attached to the neck and sides of the vessel in the same unusual idiomatic manner. The 'Savoy Vase' has always been published as a product of George Ravenscroft's glass-house about 1674–5, most recently by J. Paul Hudson, 'George Ravenscroft. . . .', *Antiques*, xcii, (Dec., 1967), pp. 822ff, fig. 29; again, it has been described as a 'lead-metal' but no authority for its scientific analysis has been named.

The recent analysis of two indisputable examples of Ravenscroft glass (including no. 189 in this exhibition) has revealed that they have a high lead content and bear no close resemblance to the composition of the 'Amiens Chalice' or the Slade companion piece. Therefore, unless a group of experimental glasses from Ravenscroft glass-house can be shown to have the low lead content, the attribution of the 'Amiens Chalice' to Ravenscroft is unacceptable.

The conclusion that seems, at present, to be the most acceptable attributes the 'Amiens Chalice' to a French glass-house during the late 17th century. Recent analysis of two glass vessels, previously held to be of French 17th-century origin, revealed almost identical results—a potash content of about 12 per cent and a lead content of about 1–3 per cent.

On stylistic grounds, the 'Amiens Chalice' can be compared with certain vessels made at the famous Nevers faïence potteries in the late 17th century—see, *Repertoire de la Faïence Française*, Paris (1935), II, pl. 6; Arthur Lane, *French Faïence*, London (1948), pp. 11–13, pl. 14; H.-P. Fourest, 'La Faïence Nivernaise au Musée de Nevers', *La Revue Française*, supplément au 118, (May, 1960); J. Giacomotti, *French Faïence*, London (1963), p. 48, fig. 11.

256. Goblet

Tall, blue, with dome cover, and resting on a colourless glass baluster stem, and a conical blue foot. The cover is surmounted by a finial composed of colourless bulbs, bearing a blue knop surmounted by a strawberry prunt.

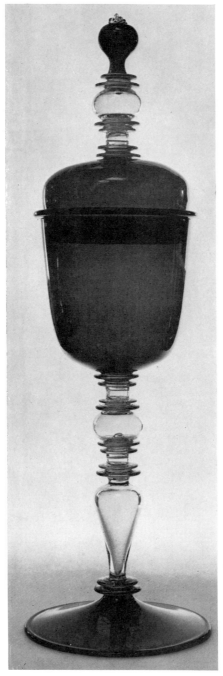

256

H, 40.6cm.

Reg. no. S 874.

Nürnberg; late 17th century / Bequeathed by Felix Slade, Esq., F.S.A., 1868.

BIBLIOGRAPHY: Nesbitt (1871), p. 148; Klesse (1963), p. 135, no. 294; Düsseldorf-Kunstmuseum (1966), p. 107, no. 326.

257. Covered Goblet

Deep blue glass; cylindrical bowl with rounded base, on a stem composed of a knop and an inverted hexagonal baluster, supported by a conical foot; cover terminating in a finial similar to the stem in reverse. The cover, base of bowl, stem and foot all enriched with circuits of a simple, cut leaf pattern; a band of cut

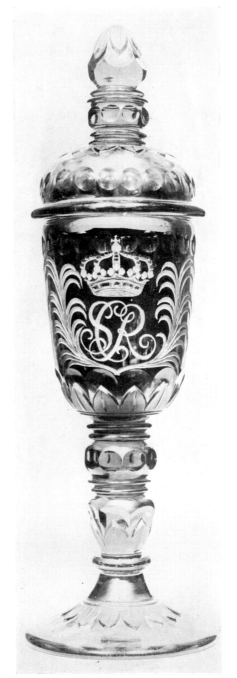

257

and polished circles ornaments the lower part of the cover and upper part of the bowl. The sides of the bowl engraved with cypher, 'SCR' beneath a crown and framed by two large fronds of laurel.

H, 31cm.

Reg. no. 1907, 7–26, 1.

Germany, Potsdam; engraved between 1701 and 1705 / Purchased, 1907.

BIBLIOGRAPHY: R. Schmidt, *Brandenburgische Gläser*, Berlin (1914), p. 66, fig. 14; A. Rohde, *Barock*, Hamburgische Museum für Kunst und Gewerbe (1925), pl. IX; Düsseldorf-Kunstmuseum (1966), p. 125, no. 381.

NOTE: The monogram 'SCR' was used by Queen Sophia Charlotte, sister of George I of England and wife of Frederick I of Prussia. The dukedom of Prussia was erected into a kingdom in 1700 and Queen Sophia Charlotte was crowned in 1701. She died in 1705.

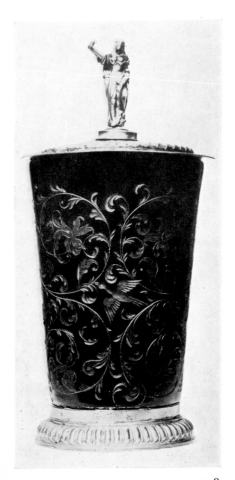

258

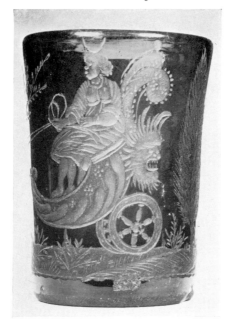

259

258. Beaker

Ruby glass, with silver-gilt mounts; cylindrical, tapering inwards towards the base. The sides are wheel-engraved with symmetrical foliage scrolls, birds and fruit. The cover consists of a ruby glass lid, engraved with four foliate scrolls and bunches of fruit, an outer silver-gilt mount, plain except for the claws gripping the glass roundel, and in the centre, a silver-gilt standing female figure with cornucopia on a circular shallow plinth; on the mount around the foot-rim, embossed vertical ribs in relief.

Silver mounts are hall-marked: Augsburg; maker's mark, 'TB' (Rosenberg, 195(?) and 708).

H, 21.5cm.

Reg. no. Æ. 3147.

Southern Germany, or Nürnberg, second half of the 17th century. Silver-gilt mounts: Augsburg, late 17th century / Bequeathed by Sir Augustus Wollaston Franks, 1887.

BIBLIOGRAPHY: R. Schmidt, *Brandenburgische Gläser*, Berlin (1914), pls. 17(7), (9); Schmidt (1914), pp. 45–6, no. 181; Schmidt (1926), pp. 47–8; Sir Hercules Read and A. Tonnochy, *Catalogue of the Silver Plate . . . Franks, K.C.B.*, London (1928), p. 14, no. 37; Meyer-Heisig (1963), p. 61f., nos. 14, 18, 35; Düsseldorf-Kunstmuseum (1966), p. 325, no. 327.

NOTE: Ruby glass (Ger. *Rubinglas*), a technique discovered by an alchemist, Johann Kunckel (1630–1703) in, or before, 1679. It has been supposed that the secret of ruby glass remained for a long time a possession of the Potsdam factory, but this is undoubtedly an error. A number of specimens of ruby glass, similar to this beaker, are now attributed to Nürnberg or one of the Southern German glass-houses.

259. Beaker

Cylindrical beaker, flaring slightly towards the rim, in very thick ruby glass; the sides are wheel-engraved with Diana seated in a chariot drawn by two geese with stars above, and a stag couchant between trees, under a sun; on the under-side of the base, a single flower-spray. The foot-rim is roughened on the wheel, as if originally intended to be fitted with a metal mount.

H, 11.9cm.

Reg. no. 1939, 1–3, 1.

Potsdam or Nürnberg, late 17th century / Purchased, 1939.

BIBLIOGRAPHY: Schmidt (1914), pp. 44–6, no. 181; Schmidt (1926), pp. 46–8; H. Tait, 'Review of Post-Medieval European Glass Acquired since the Outbreak of the Second World War', Part I: 1939–49, *BMQ*, XXVII, nos. 1–2, p. 29, pl. X, a, b, c; Meyer-Heisig (1963), nos. 62–3.

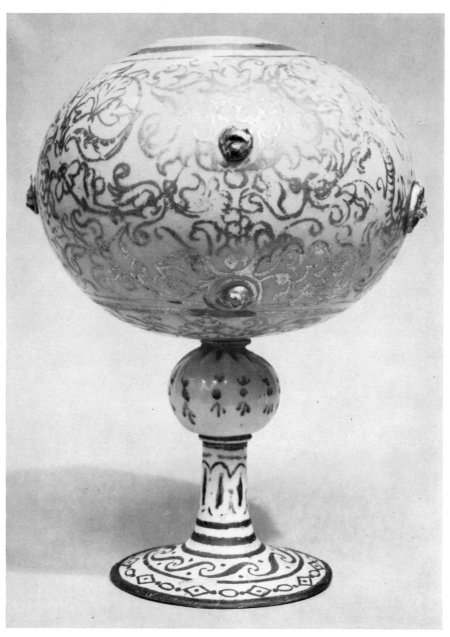

260

260. Spherical Vessel

Opaque-white glass; the surface has elaborate gilded decoration, comprising scrolls and 'mermaids'; bosses on various parts of the spherical body are decorated with masks; supported on a bulb stem and foot.

H, 24.1cm.

Reg. no. S 402.

Venice, early 16th century / Formerly in the collection of the Marchese d'Azeglio./ Bequeathed by Felix Slade, Esq., F.S.A., 1868.

BIBLIOGRAPHY: Nesbitt (1871), p. 79, fig. 91; Honey (1946), p. 62; Gasparetto (1958), pp. 95–6, fig. 51.

NOTES: Perhaps intended as a wig-stand rather than a decorative vase—see Frankfurt faïence examples of 17th-century date with oriental decoration (*Fayencen de Historischen Museum*, Frankfurt-am-

Main, 1958, no. 19, pl. 19).

This vessel is the only example of this shape in Venetian glass known to have survived and is one of the earliest examples of the use of opaque white glass by the Venetians. The style of the gilded decoration has been compared to the carving in relief of the tomb monument of Naldo da Brisighella in the church of S.S. Giovanni e Paolo, in Venice.

A similar spherical clear glass vessel dated 1677, with typical German enamelled decoration, is described as 'Studierlampe' (Kestner-Museum (1957) p. 58, no. 65, pl. 17).

261. Jug

Semi-opaque bluish-white or opaline glass, on a foot-ring of the same gather; an opaque white loop handle applied to shoulder and neck. Beneath rim, applied ring with enamelled beading, below which the inscription: 'ANNO 1651'. Bowl decorated with formal foliage scrolls in blue, green, yellow and black enamel.

H, 12.9cm.

Reg. no. 72, 5–17, 16.

Perhaps Bohemia or Germany; dated 1651 / Presented by the executors of the late Felix Slade, Esq., F.S.A., 1872.

BIBLIOGRAPHY: Schlosser (1956), colour pl. IV; W. Bernt, *Altes Glas*, p. 55, no. 44; Klesse (1963), p. 130, no. 279; Klesse (1965), p. 166, no. 140.

NOTES: The origin of this piece is problematical; certain features of the decoration of this glass are exceptional and cannot be related with certainty to a particular area of production.

262

262. Beaker

Opal-coloured, semi-opaque glass, with enamelled decoration in white, red, blue, green and black with sparsely applied gilding; on one side, a coronet over a monogram, 'CE' or 'CVE', enclosed by a foliate wreath, and on the other an unidentified coat-of-arms in a similar wreath subscribed: '1681'; the two being separated by flowers.

H, 14.9cm.

Reg. no. 1939, 1–2, 1.

Germany, probably Saxony; dated 1681 / Lent to the Rijksmuseum, Amsterdam, for the 'Tentoonstelling van oude Kunst uit het bezit van den internationalen Handel', in 1936 / Sotheby & Co., Sale Catalogue, 10 November, 1938, lot 101 / Purchased, 1939.

BIBLIOGRAPHY: Hugh Tait, 'A Review of Post-Medieval European Glass Acquired since the Outbreak of the Second World War', *BMQ* (1963–64), XXVII p. 29, pl., ix; von Saldern (1965), p. 205, fig. 365. E. Schenk zu Schweinsberg, *Form und Schmuck des Hohlgläses an Beispielen der Sammlung Schott*, Mainz (1966), pp. 78–9 (with illus.).

NOTE: The coat-of-arms was said in 1938 to be that of 'Holtzern' but this seems to be incorrect; no reliable identification has since been made.

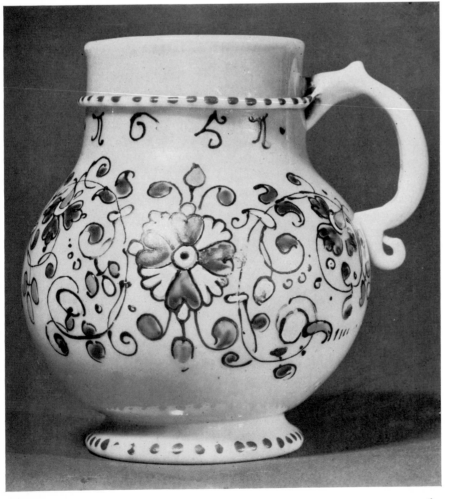

261

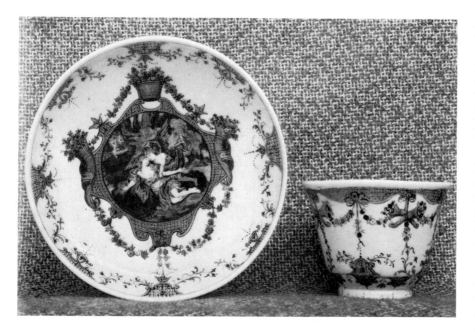

Meissen (Dresden) and the Vienna factories in the period 1730–50.

Perhaps the closest similarity is to be found not on the porcelain made and decorated in the two factories, but on their wares decorated by 'outside' enamellers (*hausmaler*, in German terminology). A porcelain tea-pot and tea-bowl with saucer (in the Landes-Gewerbemuseum, Stuttgart) signed by the well-known 'outside' decorator, Johann Friedrich Metzsch, is decorated in an almost identical manner, incorporating all the same decorative motifs—See G. A. Pazaurek, *Deutsche Fayence- und Porzellan-Hausmaler*, Leipzig (1925), p. 254f., colour pl. 21.

The initials, 'D.B.', may be those of the enameller or they might be those of the artist whose composition has been copied for this representation of the scene. Research on this point is still being pursued.

The mark of the reverse of the saucer may be read as a 'W' and a 'K' conjoined, or less probably as 'V V K' conjoined. At present, the significance of this mark has not been established but the absence of marks of this kind on glass indicates that this piece was very deliberately made in imitation of porcelain, in which field the marking of factory products in this way had become an established practice in Germany by the middle of the 18th century.

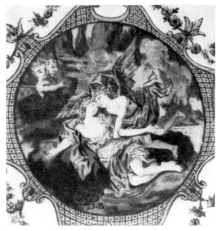

263

263. Cup and Saucer

Opaque-white glass with enamelled decoration; the cup (no handle) or tea-bowl is painted with delicate pattern of swags, festoons and chequer-patterned cartouches, and the foot-rim on both sides is ornamented with a pattern of dots; the under-side of the base has a circle of dots and in the centre a cinque-foil flower covers the pontil-mark.

The saucer has a central roundel painted with the mythological scene of Cupid and Psyche, observed by two putti; in the foreground to the left, the initials 'D.B.' The roundel is framed by a chequer-patterned cartouche incorporating a cornucopia on either side and garlands of flowers, hanging from a basket of flowers.

The base of the saucer bears the enamelled mark (in light blue): W\

D (of saucer), 12cm.; H (of cup), 5.6cm.

Reg. no. 1963, 4–4, 1.

Probably Germany; perhaps Bayreuth in the workshop of Johann Friedrich Metzsch, about 1740–50 / Purchased, 1963.

BIBLIOGRAPHY: Düsseldorf-Kunstmuseum (1966), p. 102, no. 310.

NOTES: The decoration is executed in close imitation of contemporary porcelain, especially the products of the

264. Plate

Opaque-white glass, painted in red with a view of San Giorgio Maggiore, Venice.

D, 22.7cm.

Reg. no. S 387.

Venice; probably made and decorated at the Miotti glass-house, Murano, Venice, between June and July, 1741 / Formerly in the collections of Horace Walpole at Strawberry Hill (before 1774) and Ralph Bernal, M.P. / Bequeathed by Felix Slade, Esq., F.S.A., 1868.

BIBLIOGRAPHY: *Description of the Villa of Horace Walpole . . . at Strawberry Hill* (1774), p. 9; *Catalogue of the Classic Contents of Strawberry Hill* (sale from 25 April, 1842), Twelfth Day's sale, lots 41–4; H. G. Bohn, *A Guide . . . of the Bernal Collection* (1857), p. 321f., no. 3212; G. Morazzoni, 'Il Lattimo Veneziano', *Dedalo* (November, 1923), pp. 384–5; R. J. Charleston, 'Souvenirs of the Grand Tour', *JGS*, I (1959), pp. 63ff., figs. 2–3.

NOTES: This plate is one of a set of twenty-four plates bought back to England by Horace Walpole from Venice, where he was staying in 1741.

The scene on this plate is copied from an etching by Luca Carlevaris (no. 6 from the series: *Le Fabriche, e Vedute di Venetia*, 1703).

A hitherto unrecorded plate belonging to this series of views of Venice—depicting the church of the Carità—has recently been acquired by the Corning Museum of Glass, New York (*Burlington Magazine*, CIX (October, 1967), p. 588,

264

fig. 57). A similar plate, illustrated by Charleston, *op. cit.*, fig. 16, has minor differences, especially in the disposition of the gondolas in the foreground. A third variant of this scene survives on a rectangular opaque white glass plaque in the Museo Vetrario, Murano, Venice, also illustrated by Charleston, *op. cit.*, fig. 17, which was probably made before the sets of plates were commissioned in 1741 by a small group of English visitors as souvenirs of 'The Grand Tour'.

265

265. Bottle

Opaque-white glass, with a tiny pouring lip in colourless glass. On the neck, enamelled coat-of-arms, per fesse or and azure a bend gules, under a coronet; floral ornament in polychrome enamel. The bowl encircled by a landscape in which stand three children and a female figure—possibly representing Charity. On the under-side of the base, the enamelled inscription: 'Murano Miotti 1747'.

H, 23.9cm.

Reg. no. 1958, 4–3, 1.

Venice; a Murano glass-house belonging to the Miotti family; dated 1747 / Formerly included among the collection of glass presented by the executors of Felix Slade, Esq., to the British Museum in 1872 but rejected at the time as 'the genuineness of the painting' was doubted. Collection of Mrs. Viva King / Purchased, 1958.

BIBLIOGRAPHY: B. Cecchetti and V. Zanetti, *Monografia della Vetraria Veneziana e Muranese*, Venice (1874); R. J. Charleston, 'Souvenirs of the Grand Tour', *JGS*, I (1959), p. 80 (n. 113); G. Mariacher, 'I' Lattimi' dei Miotti al Museo Vetrario di Murano', *Bolletino dei Musei Civici Veneziani*, II (1958), pp. 5–13.

NOTES: The Miotti family's glass-house at the sign 'Al Gesu' was active from the beginning of the 17th century, if not earlier. In 1717, it was run by Vincenzo, son of Daniel Miotti, and his sons; a Domenico Miotti is described as a 'very able painter in enamel colours on *smalti*'. A number of items of enamelled opaque-white glass have survived bearing the mark 'Al Gesu', with dates ranging from 1731 to 1747.

This bottle is, therefore, one of the latest in date known to have come from the Miotti glass-house in Murano, where for nearly twenty years the enamelling of opaque-white glass had been a specially ambitious line. A bottle dated 1736 and inscribed 'Al Gesu' is preserved in the Museo Vetrario, at Murano.

266

267. Covered Jar

One of a pair of covered jars, of opaque-white glass; the body ornamented on one side with polychrome enamel decoration of naturalistic floral sprays and, on the reverse, with three leafy sprigs. The slightly domed cover enriched with a floral branch, bird and a ladybird.

H, 20.3cm.

Reg. no. 1905, 2–18, 4.
England; perhaps London or the Midlands, about 1760 / Formerly in the collection of William Edkins Junior, the grandson of Michael Edkins, the Bristol decorator of glass / Presented by Charles Borradaile, Esq., 1905.

BIBLIOGRAPHY: H. Owen, *Two Centuries of Ceramic Art in Bristol* (London, 1873), p. 384, colour plate facing; Buckley (1939), no. 540, pl. 169; Honey (1946), p. 114, pl. 56D; R. J. Charleston,

266. Pair of Candlesticks

Opaque-white glass, with wrythen stems and domed feet; the grease-pans are separate and are not made of glass but of opaque-white enamel on copper; painted in bright enamel colours with naturalistic flowers; only slight differences exist between the two.

H, 16cm. (86, 2–14, 12); H, 16.1cm. (86, 2–14, 13).

Reg. no. 86, 2–14, 12 and 86, 2–14, 13.
England; perhaps London or the Midlands, about 1750–60 / Presented by J. E. Nightingale, Esq., F.S.A., 1886.

BIBLIOGRAPHY: Honey (1946), p. 114, pl. 56D; R. J. Charleston, 'Michael Edkins and the Problem of English Enamelled Glass', *Trans. of the Society of Glass Technology* (1954), XXXVIII, pp. 3–16, fig. 3.

NOTES: This type of English enamelled glass has until recently been regarded as the work of a Bristol artist, Michael Edkins, in the second half of the 18th century. Serious doubts have been thrown on this attribution and the present attribution to a London or a Midland workshop has yet to be conclusively proved.

The separate copper enamelled grease-pans are decorated with flower-sprays in a style generally attributed to the Midlands, especially Birmingham.

267

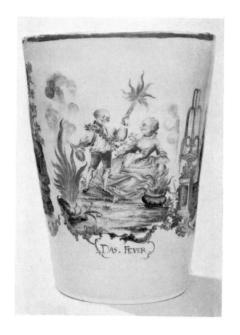 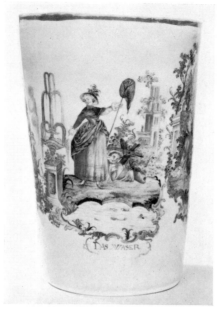

268

BIBLIOGRAPHY: Honey (1946), p. 82, pl. 61B; *Florilège de la Verrerie Ancienne*, Museés Royaux d'Art et d'Histoire, Brussels (1965), no. 328, colour pl. facing p. 24.

NOTES: The painting is executed in a style similar to that used by decorators of porcelain in 1750–70. A similar 'beaker', decorated with Mars, attired in military costume of the 17th century, is preserved in the Museés Royaux d'Art et d'Histoire in Brussels and may have come from the same workshop.

'A Painter of Opaque-white Glass', *Glass Notes compiled by Arthur Churchill Ltd.*, XIII (December, 1953), pp. 1–8, fig. 5; R. J. Charleston, 'Michael Edkins and the Problem of English Enamelled Glass', *Trans. of the Society of Glass Technology* (1954), XXXVIII, pp. 3–16, figs. 1–18.

NOTES: For doubts on the previous attribution of this piece to Michael Edkins, see note to no. 266 of this catalogue.

A set of three covered jars in the Cecil Higgins Museum, Bedford, are almost identically decorated and certainly executed by the same hand. These large floral sprays are reminiscent of the decoration on certain enamelled Worcester porcelain mugs of the period 1755–65, and may be the work of a porcelain decorator.

268. Beaker or Ice-Pail

Opaque-white glass; a narrow band of gilt below the rim, both inside and out. The sides enamelled with four scenes, each containing a man and a woman and each illustrating one of the Four Elements; each appropriately inscribed:

'DAS.FEVER', 'DAS.WASER', 'DIE.LUFFT' 'DIE.ERDE'.

H, 22.9cm.

Reg. no. 73, 3–1, 2.

Probably Bohemia, about 1750–70 / Presented by the executors of the late Felix Slade, Esq., F.S.A., 1873.

BIBLIOGRAPHY: Nesbitt (1871), p. 145; Schmidt (1922), p. 368f., fig. 222; *Katalog. Ausstellung von Gläsem*, Österreichisches Museum für Kunst und Industrie, Vienna (1922), pp. 3–45, nos. 1–78; H. Trenkwald, *Gläser der Spätzeit* (um 1790 bis 1850), Vienna (1923); G. E. Pazaurek, *Gläser der Empire und Biedermeierzeit* Leipzig (1923), pp. 311ff.; Honey (1946), p. 91f., pl. 48C; Strauss Exhibition (1955), p. 111f., no. 280, with illustration; Jantzen (1960), p. 43f., pl. 62–3; Klesse (1965), p. 321, nos. 376–7; Düsseldorf-Kunstmuseum (1966), p. 142f., nos. 430–2.

NOTES: Mildner (born 1763; died 1808) specialized in a technique which continued the practice of the *Zwischengoldgläser* (nos. 200 and 201 of this catalogue) in a new way. Mildner created medallions of glass with the inner surface decorated in gold-leaf and red lacquer and applied them into roundels exactly cut out to receive them so that they became flush with the outer walls of the vessels.

Only rarely—and apparently only at the beginning—did Mildner use an opaque-white glass for this type of decorative beaker; the majority are made of clear glass. This piece is among the earliest dated specimens of his work.

269

269. Tumbler

Opaque-white glass tumbler, with medallions in gold and ruby colours. Two medallions are inserted into roundels cut in the outer surface of the sides:

(i) bears a monogram formed of the letters 'HvP';

(ii) has a representation of a building with a bell turret and two chimneys, with the inscription: 'FÜRNBERGISCHES SCHWEMHAUS STIFT' (The Fürnberg establishment for floating wood). The base is formed of a gold and ruby medallion with a view representing a mountain from which issues through a funnel a watercourse with floating logs of wood; over the archway is a tablet inscribed: 'BERG GRUBEN' (The Hill Tunnel); above is Victory holding a shield and blowing a trumpet; around the edge of the medallion is the legend:

'FECERAT HERCULEOS IS NEMPE IN MONTE LABORES QUI MONTEM IN SCUTO NOBILITATIS HABET—Verfertiget Von Mildner im Jahr 1788.'

(He, that made in the mountain these Herculean labours, has in his coat-of-arms a mountain.—Made by Mildner in the year 1788.)

The rim of the goblet is mounted with a narrow band of silver.

H, 10.8cm. D, 7.8cm.

Reg. no. S 866.

Lower Austria; made at the glass-house of Johann Joseph Mildner (1763–1808) at Gutenbrunn; dated 1788 / Bequeathed by Felix Slade, Esq., F.S.A., 1868.

BIBLIOGRAPHY WITH SHORT TITLES

ADRIANI (1967): A. Adriani, in *Bull. Soc. Archeol. d'Alexandrie* no. 42 (1967), pp. 105–27.

AKERMAN (1855): J. Y. Akerman, *Pagan Saxondom* (1855).

ASHMOLE (1967): B. Ashmole, 'A New Interpretation of the Portland Vase', in *Journal of Hellenic Studies*, LXXXVII (1967), pp. 1–17.

BALDWIN BROWN (1915): G. Baldwin Brown, *Arts in Early England*, IV (1915).

BARAG (1962): D. Barag, 'Mesopotamian Glass Vessels of the Second Millennium B.C.', in *JGS*, IV (1962), pp. 9–27.

BARRELET (1953): J. Barrelet, *La Verrerie en France de l'époque gallo-romaine à nos jours* (Paris, 1953).

BARTOCCINI (1935): R. Bartoccini, in *Iapigia*, VI (1935).

DE BAYE (1893): J. de Baye, *Industrial Arts of the Anglo-Saxons* (1893).

BERGER (1960): L. Berger, *Römische Gläser aus Vindonissa* (Veröffentlichungen der Gesellschaft pro Vindonissa, Basel, 1960).

Bernal Collection (1857): H. G. Bohn, *A Guide . . . Catalogue of the Bernal Collection* (London, 1857).

BOESEN (1960): G. Boesen, *Ventianske Glas På Rosenburg* (Copenhagen, 1960).

BJ: *Bonner Jahrbücher.*

BRAILSFORD (1964): J. W. Brailsford, *Guide to the Antiquities of Roman Britain* (British Museum, 1964).

BREMEN (1964): W. Bremen, *Die alten Glasgemälde und Hohlgläser der Sammlung Bremen in Krefeld* (Cologne, 1964).

BMQ: *British Museum Quarterly.*

BROCK and MACKWORTH YOUNG (1949): J. K. Brock and G. Mackworth Young, 'Excavations in Siphnos', in *Annual of the British School at Athens*, XLIV (1949), pp. 90–91, pls. 33, 34.I.

BRONEER (1930): O. Broneer, 'Inscriptions from Upper Peirene', in C. W. Blegen, O. Broneer, R. Stillwell and A. R. Bellinger (eds.), *Corinth III, Part I, Acrocorinth Excavations in 1926* (Harvard University Press, 1930), pp. 50–60.

BUCKLEY (1925): F. Buckley, *Old English Glass* (London, 1925).

BUCKLEY (1929): W. Buckley, *Diamond Engraved Glasses of the Sixteenth Century* (London, 1929).

BUCKLEY (1939): W. Buckley, *The Art of Glass* (London, 1939).

CARABELLA (1879): Titus Carabella, 'Fouilles de Cyzique. La Tombe d'un Athlète et les Jeux Gymniques à Péramo', in *Revue Archéologique*, XXXVII (1879), pp. 204–15 and pl. VII.

Castellani Catalogue (1884): *Catalogue de la Collection Alessandro Castellani* (Rome, 1884).

CESNOLA (1877): L. P. di Cesnola, *Cyprus, its Cities, Tombs and Temples* (London, 1877).

CHAMBON (1955): R. Chambon, *L'Histoire de la Verrerie en Belgique* (Brussels, 1955).

CHIRNSIDE and PROFFITT (1963): R. C. Chirnside and P. M. C. Proffitt, 'The Rothschild Lycurgus Cup: An Analytical Investigation', in *JGS*, V (1963), pp. 18–23.

CLAIRMONT (1963): C. W. Clairmont, *The Excavations at Dura-Europos, Final Report IV, Part V, The Glass Vessels* (New Haven. Dura-Europos Publications, 1963).

CHARLESWORTH (1966): D. Charlesworth, 'Roman Square Bottles', in *JGS*, VIII (1966), pp. 26–40.

COLONNA-CECCALDI (1882): G. Colonna-Ceccaldi, *Monuments antiques de Chypre, de Syrie et d'Égypte* (Paris, 1882), pp. 208–9 (= *Rev. Arch.* n.s., xxix (1875), p. 99).

COMARMOND (1851): *Catalogue by Dr. Comarmond of the Collection of Antiquities Purchased from him in 1851* (Ms. in B.M. Dept.).

CONTON (1906): L. Conton, 'I più insigni monumenti di Ennione', in *Ateneo Veneto*, xxix (1906), ii, pp. 1ff.

CORNING MUSEUM (1958): *Glass from the Corning Museum of Glass. A Guide to the Collections* (Corning, New York, 1958).

CIL: *Corpus Inscriptionum Latinarum.*

DALTON (1901a): O. M. Dalton, *Catalogue of Early Christian Antiquities and Objects*

from the Christian East in the Department of British and Mediaeval Antiquities and Ethnography of the British Museum (London, 1901).

DALTON (1901b): O. M. Dalton, 'The Gilded Glasses of the Catacombs', in *Archaeological Journal*, LVIII (1901), pp. 225–53.

DALTON (1911): O. M. Dalton, *Byzantine Art and Archaeology* (1911).

DAREMBERG et SAGLIO: Ch. Daremberg et Edm. Saglio (eds.), *Dictionnaire des Antiquités grecques et romaines*.

DAWSON (1944): C. M. Dawson, *Romano-Campanian Mythological Landscape Painting* (Yale Classical Studies, vol. Nine. Yale University Press. 1944).

DEONNA (1925): W. Deonna in *Rev. Études anc.*, XXVII (1925).

DILLON (1907): E. Dillon, *Glass* (1907).

DÖLGER (1927): F. J. Dölger, ΙΧΘΥC. *IV. Die Fischdenkmäler in der früchristlichen Plastik, Malerei und Kleinkunst: Tafeln* (Münster in Westf. 1927), pl. 140, no. 5.

DOPPELFELD (1966): O. Doppelfeld, *Römisches und Fränkisches Glas in Köln* (Köln, 1966).

DÜSSELDORF-KUNSTMUSEUM (1966): *Kataloge des Kunstmuseums Düsseldorf, Glas*, I (Düsseldorf, 1966).

EGGERS (1951): H. J. Eggers, *Der römische Import im freien Germanien* (Hamburg, 1951).

EVISON (1955): V. I. Evison, 'Anglo-Saxon finds near Rainham, Essex, with a study of glass drinking-horns', in *Archaeologia*, XCVI (1955), pp. 159ff.

FITCH (1864): S. E. Fitch, 'Discovery of Saxon Remains at Kempston', in *Associated Architectural Societies' Reports and Papers*, VII, Pt. II (1864), pp. 269–300.

FORBES (1966): R. J. Forbes, *Studies in Ancient Technology*, V (2nd ed., 1966), 'Glass', pp. 112–216.

FOSSING (1940): P. Fossing, *Glass Vessels before Glass-Blowing* (1940).

FOWLER (1932): H. N. Fowler, 'Corinth and the Corinthia', in H. N. Fowler and R. Stillwell (eds.), *Corinth, I, Introduction. Topography. Architecture* (Harvard University Press, 1932), pp. 18–114.

FREMERSDORF (1933–34): F. Fremersdorf, 'Zur Geschichte des fränkischen Rüsselbechers', in *Wallraf–Richartz Jahrbuch*, II–III (1933–34).

FREMERSDORF (1938): F. Fremersdorf, 'Römische Gläser mit buntgefleckter Oberfläche', in H. v. Petrikovits und Albert Steeger (eds.), *Festschrift für August Oxé zum 75. Geburtstag 23. Juli 1938* (Darmstadt, 1938), pp. 116–21.

FREMERSDORF (1951): F. Fremersdorf, 'Figürlich Geschliffene Gläser, Eine Kölner Werkstatt des 3. Jahrhunderts', in *Römisch-Germanische Forschungen*, 19 (Berlin, 1951).

FREMERSDORF (1956): F. Fremersdorf, 'Ältestes Christentum mit besonderer Berücksichtigung der Grabungsergebnisse unter der Severinskirche', in *Kölner Jahrbuch für Vor- und Frühgeschichte*, II (1956), pp. 7ff.

FREMERSDORF (1959): F. Fremersdorf, *Römische Gläser mit Fadenauflage in Köln (Schlangenfadengläser und Verwandtes). Die Denkmäler des römischen Köln*, V (Cologne, 1959).

FREMERSDORF (1961): F. Fremersdorf, *Römisches Geformtes Glas in Köln. Die Denkmäler des römischen Köln*, VI (Cologne, 1961).

FREMERSDORF (1962): F. Fremersdorf, *Die römischen Gläser mit aufgelegten Nuppen. Die Denkmäler des römischen Köln*, VII (Cologne, 1962).

FREMERSDORF (1967): F. Fremersdorf, *Die römischen Gläser mit Schliff, Bemalung und Goldauflagen aus Köln. Die Denkmäler des römischen Köln*, VIII (Cologne, 1967).

FRÖHNER (1879): W. Fröhner, *La verrerie antique; descr. de la collection Charvet* (Le Pecq, 1879).

FRÖHNER (1898): W. Fröhner, *La Collection Tyszkiewicz, Choix de Monuments* (Paris, 1898).

FROTHINGHAM (1963): A. Frothingham, *Spanish Glass* (London, 1963).

Frühchristliches Köln (1965): *Frühchristliches Köln* (Römisch–Germanisches Museum, Köln, 1965).

GASPARETTO (1958): A. Gasparetto, *Il Vetro di Murano* (Venice, 1958).

VAN GELDER (1955): H. E. van Gelder, *Glas en Ceramiek* (Utrecht, 1955).

GERSPACH (1885): Gerspach, *L'Art de la Verrerie* (Paris, 1885).

HABEREY (1957): W. Haberey, 'Der Werkstoff Glas im Altertum', in *Glastechnische Berichte*, XXX (1957), Heft 12, pp. 505–9.

HABEREY (1958): W. Haberey, 'Der Werkstoff Glas im Altertum', in *Glastechnische Berichte*, XXXI (1958), Heft 5, pp. 188–94.

HAEVERNICK (1959): Th. E. Haevernick, 'Beiträge zur Geschichte des antiken Glases. I. Zu den Glasbügelfibeln. II. Stachelfläschen', in *Jahrbuch des Römisch-Germanischen Zentralmuseums Mainz*, VI (1959), pp. 57–65.

HAEVERNICK (1960): Th. E. Haevernick, 'Beiträge zur Geschichte des antiken Glases. III. Mykenisches Glas. IV. Gefässe mit vier Masken. V. Kleine Beobachtungen technischer Art', in *Jahrbuch des Römisch-Germanischen Zentralmusuems Mainz* VII (1960), pp. 36–58.

HAEVERNICK (1961): Th. E. Haevernick, 'Beiträge zur Geschichte des antiken Glases. VI. Die Aggryperlen = Chevron-Beads = Rosettaperlen = Star-beads. VII. Zu den Stachelfläschen', in *Jahrbuch des Römisch-Germanischen Zentralmuseums Mainz*, VIII (1961), pp. 121–38.

HAGUE GEMEENTE MUSEUM (1962): *Catalogus van Noord- en Zuidnederlands Glas* (Gemeentemuseum den Haag, 1962).

HARDEN (1933): D. B. Harden, 'Ancient Glass', in *Antiquity*, VII (1933), pp. 419–28.

HARDEN (1934): D. B. Harden, 'Snake-thread Glasses found in the East', in *JRS*, XXIV (1934), pp. 50–5.

HARDEN (1935): D. B. Harden, 'Romano-Syrian Glasses with Mould-Blown Inscriptions', in *JRS*, XXV (1935), pp. 163–86.

HARDEN (1936): D. B. Harden, *Roman Glass from Karanis* (University of Michigan Press, 1936).

HARDEN (1947): D. B. Harden, 'The Glass', in C. F. C. Hawkes and M. R. Hull, *Camulodunum* (Reports of the Research Committee of the Society of Antiquaries of London, 1947), pp. 287–307.

HARDEN (1956a): D. B. Harden, 'Glass and Glazes', ch. 9 in C. Singer, E. J. Holmyard, A. R. Hall and T. I. Williams (eds.), *A History of Technology, II, The Mediterranean Civilisations and the Middle Ages c. 700 B.C. to c. A.D. 1500* (Oxford 1956), pp. 311–46.

HARDEN (1956b): D. B. Harden, 'Glass Vessels in Britain and Ireland, A.D. 400–1000', in D. B. Harden (ed.), *Dark-Age Britain: studies presented to E. T. Leeds* (London, 1956).

HARDEN (1958): D. B. Harden, 'A Roman Sports Cup', in *Archaeology*, XI (1958), pp. 2–5.

HARDEN (1959): D. B. Harden, 'The Highdown Hill Glass Goblet with Greek Inscription', in *Sussex Archaeological Collections*, XCVII (1959), pp. 3ff.

HARDEN (1960): D. B. Harden, 'The Wint Hill Hunting Bowl and Related Glasses', in *JGS*, II (1960), pp. 44–81.

HARDEN (1963): D. B. Harden, 'The Rothschild Lycurgus Cup: Addenda and Corrigenda', in *JGS*, V (1963), pp. 9–17.

HARDEN (1968a): D. B. Harden, in *Annales du 4ᵉ Congrès International . . . des 'Journées Internationales du Verre', Ravenne, 13–20 mai*, 1967 (Liège, 1968).

HARDEN (1968b): D. B. Harden, in *JGS*, X (1968).

HARDEN (1968c): D. B. Harden, in I. M. Stead, 'An Early Iron Age Burial at Welwyn Garden City', in *Archaeologia*, CI (1968), pp. 14–16.

HARDEN and TOYNBEE (1959): D. B. Harden and J. M. C. Toynbee, 'The Rothschild Lycurgus Cup', in *Archaeologia*, XCVII (1959), pp. 179–212.

HARTSHORNE (1897): A. Hartshorne, *Old English Glasses* (London and New York, 1897).

HAYNES (1964): D. E. L. Haynes, *The Portland Vase* (British Museum, 1964).

HEAD (1889): Barclay V. Head. *Catalogue of Greek Coins. Corinth, Colonies of Corinth, etc.* (London, British Museum, 1889).

HIGGINS (1954): R. A. Higgins, *Catalogue of the Terracottas in the Department of Greek and Roman Antiquities, British Museum. I. Text. Greek: 730–330 B.C.* (London, British Museum, 1954).

HODGES (1905): C. C. Hodges, 'Anglo-Saxon Remains', in E. Page (ed.), *Victoria History of the County of Durham*, I (London, 1905), pp. 211–40.

HONEY (1946): W. B. Honey, *Glass. A Handbook* (London, 1946).

HÜBNER (1873): E. Hübner, *Corpus Inscriptionum Latinarum*, VII (1873).

HÜDIG (1926): F. Hüdig, *An Essay on Dutch Glass Engravers* (Plymouth, 1926).

HULL (1958): M. R. Hull, *Roman Colchester* (Reports of the Research Committee of the Society of Antiquaries of London, XX, 1958).

HULL (1963): M. R. Hull, 'Roman Gazetteer', in W. R. Powell (ed.), *Roman Essex* (Victoria History of the Counties of England, A History of Essex, III, 1963).

IG, XIV: I. G. Kaibel (ed.), *Inscriptiones Graecae XIV : Inscriptiones Siciliae et Italiae additis Galliae Hispaniae Britanniae Germaniae inscriptionibus* (1890).

ISINGS (1964): C. Isings, 'A Fourth Century Glass Jar with Applied Masks', in *JGS*, VI (1964), pp. 59–63.

JACOBSTHAL (1944): P. Jacobsthal, *Early Celtic Art*, I (1944).

JANTZEN (1960): J. Jantzen, *Deutsches Glas aus fünf Jahrhunderten* (Düsseldorf, 1960).

VON JENNY (1943): W. A. von Jenny, *Die Kunst der Germanen im frühen Mittelalter* (2nd edn., Berlin, 1943).

JGS: *Journal of Glass Studies*.

JRS: *Journal of Roman Studies*.

KELLER (1863): F. Keller, in *Archaeological Journal*, XX (1863), pp. 331ff.

KESTNER-MUSEUM (1957): *Bild-Kataloge des Kestner-Museums Hannover*, *II*, Die *Glas-Sammlung*, revised by C. Mosel (Hannover, 1957).

KISA (1908): A. Kisa, *Das Glas im Altertume* (Leipzig, 1908).

KLESSE (1963): B. Klesse, *Glas, Katalog des Kunstgewerbemuseums, Köln*, I (Cologne, 1963).

KLESSE (1965): B. Klesse, *Glassammlung Helfried Krug* (Munich, 1965).

KÜHN (1965): H. Kühn, *Die germ. Bügelfibeln d. Völkerwanderungzeit in d. Rheinprovinz* (2nd edn., 1965).

LAMM (1930): C. J. Lamm, *Mittelalterliche Gläser und Steinschnittarbeiten aus dem Nahen Osten* (Berlin, 1930).

LANCIANI (1884): Lanciani, in *Bullettino della Commissione Arch. Comunale* (1884), p. 55.

LAYARD (1849): A. H. Layard, *Nineveh and its Remains* (London, 1849).

LAYARD (1853): A. H. Layard, *Discoveries in the Ruins of Nineveh and Babylon* (1853).

LAYARD (1854): A. H. Layard, *Popular Account of Discoveries at Nineveh* (new edn., 1854).

MAGGIORA-VERGANO and FABRETTI (1875): Maggiora-Vergano and A. Fabretti, 'Coppa di vetro di Refrancore', in *Atti Soc. Archeol. e Belle Arti di Torino*, i (1875).

MALLOWAN (1966): M. E. L. Mallowan, *Nimrud and its Remains* (1966).

MARIACHER (1961): G. Mariacher, *Italian Blown Glass* (London, 1961).

MAYER (1933): L. A. Mayer, *Saracenic Heraldry, a Survey* (Oxford, 1933).

MEYER-HEISIG (1963): E. Meyer-Heisig, *Der Nürnberger Glasschnitt des 17. Jahrhunderts* (Nürnberg, 1963).

MOREY (1959): C. F. Morey, *The Gold-Glass Collection of the Vatican Library, Catalogo IV del Museo Sacro della Biblioteca Apostolica Vaticans* (ed. G. Ferrari, Rome, 1959).

MORIN-JEAN (1913): Morin-Jean, *La Verrerie en Gaule* (Paris, 1913).

MÜLLER (1835): K. O. Müller, *Handbuch der Archäologie der Kunst* (2nd edn., Breslau, 1835).

MÜLLER–WIESELER (1869): C. O. Müller and Friedrich Wieseler, *Denkmäler der Alten Kunst*, II (Göttingen, 1869).

MURRAY, SMITH and WALTERS (1900): A. S. Murray, A. H. Smith and H. B. Walters, *Excavations in Cyprus* (London, 1900).

NESBITT (1871): A. Nesbitt, *Catalogue of the Collection of Glass formed by Felix Slade, Esq.* (London, 1871).

NEUBURG (1949): F. Neuburg, *Glass in Antiquity* (London, 1949).

NEUBURG (1962): F. Neuburg, *Ancient Glass* (1962).

NEUSS (1933): W. Neuss, *Die Anfänge des Christentums im Rheinland* (Bonn, 1933).

NEUSS (1964): W. Neuss, *Geschichte des Erzbistums Köln*, I (Cologne, 1964).

OATES (1966): D. Oates, 'Excavations at Tell al Rimah, 1965', in *Iraq*, XXVIII (1966).

OLIVER (1967): A. Oliver, Jr., 'Late Hellenistic Glass in the Metropolitan Museum', in *JGS*, IX (1967), pp. 13–33.

OSWALD and PRYCE (1920): F. Oswald and T. Davies Pryce, *Introduction to the Study of Terra Sigillata* (London, 1920).

OCD: *Oxford Classical Dictionary*.

PAYNE (1877): G. Payne, Junior, 'Roman Interment Discovered at Sittingbourne', in *Archaeologia Cantiana*, XI (1877).

PAYNE (1886): G. Payne, 'Romano-British Interments Discovered at Bayford Next Sittingbourne, Kent', in *Archaeologia Cantiana*, XVI (1886).

PEET and WOOLLEY (1923): T. E. Peet and C. L. Woolley, *Tell-El-Amarna. The City of Akhenaten* (1923, etc.).

PETRIE (1900): W. M. F. Petrie, *Dendereh 1898* (1900).

PETRIE (1925): W. M. F. Petrie, *Tombs of the Courtiers and Oxyrhynkos* (B.S.A. Egypt, xxxvii, 1925).

VON PFEFFER (1952): W. von Pfeffer, in *Festschrift des röm. germ. Zentralmuseums in Mainz zur Feier seines 100 jährigen Bestehens 1952*, III, pp. 147ff.

VON PFEFFER (1960): W. von Pfeffer, 'Fränkisches Glas', in *Glastechnische Berichte*, XXXIII (1960), Heft 4, pp. 136ff.

PINDER-WILSON (1963): R. Pinder-Wilson, 'Cut-Glass Vessels from Persia and Mesopotamia', in *BMQ*, XXVII (1963), pp. 33–9, pls. XV–XVIII.

PLENDERLEITH (1962): H. J. Plenderleith, *The Conservation of Antiquities and Works of Art* (London, Oxford University Press, 1962).

RADEMACHER (1933): F. Rademacher, *Die deutschen Gläser des Mittelalters* (Berlin, 1933).

RADEMACHER (1942): F. Rademacher, in *BJ*, 147 (1942), pp. 285–344.

REINACH (1912): Salomon Reinach, *Répertoire de Reliefs Grecs et Romains II, Afrique— Îles Britanniques* (Paris, 1912).

ROACH SMITH (1868): C. Roach Smith, *Collectanea Antiqua*, VI (1868).

ROACH SMITH (1871): C. Roach Smith, *A Catalogue of Anglo-Saxon and other Antiquities discovered at Faversham in Kent and bequeathed by William Gibbs, Esq., of that Town to the South Kensington Museum* (London, 1871).

Römer am Rhein (1967): *Römer am Rhein* (Katalog der Ausstellung des Römisch-Germanischen Museums, Köln, 1967).

ROSTOVTZEFF (1941): M. Rostovtzeff, *Social and Economic History of the Hellenistic World*, I (1941).

VON SALDERN (1959a): A. von Saldern in *JGS*, I (1959).

VON SALDERN (1959b): A. von Saldern, in *Glastechnische Berichte*, 32k (1959), Heft VIII, pp. 1–8.

VON SALDERN (1965): A. von Saldern, *German Enameled Glass* (Corning, New York, 1965).

VON SALDERN (1966): A. von Saldern, 'Mosaic Glass from Hasanlu, Marlik and Tell al-Rimah', in *JGS*, VIII (1966), pp. 9–25.

SCHLOSSER (1956): I. Schlosser, *Das alte Glas* (Braunschweig, 1956).

SCHMIDT (1914): R. Schmidt, *Die Gläser der Sammlung Mühsam* (Berlin, 1914).

SCHMIDT (1922): R. Schmidt, *Das Glas* (Berlin, 1922).

SCHMIDT (1926): R. Schmidt, *Die Gläser der Sammlung Mühsam*, N.F. (Berlin, 1926).

SCHRIJVER (1961): E. Schrijver, *Glas en Kristal* (Bussum, 1961).

SCHUERMANS (1898): H. Schuermans, 'Verre à cours de chars', in *Annales de la Société archéologique de Namur*, XX, p. 165 and pl. facing p. 145.

SCHÜLER (1959): F. Schüler, 'Ancient Glassmaking Techniques. The Moulding Process', in *Archaeology*, XII (1959), no. I, pp. 47–52.

SCHÜLER (1966): I. Schüler, in *JGS*, VIII (1966).

SCHULZ (1953): W. Schulz, *Leuna. Ein germanischer Bestattungsplatz der spätrömischen Kaiserzeit* (Berlin, 1953).

SKILBECK (1923): C. O. Skilbeck, 'Notes on the Discovery of a Roman Burial at Radnage, Bucks.', in *Antiquaries Journal*, III (1923), pp. 334–7, pl. XXXV, figs. 1 and 2b.

SMITH (1903): R. A. Smith, 'Anglo-Saxon Remains', in H. A. Doubleday and W. Page (eds)., *Victoria History of the County of Essex*, I (London, 1903), pp. 315-31.

SMITH (1904): R. A. Smith, 'Anglo-Saxon Remains', in H. A. Doubleday and W. Page (eds.), *Victoria History of the County of Bedford*, I (London, 1904), pp. 175-90.

SMITH (1922): R. A. Smith, *Guide to the Antiquities of Roman Britain* (British Museum, 1922).

SMITH (1923): R. A. Smith, *A Guide to the Anglo-Saxon and Foreign Teutonic Antiquities in the Department of British and Mediaeval Antiquities* (British Museum, 1923).

SMITH (1933): R. A. Smith, 'A Roman Glass Flask from Richborough', in *BMQ*, VII (1932-33), pp. 11-12, pl. X, I.

STEINDORFF (1960): G. Steindorff, *Die Blütezeit des Pharaonenreiches* (1900).

STRAUSS EXHIBITION (1955): *Glass Drinking Vessels from the Collections of Jerome Strauss and the Ruth Bryan Strauss Memorial Foundation. A Special Exhibition* (Corning, New York, 1955).

STRONG (1966): D. E. Strong, *Greek and Roman Silver Plate* (Methuen, 1966).

SURTEES (1816): R. Surtees, *The History and Antiquities of the County Palatine of Durham*, I (1816).

TAIT (1967): Hugh Tait, 'Glass with Chequered Spiral-Trail Decoration', in *JGS*, IX (1967), pp. 94-112.

TAYLOR COMBE (1816): Taylor Combe, *A Description of the Collection of Ancient Marbles in the British Museum* (London, 1818).

THORPE (1929): W. A. Thorpe, *A History of English and Irish Glass* (London, 1929).

THORPE (1939): W. A. Thorpe, in *Trans. Soc. Glass Technology*, XXII (1938).

THORPE (1949): W. A. Thorpe, *English Glass* (2nd edn., 1949).

THORPE (1961): W. A. Thorpe, *English Glass* (Adam and Charles Black, London, 3rd edn., 1961).

TORR (1898): C. Torr, *On Portraits of Christ in the British Museum* (London, 1898).

TOWNELEY CATALOGUE: *Ms.* catalogue of the Towneley Collection in the Dept. of Greek and Roman Antiquities, *Towneley Collection. Catalogue of Ancient Marbles* (on binding), and *A Catalogue of the Ancient Marbles in Park St. Westm. The places where they were found and where they were bought* (on title page).

TOYNBEE (1964): J. M. C. Toynbee, *Art in Britain under the Romans* (Oxford, 1964).

Trois Millénaires (1958): *Trois Millénaires d'art verrier à travers les Collections publiques et privées de Belgique. Catalogue général de l'exposition* (Liège, Musée Curtius, 1958).

VESSBERG (1952): O. Vessberg, 'Roman Glass in Cyprus', *Opuscula Archaeologica*, VII (1952), pp. 109-65.

VOPEL (1899): H. Vopel, *Die altchristlichen Goldgläser* (= J. Ficker, *Archäologische Studien zum christlichen Altertum und Mittelalter*, V, Freiburg, 1899).

WALLACE-DUNLOP (1883): M. A. Wallace-Dunlop, *Glass in the Old World* (London, 1883).

WALLIS BUDGE (1925): E. A. Wallis Budge, *The Mummy. A Handbook of Egyptian Funerary Archaeology* (2nd edn., Cambridge, 1925).

WALTERS (1926): H. B. Walters, *Catalogue of the Engraved Gems and Cameos, Greek, Etruscan and Roman in the British Museum* (London, 1926).

WEINBERG (1965): G. D. Weinberg et al., 'The Antikythera shipwreck reconsidered', in *Trans. Amer. Philos. Soc.*, n.s. LV, pt. 3 (1965).

WHEELER (1932): R. E. M. Wheeler et al., *Romano-British Kent* (Victoria County Histories, Kent, III, 1932).

WITT (1871): G. Witt, 'An Account of Implements for the Bath found in a Stone coffin at Urdingen, near Düsseldorf' (Read 23 February, 1865), in *Archaeologia*, XLIII (1871), pp. 250-7.

DE WITTE (1836): J. de Witte, *Description des Antiquités et Objets d'Art Qui Composent le Cabinet de Feu M. Le Chevalier E. Durand* (Paris, 1836).

WOOLLEY (1927): C. L. Woolley, 'The Excavations at Ur, 1926-7', in *Antiquaries Journal*, VII (1927).

WOOLLEY (1955): Sir Leonard Woolley, *Alalakh* (Research Reports of the Society of Antiquaries of London, XVIII, 1955).

WOOLLEY (1962): Sir Leonard Woolley, *Excavations at Ur, the Neo-Babylonian and Persian Periods* (1962).

WUILLEUMIER (1930): P. Wuilleumier, *Le Trésor de Tarente* (1930).

WUILLEUMIER (1939): P. Wuilleumier, *Tarente des origines à la conquête romaine* (Bibl. Ec. franç. Athènes et Rome, fasc. 148, 1939).